Tom and Jack

Tom

and Jack

The Intertwined Lives
of Thomas Hart Benton
and Jackson Pollock

Henry Adams

BLOOMSBURY PRESS
New York Berlin London

Photograph of Thomas Hart Benton by Alfred Eisenstadt, 1969. Photograph of Jackson
Pollock, photographer unknown, 1929. Jackson Pollock Papers, Archives of American Art.

End paper images: Front: *America Today*, AXA Equitable Life Insurance, Seventh
Avenue, New York. Back: *Blue Poles: Number 11, 1952*, National Gallery of Australia,
Canberra, © The Pollock-Krasner Foundation / Artists Rights Society (ARS), New York.

Unless otherwise indicated all Jackson Pollock images are © 2009 The Pollock-Krasner
Foundation / Artists Rights Society (ARS), New York.

Published by Bloomsbury Press, New York

All papers used by Bloomsbury Press are natural, recyclable products made
from wood grown in well-managed forests. The manufacturing processes
conform to the environmental regulations of the country of origin.

LIBRARY OF CONGRESS CATALOGING-IN-PUBLICATION DATA

Adams, Henry, 1949–
Tom and Jack : the intertwined lives of Thomas Hart Benton and Jackson
Pollock / Henry Adams.—1st U.S. ed.
p. cm.
Includes index.
ISBN-10: 1-59691-420-3
ISBN-13: 978-1-59691-420-9 (alk. paper)
1. Benton, Thomas Hart, 1889–1975. 2. Pollock, Jackson, 1912–1956.
3. Painters—United States—Biography. I. Title. II. Title: Intertwined lives
of Thomas Hart Benton and Jackson Pollock.
ND237.B47A85 2009
759.13—dc22
2009012309

First U.S. Edition 2009

1 3 5 7 9 10 8 6 4 2

Typeset by Westchester Book Group
Printed in the United States of America by Quebecor World Fairfield

To the memory of Ed Fry and Robert Rosenblum, who encouraged me to write this book; and to my son Tommy, who taught me to *see* the work of Jackson Pollock.

Contents

The Multi-Million-Dollar Drips

It is very dangerous to go into eternity with possibilities which one has oneself prevented from becoming realities. A possibility is a hint from God. One must follow it. In every man there is latent the highest possibility; one must follow it. If God does not wish it, then let him prevent it, but one must not hinder oneself. Trusting to God I have dared, but I was not successful; in that is to be found peace, calm, and confidence in God. I have not dared: that is a woeful thought, a torment in eternity.

—*Søren Kierkegaard*

1

Against the Cold

During the winter the drafty farmhouse at Springs got fiercely cold. For the first few years the only heat came from a small stove. Coal was hard to get, and wood burned up like paper; as it evaporated in the flames one could feel the descending chill. The winter of 1945–46 was particularly harsh. There was no indoor plumbing, and when there was a blizzard a trip to the outhouse became a kind of arctic adventure. "I opened the door this morning," Jackson wrote, "and never touched ground until I hit the side of the barn five hundred yards away—such winds."

By the next winter they had installed plumbing, but when it dropped below zero there was often ice in the toilet: Jackson sometimes had to melt it out with a blowtorch. When Peggy Guggenheim bravely came to visit, Lee gave her an oil stove she carried around with her, but it never seemed to create any real warmth. One morning when she came down to the living room in her negligee, clutching the heater, she remarked that she had never known such cold, aside from some drafty castles in England.

Such severe conditions often made it difficult to work. During the first winter making paintings in the barn was out of the question. Too cold, and also no window and no light. Instead, Jackson painted in a small bedroom upstairs. In January he started a few small canvases, but when the weather warmed he set his art aside and took a break to plant a vegetable garden and to roam around the property with a mongrel collie he had adopted, which he called Gyp after the dog he had had when

he was a boy. In June, with some help from local fishermen, he set about turning the barn into a usable studio. First he moved it from its original site, which blocked the view to the harbor, to a position closer to the house but out of the line of view. Then, after it was in place, he added a window high up in the north wall, like the one he cut into Jack's Shack when he lived on Martha's Vineyard with his teacher Tom Benton— resisting Lee's suggestion to put it lower down, since he didn't want to be distracted by an outside view. He wanted a studio that was completely closed off, that became an inner world of its own.

In retrospect, it's clear that during this break from actual work Jackson Pollock was going through some process of gestation. As summer and fall progressed, he began making paintings, slowly gathering a sort of momentum. Modest in scale, they are cheerful in feeling compared to most of his works. Playful, wiggly outlines trace biomorphic shapes reminiscent of a child's drawing. The color is rather Matisse-like, surely reflecting the influence of Lee Krasner, who admired Matisse's work. While modestly inventive, when compared to Pollock's best earlier work, such as *Male and Female, Guardians of the Secret*, or *The She-Wolf*, they seem like a falling off. They lack the brooding quality, the strange sense of emotional intensity. One would hardly guess that Pollock was on the threshold of his greatest period.

Curiously, we know very little about the process by which he moved from these relatively minor canvases to producing his masterworks. Clearly something odd was going on, something a little bit weird, for while Pollock usually worked in fits and starts and seems to have been vulnerable to seasonal mood swings, on this occasion, as the weather grew worse, as the temperature dropped, as even going into the cold barn became a task that required a certain power of will, Pollock did not cut off his painting activity but accelerated. Remarkably, the climactic moment came about when the season had shifted to wintry cold, with only a few hours of icy daylight—with Jackson bundled against the cold, with only a cigarette for warmth. We don't know which drip painting came first, or the order of those that followed, nor the exact time when the dripping started, although it was probably at some time in December 1946 or January 1947. Around this point Pollock entered the phase of his major achievements, the longest sustained period of creativity of

his career, the period of paintings that have become landmarks of American art, such as *Cathedral, Lavender Mist, Autumn Rhythm,* and *Blue Poles.*

In his works of this period, he made two radical decisions. One was to put the painting on the floor. This was partly a matter of necessity, since paintings such as *The Key,* attached to a stretcher, were too big to stand upright in his upstairs bedroom. Once he moved to the barn he continued to place paintings on the floor. The result was a new kind of composition, which fragmented the image, as he worked on it from all sides. It also produced a new kind of physical relationship with the canvas, which was more emotionally intense. In 1947 Jackson wrote a statement for the premier issue of *Possibilities*, edited by Harold Rosenberg and Robert Motherwell:

> My painting does not come from the easel. I hardly ever stretch my canvas before painting. I prefer to tack the unstretched canvas to the hard wall or the floor. I need the resistance of a hard surface. On the floor I am more at ease. I feel nearer, more a part of the painting, since this way I can walk around it, work from the four sides, and literally be in the painting. This is akin to the method of the Indian sand painters of the West.

The other decision was to start dripping paint. And dripping and spattering paint soon spawned a collection of additional artistic tricks. Pollock experimented with adding materials such as gravel, nails, tacks, buttons, keys, combs, cigarettes, and matches to provide texture and mystery, as well as with using aluminum paint, as his teacher Benton had years before in *America Today*. He dripped, dribbled, and flung the paint. He created puddles, pools, and lines. He made grand, solid lines by slowly sweeping his arm and spattery lines by quickly flicking his wrist. He used a wide, stiff brush, which holds more paint but produces a clumsy mark, as well as a stick, which crafts a line that is finer and more consistent but requires more reloadings. He used paint that was thick and viscous and paint that he thinned, and by controlling the viscosity of paint he was able to achieve some quite peculiar effects, such as something known as "coiling," when the pigment falls in a wiggly line,

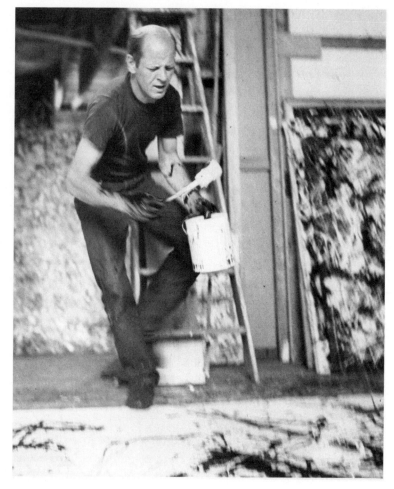

In the winter of 1946–47 Jackson Pollock began dripping and splattering paint onto canvas laid on the floor. One of these drip paintings recently fetched the highest price ever paid for a work of art: $142 million. (Photo by Hans Namuth, 1950. Estate of Hans Namuth, courtesy of the Center for Creative Photography, Tucson, Arizona.)

somewhat similar to a vibrating string, even when the paint is poured with a steady hand. Sometimes he looped the lines, as in *Vortex,* sometimes laid them straight, as in *Phosphorescence.* As he wrote:

> I continue to get further away from the usual painter's tools such as easel, palette, brushes, etc. I prefer sticks, trowels, knives and dripping fluid paint, or a heavy impasto with sand, broken glass and other foreign matter added.

When I am in my painting, I'm not aware of what I'm doing. It is only after a sort of "get acquainted period" that I see what I have been about. I have no fears about making changes, destroying the image, etc., because the painting has a life of its own. I try to let it come through. It is only when I lose contact with the painting that the result is a mess. Otherwise there is a pure harmony, an easy give and take, and the painting comes out well.

One of these paintings, *Number 5, 1948*—described by one writer as "a nest-like drizzle of yellows and browns on fiberboard"—recently sold for $142 million, not only setting a record for a piece of American art but making it the world's most expensive art object, the most costly painting ever sold. How can we set this in perspective? Let's consider, for example, that an individual making $100,000 a year, far more than the annual income of most Americans, would need to work for nearly fifteen hundred years before she or he could afford a Pollock drip painting, assuming that the person's entire income was set aside for this purchase, with nothing left over for living expenses. Moreover, that is assuming that the price of a Pollock would hold steady. In fact, Pollock's work seems to double in value about every seven years, meaning that in fifteen hundred years the price would be even more out of reach than it is now. Not bad for five or six hours of work.*

Of course, I don't wish to suggest that the value of Pollock's work can be assessed in purely monetary terms. Clearly what his paintings offer is more complex, something rather akin to the spiritual, which is not easily translated into dollars and cents. But prices like this do suggest that even those who do not like Pollock's work should stop a moment to reflect on his achievement and its enormous, almost unbelievable cultural impact.

How can some drips of paint be worth such an incredible sum? This book will grapple with this mystery. While at times it may inject a note

* In fact, the average income of a working-age American is a mere $27,412 with the result that under the terms and conditions already described it would take 5,376 years, or roughly 135 generations, to save up enough for a Pollock painting. If we suppose that a continuous line of fathers and sons began saving their entire income for a Pollock painting about 500 years before the construction of the Great Pyramid of Egypt, they would finally be able to acquire it today.

of skepticism, it is based on the belief that there is value in Pollock's paintings that is real, that they do in fact reflect remarkable ability of some sort and contain meaning that is significant. Like the *Mona Lisa*, the Parthenon, the Pyramids of Egypt, and Beethoven's Fifth Symphony, Pollock's paintings have become a fundamental cultural reference point—a benchmark of some sort against which we measure our accomplishments and who we are.

Money is one crude way of measuring this impact, but there are certainly many others, though any one of them, like money, if taken in isolation, is mildly ludicrous. For example, it's remarkable how many articles have been written about Pollock (well over a million), or how often his name appears in the comics section of the newspaper, or that newspaper stories about him are picked up not only in America but in Bulgaria as well. And of course all these things ultimately depend on what happens when we simply stand in front of a painting by Pollock, experience its visual impact, and try to make sense of its wildness, power, and mystery— its strange mix of chaos and control.

In fact, while at first such humongous sums of money for something seemingly crude and simple may sound bizarre, the case of Pollock has many interesting parallels in our culture. At the risk of sounding irreverent, it's useful to compare the phenomenon of Pollock to that of hundreds of basic consumer products, such as Heinz Ketchup or Hellman's Mayonnaise or Coca-Cola—products whose financial value makes that of a Pollock painting seem like chump change. Nothing sounds simpler than cooking down tomatoes to make ketchup or mixing eggs with vinegar to make mayonnaise or mixing caffeine and sugar to make Coke. But for year after year, decade after decade, these products have earned billions of dollars annually and have enjoyed dominance in the marketplace, despite fierce, well-funded, savagely waged campaigns to dislodge them.

In part the success of such brand names can be explained by efficiency of production and well-organized publicity campaigns, but in addition there seems to be something about the products themselves that is a little different, that is not easy to duplicate or imitate. Urban folklore often maintains that there is some secret ingredient, whose formula is carefully guarded in a bank vault. But from what has been reported with reasonable credibility on the subject, it appears that the actual ingredients

in Coke or Heinz Ketchup are fairly simple and that most of them can be found in a typical home kitchen. The trick is not some secret ingredient but using simple ingredients in a highly creative way. More specifically, the trick seems to lie in the phenomenon known as "blending," that is, mixing things together so that the flavors "blend" into something new, in which the individual ingredients are no longer easy to identify but coalesce into one flavor. With Pollock as well, the secret seems to have something to do with "blending" a lot of different styles and ideas into what seems like a simple unity. The key to understanding Pollock lies in grasping the nature of this mix.

The most notable feature of Pollock's paintings is that he made them by dripping paint, and there are many wonderful and dubious stories about how he came to the discovery. He is said to have had a leaky pen, or to have accidentally kicked over a pot of paint on one of Lee Krasner's pictures. A widely circulated bit of popular humor is an image of Jackson Pollock as a child spilling spaghetti on his mother's apron to create his first Abstract Expressionist masterpiece. Many people have claimed credit for Jackson's paint-dripping, including Whitey Hustek, the local housepainter, who believed that Pollock was inspired by the board on which he cleaned his brushes.

A number of art historians have investigated the matter very thoroughly, and what they have discovered is that quite a few artists dripped paint before Pollock did, including several individuals whom he knew. The Surrealist Max Ernst (who was married to Pollock's dealer, Peggy Guggenheim) poked holes in the bottom of a paint-filled bucket and then swung the bucket back and forth over a canvas. André Masson dribbled glue. William Baziotes seems to have preceded Pollock in making paintings based on drips, as also did Wolfgang Paalen, Gordon Onslow Ford, Francis Picabia, and Joan Miró. Hans Hofmann claimed to have made a drip painting in the 1920s and accused Pollock of stealing the idea from him. One can trace the idea of flinging paint as a gesture of rebellion against authority back to the earliest years of modern art. As early as 1877 the conservative English critic John Ruskin accused Whistler, the first artist to make paintings that are arguably abstract, of "flinging a pot of paint in the public's face."

Well before 1946 Pollock himself experimented with making compositions from drips. In high school he dripped paint onto a plate of glass

covered with water. In 1934 he worked with Benton's wife, Rita, creating ceramic bowls on which he dripped and dribbled ceramic glazes. In 1938 he worked closely with the Mexican muralist David Alfaro Siqueiros, who encouraged his associates to throw and splatter pigment, so that it landed in coagulated blobs. Several of Pollock's paintings of the early 1940s, such as *Male and Female* of 1943, have extensive passages created with dripped paint. And while Pollock's great phase of drip painting seems to have started in 1946, he produced a remarkable canvas that is mostly done with poured pigment, *Composition with Pouring II,* as early as 1943.

In short, what was new about Pollock's work of late 1946 and early 1947 is not simply that he dripped and splattered paint but that he did so with a new vision. If we set earlier drip paintings beside those that Pollock began making around 1946, they feel tentative and unsure; they look compositionally unresolved and weak. While initially Pollock's famous paintings may appear chaotic, if we set them beside the work of other figures, we sense that something about them is different, that they are grander in design and more emotionally powerful. Essentially, this book proposes that writers on Pollock have missed a key ingredient—the influence of Thomas Hart Benton, Pollock's teacher and father figure.

"All I Taught Jack"

When the columnist Leonard Lyons asked Thomas Hart Benton about his relationship with Jackson Pollock, Benton deflected the question with a sarcasm. "It was obvious from the first," Benton said, "that Pollock was a born artist. All I taught Jack was how to drink a fifth a day."

Benton clearly intended this statement to be funny, as well as to bolster his own tough-guy persona. But as Freud has revealed to us, jokes touch on forbidden, repressed feelings. In fact, there's a good deal of evasion and concealment to Benton's quip, for Benton knew very well that his relationship with Pollock went deeper than casual drinking. Pollock received his only formal artistic training from Benton, learned to paint like Benton, and lived for six years virtually as a member of the Benton family. Indeed, for Pollock, Benton became a surrogate father—a substitute for the weak, absent father that nature had given him—just as for Benton, Pollock became a substitute son.

The pull between the two figures was so strong that it is curious that

it has been systematically passed over by most writers on Pollock. One reason, of course, is that Benton has generally been dismissed as a "conservative" artist—which in fact was very far from the case. While Pollock has come to be viewed as the exemplar of all that is most exciting about modern art, Benton has been equated with all that is most wrongheaded and reactionary.

"I am a very fortunate artist," Benton once commented. "A lot of people have disliked my art intensely enough to keep it under continuous attention. This has stimulated public interest and made me successful." Benton was not exaggerating about the extent of the dislike, which is still very much alive in some quarters.

Some years ago, when I had just started working with the filmmaker Ken Burns on a documentary about Benton, he expressed concern that it might be difficult to create enough clash of divergent opinions to make the movie interesting. He had just finished a film on the southern demagogue Huey Long, and he feared that Benton would not stir up as much emotion. "People wanted to kill Huey Long," he commented to me. "No one wanted to kill Thomas Hart Benton."

As it happened, our first interview was with Hilton Kramer, the former art critic for the *New York Times,* and it quickly became apparent that Kramer might well have been happy to kill Benton; in fact he referred to his art as a "corpse." After that interview, Ken never again expressed concern about any lack of dramatic conflict.

The vehemence of Kramer's contempt is difficult to convey through a brief excerpt; throughout the interview his tone of disparagement never softened, even for a moment. He repeatedly insisted that there was absolutely nothing whatsoever in Benton's work worth looking at or taking seriously. In a typical outburst, he declared:

Twenty-five years ago, one never dreamed there would be a revival of Benton. The whole attitude towards art that's embodied in his work, embodied in his writing, embodied in his career, seemed safely dead . . . His work, to me, is a sort of corpse that's been disinterred . . . To me it doesn't really exist as an aesthetic object.

Kramer's stance was one that became widespread in the American art world in the second half of the 1940s. Before that period, while Benton

stirred up controversy, mostly for the alleged vulgarity of his subject matter, he also had vigorous defenders. After World War II, however, with the emergence of the Museum of Modern Art as a major force in American culture, and the widespread enthusiasm for painters such as Matisse and Picasso, Benton came to be seen as an intransigent foe of modern art, and as a sort of embodiment of reactionary beliefs of every sort.

In May 1946, for example, the noted art historian H. W. Janson, author of what for decades was the standard textbook on the history of art, published an attack on Benton in the *Magazine of Art*. The vitriol of this piece is unlike anything else in Janson's writings, which tend to be rather dry. After opening with the declaration that Benton's work was "essentially anti-artistic in its aims and character," he went on to maintain that it was nourished by "the same ills that, in more virulent form, produced National Socialism in Germany." Not content with this, he wrapped up his diatribe with an ad hominem dig. "He seems to go through life in constant fear of being called, 'Shorty,'" Janson concluded, "a condition not unfamiliar to psychologists."

No one came to Benton's defense. Within a few years, in a remarkable cultural shift, Benton, who had been arguably the most famous American painter of the 1930s, was pushed off the stage. In 1948, for example, when *Look* magazine asked a group of American art experts to list "the ten best painters in America today," Benton did not even make the list.

It would take a psychologist to explain why Benton was particularly singled out for such attacks, over any other painter, and became a sort of bogeyman to the East Coast cultural establishment. At some level, I suspect criticism of Benton and his art provided a screen for the expression of prejudices that would have been socially unacceptable in other arenas. Benton's delight in presenting himself as a midwestern hillbilly surely played on many easterners' perception that those from the hinterlands are uncultured political reactionaries and bigots. Indeed, much of the criticism of Benton, even today, contains an undercurrent of social and regional bias.

Even today, in many artistic circles, Benton's name seems to trigger some strange sort of cultural taboo, which makes it not only impermissible to admire his work, but somehow dangerous even to look at it. This sense of Benton's pictures as taboo—something that should not be

touched or looked at—was explicit in Hilton Kramer's remarks, but an even more striking expression of it came from John Russell, another *New York Times* art critic, who visited Kansas City to view a large group of Henry Moore sculptures that had just been donated to the Nelson-Atkins Museum. The Benton retrospective was running at the same time, but when asked whether he wanted to go through it Russell replied, with a shudder, "No."

Much of the commentary on the show ranged from condescending to outright vituperative. Robert Hughes in *Time* magazine wrote: "Benton was a dreadful artist most of the time . . . He was flat out lapel-grabbing vulgar, incapable of touching a pictorial sensation without pumping and tarting it up to the point where the eye wants to cry uncle." The art critic for the *Kansas City Star*, not to be outdone in disdain by his New York counterparts, called it "the worst exhibition I have seen in forty years."

Over the last decade or two attitudes toward Benton have somewhat softened, and he has even been mentioned at times in writing on Pollock as a possible influence. But this sort of investigation never seems to extend very far, and one of the tropes of such analysis seems to be that no mention of Benton can be made unless one wraps up the discussion with a deprecating remark. Many of these criticisms of Benton do not hold up if one takes the trouble to actually look at Benton's paintings. In recent years, for example, a good many writers have criticized Benton for presenting a falsely idealized view of the 1930s. In actual fact Benton's paintings of the 1930s are filled with social commentary and social criticism. Somehow these writers have confused his work with that of a very different midwestern painter, Grant Wood.

Needless to say, if one is not willing even to look at Benton's work, this rules out the possibility that one will appreciate his influence on Pollock. And John Russell's reaction was certainly not unique, as we will see.

I will not attempt to go into all the reasons for this hostility against Benton here, but to follow my argument you will need to set such prejudices aside. I will ask you to keep your eyes open when you look at Benton's work, so that you can see the very obvious ways in which it was influenced by French modern art, and the equally obvious ways in which Pollock's work—particularly the famous drip paintings—were dependent on Benton's teachings.

The other reason why the relationship between Benton and Pollock has not been explored is perhaps more excusable. It is that Pollock's relationship with Benton was not a smooth or straightforward one. Instead, it was a turbulent, oedipal affair, filled with anger, rebellion, and misunderstanding—a relationship between a loving but difficult father and his rebellious son.

In short, Pollock's art is great because it achieves a "blend" of a very special sort. He did in fact learn from Picasso, the Surrealists, and all the various figures on display in the newly opened Museum of Modern Art. But he also absorbed artistic ideas through a different channel, that of Thomas Hart Benton. Through Benton he absorbed a different interpretation of European modern painting, as well as a number of bold ideas about how an artist could achieve greatness as an American.

Notably, the influence of Benton was not simply formal—that is to say, it did not simply affect Pollock's handling of shape, color, and composition. It went deeper. Benton influenced Pollock's ideas about the role of the artist, about how to promote oneself, about how to stand out from the pack, about how to take European ideas and convert them into something distinctively American. Indeed, one of the most notable lessons was that Benton taught Pollock something about how to harness the power of myth and national identity. It was the blend of these two traditions, that of conventional modernism and that of Benton's renegade American modernism, that created a figure who was unique and not easy to imitate. This book is the story of that mix, as well as of the explosive relationship between the two men.

2

The Pollock in My Office

I come to this quest from an unusual perspective—that of having lived for years, on intimate terms, with paintings by both Benton and Pollock. In 1985, when I settled into the Nelson-Atkins Museum of Art in Kansas City, with the assignment of organizing a major exhibition of Benton's work, one of the first things I did was to hang a painting by Jackson Pollock on my wall. Today, when paintings by Pollock are often so fabulously expensive, this sounds like an amazing thing to do. Of course, I was dealing with a Pollock of a very different sort than one of his famous works.

The name Jackson Pollock summons up images of huge mural-size canvases covered with splatters and drips such as *Autumn Rhythm* or *Blue Poles*. This was something of another category, a tiny oval painting on board, just seven or eight inches high, which had been left to the museum by Benton's wife, Rita. It showed the boat of Benton's son, Thomas Piacenza Benton—always known as T. P.—sailing on Menemsha Pond off Martha's Vineyard. Everyone agreed that the painting was extremely ugly—and that it certainly didn't belong up in the galleries. One person even suggested that its brownish forms in their circular setting resembled the contents of an unflushed toilet bowl.

Having it on my wall was a joke of sorts, although one I hoped to learn from. While Pollock and Thomas Hart Benton are usually considered worlds apart, actually, as I already knew, Pollock was Benton's pupil and tried hard to paint just like him when he was a student. The painting

in fact was extremely Benton-like, with objects that can be matched one-to-one with many paintings by Benton, all organized with the sweeping Mannerist rhythm characteristic of Benton's work. Even the muddy color and crusty surface relate to works by Benton—although not so much to the midwestern scenes for which Benton is best known as to a series of seascapes he made in the 1920s, in which he paid tribute to Pollock's favorite American artist, the visionary painter of night, moonlight, boats, and the sea, Albert Pinkham Ryder.

Considered from a technical standpoint, the painting showed a level of talent that seemed very marginal. When rendering a boat, a tree, a sandbar, or a cliff, Pollock's technical skill resembled that of a small child. And yet for some reason the painting was fascinating. What was marvelous was the way the forms flowed into each other. Slightly at the expense of normal spatial relationships, the sinuous line of land formed a pathway to the clouds and sky. The boat chased the setting sun, indeed, seemed to threaten to levitate and join the cloud floating over it. The painting captured the magic of sailing as a form of escape, when we can imagine disappearing over the horizon and entering new worlds. While I initially put up the painting as a joke, I lived with it for slightly over eight years and never got tired of looking at it. It became a friend, and something that added interest and vitality to my life.

I mention my experience because it is usually supposed that Pollock's early work bears little relationship to his great mature achievements, and yet, when I lived with one of his early paintings, I found that its impact was curiously similar, although admittedly less powerful. A recurrent theme, for example, in accounts of those who first encountered Pollock's work is the notion that it is ugly and lacking in skill. Indeed, not unlike the little boat painting I got to know, the mature paintings have often been compared to clumps of vomit or excrement. Take, for example, the account of the English museum director and Renaissance scholar Sir Kenneth Clark, who went to Venice in 1950 to see the great Giovanni Bellini exhibition and while there encountered Jackson Pollock's work for the first time. In many ways, Clark was a figure wedded to tradition: his great love was the art of the Italian Renaissance. What is interesting about his account is the frankness with which he reveals his initial dismay, as well as the interesting fact that he then reversed his judgment and decided that Pollock was a genius.

Walking back to the Hotel Monaco, at the corner of the Piazza, I could see through the open doors of an exhibition gallery large canvasses covered with scrawls of aggressive paint. They screamed and shouted at one from the back of the banal modern gallery. No greater contrast to the quiet and comforting voice of Bellini can be imagined. At first I was horrified, but in the end I went in before visiting the Bellinis, and recognized that these explosions of energy were the work of a genuine artist. It was the first European exhibition of Jackson Pollock. Now that an enormous painting by Jackson Pollock has been made the culminating point in the Metropolitan's exhibition of its masterpieces it may seem that I have no cause to congratulate myself on recognizing his greatness; and indeed in his native land there is no difficulty in doing so. He is the archetypal American painter, as Whitman is the archetypal American poet. But in Venice, in the year of the Bellini exhibition, it was less easy.

Pollock's paintings, in short, initially seem lacking in skill or ability of even the most elementary sort, but as one lives with them, they start to become fascinating, haunting, unforgettable. They get under one's skin. To put it in a way that sounds like a contradiction, they display some kind of skill that is lacking in skill. What is more, this quality is found in Pollock's earliest works, the ones that imitate the work of Benton, as well as in his later grand achievements. Could it be that this quality in his work was somehow linked with Benton, whether in the manner of organizing form and composition or in some deeper affinity of character or temperament shared by these two remarkable figures? Was it somehow associated with what Pollock learned from Benton? What were the links between these two figures—and what were the tensions that made them ultimately work in such different modes? What does the art of these two figures say about the worlds they lived in and the dramatic historical changes they lived through? In a sense this book is an attempt to answer the questions I asked myself daily during those years when Jack Pollock's little painting hung beside me on my office wall.

Part Two

Benton and the Pollock Boys

Years before I commenced the practice of referring to actual objects for the subject matter of my pictures, I would get fascinated with the nature of a fence post, a bush, a rock, or a ripple of water, and I would pass from an abstracted study of one of these into a long and, as far as I could ever explain it, an empty reverie. This psychological failing developed long before I ever thought of myself as an artist.

—*Thomas Hart Benton*

The Kid from Cody

Jackson Pollock was the sort of person that Thomas Hart Benton pretended to be: the child of poor, working-class drifters, with little education and few prospects. In a sense, Pollock was the embodiment of the impoverished, inarticulate America that Benton sought to capture, out of some strange, seemingly illogical conviction that something about these people was beautiful.

Thomas Hart Benton liked to present himself as a crude, uneducated hillbilly, but in fact he was very far from that. He was the son of a U.S. congressman, spent much of his childhood in Washington, D.C., went to private schools, and was exposed as a child to art, classical music, fine dining, political discussion, the niceties of social etiquette, and books of all kinds, particularly works on politics and history. To be sure, as a boy Benton also spent time in Neosho, Missouri, where he was exposed to the hardscrabble life of Ozark farmers. During his years of struggle to establish himself as an artist, he experienced poverty that was very real, supporting himself through hard manual labor, such as working as a stevedore, and even stealing food to survive. But Benton's inner self-confidence despite years of devastating rejections, his wide range of interests, and his remarkable skill with words, which made his autobiography one of the best books written in the 1930s, all provide clues that his background was in some way socially privileged; these things reveal, despite all his pretenses to the contrary, that in actual fact he came from a family of prominent lawyers and politicians rather than people who

were simply laborers or subsistence farmers. As the folksinger Burl Ives commented in an interview with Ken Burns: "You see, Tom Benton . . . He liked to be a 'hail fellow well met' and one of the gang but he wasn't. He was an introspective, thinking man. He was very well read—all the classics—but he didn't want anybody to know it. Tom Benton was an aristocrat."

The bond between Benton and Pollock, in short, was far from straightforward; it was forged out of their differences as well as their emotional connections. Indeed, even when we retrace the jagged history of their relationship, there are several key events that seem highly implausible: Pollock's decision to become an artist (a profession hardly typical for someone of working-class background); his learning about Benton and seeking him out as a mentor; their forming a lifelong bond (which was broken only by Pollock's death); or Pollock's ascent to his position as the most celebrated figure in the history of American art.

Both of Jackson Pollock's parents, Stella and Roy, came from brutally humble backgrounds, similar to that of the Ozark hillbillies, the people often described as "white trash," whom Benton liked to sketch. Pollock's mother, Stella McClure, the eldest child in her family, was born on May 20, 1875, in a log house near the little town of Mount Ayr, Iowa. Her parents were stern Presbyterians who believed that there was just one straight and narrow path to salvation. Life on the McClure farm was harsh and strictly regulated, and misfortunes, which came frequently, were accepted with a kind of stoic resignation. One of Stella's sisters died of convulsions in her arms; another died young of tuberculosis. Around 1890 the farm failed, and the family moved to Tingley, Iowa, where her father, John McClure, found work as a brick-mason and plasterer.

The woman who emerged from this harsh background was at once strong-willed and strangely inexpressive. "You couldn't read her at all," noted Ethel Baziotes, the wife of the painter William Baziotes, when she met Stella in the early 1940s. "She was like an American Indian woman. She sat like statuary the entire evening and didn't move once, but she followed everything." Despite her reserve, Stella had a will of iron. "Mother always had control," Jackson's brother Charles noted. "She knew what she wanted, and what she thought was worthwhile, and she knew how to get it."

The background of Jackson Pollock's father was, if possible, even

grimmer than that of his mother. Two years younger than his wife, Roy Pollock was born to the name of LeRoy McCoy on February 25, 1877, on a small farm in Ringgold County, Iowa. In 1879, when LeRoy was two, his mother and sister both died of tuberculosis. Despairing and destitute, John McCoy gave away his infant son to James and Lizzie Pollock, a poor farm couple in Tingley who were not his relatives. McCoy then moved back to his home state of Missouri, and not long afterward he married a relatively wealthy landed woman and raised a family. But he never sent for or in any way acknowledged the existence of his first son.

The Pollocks were penny-pinching skinflints and religious zealots. LeRoy grew up in a loveless home and was financially exploited by his foster parents, who often sent him out to work for other farmers and pocketed the modest income. Twice during his childhood, LeRoy ran away from home but returned in a destitute state just short of starvation. Just a few days shy of his twentieth birthday, the Pollocks legally adopted LeRoy, with an indenture that specified that "said Roy McCoy shall hereafter be called Roy Pollock." Their motive seems to have been to gain legal control so that they could keep him from running away again and continue to financially exploit him. Around the time of his marriage, Roy is said to have attempted to change his last name from that of his hated foster parents back to McCoy, but he didn't have enough money to pay the fees requested by the lawyer. But for this fact, Jackson Pollock would today be known as Paul Jackson McCoy.

Roy Pollock emerged from this ordeal a shy, sensitive man, no match for the formidable Stella McClure, and he seems to have started drinking to escape his problems while still in high school. Yet in his quiet way, Roy was an independent thinker, opposed to the hypocritical formal religion of his stepparents and a believer in socialism and the rights of working men—"the lone socialist in Ringgold County."

It's not recorded how Roy and Stella met, although Roy was a high school classmate of Stella's younger sister Anna. Their relationship became a romance when they were in their mid-twenties, and in 1902, when she was twenty-seven, Stella discovered that she was pregnant. On Christmas Day that year she gave birth to her first child, Charles, while staying with her sister in Denver. LeRoy Pollock was still in Tingley, but three weeks later he headed west and the two met in Alliance, Nebraska, where they were married with scant ceremony at the Alliance Methodist

Episcopal Church by a minister they had met only moments before. With her typical silent stoicism, Stella always concealed the fact that Charles was born out of wedlock. Charles learned the fact only after her death. Shortly after their marriage, the Pollocks moved to Cody, Wyoming, where Roy Pollock worked at a variety of menial jobs. In the nine years they lived there, Roy and Stella had four more sons: Marvin Jay, Frank, Sanford (always known as Sande), and finally Paul Jackson, the youngest, born on January 28, 1912.

Although in his biographical statements Jackson Pollock always mentioned being born in Cody, in fact he had no memories of the place. Ten months after he was born, the family moved to National City, California. After staying there only a few months, they moved to Arizona, and Roy purchased a twenty-acre plot of land six miles east of Phoenix, on the road to Tempe.

The next four years, spanning Jackson's life from the ages of two to six, were the happiest years for the Pollocks, their only years when they functioned together as a family unit. The house was a small adobe, with just four rooms. There was no bathroom, but rather an outhouse. During the winter the boys slept in a bedroom with three beds for the five of them, but during the summer they usually slept outdoors, dragging the beds out under the trees. They had a cat and a dog, Gyp, a mixture of collie and terrier, with short legs and a brown patch around one eye. The older children had chores to do, but Jack, the youngest, simply roamed around the place. Jack's constant companion was his just-older brother Sande, who also cared for him later in life, when they lived together in New York. His brother Frank later recalled that "it was always 'Jack and Sande' . . . they were like two burrs on a dog's tail." Looking back on these years, Roy would write wistfully: "I wish we were all back in the country on a big ranch with pigs cows horses chickens . . . The happiest time was when you boys were all home on the ranch. We did lots of hard work, but we were healthy and happy."

This idyll ended in 1917 due to a combination of financial pressures and Stella's unrealistic dreams. Prices for produce were dropping, and Stella had set her mind on moving on to a place with better prospects and better schools for her boys. On May 22, 1917, they sold the farm at auction. Frank later recalled that his father never got over the disappointment of losing it. As he said, "It was the end of my dad." At this

point the Pollocks began a downward spiral. They would live in seven or eight houses over the next six years while the family gradually fell apart.

In 1917 they moved to Chico, California, where they acquired a fruit farm. The farm lost money, so they moved to Janesville, California, where they acquired a small hotel. The hotel lost money, so they sold it to acquire a farm in Orland, California. But this farm was never actively maintained, since by this time Roy had moved out and was working at odd jobs elsewhere—sending checks home to his wife. The financial situation continued to grow worse. In 1923 Stella sold the Orland farm in exchange for a Studebaker and some cash. She drove to Phoenix, not far from where Roy was then working, and rented a house in a poor neighborhood. When she could no longer pay the rent, she took a job as a housekeeper for a widowed farmer, Jacob Minsch. When Minsch remarried she moved once again, taking a job as a cook on a ranch outside of Phoenix.

Throughout this period Roy drifted from one low-paid job to another in a slow but steady descent, moving from small-scale truck farmer to laborer on ranches and road crews, often half a continent away from his family—slowly drifting away from his wife and five children into despair and alcoholism. For a time the eldest brother, Charles, served as a sort of surrogate father. In 1921, however, Charles quit high school and left for Los Angeles, once again depriving Jackson of a paternal figure. "I sometimes feel my life has been a failure," Roy wrote to Jackson in 1927, when Jackson was fifteen, "but in this life we can't undo the things that are past we can only endeavor to do the best possible now."

After Charles's departure the family grew increasingly scattered. Jackson, being the youngest, generally stayed with his mother, while the others drifted in and out of the household, as they struggled to support themselves and find a path in life. In September 1924 Stella moved again, this time to Riverside, California, apparently so that the two youngest boys, Sande and Jackson, the only ones remaining under her wing, could attend a good school. Jackson enrolled in Riverside High, but in the spring, shortly after getting in a fight with an ROTC instructor, he dropped out. Shortly afterward, in September 1928, Stella moved still one more time, to Los Angeles. She had apparently grasped that Jackson did not connect well with reading, writing, and academic subjects and wanted him to attend a school that better suited his interests: Manual Arts, a large

public school with over three thousand students, devoted, as its name suggests, to art and vocational training.

The Phrenocosmian Club

Up to this point, Jackson's life was just a narrative of wanderings. What is remarkable, in fact, coming from the background he did, just one step up from the homeless Okies Steinbeck celebrated in *The Grapes of Wrath*, is that Jackson Pollock ever chose to become an artist. But his father, Roy, despite his feckless ways, had a love of books and a belief in education as something that could improve one's life. Above all, Jackson's mother, Stella, the backbone of the family, had social and cultural aspirations, apparently largely gleaned from reading women's magazines. She taught her boys to dress stylishly and be well behaved: she had high aspirations for them. She wanted them to rise above the rough, barely subsisting lifestyle that she and her husband had known.

It was Jackson's brother Charles who turned the family toward art. From childhood Charles had excelled in calligraphy and drawing—an interest encouraged both by his mother and by a series of supportive art teachers—and by high school he had decided that art would provide an escape from the hardscrabble working-class existence of his parents. Remarkably, all five of the Pollock brothers at some point aspired to become artists, and three of them attained this goal. All agree that Jackson chose to become an artist because Charles provided a model for him to do so. As Stella told an interviewer from the *Des Moines Register* in 1957: "When Jackson was a little boy and was asked what he wanted to be when he grew up, he'd always say, 'I want to be an artist like my brother Charles.'" For years, however, it was Charles who seemed the most gifted member of the family, and Jackson, lacking in any evidence of ability, simply played catch-up.

By the time he settled in Riverside, Jackson had taken on the persona of an artist, although by all accounts he showed no artistic talent and did not do much in the way of actually making art. At Manual Arts he immediately became part of the group that gathered around the most eccentric member of the faculty, the head of the art department, Frederick John de St. Vrain Schwankovsky, generally known as Schwanny. Schwanny had studied at the Art Students League in New York and had

then moved to Hollywood to design sets for Metro Pictures. When Metro was absorbed into Metro-Goldwyn-Mayer, he was laid off and took a temporary job as a high school art teacher. The temporary job became permanent. Schwanny stayed on at Manual Arts for another thirty-two years, designing stage sets, organizing a fencing team, instituting a "color week," and singing solos at school assemblies. His own work consisted of amateurish Cézanne-like landscapes, thoroughly conventional still-life paintings, and movie star portraits. But he had been introduced to mysticism by his wife, Nellie Mae Goucher, and he encouraged his students to let their minds go, to paint their dreams, and to "expand their consciousness." He even formed a philosophical society called the Phreno-cosmian Club.

In the period when Jackson attended the school, Schwanny had a cluster of gifted students, several of whom went on to notable careers. The best known of these today is Phillip Goldstein, who later, to hide his Jewish background, changed his name to Philip Guston and became illustrious, like Pollock, as an Abstract Expressionist. Jackson's closest friend was Manuel Tolegian, who would also go on to study with Thomas Hart Benton and exhibited talent as a painter, musician, and inventor but never hit the big time. Later in life, Tolegian bitterly resented Pollock's success and disparaged his talent. "He worked hard to make conventional drawings," Tolegian stated, "but he just didn't have what it takes."

Like many other high schools, Manual Arts was largely focused on sports and largely ruled by the football team. Pollock was part of a small artistic clique that opposed this group. In March of 1929 Phillip Goldstein and others printed up a pompously written one-page leaflet opposing the way that sports dominated the school—"we oppose most heartily the unreasonable elevation of athletic ability," it stated—and even suggesting that letters should be awarded for artistic rather than physical prowess. While he had nothing to do with creating it, Pollock was caught by a janitor distributing the leaflet and was suspended from the school. His co-conspirators Don Brown and Manuel Tolegian managed to graduate, but Phillip Goldstein was identified as one of the authors of the pernicious tract and was also suspended.

As Charles Pollock once commented, his youngest brother always showed a weakness for joining cults, whether they were spiritual or artistic. During the period of his suspension, Jackson attended a spiritual rally

presided over by the Indian mystic Krishnamurti. By the time he returned to school in September, he had begun dressing like Krishnamurti and was writing letters about spiritual doctrine to Charles. Unfortunately, spiritual enlightenment did not make his school experience any easier. On the contrary, his long locks and artsy friends made him a natural target. That fall a group of football players attacked him, cut his long hair, and then dragged him to a bathroom, where they forced his head into the toilet. Shortly afterward, Jackson had a fight with the football coach, Sid Foster, and was suspended once again. In February 1930, apparently through Schwanny's intervention, Jackson was permitted to return on a limited basis, to take classes in modeling and sculpture, but his work was ungraded, and at the end of the term he did not have enough credits to graduate.

That summer, Jackson worked for a time with his father on a road camp, but apparently something about the experience went bad: according to one account, the two got involved in a fistfight. Jackson returned home from the camp a month early and never worked with his father again. Indeed, they hardly saw each other again: one might almost say that Jackson's relationship with his father ended at this point. But at this seemingly unpropitious time, Jackson Pollock made one of the turning-point decisions of his life. Rather than returning to school, he decided to go to New York with his brothers Charles and Frank to study with Thomas Hart Benton.

Benton and the Pollock Boys

Charles Pollock, ten years older than Jackson, was the one who discovered Benton and first went to study with him. In 1926 Charles got a job at the *Los Angeles Times* and worked his way into the layout department, where the pay was good. He also took art classes at the Otis Institute but was bored by them. One day he picked up a copy of *Shadowland,* a movie magazine. Very likely he acquired it for the girlie pictures, which were plentiful, but it also carried stories about contemporary art, and it had an article by a young writer named Thomas Craven about Thomas Hart Benton. Charles liked the racy prose with which the story was written. Equally significant, he liked the masculinity and modernity of the work itself, which strikingly contrasted with the insipid California Tonalism and Impressionism that surrounded him. On the recommendation of a

friend, the art critic Arthur Millier, he decided to move to New York to study with Benton at the Art Students League.

When Charles knocked on Benton's door, he was welcomed as if he were the prodigal son. No doubt based on some insecurity in his own character, Benton had a particular affinity with raw young western boys who came east to confront the challenge of making great art. Showing up unannounced at Benton's apartment on Hudson Street, near Abingdon Square, Charles was "received with open arms," and from that moment he became not only a regular in Benton's class but a constant visitor to his home, a virtual family member. By the fall of 1927 Charles had an apartment in the same building as the Bentons, and in the summer of 1928 he visited with the Bentons at their cottage on Martha's Vineyard. When Charles needed money, Rita found him work designing motion picture display cards for a Long Island printing firm, and Benton found him a part-time teaching job at the City and Country School on West Thirteenth Street, where their son, T. P., was a student, run by their close friend Caroline Pratt. As Charles later confessed, he responded to Benton with "total devotion": "Whatever talent I had when I came to New York was nonexistent. I had only enthusiasm, excitement, and a

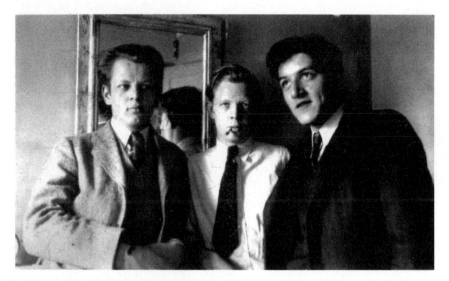

Jackson Pollock (left) with his brother Charles (center) and their friend Manuel Tolegian, shortly after Jackson's arrival in New York. (Pollock-Krasner Study Center, Jeffrey Potter Collection.)

burning desire to study with him." He even took to dressing like Benton, quickly shifting from white spats and silk vests to rumpled shirts and suspenders such as Benton wore.

Charles was soon followed by his brother Frank, who also came east to study with Benton and also fell under his spell. Jackson, the baby of the family, followed a year later, moving with his brothers into the apartment in the same building as the Bentons. All the Pollocks were treated as if they were members of the Benton family, and they were constantly wandering in and out of the Benton home. Jackson, being the youngest, was particularly mothered by Rita, who would often hire him to baby-sit for T. P. and then use this as an excuse to invite him to stay for dinner. Jackson was quickly pulled into Benton's artistic orbit as well: within weeks of his arrival, Jackson was doing "action posing" at a loft on Twelfth Street for Benton's first great mural, *America Today.*

Even those who didn't like Benton had to admit that he was an electrifying figure—a kind of lightning rod. As Pollock's biographers Steven Naifeh and Gregory White Smith have commented:

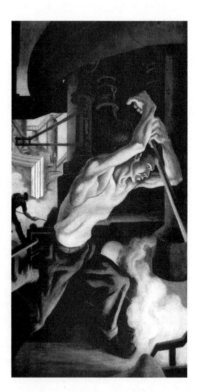

Soon after arriving in New York, Pollock did action posing for Benton's mural *America Today.* (AXA Equitable Life Insurance, Seventh Avenue, New York, Licensed by VAGA, New York)

What Hemingway was to a generation of writers, Benton was to a generation of American painters, the ideal against which, consciously or unconsciously, they measured themselves—as drinkers, as fighters, as rebels, as provocateurs, as womanizers, as debunkers, as outsiders, as Americans, and as artists. No one felt the force of Benton's oversized personality more fully or was more transfixed by it than Jackson Pollock.

Jackson duplicated his brother's extravagant admiration for Thomas Hart Benton but did so with even greater intensity. In fact, Benton, then forty-one years old, made a natural father figure for him: he even looked somewhat like Roy Pollock—short in stature, self-conscious, pugnacious, with a creased face and leathery hands. Harry Holtzman commented that Jackson "tailed after Benton like a puppy dog. Whatever Benton did he wanted to do." As George McNeil said, "There was a rhythm between Jackson and Benton from the time they met until the time Jackson died. The rhythm was physical, gestural. The two men were *bonded,* you could almost say." Stanley William Hayter recalled that Jackson "never mentioned his own father" but "had found a substitute one in Benton."

From the first, Benton attracted and was attracted to students of a particular type. Benton was the first American artist to explore the social problems of America as a whole: to depict rich and poor, worker and capitalist, as well as the full (or nearly full) range of American regions and professions—north, south, east, and west as well as farmer, coal miner, steelworker, cowboy, soda jerk, stevedore, tailor, musician, secretary, and stockbroker. Despite his privileged childhood, he looked at America from the standpoint of the poor and dispossessed; he himself had felt poverty so long and so deeply that this viewpoint fit him naturally. As a consequence, Benton's art had a particularly strong appeal to those from humble backgrounds. As Benton later wrote of Jack:

He was very young, about eighteen years old. He had no money, and, it first appeared, little talent, but his personality was such that it elicited immediate sympathy. As I was given to treating my students like friends, inviting them home to dinner and parties and otherwise putting them on a basis of equality, it was not long before Jack's appealing nature made him a sort of family intimate. Rita,

my wife, took to him immediately, as did our son T. P., then just coming out of babyhood. Jack became the boy's idol and through that our chief baby-sitter. He was too proud to take money, so Rita paid him for his guardianship sessions by feeding him. He became our most frequent dinner guest.

Although . . . Jack's talents seemed of a most minimal order, I sensed he was some kind of artist. I had learned anyhow that great talents were not the most essential requirements for artistic success. I had seen too many gifted people drop away from the pursuit of art because they lacked the necessary inner drive to keep at it when the going was hard. Jack's apparent talent deficiencies did not thus seem important. All that was important, as I saw it, was an intense interest, and that he had.

Figures like Fairfield Porter, who had inherited culture and wealth and had gone to Harvard, could grudgingly admire aspects of Benton and admit that he was a man of sharp intelligence, but they could not quite empathize with Benton as a whole, or embrace his rough-hewn persona. "He had what James Truslow Adams calls the 'mocker' pose," Porter once commented of Benton. "He liked to pretend; he liked to act as though he were the completely uneducated grandson of a crooked politician. I found that sort of tiresome."

To those of more humble origin, however, particularly those who, like Pollock, came from the West, he was a friend, a model, a magnet, an inspiration. Indeed, westerners, such as the Pollock brothers, were always at the center of Benton's circle. For some reason, regardless of their level of artistic talent, he felt a particular fondness for them: probably they reminded him of the country boys who had been his companions during his childhood in southwest Missouri. In fact, Jackson Pollock was the paradigm of the kind of student Benton liked best: a westerner from a poor background, preferably rural, who had an emotionally troubled relationship with his father. In complex ways these traits all mirrored qualities of Benton himself.

Since they were generally poor, most of Benton's students had trouble paying tuition. Benton always had to scramble to get them scholarships or find them odd jobs sweeping floors or working in the cafeteria of the League. Edith Bozyan, who also studied with Benton at this time, has

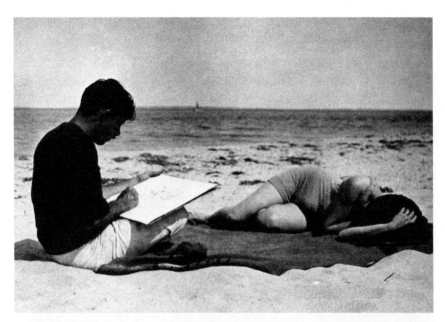

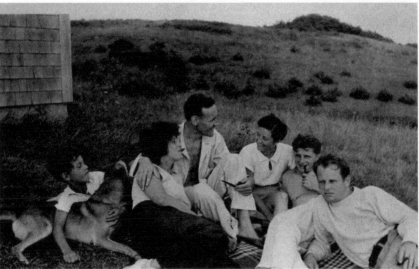

Top: Thomas Hart Benton sketching his wife, Rita, on the beach at Martha's Vineyard, 1922. *Bottom*: Jackson Pollock (far right) with Rita (left), Benton's son, T.P. (with the dog), and a group of friends. (Benton research collection, Nelson-Atkins Museum of Art, Kansas City.)

told me that Rita Benton arranged for milk to be delivered to the Pollock brothers every morning at her own expense and that this provided their only breakfast since they didn't have enough money to buy food. Indeed, Rita mothered all of Benton's students and looked for suitable excuses to invite them to her spaghetti dinners. When Jackson was sick, Rita nursed him.

Rita Benton

While Tom was short and swarthy, Rita Benton was tall, slender, and exceptionally beautiful in a dark-toned Italian way that must have seemed thoroughly exotic, almost otherworldly at the time. The beauty was not simply in her figure but in the way she moved, and laughed, and greeted people. "Oh boy, Rita Benton! Boy . . . what a woman," commented Benton's student Earl Bennett, when Ken Burns asked about her. "There was more fire in that Italian lady than I ever saw in any woman. I loved Rita, and I think anybody who knew Rita loved Rita Benton."

During his early years in New York, Benton's inability to retain girl-friends had provided a subject for mirth among his friends. One of them became so angry that she stabbed him in the back with a kitchen knife. None of them seemed to last for very long. Then to everyone's amazement he finally found a woman who would put up with him. Their one point of mutual agreement was that the other was fundamentally unreasonable. "No American woman would put up with Tom," Rita declared repeatedly, while Benton once took aside Rita's brother Santo to explain to him, "It's been very hard to live with your sister all these years—a hard woman to get along with."

Rita's relationship with Tom was high drama at every moment. Instead of the long silences, the unspoken resentments and tensions, of the Pollock household, the Benton home was one of constant verbal skirmishes. "They were always hollerin' at each other," recalled one of the neighborhood children, Margo Henderson, "and he used words that made a child's hair curl." But for all his bluster, Benton put everything practical in his wife's hands. Benton's friend Roger Baldwin, the founder of the American Civil Liberties Union, has commented that "Tom was Rita's man, totally dependent, but acted as if he were not." Despite the macho posturing, it was Rita who took care of Tom completely. She

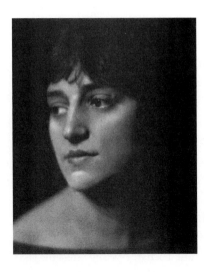

Rita Benton, circa 1920. (Benton research collection, Nelson-Atkins Museum of Art, Kansas City.)

cooked his meals, bought his clothing, cut his hair, read his mail, and sold his paintings. In the early years, she earned money for the rent by designing and fabricating hats and posing for fashion periodicals. Late in life, Benton confided to Santo that he never would have succeeded without Rita's support. "I was a bum, I would still be a bum, and I wouldn't have a dime to my name," he said.

She and Benton had met when Benton was teaching at the Henry Street Settlement, when she was about seventeen. Her Italian childhood had been one of utter poverty in a tiny house with just two rooms, one of them the bedroom where the entire family slept in a single bed. But in America her father, Ettore Piacenza, a copper worker, had found a good job, and they had a six-room house in the Bronx, not too far from the subway, complete with a vegetable garden and a henhouse with twenty-six chickens. Since she had arrived in America at the age of thirteen, she never lost her Italian accent, which sounded all the more peculiar because she learned to speak English from a man with a Scottish brogue, and the rhythms of the two languages collided with each other to create a lilt that was utterly unique, voiced in a rich contralto. For Benton she provided a mode of access into the world of Italian old masters, and in one of his most graceful early paintings he portrayed her as a Madonna, with T. P. on her lap.

Initially, Tom was the one who pursued her. One day he asked her to stay after class and made a sketch. When she came back a few days later,

she found that he had sculpted her head in plaster, focusing on her swan-like neck, like that of a figure in a painting by Pontormo, which emerged from the base with a curve like that of a breaking wave. As the relationship developed, however, Tom's ardor seemed to cool and it became she who kept after him, since his memories of the marital conflicts of his parents, combined with his incurable restlessness, made him reluctant to settle down. Eventually she persuaded him to tie the knot: the ceremony took place at St. Francis Xavier Catholic Church in New York, even though Tom was not a Catholic. Neither family was in any way pleased. Tom's mother was a snob and for the remainder of her life was hardly willing to recognize Rita's existence. Rita's family were appalled that she was marrying someone who didn't have a dime, showed no promise of ever learning to earn one, and was content to live off the income that Rita earned designing hats. "You know, the Italians have a funny way about that," her brother Santo later explained. "They expect the man to support the wife, not the wife to support the husband."

Rita never seems to have been distressed by their poverty, which was such that when their son was born they had no money to buy a cradle and kept him in a bureau drawer. At a low point early in their marriage, they were living in a five-story walk-up with just two rooms, with no light except for a kerosene lamp and no heat other than the kitchen stove. Their furniture consisted of a table and two chairs. One day Thomas Craven's wife, Aileen, came by for a visit and was appalled by their abject poverty. "How can you live under these conditions?" she exclaimed. To which Rita replied, with a touch of hauteur, "My husband is a genius."

Yet while devoted to Benton, Rita greatly enjoyed the attention of other men as well. Ruth Emerson has commented that "she was often flirtatious with other men . . . even with my husband, and he was crazy about her." Pollock's friend Reuben Kadish recalled that "she was a very flirtatious woman, very vivacious, very Mediterranean. She had a way of making you feel, as you sat at a table with twenty other people, that she had cooked this meal especially for you." Jackson's brother Frank has confessed that the seductiveness of her beauty was sometimes overwhelming: "She had winning ways that were pretty damned hard to resist. Her lips were different than Mother's. She had an angular face and polished skin, black hair and sparkling eyes—a voluptuous Italian, very voluptuous. I wasn't used to being in such company." Frank once found

himself alone with her in the kitchen, and Rita started discussing a book about lesbianism that she had been reading, *The Well of Loneliness*. "I got very uncomfortable with just the two of us there," Frank recalled. On another occasion he accompanied Rita and some friends to a Harlem club, where a male stripper named Snake Hips went through a twenty-minute serpent dance. At one point Frank felt Rita's hand on his knee. "I wasn't used to that sort of thing, and all I can remember is my embarrassment. I couldn't believe it was true," he would say years later.

Among the many who fell in love with her was Jackson Pollock. Indeed, the greater part of his interaction with the Bentons occurred not with Tom but with Rita. She immediately took to Jackson, who became her special child, and he responded with complete devotion. In New York he did chores with her, washing windows and sweeping the apartment while she supervised, and on Martha's Vineyard he spent most of the day in her company, while Tom disappeared into his studio to work. "She was the eternal mother," her niece Marie Piacenza has commented. "Mother with a capital *M*. She just adored and worshipped children, her children, all children." "She was the mother of the world," one neighbor recalled.

Tom Benton as a Teacher

To understand his influence on Pollock, it is helpful to know something of Benton's background as a teacher. He first became involved in teaching in 1917 at the Henry Street Settlement, through his friendship with a Jewish art organizer and social idealist, John Weichsel, the founder of the People's Art Guild. His main job was to keep an art room open, but he also provided instruction, to the extent that people asked for it. As Benton later told Paul Cummings:

> The first teaching I did in New York was in the public schools of the Chelsea Neighborhood Association at night for adults. I used to set up still-lifes and let them draw them and paint them if they wanted to. I don't think anybody painted because the light wasn't good enough. But we'd draw. And we talked. Young people would come in there, like my wife came as a young girl—seventeen or eighteen years old—and other young people. I had some very interesting Jews, Italians. Mostly that's what they were.

This early teaching ended in 1918, in the final year of the First World War, when Benton entered the navy. When he returned to New York in 1919 he discovered that the People's Art Guild had folded, so he did not go back to the Chelsea Neighborhood Association. But most probably it was through his friendship with Weichsel that he briefly taught at the Young Women's Hebrew Association in 1919.

The next few years, from 1919 to 1925, were the years in which Benton developed his mature artistic style. During this period he did not teach. In 1926, however, he took up teaching in earnest when his friend Boardman Robinson got him a position at the Art Students League. The job paid $103 a month, the first steady income Benton had enjoyed in years. For the next fifteen years—the most productive period of his career—teaching played a major role in Benton's life. Throughout this period Benton's social life consisted largely of contact with his students. "If I'd stayed in New York I would have stayed with the League," Benton told Paul Cummings, about a year before his death. "I'd be there yet. I liked the place. It was very exciting with all those young people all the time."

The Art Students League, founded in 1875 by a refugee from the conservative National Academy of Design, always catered to free spirits. It had no required courses, no fixed standards of instruction, no grades, and no class attendance records. Students enrolled month-to-month for twelve dollars, a significant sum at the time. Benton taught in Studio 9, on the fifth floor at the top of the stairs. He chose as his focus life drawing, since it allowed him to work from a live model and he couldn't afford one on his own.

Loosely speaking, one might divide Benton's teaching into three phases, each one of which attracted a distinct group of followers. During the twenties, when he was still considered a modernist, he gathered around him a small, informal, irreverent, and extremely diverse group. Except for Boardman Robinson, who had gotten him his job, Benton saw nothing of the other teachers at the League. Indeed, he was critical even of Robinson, who he felt was too wrapped up in the "great master" role and too aloof from his pupils. He made a point of treating his students as equals. "My students didn't study *under* me but *with* me," he once boasted. Several figures in Benton's circle at this time went on to play a major role in American art, including the painters Reginald Marsh and

Fairfield Porter and the sculptors William Zorach, Gaston Lachaise, and Alexander Calder. There were also some good writers, including Lewis Mumford, the Marxist historian Leo Huberman, the poet e. e. cummings, and Benton's former roommate, the vituperative art critic Thomas Craven, who at this point had aligned himself with progressive trends and was blasting away at academic painters for the modernist magazine *The Dial*.

"I began with very few and I never had a big class," Benton later recalled. (When Charles Shaw joined his life drawing class in 1926, it contained only six students.) "But I had some very interesting people," Benton added. "I would say an awful lot of artists who became well known were my students there. If they weren't students they were visitors to the place, say, like Sandy Calder and Reggie Marsh."

"We had a crowd," Benton told Paul Cummings. "They'd come down to my house. We had dinners and parties." Stewart Klonis, who studied at the League in the twenties, later commented of Benton that he "was very pugnacious, very independent. Yet his students were terribly devoted to him . . . There was a great deal of camaraderie among the students. It was a very close group."

With a few loyal exceptions, such as Charles Pollock and Thomas Craven, this early circle began to dissolve around 1930, when Benton completed his mural *America Today* and his reputation soared. This marked the beginning of a second phase. No doubt jealousy was part of the problem. Some members of the group, such as Lewis Mumford, became estranged; others just drifted away. But the Benton home remained a sociable place, with an endless assortment of interesting guests, from the perennial Socialist candidate for president Norman Thomas to the French experimental composer Edgar Varèse.

Of particular interest to Pollock was the Mexican painter José Clemente Orozco, whose great mural of Prometheus he had admired at Pomona College shortly before leaving for New York. Along with David Siqueiros and Diego Rivera, Orozco had achieved world fame in the 1920s as one of the three great masters of the Mexican mural movement. But his scenes of massacres and corrupt officials and priests also earned him enemies, and in 1927 hostile forces became so powerful and threatening that Orozco fled from Mexico and moved to New York. Just as his money was running out, a small group of enthusiasts learned that he

had settled in the city and took steps to promote his work. The most elo-quent, active, and effective of these supporters was Benton, who arranged Orozco's first American show in Philadelphia and shortly afterward orga-nized an ambitious retrospective at the Art Students League—despite violent resistance from other members of the League who objected that Orozco was not on the faculty and, in addition, was a Mexican and for-eigner rather than a true American. With characteristic forcefulness, Ben-ton rode roughshod over the opposition. The show he organized brought Orozco both publicity and much-needed sales, and from that time for-ward Orozco always remained friendly and loyal to Benton, even during difficult dips in his career. For a time Benton even showed at the Delphic Studios gallery, managed by Alma Reed, Orozco's blond and buxom mistress.

While the early thirties saw many departures from Benton's circle, the empty spaces were quickly filled by young students, such as the Pol-lock brothers, who often came from some distance to study with Benton, generally because they were attracted to the social content of his work. These acolytes fit into three fairly definite categories: poor city boys, mostly Jewish; poor blacks from the Deep South, who had somehow gotten the money to come north to study (for a time Benton attracted nearly all the African Americans at the League); and poor working-class boys, generally of rural background, from the West. Axel Horn, who began studying with Benton in 1933, noted that inside his class "was a hard core of devotees who spent much of their time outside the class with Benton, as his assistants and as models for a mural on which he was working, and also playing in the hill-billy band that he had organized."

Thus, the range of Benton's acquaintances narrowed to include fewer peers and a younger, less critical group of followers. Despite, or perhaps because of, this change, the atmosphere around Benton grew even more focused and intense. Students tended to cluster around favorite teachers, and Benton was notorious for attracting a group of loyalists, who stood apart from everyone else in the school. They not only studied with Ben-ton but socialized with him and imitated the way he spoke and dressed and his cocky walk.

Jackson Pollock came to study with Benton just at the time this sec-ond phase, with its musical emphasis, was beginning. Benton drew him

several times, and Pollock appears in two of Benton's major paintings, *The Ballad of the Jealous Lover of Lone Green Valley* of 1931 and the panel of *Arts of the West* in Benton's 1934 Whitney Museum mural, in both of which he plays the kazoo.

The third phase of Benton's stay in New York, from about 1932 to 1935, was the most difficult. With the rise of hard-line Marxism, Benton's irreverent treatment of working-class Americans became politically suspect, and after he executed his mural for the Whitney, with its panoramic survey of American types, he was even accused of racism or anti-Semitism. During this period many of Benton's Jewish and African American students dropped away, and hecklers began to show up at his lectures. Benton's enrollment in his class fell from twenty-nine in 1930 to only seven in the fall of 1932. Several longtime friends, such as the historian Leo Huberman, broke off all contact with him. "Damn it!" Benton told Paul Cummings. "There were a lot of those who were my students who became my enemies when the thirties came . . . But I just can't remember their names. They were important for a moment but they never really made any impact."

Throughout this difficult period a strong core of supporters, such as the Pollock brothers, and a number of old Jewish friends, such as his personal lawyer, Hymie Cohen, remained loyal. But due to the pressure of work and the irritation of public harassment, Benton drank heavily and began showing up at his classes only infrequently, sometimes drunk, often being gone for months at a time. This period of emotional tension finally came to an end in 1935, when Benton packed his bags and moved back to his home state of Missouri.

To replace the writers and intellectuals who deserted him in the early 1930s, at this time Benton began to socialize with composers and musicians. He himself had just become involved with music, since he had taken up the harmonica to amuse himself while in an emotional slump after completing his New School mural. Before long he pulled his students into his new interest. Charles Pollock learned to play the harmonica (badly), and Bernard Steffen and Manuel Tolegian grew extremely adept—Tolegian so much so that in 1939 he performed on the harmonica for a show on Broadway, the Pulitzer Prize–winning William Saroyan play *The Time of Your Life*. Since none of them could read music, Benton

devised a new form of musical notation, showing them which hole to blow through and whether to draw in or blow out. "There was plenty of drinking," Charles Pollock recalled, "and, I suppose, here and there, some serious discussion." The students were often joined by Benton's neighbors, including a local furrier who played the guitar.

"I was always looking up suitable music," Benton told Paul Cummings. "Digging around in the libraries for early forms. Our orchestra attempted Bach, Purcell, Couperin, Thomas Farmer, Josquin Desprez, and others . . . My ear improving, I picked up American folk tunes on my summer travels." Thanks to his new musical interests, Benton made a number of new friends at this time, including the musicologist Charles Seeger (father of the folksinger Pete Seeger) and the composers Carl Ruggles and Edgar Varèse. Ruggles even composed some music for Benton, which the harmonica troupe performed at the opening of Benton's show at the Ferargil Galleries in 1934.

Becky Tarwater

Pollock's most intense, if peculiar, early romance related in interesting ways to Benton's musical interests. In February 1937 Tom and Rita, who by then had moved to Kansas City, came back to New York for the opening of a show at the Municipal Art Galleries including work by many of Benton's former students and held a party at their former apartment on Eighth Street, then occupied by the Pollock brothers.* While the party celebrated painting, country music was the dominant theme of the affair, and it included a reunion of the Harmonica Rascals, with Bernard Steffen on the dulcimer and Sande Pollock, Manuel Tolegian, and Benton harmonizing on the harmonica. Other musicians came as well, and at the event Jackson fell instantly and passionately in love with a young woman with a pale face and shoulder-length brown hair who sat on a stool in the front room, her back against the window, playing a banjo and singing sad Tennessee ballads in a high, plaintive voice.

* In September 1933 the Bentons had moved from Hudson Street to an apartment at 10 West Eighth Street. By 1935 they were living in an apartment at 46 West Eighth. The Pollock brothers took it over when Benton left New York for Kansas City in the spring of 1935, and it was there that Jackson painted many of his early masterworks, including his mural for Peggy Guggenheim.

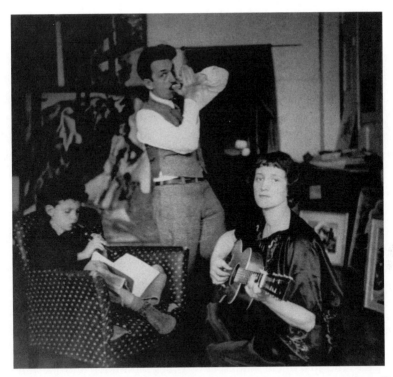

During an emotional slump after completing *America Today*, Benton taught himself to play the harmonica. Here he performs with his wife, Rita, and his son, T.P. (Benton research collection, Nelson-Atkins Museum of Art, Kansas City.)

This was Becky Tarwater, who, like Benton, was a peculiar mix of hillbilly and sophisticate. Born in Rockwood, Tennessee, she came from a well-to-do family, went to a girls' school in Philadelphia, studied dance and music for eight years in Washington, D.C., and even spent a year in Paris. But she never lost touch with her Tennessee roots. "We were hillbillies," she later commented, without shame.

Being a hillbilly meant learning ballads. In her family everybody sang, and she learned eighteenth-century ballads as a child from her grandmother, who in turn had learned them as a child from her mother and grandmother—a lineage of musical transmission that quickly brings one back to colonial times and the very early days of the western frontier. In fact, at the time of Benton's party, Becky had just come from making a recording of "Barbara Allen," for the Library of Congress folk music project of Benton's friend Charles Seeger. Sung without accompaniment,

her performance has become something of a classic: one of the purest reflections of a form of music dating back to the eighteenth century and earlier, which had somehow survived unsullied in the isolation of the Tennessee hill country.*

Pollock's romance was passionate and brief, since it existed only in his own head, and Becky already had a boyfriend, a doctor with the fitting name of Hicks, who had been her childhood suitor. When she left the party, Jackson followed her, staying a few steps back and, in a kind of child's game, stopping when she stopped. On the street he stayed at a distance, and when she turned back to look he would duck into a doorway. At the Astor Place subway station she turned on him and said quietly but firmly: "Jack, I don't want you coming home with me. I am perfectly all right." She was staying at a women's hotel, the Allerton, on Fifty-seventh Street, and didn't want Jackson to appear there and cause a scandal.

She had left behind her banjo, and Jackson immediately decided that he would become a musician, even asking his friends for an instruction book. But his talents did not lie in this direction. As he noted in a letter to Charles, "All I'm able to do so far is to get it out of tune." She returned to the apartment a number of times for dinner, and she and Jackson had a relationship for about five months, although not one that she ever took seriously. They never went out on a date or out to dinner at a restaurant, and he never spoke about his past, his family, or his painting—she later commented that "painting and anything of that sort wasn't on his mind." She remembered him as "a tortured, sensitive person who was very touching," but he never touched on the sources of his mental anguish. She felt that what he needed was not a wife but a mother. On one occasion she witnessed his anger. When they were out walking he saw a well-dressed woman with a tiny dog on a leash. Something about her attention to the animal outraged him, and he went over and began kicking the dog, in a shocking, seemingly inexplicable outburst of violence completely at odds with his usual gentle manner. "I was terrified the police would come," Becky recalled.

They met for the last time at a White Castle restaurant not far from

* Becky Tarwater's rendition of "Barbara Allen" is the fourth cut on the CD *Anglo-American Ballads*, American Folklife Series no. 1, Rounder Records in collaboration with the American Folklife Center, Library of Congress.

the Eighth Street apartment, just before Becky returned to Tennessee. Jackson walked in carrying a single white gardenia, and after they sat down, surrounded by the aroma of grease and onions, he impulsively asked Becky to marry him. She paused for a moment, not because she took the offer seriously but to reflect on how to reply. She then explained how marriage with him would not fit with her plans for her career and said that if she did marry she would choose her childhood sweetheart, Mason Hicks, who was then finishing a residency at Bellevue Hospital. When she was done, she picked up the gardenia and walked away. Jackson never saw her again, although the next summer he sent her a letter with a painting of tuberoses and asked her to stay in touch with him.

She never did. A few months later she married Mason Hicks and returned to New York, where he developed a successful practice and the couple lived in a fancy apartment on Fifth Avenue. For the next twenty years she watched with approval when she saw Jackson's picture in magazines and newspapers, and she once thought of going to one of his openings but decided against it. "I had another life and it would have been foolish to go outside it," she later commented.

"My Drawing Is Rotten"

Despite his ferocious reputation, Benton's comments to his students were invariably gentle. As one of his students, Charles O'Neill, has written: "Benton was a fine man. I don't remember his ever humiliating a student, even if preoccupied by painting." Nonetheless, the atmosphere was strangely intense, as many of his students have testified. "In the studio there was no fooling around," Jack Barber observed. "It was like going to work." Bill McKim commented, "You learned to work independently, and that is a very important thing." "Benton demanded a lot of work," one of Jackson's classmates at the League later stated. "His students didn't spend much time in the lunchroom."

While Pollock idolized Benton, many reports corroborate that he had difficulty mastering Benton's artistic techniques. Benton later remembered, "He had great difficulties in getting started with his studies, and, watching other more facile students, must have suffered from a sense of ineptitude." His brother has confirmed this assessment. As Charles Pollock recalled: "Everything Jack did in his student days was a struggle,

a struggle for things to come together the way he wanted them to. I don't know if it was a question of drawing per se, but it was a question of getting things down on the paper in some organized way that suited him."

Benton's students were famous for picking up his scribble-scrabble line quality, which made his cross-hatching look like a head of tangled hair, but "Jackson's drawings were easily the 'hairiest,'" Axel Horn remembered. "They were painfully indicative of the continuous running battle between [him] and his tools." Pigment gave Pollock as much difficulty as the pencil. "Jack fought paint and brushes all the way," recalled Horn. "They fought back, and the canvas was testimony to the struggle. His early paintings were tortuous with painfully disturbed surfaces. In his efforts to win these contests, he would often shift media in mid-painting." Pollock also had difficulty breaking down his work into logical units. He would fuss endlessly over some detail and then leave blank spots in the more difficult passages, such as hands and faces, which he intended to finish later but never got around to. As Benton told an interviewer in 1959, Pollock "was out of his field . . . His mind was absolutely incapable of drafting logical sequences. He couldn't be taught anything."

Pollock's lack of ability strikingly contrasted with the skills of his high school classmate Manuel Tolegian, who had also come to study with Benton and who rapidly became quite accomplished. "They would insult each other continuously," one classmate recalled. "Jack would call Manuel a Turk, which annoyed him no end. It seemed friendly enough, but they were getting in their jabs." Tolegian was also more verbal than Pollock. As Axel Horn recalled: "He was always explaining what he was doing. Always rationalizing it, always defining it." By contrast, Pollock had difficulty talking about what he felt. As Benton remembered:

> He developed some kind of language block and became almost completely inarticulate. I have sometimes seen him struggle, to red-faced embarrassment, while trying to formulate ideas boiling up in his disturbed consciousness, ideas he could never get beyond a "God damn, Tom, you know what I mean!" I rarely did know.

Many of his classmates thought that Pollock was mentally stunted. "Jackson always seemed to be in a daze," one recalled. Benton, however,

remained supportive. "The deep wellsprings of the visual art," he later commented, "are in fact nearly always beyond verbal expression."

Sensing Jack's difficulties, Benton often invited him back to his apartment on Hudson Street, where he provided private instruction in drawing and composition. After class ended at the League, he and Benton would ride the subway together to Fourteenth Street. By early 1931 Frank was at Columbia and Charles was teaching, so Jackson often came alone. Pollock seems to have been the only student at the League who enjoyed such easy and intimate access to the Benton home.

It is no exaggeration to say that Benton created Pollock as an artist. The fact is, we have nothing that Pollock made before he worked with Benton, and before working with Benton he seems to have made very little. What we know of Pollock's work before he studied with Benton is pretty much what he himself confided in a letter to Charles in which he commented: "My drawing I will tell you frankly is rotten it seems to lack freedom and rhythm it is cold and lifeless, it isn't worth the postage to send it . . . The truth of it is I have never really gotten down to real work and finished a piece I usually get disgusted with it and lose interest . . . Although I feel I will make an artist of some kind I have never proven to myself nor anybody else that I have it in me."

Such feelings can easily lead to paralysis. Perhaps Benton's greatest lesson to Pollock was to set aside such worries; he believed, above all, that artists shouldn't sit on the couch but should get up and do something. At some level Benton was naturally a brooder: perhaps in reaction against this, he made his art not a matter of neurotic musings and self-examinations but of constant action and motion. He himself was in a constant swirl of activity. If a painting didn't work, he wouldn't sulk but turn it over and make a new painting on the back. If that didn't work, he would turn it over again and make another painting still. Creative breakthrough, he believed, was not simply a matter of abstract ideas but of new possibilities suggested by one's play with materials. As he once wrote:

The creative process is a sort of flowering, unfolding process, where actual ends, not intentions but ends arrived at, cannot be foreseen. Method involving matter develops, whether the artist wills it or not, a behavior of its own, which has a way of making exigent demands,

devastating to preconceived notions of a goal. Art is born not in preconception or dreaming but in work. And in work with materials whose behavior in actual use has more to do than preconceived notions with determining the actual character of ends.

Could there be a better statement of Pollock's creative approach, in which unforeseen developments, like splatters and drips—the surprises that come about in making things—help to shape the ultimate artistic product?

Art history seeks explanations, but frequently any review of historical facts comes upon critical junctures that are not easy to construe—things that are inherently puzzling, bizarre, and irrational, things that defy any simple form of answer. It's surely curious that Benton, an exceptionally literate man, did not focus on the seemingly most talented, cultured, and well-connected students in his class—on upper-crust material, on people with education and pedigree, such as Whitney Darrow, who had attended Princeton, or Fairfield Porter, who had studied at Harvard with Ralph Waldo Emerson's grandson Edward Forbes. How can we explain that Benton attended instead to Jackson Pollock—an uncouth, awkward, inarticulate working-class western boy, who couldn't paint or draw with the slightest skill, whom many dismissed as mentally a dullard, who in the view of most lacked even the slightest hints of artistic vision or talent? On the face of it Benton's behavior seemed utterly perverse.

Not surprisingly, many of Benton's contemporaries were mystified and offended by the way he behaved. They dismissed him as a hillbilly, a boob, a figure with a chip on his shoulder—someone with no real understanding of either art or culture, a figure fundamentally insensitive and anti-artistic. Indeed, this view of Benton is still widely held today. For some reason the nasty name-calling has stuck, and art historians still take pleasure in showering Tom Benton with mud.

Yet in this instance, at least, Benton's decision seems exactly on the mark and stunningly, almost miraculously clairvoyant. Could Benton have somehow sensed that Jackson Pollock was destined to become "the greatest American painter"—the figure who would not only change the face of American art but alter the very fabric of American culture? Perhaps that's going too far, given the emotional turmoil of their relationship,

but what's clear is that Pollock would not have become the artist he did without Benton's influence—and without his very real, if roughly expressed, affection.

Hollows and Bumps

Benton taught by example rather than through a rigorous set of exercises. He made few criticisms and from the conventional standpoint wasn't much interested in technique. Once he had provided some initial stimulus, he usually didn't interfere with what his students were doing unless they asked him to. He left them free to flounder around and find their own way. As Peter Busa recalled, Benton "was less interested in looking at what we were doing than in principles and ideas." "He seemed to talk more about life than about art," Herman Cherry recalled. "He'd been through the art-for-art's sake stuff and wanted to get back down to earth."

Throughout his career, Benton taught by working alongside his students, and his teaching focused on the problems that he himself was trying to solve. "I taught what I was trying to learn," Benton once commented. At the time he began teaching at the League, for example, he was just beginning to produce large-scale mural compositions, for an epic series on American history, but was unable to afford a model. Since the League provided one, he was able to spend much of his classroom time making studies for his paintings. Benton confessed:

Looking back I can see that I was not a very practical teacher, especially for novices . . . Although I had pretty clear ideas as to my ends, I was still searching for a means to achieve them. Often, when I needed a figure action for some painting I would use the class model, making mistakes, rubbing out, and destroying my studies, with complete indifference to suspicions of ineptness that might be aroused among the students. After indicating in a general way the directions I thought profitable to pursue, I expected the members of my class to make all their own discoveries. I never gave direct criticisms unless they were asked for and even then only when the asker specified what was occasioning difficulty. There were several more convinced leaders of the young than I at the Art Students League,

and my students were always leaving me for them because, as they said, "I did not teach anything."

Figure drawing always remained the core of Benton's classes at the League. And despite his disclaimers, Benton had a very definite approach to figure drawing and composition. While his methods evolved over time and changed significantly after he moved to Kansas City, he always remained true to certain basic principles: teaching through doing, a distinctive style of figure drawing, and extensive analysis of composition, including analysis of the old masters. As Charles Pollock later noted, "Benton had a perfectly logical system of teaching, and it remained consistent from beginning to end."

While Benton shared with the École des Beaux-Arts a strong interest in the human figure, his method was exactly opposite to that of the École in two respects. In the first place, he taught a different approach to drawing. The École taught students to achieve a polished surface and a photographic look, even if the underlying structure was a little wobbly. Benton, on the other hand, taught his students to work toward an understanding of the bulges and hollows of the sculptural form, with a network of agitated lines, and to completely eschew any elegance of surface effect. As a consequence of this attitude, the work of all Benton's students had a distinctive look. Thus, for example, Axel Horn recalled that "in a matter of weeks, drawing on brown wrapping paper with the characteristic scribbly line, I had adopted the class objectives—to be able to articulate and express the softness, the extensions, the recessions, and the projections of the forms which make up the human figure." Ed Voegele remembers that Benton encouraged him to abandon his search for the perfect line: "He told me to use many lines when sketching, giving the viewer the opportunity to select the line that is most pleasing. This participation permits the viewer to enjoy an experience of *creating* an image. At least that's my interpretation of Tom's theory."

Benton's key phrase for figure drawing, "the hollow and the bump," signified a search not only for curvatures but for rhythmic relationships. The phrase had an almost mystical significance, like the yin and yang of Oriental philosophy. Focusing on this principle was a means of discarding conventional ideas of rightness or mechanical precision and focusing instead on a kind of rhythmic flow. Indeed, while some of Benton's

Benton's figure drawings are often strange in their proportions but wonderfully convey a sense of rhythmic energy. Pollock learned to draw with a similar disregard of photographic accuracy. (*Study of a Female Nude* [c. 1916]. Private collection, Cleveland, Ohio.)

drawings of this period are stunningly accurate, equally fascinating are those in which the proportions are all off, in fact quite grotesque, in which, to cite one striking example, scribbled hastily in pen on a sheet of writing paper, the two breasts are different sizes, the collarbone exaggerated, and the torso oddly stretched, but in which we are nonetheless caught up in the strange rhythmic undulations of collarbone, breast, neck muscles, torso, and thighs, which, taken as a whole, create a wonderful sense of how the parts of the body work against each other, in a moving pattern as tensely harmonious as a beautiful piece of music.

Along with making drawings, Benton encouraged his students to look at them; he himself had spent a good deal of time studying the drawings of the old masters, starting with visits to the drawing room of the Louvre when he was a student in Paris. According to Busa he told his students, "When you look at a finished work, you're just seeing the skin of the building. Look at the drawings."

In the second place, again in direct opposition to the way he himself had been taught, Benton stressed composition above all other principles.

According to Earl Bennett, Benton would say: "Grand design. You've got to get the grand design first. Don't get into detail and don't get into this, that, and the other thing until you've got the grand design. When you've got the grand design you can make a painting." Ed Voegele recalls Benton saying, "If you have a good composition, hang the painting upside down, down side up, or on either side. The composition will still look good." Mervin Jules has also left a description of Benton's approach:

> Every part of the picture had to be broken down into block forms and then reconstructed—everything from a horse's pelvis to the turn of an outstretched hand. After that, you would break down the tonality—in other words, where did the light come from? When you had done that, you would take a piece of transparent paper, put it over the drawing, and using a variety of whites and blacks, fill in the block figures to indicate the structure of tonal relationships.

In addition to asking his students to create compositions, Benton had them analyze the compositions of artists of the past. Often the students sketched from projected slides, rendering in abstract the compositions of great artworks from the past, ranging from Egyptian and Assyrian reliefs to paintings by Rubens and El Greco. As Axel Horn recalled:

> His method of analysis was to produce in gray tones a famous work of art, stressing the interplay of direction in the various forms by simplifying and accentuating changes in plane. Breughel, Michelangelo and Assyrian bas-reliefs were all popular subjects for this exercise. We would, in addition, construct actual three-dimensional dioramas in wood or clay, treating the painting as a deep relief, and also painting it in tones of grays, in order to discover for ourselves the rules by which each work was internally arranged and the forms related spatially . . . Through all this ran the search for the hollow and the bump; the ability to utilize and express recession, projection, tension, and relaxation.

In carrying out their analysis, Benton taught his students to make two types of drawings. One was to diagram the famous work in lines that explored the pattern of visual movement on the picture surface. The

other was to re-create them in cubic blocks, which indicated the spatial position of the principal elements. In short, Benton was interested both in linear flow on the surface and cubist organization in depth. The trick of successful pictorial organization, so he believed, was to coordinate these two systems.

Benton's emphasis on composition was completely at odds with the Beaux-Arts approach, which taught the student how to render the figure but not how to make a painting. When Thomas Eakins, for example, studied in Paris, he learned to draw from plaster casts and to render the nude model first in pencil and then in oil. But at no point during his years of study, first with Jean-Léon Gérôme and later with Léon Bonnat, was he actually expected to make a painting. He made his first original composition only after he had left his teachers, and at the time he returned to the United States he had only made a single figure painting—an extremely awkward one.

What were the sources of Benton's teaching approach? Not his own academic training; in fact, his system was consistently at odds with the methods by which he himself had been taught. Instead, though certainly endowed with some quite personal twists, Benton's teachings were derived from his youthful romance with modern art. More specifically, his methods were rooted in his friendship with Stanton Macdonald-Wright and in his involvement with Synchromism, a movement that synthesized the achievements of Henri Matisse, Pablo Picasso, and the other leading modernists of the time.

How to Make an Abstract Painting

That Pollock eventually learned something of Benton's methods is evident from a sketchbook now in the Metropolitan Museum of Art, filled with compositional studies after Signorelli, Michelangelo, Tintoretto, El Greco, and Rubens, the very artists whom Benton recommended his students study closely. Despite Benton's frequent statements that Pollock could never learn to draw, their execution is quite accomplished. Thus, whatever his struggles may have been along the way, there can be no doubt that by the time that Pollock finished his training with Benton, he had thoroughly mastered his fundamental techniques. Most writers on Pollock have briefly taken note of Pollock's work of this sort and then moved on—have cheerfully assumed, in other words, that while Pollock learned some of Benton's techniques, he later dropped them and progressed to other interests. Pollock's relationship with Benton, in short, has been treated as the art historical equivalent of a youthful sexual indiscretion—as something that happened but is best forgotten.

But surely this is a blinkered view of Pollock's development. In fact, as we shall see, Pollock's study of old master composition has direct bearing on his masterful late drip paintings. Equally significant, Pollock's debt to Benton went deeper. Benton also taught Pollock how to make abstract designs—and Benton himself, in contradiction to the widespread belief that he was hostile to abstract painting, created abstract paintings in every decade of his career. This realization was most strikingly presented by Stephen Polcari, in an article published in *Arts* magazine in

Jackson Pollock's early drawings
deconstruct the human figure and
search for rhythmic energies
according to Benton's principle of
"the hollow and the bump."
(*Figure Drawing,* from *Sketchbook I*
[c. 1938], Metropolitan Museum of Art,
New York.)

1979. Polcari noted that the compositions of all of Pollock's major drip
paintings match up perfectly with a group of diagrams that Benton had
published in *Arts* fifty-two years earlier, where they accompanied a series
of articles with the somewhat forbidding title "The Mechanics of Form
Organization in Painting." In essence, Benton laid out how to create an
interesting abstract design, and Pollock, in his drip paintings, followed
his directions step by step.

From time to time subsequent scholars have taken note of Polcari's
discovery, but their reaction has invariably been begrudging. Thus, they
have generally dismissed Benton's connection to Pollock as something
superficial or "mechanical"—in large part because their understanding
of Benton (and of modern art) was superficial, and they did not grasp
the ways in which Benton's achievement was rooted in Synchromist theo-
ries about the evolution of modern painting. Because Benton's art has
been out of fashion, they have failed to recognize how profoundly Benton
influenced Pollock, not only during the period when Pollock studied

with him but for the entirety of his career. Indeed, one of the unstated rules almost universally followed in writing about Pollock has been that any potentially favorable comment about Benton should be followed by a passage that somehow disparages his work.

Since most writers have been antagonistic to Benton's realism, they have not looked at the actual sources of his ideas about visual form. In fact, Benton was one of the few American artists with direct ties with European modernism and a deep understanding of the principles of abstract design.

Benton's viewpoint on modern art was largely shaped by his close friendship with Stanton Macdonald-Wright, who was his best friend in Paris. Along with Morgan Russell, Macdonald-Wright cofounded Synchromism—the only movement of modern art in Paris that was introduced by Americans. The movement was a hybrid. Synchromism used Cubist techniques of faceting forms to analyze the rhythmic formal sequences of old masters such as Michelangelo. It also employed prismatic sequences of color to articulate, spiritualize, and dramatize these formal sequences. Synchromist painting could be either abstract or fairly realistic. It ranged from purely abstract color spirals to figure paintings, in which representational shapes were only thinly disguised by veils of luminous color. Because of this variety, the Synchromist system is sometimes difficult to recognize. To do so we often need to disregard surface effects and think about underlying principles of formal structure.

Benton left Paris just a few months before Synchromism was developed, but he connected with the movement in 1914 when Macdonald-Wright returned to the United States. Indeed, Macdonald-Wright produced his finest Synchromist paintings in the period from about 1914 to 1916 when he was drawing the figure alongside Benton. Benton helped promote Wright's first Synchromist show in New York, held at the Carroll Galleries in March of 1914, and in 1916 Benton himself showed brightly colored Synchromist paintings—including both figure paintings and pure abstractions—at the Forum Exhibition, the first comprehensive group exhibition ever staged of work by modernist American artists. Equally significant, Benton was sharing an apartment with both Stanton Macdonald-Wright and his brother, Willard Wright, during the period when Willard wrote his book *Modern Painting*, published in 1915, which was based largely on Stan's ideas. Thus, Benton actively participated in

During the twenties Benton played with multi-sided compositions, as in this near-abstract rug design showing a train emerging from a tunnel. (Art © T. H. Benton and R. P. Benton Testamentary Trusts/UMB Bank Trustee/Licensed by VAGA, New York, NY.)

the heated arguments between the two brothers that shaped the book—arguments about the meaning and direction of modern art.

From 1916 to 1919 Benton gradually moved his work away from the rainbow colors and translucent forms of Synchromism but stuck with the Synchromist goal of developing extended rhythmic sequences of form, whether with figures or purely abstract shapes. In April and June of 1923 Benton's art was written up by his friend Thomas Craven, in two articles titled "The Progress of Painting," which appeared in the *Dial*, the leading magazine of modern art and literature of this period—the place, for example, where T. S. Eliot's poem "The Waste Land" first appeared. These two essays by Craven can be best understood as a kind of sequel to Wright's *Modern Painting*.

Essentially, Craven argued that progress in art, from Masaccio and Michelangelo to the Cubists, represented a quest for mastery of form. He admired Cézanne and the Cubists for their "revolt against the formless productions of the Impressionists." Thus, in Craven's view, Benton's work represented the culmination of the main direction of modern painting. As he wrote, "For the development of a complete rhythm extending through large masses of sculptural form, modern art has uncovered no gift like that of Thomas H. Benton, a painter who seems to belong neither to his own department nor to the domain of sculpture."

Even more significant than Craven's statement is one that Benton wrote himself in 1926–27, shortly after he began teaching at the Art

Students League. This was the five-part series of articles in *Arts* magazine. As will be analyzed toward the conclusion of this book, these laid out what became the basis of Pollock's compositional method.

No writer on Pollock has ever mentioned Synchromism. But while on the surface he was an all-American Missouri hillbilly, underneath Benton was a closet Parisian Synchromist. Indeed, his understanding of the principles of formal arrangement—his mastery of abstract form—was more complete, more inventive, more varied, and more exciting than that of any abstract painter of the period. Thus, Pollock did not even need to invent an abstract language. He simply took Benton's language, stripped of its figurative facade—simplified to its essential structural elements—and used it unchanged.

Of course, Benton did not generally draw attention to his years of study in France, or to the fact that he had spent the first decade of his career struggling to master the principles of modern art. Like the fact that he was well read and knew all the classics, it was something he liked to conceal behind the persona of a semi-literate hillbilly. But Benton's personality was always a storm center of conflicting forces. In self-reflective moments, Benton had kind words about the great French modern painters and generously acknowledged Macdonald-Wright's talent and influence, describing him in a memoir as "the most gifted all-round fellow I ever knew."

Indeed, Benton's students were all very aware of his great debt to Macdonald-Wright. "I don't think Tom learned anything from anybody," Bill McKim once commented, "unless it was from his friend Macdonald-Wright." And Roger Medearis once described meeting Macdonald-Wright as "the breakthrough for Tom Benton," the event that led to the creation of "the style that we know as Tom Benton."

In short, to understand either Benton's own style or what it was that he passed on to Jackson Pollock, we must go back to his years in Paris and examine his struggle to master the principles of modern painting. A good place to begin our journey is with Benton's meeting with Macdonald-Wright, when he was just nineteen and had been studying in Paris for a little less than a year. Like a small snowball that starts an avalanche, this meeting set in motion a long chain of subsequent actions and reactions that finally culminated in the drip paintings of Jackson Pollock. From this moment, thirty-nine years before Pollock's famous

Pollock's early paintings are often surprisingly similar to Benton's abstract studies, though more fluid in execution. For both artists, a key goal was to devise a scheme of rhythmic movement that would lead the eye through every sector of the composition. (*Top*: Pollock, *Rhythmic Construction* (c. 1940), courtesy the Pollock-Krasner Foundation. *Bottom*: Benton, *Rhythmic Construction* [1919]. The Benton Trust, UMB Bank, Kansas City, Missouri, original art © T. H. Benton and R. P. Benton Testamentary Trusts/ UMB Bank Trustee/Licensed by VAGA, New York, NY.)

drip paintings, we will gradually move forward in time, tracing successive episodes in the history that set the stage of Pollock's achievements.

To describe Thomas Hart Benton as a mysterious figure at first seems like a contradiction in terms. Surely no American painter has ever expressed himself more brashly, whether one considers the bold forms and bright colors of his paintings, which have about the same subtlety as a roadside billboard, or the punch and vigor of his statements about art, which always made good newspaper copy and still make entertaining if sometimes exasperating reading. Yet oddly, behind Benton's forcefulness lay something profoundly complex and conflicted, with the result that nearly every statement one can make about Benton is no more true than its contradiction. Yes, Benton was a Regionalist, who celebrated midwestern subject matter. Yet Benton was also an exceptionally cosmopolitan man, who read novels in French for relaxation, passionately loved the intellectual life of New York and Paris, and wrestled with the challenge of modern art. Yes, Benton was the champion of a homespun realism in art and produced paintings of cows and hillbillies and outhouses. Yet he was also in some curious way a modernist, who never abandoned the Synchromist principles he learned from his close friend Stanton Macdonald-Wright and who was the teacher of the greatest modernist America has yet produced, Jackson Pollock. Yes, Benton was a strong advocate of American values and American scenes, a man who insisted that American art should speak an American language. Yet no other American painter, of any period, so closely studied the European old masters. Yes, Benton could be profoundly homophobic and often comes across as slightly ridiculous in his macho posturings. Yet his closest artistic alliance was with a homosexual, Grant Wood, and he broke down in tears when he learned of Wood's death. Yes, Benton often denounced what he saw as the excesses of modern art. Yet he also wrote the single most important essay by an American on the fundamental principles of abstract painting.

Curiously, one of the few to appreciate Benton's significance was not an Americanist but the historian of French modern art Edward Fry, author of what is still probably the best book yet written about Cubism. When asked not too long before his death about Benton by Ken Burns, Fry noted that he was fascinated by the way in which Benton forged "a marriage between European culture and the authentic and sometimes

very raw American experience." "I think his critical standing is going to improve rather rapidly," he commented, and then added, "He had a great student, Jackson Pollock, and I cannot imagine Pollock having come into the world without Benton—coming into the world in the sense of becoming a world class artist."

Indeed, at some level, those who knew Pollock sensed that there was some secret ingredient to his art, some element in his formula that they could not explain. "What is interesting about Pollock," commented a fellow artist, George McNeil, "is that he came from very bad influences like Benton and the Mexican muralists and other anti-painterly influences, and yet, somehow, in a kind of alchemy, he took all the negatives and made them into a positive. It's a mystery. The rest of us were following the right path and therefore the magic didn't ensue."

The Formula

Good art starts fights in bars.

—*Peter Lewis*

Mixed Up with Modern Art

A warm autumn day, 1909. An outdoor table at Le Dôme. Although at the height of his career Thomas Hart Benton would favor working-class all-American attire, at that moment he was dressed somewhat foppishly, in French artist's garb, in the fashion of the Quartier Latin—a black suit with a black cape and a black-flat-brimmed hat and finally, to cap off the effect with appropriate flair, an impressively large black Balzac cane with a gold knob. (A few years later he lent the cane to Rudolph Valentino, when they were making a movie together in New York.) A hapless American at a table nearby spoke only stumbling French, and Benton helped him order from the waiter. They then struck up a conversation, and the young man, who called himself "Okie," revealed that he had just come from California with a very talented artist-friend. They gabbed on for half an hour or so and agreed to meet again the next day at the same place. When Benton showed up, Okie was already there with a pasty-faced young man in expensive clothes who introduced himself somewhat pretentiously as "S. Macdonald-Wright."

It soon became apparent that Macdonald-Wright was something quite peculiar—a figure who was never quite what he claimed to be. He ordered a beer with an impeccable French accent. After completing the task, he commented to Benton that he had spoken French since childhood, having had a French governess. A little later, however, when the waiter addressed him, it became clear that Macdonald-Wright did not comprehend what he was saying. Clearly his knowledge of French consisted of a

Benton's best friend in Paris was Stanton Macdonald-Wright, whom he later described as "the most gifted all-round man I ever knew." He later recalled that when he first saw Macdonald-Wright's paintings, "their bravura, their confident brush stroking, took my breath." (Wright, *Self Portrait* [c. 1910]. The Nelson-Atkins Museum of Art, Kansas City, Gift of the Enid and Crosby Kemper Foundation.)

few rote phrases he had learned from a tourist's booklet. Indeed, at a later meeting, Okie informed Benton that Macdonald-Wright had brought such a booklet with him on the voyage over and had learned how to pronounce sentences from his cabin steward. Macdonald-Wright's enunciation was so perfect, however, that his account of his French governess momentarily seemed convincing. As Benton commented, "Later on as I got to know him, Wright's acute ear and talent for mimicry would continue to amaze me. In a few months he would speak a much better French than I and better than some Americans who had lived in France for years."

This first exchange with Macdonald-Wright went well and was followed by a few others, equally enjoyable. Then their contact ceased for several months. Benton had established a liaison with a working-class French girl, Jeanette, and to his surprise and dismay she became pregnant. As her pregnancy advanced, she became increasingly fearful that Tom would abandon her, and he virtually ceased going out of his apartment. After long months, the ordeal came to a shocking end, as Benton

watched in horror, when she gave birth to a stillborn child in the studio. Only after this miserable experience was over did Benton start going out again to the cafés. When he finally stopped in again at the Café Dôme, he found Macdonald-Wright sitting at a table with a phrase book. Miraculously, by this time Macdonald-Wright had become fluent in French and was having an animated conversation with the waiter. As Benton greeted him, Macdonald-Wright hastily shoved the exercise book in his pocket and rushed over to grasp his hand.

"Where the hell have you been?" he asked. "I've asked everyone about you. Nobody knew where you lived or what became of you."

"I've been sick," Benton fibbed.

"You look like a ghost," Macdonald-Wright remarked.

They then sat down and exchanged stories. Macdonald-Wright, if one could credit his account, had tried most of the art schools in Paris—those of Julian, Friesecke and Miller, Carol Delvaille, and others, each one of whom he dismissed as "fat heads." He was now working on his own in his studio. Benton confessed that he had not tried as many places but had come to the same conclusion. He had quit the schools and was working on his own. He talked about his Impressionist experiments, his studies in the Louvre, the life sketches he made in the cafés, and his theories about color values. Macdonald-Wright listened attentively, and as Benton wound down he remarked: "Benton, you're great. Really great. You're the only intelligent man I've met in Paris."

"It was as if he'd put a bond between two superior men," Benton later recalled. "Liar or not, he himself was superior, and I was happy that he thought me so. Nobody else did." After that, they met frequently at the Dôme. One day, at Benton's suggestion, they went to Macdonald-Wright's studio, and he showed off his paintings. Because of Jeanette, Benton was reluctant to reciprocate. According to American middle-class mores of the period it was both a sin and a social lapse to live with a woman outside of marriage, and he was fearful that Macdonald-Wright would disapprove and cut off their relationship. But one day he got Jeanette to agree to stay away for a few hours and invited Macdonald-Wright over. The Californian arrived on the minute, immaculately dressed and sporting a new and extra-tall gold-headed cane. He came into the studio with head high, like a young general, and sniffed a little.

"There's a woman here," he exclaimed.

Flustered, Benton confessed that this was the case.

"Don't be a fool, Benton," Wright responded. "I know about these things. I know about you too. Everybody in the Quarter does. You don't have to be sneaky with me."

"What a nervy son of a bitch," Benton thought. But at that moment Macdonald-Wright's whole demeanor changed, his posture drooped, his face took on a vulnerable, almost pleading look, and his conversation became conciliatory.

"I came to see your work," he said, and with a little coaxing, Benton began to show his paintings. First Stanton admired a figure study, one of the first and best things that Benton had painted in Paris; then he expressed interest in seeing the more recent, experimental work. Benton took canvas after canvas out of the stack in the corner. Wright looked at each with interest, making friendly comments and asking questions as he went. By the time he left they had become not just friends but artistic comrades. By April the two had begun doing things together almost every day.

Macdonald-Wright was a year younger than Benton, but he was unwilling to concede the loss of status that would have occurred had he confessed that he was the younger of the two. Although his actual age was eighteen, Stanton assured his friend Okie that he was nineteen, then, when he learned that Benton was twenty, raised his age by two years to twenty-one. Benton carefully noted such factual discrepancies, but nonetheless their friendship flourished.

Benton probably never did manage to break through the screen of stories that Macdonald-Wright constructed about himself, to discover the actual circumstances of his early life, but in at least rough fashion recent scholars have managed to do so. Improbably, Stanton's parents were utterly conventional. Archie Wright was a quiet, sober-minded hotel manager, by temperament somewhat retiring and timid; his wife, Annie Van Vranken Wright, was deeply devout. Yet starting at an early age, both Stanton and his older brother, Willard, marked out a bold and unconventional course for their lives. How could it be that this conscientious, pious couple produced two such madcap children? Certainly part of the explanation lies in their indulgence and devotion to their children's unmistakable gifts. Growing up in elegant hotels, with a father who was a leader of the business community, the boys never doubted

their special destiny. Throughout their childhood the family enjoyed the accoutrements of luxury: they had servants; they dined well; they made periodic visits to New York, where they stayed in good hotels, ate in fine restaurants, visited the zoo, and attended the theater. As a child, Stanton cherished the fantasy that he was a prince.

Both boys were remarkably precocious, reading and writing long before their peers and showing exceptional talent for music and drawing almost as soon as they could talk. While both attended public schools, the Wrights also employed private tutors to teach them art, music, and foreign languages. Willard liked to sight-read scores by his favorite composers, such as Brahms, Debussy, and Mahler, and at one point he considered becoming a composer himself, or a conductor. Stanton also played the piano and composed music. His knowledge of musical harmony later played a major role in his exploration of color theory. When it came to discipline, both Archie and Annie were exceptionally permissive. By the time the parents realized that more discipline would have been salutary, it was far too late.

The family opened the new century by moving to Santa Monica, California, where Archie constructed a beachfront hotel, the Arcadia. For the boys the move to California opened new worlds. Both Stanton and Willard quickly developed an aversion to polite tea and garden parties and became attracted to foul language, liquor, smoking, girls, and other fascinating vices. They spent much time on the sea, swimming, boating, and diving. A few miles north of the Arcadia was the Long Wharf, where boats from around the world docked and one could meet and befriend exotic characters.

For amusement the boys also frequented the town's bars. At one point Willard was fined the impressive sum of $120 (about three or four thousand dollars today) in damages for a bar brawl at William Reckitt's Café—one wonders whether Reckitt's name was what inspired the ruckus. Evidently concerned about his eldest son's gift for misbehavior, Archie sent him to military school shortly after their move to California, but after ten months of tromping around in a cadet's uniform at the New York Military Academy at Cornwall-on-Hudson, Willard persuaded his father to take him out. In later accounts of his life, Willard always omitted any mention of this experience.

Like his older brother, Stanton had a wild streak. By his early teens

he had become interested in girls and drinking, was a habitué of China-town, and was a customer at the local brothel, where he established a regular relationship with one of the girls. In 1907, after he was expelled from the Harvard Military School in Los Angeles for committing acts of vandalism (his second expulsion from a private school), Archie used his social and business connections to find his son jobs in a medical office and a department store. Unfortunately, in both cases Stanton lasted only a few weeks. A subsequent position as a salesclerk in an art supply emporium also came to a hasty conclusion when it was discovered that Stanton was giving very deep discounts to his friends and fellow students. In an early bid for independence, most likely in the summer or fall of 1907, Stanton ran away from home on a windjammer bound for Nagasaki but was picked up in Honolulu and returned home by detectives hired by his father.

Only a year later Stanton found a more effective form of escape: he married Ida Wyman, a girl from Wisconsin, who had been staying with her mother at the Arcadia Hotel. The courtship lasted just two weeks: they were married on January 14, 1908, in Los Angeles, without informing Stanton's parents. On the marriage license both reported their age as twenty-two, although Stanton was seventeen and Ida is said to have been about ten years older. Information is scanty about Ida: the fact is that she never made much of an impression on anyone. Thomas Hart Benton, who met her in Paris, described her as "a frail and timid American girl," and she was to prove no match for Stanton's forceful personality. Stanton seems to have been attracted as much by her money as by any other attribute, since it provided the freedom he had been yearning for. The newlyweds spent most of the next year in San Francisco before leaving for Europe in the company of the bride's mother. For the next six years Stanton lived off his wife's money. Determined to become a great painter, he pursued an independent course of reading and art education, feeling no need to become bogged down by the formal instruction of the schools. It was at this carefree time, while he was free from responsibilities or financial worries, that Macdonald-Wright first connected with Benton.

The chemistry between Macdonald-Wright and Benton at first seems curious, for they did not, in outward respects, seem much alike. They made a physical contrast. Macdonald-Wright was tall and slender, with pale, pasty skin, a receding chin, and a look of premature weariness. He

was a hothouse plant who physically verged on the effete. Benton, on the other hand, was short, solid, and thickly muscular, with blunt features and a large scar, from a boyhood accident, that ran across his forehead. Macdonald-Wright always had a debonair manner, the product of growing up in luxury hotels, and his accent had a somewhat pretentious quality, like that of a mandarin Englishman; whereas Benton always had a scrappy toughness, as if in readiness for a barroom brawl, and never quite shed the accent or mannerisms of his hillbilly frontier background.

Their views on social questions turned out to be completely at odds. Benton was a Democrat, raised in the Populist atmosphere of Missouri, and from his exposure to Bernard Shaw and other English Fabians he leaned toward socialist theories based on the idea of universal equality and justice. Macdonald-Wright, on the other hand, was a Republican, with ties to the Huntingtons, the autocratic Californian railroad magnates. He believed that the people should be kept in their place, as natural servants of the wealthy and wellborn, among whom, of course, he included himself. Unlike most Republicans, he saw the Civil War as a tragedy because it had destroyed the slave system, which was necessary to maintain an aristocratic class. He looked forward to the time when Americans would see their mistake and reenslave the blacks. While he admired the artistic traditions of France, he disdained the country's egalitarian rhetoric, admiring instead the military aristocracy of Germany, which he believed would one day have to take over France to restore the country's "noble soul." As Benton recalled:

> He would get started on a monologue and if left unchecked build up a fantastic dream world, so mesmerizing himself with the flow of his words that he became convinced it was a real one. Now and then these imaginative creations would get transferred to overt behavior and he would put on the most astonishing acts completely indifferent to their effects upon others.

Benton, for all his fondness for Stanton, always retained an uneasy feeling that he was a bit of an airhead and that much of his thinking was delusional; Stanton sensed something bold and forceful in Benton's character but found him a bit too earthbound. What was the bond that linked them? Benton is the only other artist whose name appears in Stanton's

French journals; he clearly was his closest, if not his only, friend. Benton felt an equally intense attachment: he later credited Stanton as "the only artist in all my life who, as an individual, was able to get past my suspicions of bright and clever people and have an influence on my ways."

For all their differences, there were some powerful links. Benton and Macdonald-Wright had both quit high school in their junior year believing that they knew how to educate themselves. They were both readers and particularly loved poetry: Poe, Byron, Swinburne, Rossetti, and the *Yellow Book* poets. They both enjoyed argument. They were both champion talkers—they came from talking families—and they both had a self-confident way of taking on subjects about which they actually knew very little. They both loved to theorize, whether or not their knowledge justified it. "We were an odd pair of friends," Benton later recalled. "We were totally unlike and argued incessantly. We agreed on only one thing. That was that all in Paris, but ourselves, were fools."

On one crucial point their solidarity was complete. They both felt strongly that the academic system of art-making, as taught at all the schools in Paris, was a bore—that some new approach was needed to make an art of burning significance. Their partnership gave them the confidence to reject all the formal programs of training and to paint together instead—constantly experimenting with new ideas and approaches, constantly arguing about what they were doing, and had done, and should do next.

Benton noted that whenever Stanton faced a new situation he always took on a persona that was either lordly and supercilious or one of shocking effrontery. This seemed to be some sort of protective device, as if to forestall possible attacks on his pride. In fact, when he relaxed he was exceptionally congenial and proved to have a craving for friendship.

His tendency to play the role of "the great man" sometimes led to forms of behavior that were truly amazing. At one point, for example, Stanton developed the notion of having himself photographed before the important monuments of Paris and hired a photographer to assist him. After seeing a few of these shots, Benton became curious and asked to accompany him on the next round. The site chosen was a pedestrian bridge, the Pont Neuf, or "New Bridge" (which despite its name is actually the oldest bridge in Paris, dating back to medieval times). While the photographer set up his camera and wrapped himself in his black hood,

Macdonald-Wright established himself in the middle of the bridge, with the towers of the cathedral of Notre Dame behind him, and took an erect and commanding posture. As Benton recalled:

> Folding his arms he stared out like some conquering young Siegfried, over the passing train of French secretaries and petty functionaries on their way to and from work. He drew a crowd of amused spectators, but neither they, nor their humorous comments, fazed him. He was living a dream and all else was as nothing. He was the master of Paris.

The episode brings to mind the writings of Nietzsche (one of Macdonald-Wright's favorite authors), along with the novels of another writer he admired, Balzac, and the famous description of Lucien de Rubempré, fresh from the provinces, standing on a hillside, overlooking Paris, dreaming of conquering the big city. In summing up, Benton noted:

> All of this sounds crazy, too crazy to put up with. But a few seconds after such performances a complete change of personality might occur and the lunatic young ham turned into an intelligent, reasonable and considerate friend. When he sensed I was low on funds, which frequently occurred at the end of each month, he would lend me the money to tide me over. I never asked him to do this. He divined my needs.

Benton's girlfriend, Jeanette, took an instant dislike to Macdonald-Wright and never referred to him by his real name, instead using colorful French phrases such as "Monsieur L'Epateur," "Monsieur Polisson," "Monsieur Sournois," or "Monsieur Pesteux"—loosely translated as Mr. Bigshot, Mr. Sleazebag, Mr. Shifty, or Mr. Nuisance. Nonetheless, she was sufficiently impressed by his elegant attire that she insisted that Benton go out and buy a new suit. Benton's neighbor John Thompson disliked Macdonald-Wright and his pretension even more strongly, generally referring to him as "that pasty-faced prick."

While the way they touched brush to canvas was quite different, and remained so for the rest of their lives, Macdonald-Wright and Benton were both eager to throw aside conventional ways and do something new

and original—the expression of their special, God-given genius. Neither was content with the facile decorative Impressionism of their peers, such as Abe Warshawsky or Leon Kroll. Neither was content to make a career painting picturesque scenes of Paris for American tourists. From the standpoint of making paintings that were pleasing to look at, this was not always an advantage. In this regard, Stanton was the better favored of the two, because of his exceptional mastery of sweeping brushstrokes. Benton's paintings generally looked awkward to most of his friends—indeed, even to himself; ambition still ran way ahead of achievement. Stanton was almost the only one who saw something in them.

Few paintings by either survive from this period, so their development is known mainly from Benton's descriptions. Sometimes Macdonald-Wright, sometimes Benton was the more adventurous. Generally, Macdonald-Wright was a little ahead, although he fell behind for a while in 1910, when he was chasing a good-looking model and devoted the summer to painting very realistic and conventional portraits of her in the nude, except for a big floppy hat. They both started with essentially academic styles, although with bold brushwork, and then moved on to a kind of Impressionism. By the spring of 1910 they had discovered Gauguin, Matisse, and the Cubists and were exploring all these different approaches. As Benton later recalled, "Almost each week a new discovery would send us flying into some new experiment." Even when the results looked strange, they both were convinced that they were destined to come up with some amazing new form of artistic expression, which would overwhelm their peers.

For more than a year they had no friends who shared their advanced artistic taste, but early in 1911 Benton and Macdonald-Wright met Arthur Lee, the sculptor, who in turn introduced them to a good-looking young American, Morgan Russell, another sculptor, who had a studio nearby and had attended the school of Henri Matisse.

Russell was desperately poor and quickly running out of money. From the moment of their first meeting, he was cool toward Benton but effusively friendly to Macdonald-Wright. Benton on his side took a dislike to Russell from the first. No doubt in large part this was simply a matter of competition. For several years he had been Stanton's best friend, and he could sense that he was being supplanted and replaced. He resented that Stanton, in his sublime egotism, did not see that Russell

was angling for a free meal ticket. Was there something else as well? By this time Benton had already developed an intense anxiety about effeminates and homosexuals—in part no doubt because of an unpleasant experience in Chicago, when an older man named Mr. Hudspeth had gotten him drunk, persuaded him to undress and climb into bed, and then had slipped a lubricated finger up his anus. Perhaps something feminine about Russell's manner set off alarm bells.

On the positive side, Russell brought them into a new social circle filled with enthusiasts for modern art. In the spring of 1911 Benton and Macdonald-Wright met the stage designer Lee Simonson, the sculptor Jacob Epstein, and Leo Stein (the brother of the more famous Gertrude), who was himself still painting, or apparently so, and invited them to his studio. Shortly after this friendly meeting with Leo, Macdonald-Wright and Russell visited Gertrude Stein at the rue de Fleurus, but Benton lost his nerve at the last minute and did not go. He later was glad of this, for something about Stanton's attitude annoyed the Steins and the evening was not a social success. In describing it afterward, Stanton launched into an anti-Semitic tirade, describing Gertrude by every obscenity he could think of, including the phrase "a fat-assed kike." (In Stanton's journal of the period he referred to "Steinitis: the Disease of Paris.")

Surely if Benton had stayed longer in Paris, he would have become part of the circle of modernists that gathered around the Steins. Unfortunately, Benton's position in Paris was financially precarious. His uncle Sam, who had died of tuberculosis in Arizona, had left him with a small fund for his education, but the money was running out. He hoped that his mother, who had inherited money from her parents, would continue to support him. But in March of 1911 Benton's mother unexpectedly arrived in Paris, discovered that he had a French mistress, and took her boy home.

The Cross-dresser

Benton's hasty departure from Paris was not only humiliating but had deep artistic consequences. As a result of this abrupt removal, Benton's forward development as a modernist was abruptly halted. Had he stayed in Paris, Benton would surely have played a role in the development of Synchromism, the modernist movement that Russell and Macdonald-Wright unleashed on the world in the spring of 1913. Instead, he did not learn about Synchromism until 1914, when Macdonald-Wright returned to New York to introduce Americans to the new style. Just about everything of significance that Benton passed on to Jackson Pollock was based in some way on Synchromism. For this reason, it's worth making a brief digression to describe what Benton *missed* when he left Paris—the contacts with Matisse and Picasso, the exhibitions of Futurism and Orphism, and above all to describe the birth of Synchromism and its place in the history of modern art.

A good place to start is with the biography of Macdonald-Wright's partner, Morgan Russell. While Macdonald-Wright eventually moved ahead of his partner, in the early days of their association Russell was the artistic leader. Indeed, Russell later insisted, with some plausibility, that Synchromism was his invention and that he included Macdonald-Wright in the first Synchromist exhibition only because he needed help to pay for the costs of staging the exhibition and publishing catalogues and posters. Thus, it was Russell who initiated the flood of artistic and intellectual forces that later rippled on to Macdonald-Wright, to Benton, and to Pollock.

If Macdonald-Wright was, to use Benton's words, a "psychological oddity," Morgan Russell was one to an even greater degree, for reasons that likewise stretched far back into childhood. But if Macdonald-Wright's childhood was pampered, spoiled, and indulged, Russell's was strangely bleak. Not merely economically impoverished, it was a strange, loveless emotional zero as well—not so much a dry desert as an utter vacuum. In his inner soul the unsettling emptiness of Russell's childhood never left him, and in some odd way it seems to have impelled both his astonishingly rapid progress to the center stage of modern art and his bewildered retreat once success and fame were seemingly within his grasp.

An only child, Morgan Russell was born on January 25, 1886, on Christopher Street in New York City. His father, Charles Jean Russell, an architect, died when he was nine. Three years later his mother, Miner Antoinette Russell, remarried, and at this time she broke off all communication both with her own family and with the Russells. Consequently, other than his strained relationship with his mother and his stepfather, Morgan Russell grew up without contact with family members of any sort. His mother's new husband, Charles Otis Morgan, took no interest in his stepson and even resented the burden of providing room and board. Around the age of sixteen Russell left home and began supporting himself with menial jobs, such as working in restaurants.

No doubt a major reason for Russell's poor treatment was that his family was not wealthy and providing him with money was difficult for them, but even so the way he was cast off by his mother and stepfather seems not simply heartless but psychologically peculiar. The final break came in December 1909, when Russell was just twenty-three and living in Paris. His mother died of pneumonia in New York, and Russell did not return home to attend her funeral. After that date his stepfather ceased to answer his letters, leaving him completely on his own. Ingratiating and good-looking, in a somewhat feminine way, Russell developed a talent for finding people who would provide financial help and become foster parents of a sort. By 1902, when he was sixteen, Russell began rooming with the sculptor Arthur Lee, who remained his companion and helpmate for the next four or five years. He also began posing in the nude as a model for James Earle Fraser's sculpture class at the Art Students League, an activity that introduced him to artists and the activities of artists, as well

The leader of the formative phase of Synchromism
was Morgan Russell, who took up first sculpture
and then painting after supporting himself as an
artist's model. (Photographer unknown, *Morgan Russell
Posing as a Model* [c. 1907]. Montclair Art Museum,
Morgan Russell Archives.)

as to his future patron, Gertrude Vanderbilt Whitney, one of Fraser's stu-
dents. In 1906, when Arthur Lee went to study in Paris, Russell decided
to accompany him, and by this time he had resolved to become a painter
and sculptor himself.

Along with abandoning her son, Russell's mother left emotional
scars of another sort. Russell was a cross-dresser. As is typical of cross-
dressers, this ritual seems to have been inspired by the way he was disci-
plined as a child: when he was a little boy his mother put him in women's
clothes when he misbehaved. In a chronology of his life, Russell noted of
the year 1890, when he was four, "Mother put dresses on me as a punish-
ment." His next reference to such an action is for 1895, when he was nine,
when he was "put in skirts for a week as punishment." Interestingly, 1895
was the year his father died, so this discipline must have painfully con-
fused a fragile sense of male identity already threatened by the loss of a
father figure.

"The day I was put into skirts by my mother for once and all," he
later wrote, "is as vivid to me after all these years as it was at the time."
She first pulled off his boy's clothes—his shirt, long trousers,
underwear—and then layered him in girl's clothing: a long white che-
mise, a tightly laced corset, elaborately flounced and beribboned draw-
ers, a flounced petticoat with lace, another petticoat made of taffeta, a
high-necked shirt, which she buttoned at the back so that he could not
remove it, and a heavy long skirt, which she fastened with a belt—saying

as she did this, "There—you will never get out of these for the rest of your life." As his mother did this, Russell later recalled, he could feel that her actions "drowned all masculinity from me." But while shamed, he also felt a sense of pleasure. As he later wrote, "The sensation of the long and voluminous petticoats against my bare legs was a mixture of delight and strange troubling sensation." The moment became a defining one in setting Russell's personal identity, for he began to feel excitement in thinking of it and discovered that "I feel the same emotion when recalling it as I felt when it took place." Although this cross-dressing began as a form of chastisement, by the time he was in his teens Russell found that dressing in skirts gave him a peculiar but definite sense of exhilaration.

The Circle of Gertrude Stein

Morgan Russell's rise from a busboy in restaurants to a major figure in modern art was exceptionally quick: he made his very first painting in 1907 at the age of twenty-one and was a major figure of modern art by 1913, when he was twenty-six. Such rapid artistic progress from obscurity to fame in just five years surely owed something to Russell's innate talent, but it also surely reflected Russell's exceptional good luck in arriving in Paris at what was arguably the most important juncture in the history of modern art. At the moment when Russell arrived in France, controversy about Matisse and the Fauves (or "Wild Beasts") was at its height, the moment when Cubism was being born. Matisse had just scandalized Paris with his *Blue Nude*, and Picasso, in response, was creating his *Demoiselles d'Avignon*, the single most famous painting of modern art. Remarkably, Russell got to the center of all this almost immediately. Within a week or so of his arrival in Paris, Russell made his way to the home of Gertrude Stein.

If any single figure could be termed the mother of modern art it would surely be Gertrude Stein. Fat, Jewish, and lesbian, all qualities that might have driven her toward a feeling of being outcast or ill at ease, she achieved a Buddha-like serenity and became an iconic figure of the modern age. But she had one notable advantage, inherited wealth. Gertrude's father was a merchant and speculator who developed the cable car system in San Francisco. One night he died in his sleep, and as Gertrude

With a fortune made in San Francisco cable cars, Leo, Gertrude, and Michael Stein settled in Paris, where they became the major patrons of Picasso, Matisse, and other leading figures of modern art. Morgan Russell made his way to Gertrude's salon at 27 rue de Fleurus within a few weeks of his arrival in France. (Photographer unknown, *"The Stein Corporation": Leo, Gertrude and Michael Stein.* Yale Collection of American Literature, Beinecke Library, Yale University.)

put it in her memoir, "Then our life without a father began, a very pleasant one."

Gertrude's older brother Leo was the figure who led the family to Paris and began collecting modern art. Once purchased, the paintings were hung helter-skelter in their studio at the rue de Fleurus—first a single row of paintings, then double-hanging, and finally hung floor to ceiling, with as many as four or five paintings on top of each other. Soon the Steins' salon had become one of the principal gathering places in Paris.

Some writers say that the Steins were not really wealthy. Perhaps, but they had enough money so that they did not have to work and could rent a large house in Paris with an adjacent studio, have a cook and servants, eat well, entertain friends, travel when they chose, indulge their hobbies,

and still have money left over for buying paintings. To be sure, they did not rank high in the echelons of the rich. They were able to buy paintings by Matisse and Picasso when they were cheap, generally not more than a hundred dollars or so, but as prices rose they were unable to keep up and dropped out of the competition. Their best purchases were made early on for modest sums.

When I met him at his apartment in the Chelsea Hotel, the Kansas City–born composer Virgil Thomson, who knew Gertrude Stein well, remarked to me that the key to understanding her was to realize that she was fundamentally self-centered. Somewhat paradoxically, this was what made her the greatest gatherer of artistic talent of the modern age. Other salons in Paris had formal dress codes and a strict sense of social ritual; the Steins socialized in a way that was American and informal. Just about anyone could show up, with or without an introduction, to stare at the strange modern paintings and to mingle with the other guests—artists, writers, dancers, eccentrics, and gawkers. Russell had no trouble entering the enclave, and he seems to have made an unusually strong impression on Gertrude, perhaps because something about his sexual ambiguity attracted her. She made him the subject of one of her first "word portraits," in which she speculated on whether he would achieve greatness.

Matisse and Rodin

One way of thinking of Synchromism is to view it as a synopsis of what had happened in modern art between 1909 (when Russell arrived in Paris) and 1914 (when the first Synchromist exhibition was staged). Essentially, Russell synthesized the most radical and exciting artistic developments of this period. It is convenient to think of this as a four-step process.

1. *Matisse and Rodin*

When Russell arrived in Paris, Matisse was at the peak of his influence at the rue de Fleurus, and in April 1909 Russell entered Matisse's art class, which had been formed just a few months earlier at the insistence of Gertrude's sister-in-law Sarah Stein. Those who met Matisse were generally surprised. The wild beast of modern art turned out to be a solemn, dignified man, who dressed in a conservative suit, like a banker, and had

the somewhat pompous verbal manner of a college professor. But to some extent this seems to have been a ruse, since Matisse's demeanor grew increasingly bourgeois as his art grew stranger and wilder.

The key to understanding Russell as a modern artist—as well as those affected by his ideas, through a long chain of influence—is to grasp that his outlook on modern art was primarily shaped by Matisse. The influence of Matisse, however, had a surprising aspect, since unlike most of Matisse's students, who focused on painting, Russell concentrated on sculpture. Matisse is so famous as a painter that it is easy to forget that, along with Picasso, he was arguably one of the two greatest sculptors of the twentieth century. What is more, sculpture played a key role in shaping Matisse's development as a painter. After years of unavailing struggle, Matisse took up sculpture in 1899, and in the process of mastering the medium his painting was transformed. The period in which he focused intently on sculpture is also the period in which he moved to the forefront of modern art.

When he took up sculpture, Matisse's reference point was the work of Auguste Rodin. Indeed, his first statues were not only closely based on precedents by Rodin but were made from Rodin's model César Pignatelli (nicknamed Bevilacqua) under the guidance of Rodin's studio assistant Antoine Bourdelle. At the time, Rodin's work was technically innovative. Dismissing conventional, classical notions of the human form, he faithfully followed and slightly exaggerated the irregularities of the human body, following its alternation of what he described as "lumps and holes."

In essence, Rodin had discarded a regularized sense of visual rhythm for one that was more alive, more vital, more unpredictable. This complex rhythm of hollows and bumps, which expressed the tension and relaxation of muscles, was then extended to the composition as a whole. Matisse took up this idea but employed it even more boldly than Rodin. Whereas Rodin liked to exploit the play of light on the surface of the sculpture, Matisse employed rougher surfaces and directed attention to the blocky masses of the composition as a whole. Ultimately, Rodin's concept of "lumps and holes," words roughly equivalent to "the hollow and the bump," was the source of the rhythm in Jackson Pollock's work, through a chain of influence that started when Russell studied sculpture with Matisse.

Two closely related works by Matisse, both made in 1906–7, provide

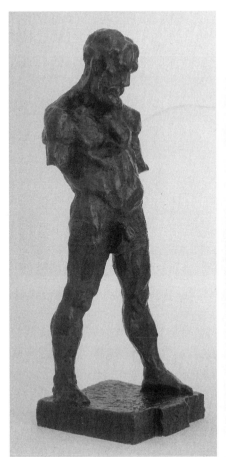

The rough, almost brutal modeling of Matisse's first major piece of sculpture, *The Slave* (c. 1900–06, left), was derived from works by Rodin, such as *Jean d'Aire* (1885, right). Matisse worked from Rodin's former model Pignatelli, under the guidance of Rodin's former studio assistant Antoine Bourdelle. (*Left*: The Museum of Modern Art, New York, Mr. and Mrs. Sam Salz Fund. © 2009 Succession H. Matisse / Artists Rights Society (ARS), New York. *Right*: Photographer unknown, statue now in the Rodin Museum, Meudon.)

the key to Russell's whole development as an artist. Russell saw them both within weeks of his arrival in Paris in 1908. One was a statue, *Reclining Nude, Aurora*, the other a painting, *Blue Nude*—the most talked-about and controversial painting in the Salon des Independents of 1907. The two pieces are closely related, essentially translations of the same conception into different media. Matisse first undertook his sculpture of *Aurora*, but after weeks of work, when the piece was nearly finished, it slipped off a table and its head was broken off. Emotionally traumatized,

Matisse's *Blue Nude* (1907, top) simplified the twists of the human figure used by Michelangelo in a fashion influenced by African sculpture. (*Top*: The Baltimore Museum of Art, The Cone Collection formed by Dr. Claribel Cone and Miss Etta Cone of Baltimore, Maryland. © 2009 Succession H. Matisse / Artists Rights Society (ARS), New York. Photography by Mitro Hood. *Bottom*: *Night* [1520–34], the Medici Chapel, Florence.)

he set aside his work in clay and rapidly painted the *Blue Nude*, in which he dramatized the twists and turns of the figure with bold brushwork and strange colors. When that was complete, he went back and completed his statuette. Both creations were acquired by members of the Stein family: the *Blue Nude* was acquired by Gertrude and Leo, the *Aurora* by Sarah. In both pieces, Matisse explored the idea of *contrapposto* and serpentine movement.

Contrapposto can be traced back to ancient Greece and was perfected and codified by Polykleitos of Argos, a sculptor of the fifth century B.C., in his statue *The Spear Bearer*. In its fundamentals the idea of *contrapposto* is very simple. Rather than showing the figure with weight equally on both feet, you put the weight more heavily on one. This instantly creates a very different sense of visual rhythm. Instead of a symmetrical arrangement, it creates a sense of surprise and irregularity, although there is a strict logic to the alternation of tense and relaxed muscles, of compressed and extended forms. Nothing is completely regular, but when done well there is a perfect sense of balance. Since people normally stand with their weight more heavily on one foot than the other, the visual effect looks completely lifelike, as opposed to the old flat-footed way of rendering the figure, which looks wooden and stiff. Developing *contrapposto* was the key to developing the classical style of Greek art, which still looks natural and convincing to us even today and which we still use as one of our key reference points when we look for an ideal of human beauty.

Since the weight is not even, *contrapposto* generally entails an element of twisting. The figure starts to become a spiral, since the torso is not squarely aligned with the hips but slightly turned. In the late Renaissance the sculptor Michelangelo became fascinated with this effect. He found that by exaggerating these twists he could not only render muscles in visually memorable and exciting ways but could create a powerful emotional effect of extraordinary tension. Renderings of this type are often described as the *figura serpentina*—the serpentine figure. Essentially, Michelangelo intensified and exaggerated the device the Greeks had discovered, to create the greatest possible tension and emotional power, and he also applied it to a greater variety of poses.

Matisse's *Aurora* and *Blue Nude* both employ the ancient principles of *contrapposto* and serpentine movement but radically simplify the

figure in a fashion influenced by African sculpture. Thus, there are no distractions of surface or detail to take away from the energy of the effect: the paintings endow these principles with a brutal force that feels modern and new. Russell was obviously fascinated and impressed by what Matisse had achieved, and he clearly studied under Matisse with this end in mind. To provide guidance, Matisse instructed Russell to carefully study not his own work but a piece in the Louvre that had been one of his principal sources of inspiration, Michelangelo's *Dying Slave*.

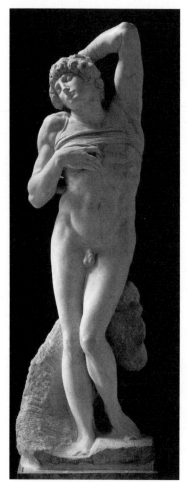

Morgan Russell used Cubist effects (right) to intensify the dynamism of the twists in Michelangelo's *The Dying Slave*. (*Left*: *The Dying Slave* [c. 1514–16]. The Louvre, Paris. *Right*: *Study for "Synchromy in Green"* [c.1912–13], Carnegie Museum of Art, Pittsburgh, gift of Rose Fried.)

Made for the never-finished tomb of Pope Julius II, *The Dying Slave* was conceived as a caryatid, or supporting figure for heavy blocks of stone piled on top of it. Its pose is one that has since become standard for girlie pictures, with the hand behind the head and the elbow bent. Such a stance not only creates a beautiful line but twists the whole figure in a provocative way, emphasizing all its sensual aspects.

This was a piece that fascinated French artists of this period—Rodin, Degas, Cézanne, and Picasso all made sculpture or paintings based on it. Matisse even owned a small replica of *The Dying Slave*, which appears in a painting of 1923, *Checker Game and Piano Music*, where it appears on top of a dresser. Russell also became obsessed with *The Dying Slave*, and his chief accomplishment while working with Matisse was a blocky sculpture based on it, which simplified its rhythms in a vaguely Assyrian fashion.

2. *Cézanne and Picasso*

In short, while studying with Matisse, Russell was introduced to many of the major themes of his career: among them the human figure in *contrapposto* and the idea that a unifying rhythm should run through the entire composition. But then, around the winter of 1910, Russell had a series of crises. For one thing, at this time Matisse fell out of favor with Gertrude Stein (who had shifted her patronage to Picasso) and was so emotionally bruised that he closed his school. Thus, Russell lost his major teacher and mentor. In addition, Russell experienced a financial crisis, which was only resolved when he attached himself to Macdonald-Wright. During this difficult period Russell shifted from sculpture to painting, perhaps in part because painting was less expensive than sculpture and could be accomplished in a smaller studio, and also no doubt because by taking up painting he was able to strengthen his emotional bond with Macdonald-Wright.

At this point Russell became fascinated by two artists who had explored new approaches to modeling form: Cézanne, who used warm and cool colors to suggest projection and recession, and Picasso, who used lines and cubes to analyze sculptural relationships and to create a new rhythmic dynamism.

Not surprisingly, Russell's starting point was Cézanne, an artist

whom Matisse admired and collected and who intensely interested both Benton and Macdonald-Wright, who were earnestly churning out imitations of his work. Cézanne came to the fore in this period, since he seemed to offer a means of using color as a constructive element. When he applied color, Cézanne did so with reference to spatial position, often organizing his paintings around the interplay between warm and cool—that is, using warm colors such as orange to indicate advancing surfaces and cool colors such as blue to articulate retreating ones. Every brushstroke seems to express a tension between an effort to record an optical sensation and an effort to weave these scattered sensations into a larger pictorial and geometric unity.

Russell's notebooks of 1910 are filled with references to Cézanne and to studies after his work. Indeed, in 1910 Russell and his friend Andrew Dasburg borrowed a Cézanne oil study of five apples from Leo Stein, in order to copy it and absorb Cézanne's methods. As Dasburg later commented, "Morgan copied it in an analytic way whereas I copied it literally."

Russell's interest in Cézanne soon led forward to an interest in the Cubism of Picasso. At this point we enter a potentially treacherous arena, for Cubism is one of the most complex and bewildering of twentieth-century movements. What is now termed Cubism is actually a succession of different styles, each of which works on slightly different principles and explores reality from the vantage point of different assumptions. Explaining any one of these phases is a challenging task, but our work will be greatly simplified if we content ourselves with looking at what Russell learned from Cubism, rather than seeking to fully comprehend what Cubism was really all about. In fact, what Russell took was relatively simple: the idea of cubes, or at least of some sort of simplified, box-like volume, which helps to define the geometric character of a space. Most of what Russell learned from Picasso he learned from a single painting of 1908–9, *Three Women* (now in the Hermitage), generally considered, along with *Les Demoiselles d'Avignon,* as one of the two most important early Cubist paintings. In 1911 *Three Women* hung at the rue de Fleurus in the collection of Gertrude Stein. It was arguably the most significant painting by Picasso in her collection, and without question the largest—it is nearly seven feet tall. There it attracted the attention of Russell, who copied it in a careful pencil sketch, reproducing the

Through copying Picasso's *Three Women*, then owned by Gertrude Stein, Morgan Russell learned two fundamental tricks of Synchromism: the fracturing of form into cubic shapes and the use of pie-shapes to create spiraling pinwheel rhythms. (*Study after Picasso's "Three Women"* [c. 1911]. Montclair Art Museum, Morgan Russell Archives.)

scaffolding of the design. It is the only painting by Picasso that he copied so carefully, and while he certainly saw many of Picasso's other works, it is hardly an exaggeration to say that everything he took from Picasso in developing Synchromism was derived from this single canvas.

The painting employs shapes similar to wedges of pie, which are piled one on top of another to create a rhythmic sequence of volumes, somewhat like the successive steps of a spiral staircase. Russell was clearly fascinated by this effect, and in the sketch in which he copied Picasso's canvas he brought it out. In two notebooks of 1911, Russell pursued the rhythmic structure of the painting further, sketching figures in an S-curve and then dividing these figures into wedge-like divisions, again shaped rather like slices of pie. By this time, Russell clearly recognized that such pie shapes were not only a useful analytical tool but had a formal beauty in their own right. Essentially, he realized that Picasso's method could be used to dramatize the sort of spiral rhythm that he loved in *The Dying Slave*. Indeed, one could intensify the sense of dynamic movement by making the figure more abstract.

3. *Futurism and Orphism*

By this time movements of modern art were starting to sprout up with some regularity, and the techniques for creating a new movement were starting to fall into a formula. Shortly after copying the painting by Picasso, Russell attended two exhibitions that had a major impact on his thinking and served a role as catalysts for the birth of Synchromism. The first was a show of Futurism, the second one of Orphism.

Futurism had started as a manifesto by the poet Filippo Marinetti proclaiming the necessity of smashing everything old and creating a new manly culture based on machines, speed, and modernity. Remarkably, Marinetti published his manifesto before the Futurist painters—Boccioni, Carra, Russolo, and Severini—had actually developed a new artistic style. But they did so shortly afterward, devising a visual language that was similar to Cubism but focused not on still life but on trains, cars, speed, and movement—that is to say, dynamic subjects expressive of the new machine age. Their most significant visual innovation was the device of "lines of force," which expressed energy rather than the physical object. On February 5, 1912, the Bernheim-Jeune Gallery opened the first show of Futurism to be staged in France. "Everybody was excited," Stein wrote of the event, and "everybody went." One of these visitors was Russell. He carefully saved the catalogue for the show and eventually gathered copies of more than twenty Futurist publications.

Only three weeks after the Futurist show opened, on February 28, Robert Delaunay staged an exhibition of a new style called Orphism at the Galleries Barbazanges in Paris. Like the Futurists, he used a Cubist language of form, focused on subjects expressive of modern life (such as the Eiffel Tower), and employed brighter colors than the original Cubists. The title of Delaunay's movement came from the poet Guillaume Apollinaire, who thought that his work had something to do with orphic mysteries.

In fact, the lessons of the two exhibitions, that of Futurism and that of Orphism, were curiously similar: they amounted to a formula for making modern art. From the visual standpoint, make Cubism a bit jazzier through the use of modern subject and bright color; from the promotional standpoint, rent a gallery, print up some posters, and write a manifesto, or get a friend to do so.

4. Percyval Tudor-Hart and His Color Theories

The stage was clearly set for a new movement of modern art. But what would it be? The key to developing Synchromism lay in a new artistic influence, the teachings of a Canadian painter (thoroughly obscure today) named Percyval Tudor-Hart (1873–1954). Russell discovered him first and then brought Macdonald-Wright to his classes. Tudor-Hart's own paintings are remarkably conservative in approach. His teaching focused on coordinating disparate parts into a larger system of unity. He was particularly obsessed with the most unruly element in painting, color, and sought to somehow control it by applying principles drawn from the most disciplined, mathematical and abstract of art forms, classical music. Russell and Macdonald-Wright both took classes with Tudor-Hart in 1911, shortly after they met, and it was by joining Tudor-Hart's theories with all that they had absorbed from French modern art that they came up with the style of painting they christened Synchromism. Russell's breakthrough came when he recognized that sequences of color, arranged in chords according to Tudor-Hart's color system, could be used to dramatize the twists and turns of the human figure that he had focused on in his study of the work of Picasso and Matisse. Color, in short, could be used to enhance and etherealize the sensation of muscular rhythm.

For nearly ninety years, writers on Synchromism, including myself, did not have a clear grasp of what the movement was really all about, in particular, what Russell and Macdonald-Wright were doing with their arrangements of color. Fortunately, a few years ago the mystery was solved by a young scholar, Will South, who took the trouble to locate one of the rarest publications in the history of modern art, Macdonald-Wright's *A Treatise on Color*, privately printed in Los Angeles in 1924. Since the color plates were made by hand, with pigments carefully mixed by the author himself, only sixty copies of this book were fabricated, with a handmade box, most of which have simply disappeared. I must confess that I have never seen an original, only a grainy photocopy, although fortunately South has reproduced the color plates in an exhibition catalogue on the work of Macdonald-Wright's career, and this makes it possible to follow the argument of Wright's text. With its help one can finally understand the principles of the Synchromist use of color

and color relationships; and due to this knowledge we now know that Synchromism was in fact quite different from Orphism, although in ways that are somewhat complicated and strange. Tudor-Hart believed that color harmony was *precisely* analogous to musical harmony. He thus redesigned the color wheel of Newton to express this relationship. Rather than the seven colors of Newton's wheel, Tudor-Hart created a color wheel with twelve colors, the same number as that of the notes of the Western musical scale, which has twelve tones—seven whole notes and five sharps and flats.

Traditional color wheels make harmonious "chords" of color by selecting equidistant intervals. In music, however, harmonious chords are not formed with equidistant notes but with firsts, thirds, and fifths. Tudor-Hart felt that harmonious color chords should use the same intervals. Thus, to make a painting according to the system devised by Tudor-Hart and employed by Russell and Macdonald-Wright, the artist followed the following three-step procedure:

1. Using the color wheel, with its colors divided into twelve "notes," the artist chooses a "tonic" color, which will be the starting point of his "scale" and will determine all the other colors he employs.

2. Starting with that color, the painter then creates a scale by going up (or around) the color wheel, using the intervals of Western music—that is, whole step, whole step, half-step, whole step, whole step, whole step, half-step. Thus, for example, the scale starting with red would run: red, orange, yellow, yellow-green, blue-green, blue-violet, and red-violet.

3. To create a color chord equivalent to a tonic chord, select the first, third, and fifth intervals of the scale. A color chord for the scale of red, for example, would consist of red, yellow, and blue-green.

Essentially—at least in theory—carrying out these steps made it possible to create an overall scheme of color harmony, so that every "note" of color had a relationship to every other note within a harmonically calibrated system. This much would have been quite complicated on its own, but Russell and Macdonald-Wright then added another

variable—that of warm and cool colors, which helped to indicate spatial position, in a fashion similar to the work of Cézanne.

On paper the Synchromist system sounds mechanical and relatively easy. Just carry out step one, step two, and step three and you're all set. In practice it turns out to be maddeningly difficult. The system works up to a point and then seems to dissolve into chaos. One of the major problems is that in music the sequence of notes is strictly linear and controlled, whereas in painting the placement of colors does not follow an orderly pathway. Our eye can scan a painting in any direction, and as a consequence it's not possible for a painter to specify the exact sequence of color notes that the viewer will be tracing.

Russell and Macdonald-Wright tried to wiggle around this problem by arranging colors in a sort of sinuous ladder. When one looks at the painting, one's eyes are supposed to run up and down this ladder, playing the color notes in the right order. Even this scheme, however, is not quite foolproof. To make an interesting composition, the ladder needs to lead out in different directions. Making the major sequence of colors is not too difficult, but what should one do with the secondary shapes and with the background elements, and with all the color units that don't form part of the main sequence of notes? Because the possible visual pathways are so numerous, Russell and Macdonald-Wright tended to handle the process most logically at the upper end of the scale, then to become more confused as they moved into the distance.

It should be noted that today scientists accept almost none of Synchromist color theory as true. Color and sound are processed by quite different physiological mechanisms and are hardly equivalent. Even the Synchromist procedure for making harmonious color chords is questionable. While Russell and Macdonald-Wright liked to work with sequences such as thirds and fifths, other color systems based on quite different intervals seem to work equally well and to be equally harmonious.

The most that can be said in defense of Synchromism is that a graduated system of intervals, whether of hue (that is, color), gradation (that is, degree of light or dark), or saturation (that is, the purity of a color) can be used to express a sequence. If this sequence is tuned or calibrated with another variable, such as position in space, it does clarify or assert relationships in a way that most viewers can grasp instinctively, without elaborate explanation.

Notably, the sequences that the Synchromists explored were those of the turns and twists, the hollows and bumps, of the human figure. In fact, Matisse's instruction to study *The Dying Slave*, and to do so very carefully, provided the basis for Russell's entire career as a Synchromist. While studying under Matisse, Russell made a blocky piece of sculpture inspired by Michelangelo's figure, and this sculpture in turn became the subject of Russell's first full-fledged Synchromist painting, *Synchromy in Green* of 1912–13. As he developed as a Synchromist, Russell repeatedly went back to *The Dying Slave* itself, analyzing its rhythms of form through sequences of color. Many of Russell's paintings initially look like pure abstractions, but when we trace carefully his working process we discover that ultimately they all go back to *The Dying Slave*, and to its spiraling rhythmic movement. Thus, ultimately, while he enhanced the effect with prismatic colors, Russell's paintings are explorations of the principle of "the hollow and the bump" that he had learned from Matisse and Rodin. Hollow and bump—the same principle that Benton passed on to Jackson Pollock. A carefully treasured formula, quietly passed from one great artist to another.

7

Astonishing the French

Russell's creative bursts, as well as his emotional breakdowns, seem to have corresponded in some way with his bursts of cross-dressing. Interestingly, in the months after he visited the exhibitions of Futurism and Orphism, Russell did not paint very much but simply made rough sketches in his notebooks. He also wore male clothing. He had gone into some phase of hibernation or gestation. By the spring of 1912, however, he had begun to plan some of his major Synchromist paintings. A notebook of May 1912, for example, contains a small diagram of what became *Synchromy in Blue-Violet* in 1913. Following the progression of his sketches is quite informative, since we can follow step by step how he moved from fairly straightforward studies of Michelangelo's *Dying Slave* to more and more abstract and generalized attempts to reproduce its essential rhythm.

By the end of 1912 Russell had begun making major paintings—the most important of his career—and he had also discarded his male clothes and turned to dressing like a woman. "Winter commenced life in petticoats," he noted in his journal. Russell's achievement of this period can be largely summed up through two ambitious paintings completed in 1913, *Synchromy in Green* and *Synchromy in Blue-Violet*, which reveal how he progressed, with surprising speed, from a slightly modulated form of realism to the verge of pure abstraction.

Synchromy in Green was a fairly realistic studio scene. While the objects were rendered in a fractured manner, reminiscent of Cubism, it's not

hard to recognize them: a still life, a woman at a table, a piano, and three pieces of sculpture. All these elements have a didactic significance and allude to the sources that Russell was drawing on to produce his new synthesis of dynamic form, color, and music. The three sculptures—all works by Russell—pay homage to Michelangelo and his principles of spiraling muscular rhythm. (One of the sculptures is quite similar to Michelangelo's *Dying Slave*, on which it was based.) The three apples on the table refer to Cézanne, who made still-life paintings of apples and who demonstrated that color could be used constructively, to enhance the sensation of form. The piano with sheet music alludes to the idea that painting should become like music and that colors should be arranged in scales and chords. The woman reading a book is probably Gertrude Stein, who, as has been noted, wrote a "portrait" of Russell during this period. Russell surely wanted to pay tribute to her role as a supporter and friend of modern art, and very likely he hoped that if he portrayed her she would purchase the painting.

Sadly, *Synchromy in Green* has disappeared: we know its appearance only from a reproduction in the catalogue of the first Synchromist exhibition. Essentially, Russell used Cubist fracturing of form as a kind of analytical tool, to bring out the twists and turns of the figure in space more forcefully than in a naturalistic rendering. Unfortunately, since the catalogue photograph was in black and white, it's not possible to reconstruct exactly how Russell employed color in the painting, although the effect was clearly prismatic and brilliant. When the painting was first exhibited, a writer for the *New York Times* described its impact as "astonishing" and noted that it was painted "in the strongest possible tones."

In short, *Synchromy in Green* was a sort of demonstration piece, which didactically laid out how Cubism and color theory could be combined to give new energy to ancient principles of *contrapposto* and rhythmic movement, as they had been developed by Michelangelo and others. For all its ambition, the painting had an additive quality, as if Russell had simply glued together a series of smaller still-life and figure studies to create a larger composition. Within a year, however, Russell went on to produce a piece that is both better integrated as a design and far more radical in conception: *Synchromy in Blue-Violet*.

More than ten feet high and seven wide, *Synchromy in Blue-Violet* was an ambitious project, which Russell developed through a series of

careful studies. Even today it impresses one as a startling and original conception, and Russell himself always regarded it as his most important painting. In two respects the canvas shows an advance over *Synchromy in Green*. First, the composition has been strengthened and simplified. A fan-like pattern radiates like a pulse of pure energy from the lower right corner up toward the upper left: thus, the effect is completely unified and has none of the additive quality of the earlier work. Second, and perhaps even more significant, it is far more abstract. Russell's early sketches for the *Synchromy in Blue-Violet* show that its origins were figural and, as before, based on Michelangelo's *Dying Slave*. But in the final design the anatomical references have almost disappeared. We are no longer looking at a collection of still-life and figural studies: the subject (and technique) has become larger and more powerful. What began as an expression of muscular torsion has been translated into a statement about the universe as a whole, in which color plays a powerful expressive role as a means of dematerializing matter into something akin to "spirit."

In fact, Russell clearly conceived the piece as a mystical and religious statement. To make this evident, when he first exhibited the painting in Paris at the Bernheim-Jeune Gallery, under the title in the catalogue he cited the famous lines from the Book of Genesis:

Then God said: 'Let there be light!' and there was light. God saw that the light was good; and God separated the light from the darkness.

In short, the subject of the painting is not just the human figure but something more cosmic. In a letter to Gertrude Vanderbilt Whitney, Russell went on to explain:

The bursting of the central spectrum in my picture on one's consciousness has surely a vague analogy with what must have happened if one can imagine the first visual organ as belonging to a conscious being. If modern painting is to express anything greater than a few apples or portraits it can only be something of this sort.

While not very clearly written, Russell's statement seems to indicate that the ultimate theme he sought to capture was the moment of first creation,

when awareness of existence flooded into human consciousness like a burst of colored light.

At this point we come to some tricky questions of definition. Should we consider Russell's painting as figurative or abstract? In fact, seeing these terms as dichotomies may not be correct. The painting does contain some vestiges of figural qualities, but these have been translated into something that is no longer literal but symbolic. Muscular form has been converted into a cosmic form of energy—that is, into something abstract. And if we accept the idea that *Synchromy in Blue-Violet* was essentially abstract, then it marked an important step in the history of modern art, since it was the first truly abstract painting ever exhibited in Paris. Essentially—as Pollock was to do later—Russell had abstracted from the rhythms of the human body, from the alternation of hollow and bump, to create a design that expressed the larger rhythms of the cosmos and that fused these rhythms into a vision of ecstasy.

Scandalizing Paris

As Russell and Macdonald-Wright surely intended, Synchromism began stirring up controversy, even before the work was exhibited. Early in 1913 Robert Delaunay and his wife, Sonia, the creators of Orphism, got word that two brash young Americans were making paintings with bright colors. Convinced that Russell and Macdonald-Wright were stealing his ideas, Robert approached Stanton in a café and inquired, "So what is this Synchromism business all about?" "It would take a man of intelligence to understand," Macdonald-Wright coolly replied, and a brawl ensued.

In March 1913 Morgan Russell showed *Synchromy in Green* at the annual Salon des Independents, the first public exhibition of a Synchromist painting, as well as the first use of the term "Synchromy," which he (or Macdonald-Wright) had coined from Greek words meaning "with color." As noted, the canvas was striking enough to merit mention in the *New York Times*. Within two months, Synchromism had blossomed into a movement.

On June 1 Russell and Macdonald-Wright opened the first Synchromist exhibition in Munich, with a catalogue and the inevitable manifesto. They seem to have conceived the event as a sort of practice session, an out-of-town tryout, for the show they had booked for two months

later in Paris. Four paintings were reproduced in the catalogue, none of which can be located today: Russell's *Synchromy in Green*, Macdonald-Wright's *Portrait of Jean Dracopoli*, and two back views of Michelangelo's *Dying Slave*, one by each artist.

To a large degree the paintings were upstaged by their catalogue statement, most likely written by Macdonald-Wright. Its inflammatory tone was borrowed from "The Futurist Manifesto." Although titled "In Explanation of Synchromism," in actual fact it didn't explain very much. It was largely an indictment of other artists and movements, such as the Impressionists, who were "mediocre," the Cubists, who were "by no means more successful in their attempts than the Impressionists," and the Futurists, who were "naïve." As was intended, the show stirred up intense interest: five thousand copies of the catalogue were gone by the second day of the exhibition, and all the hand-colored posters were stolen from the kiosks.

In October the second Synchromist exhibition opened at the Bernheim-Jeune Gallery in Paris. Once again, the catalogue insulted nearly everyone. Picasso was described as a vulgarizer of Cézanne; the Delaunays (for the first time acknowledged as rivals) were dismissed as latter-day Impressionists, equally superficial in their grasp of the fundamental principles of painting. To confuse the Orphists with the Synchromists, Wright and Russell declared, was like confusing a tiger with a zebra because they both had stripes. The only kind words in the essay were for the Synchromists themselves. Their art, the essay stated, represented a new form of picture-making "that would surpass contemporary painting in emotional power as the modern orchestra undoes the harpsichord's old solo."

Once again, the catalogues quickly sold out, an indication that the essay was indeed stirring up interest. But French critics without exception were offended and took the side of their home team, the Delaunays. One reviewer asserted that "the house painter at the corner can, when he wishes, claim that he belongs to this school." Still another declared that "Macdonald-Wright copies with a dirty broom the Slave of Michelangelo." (Macdonald-Wright did indeed often work with a very large brush, to create an intentional blurriness of stroke.) The critic André Salmon pretentiously announced that the Americans had created "a vulgar art, without nobility, unlikely to live, as it carries the principles of death itself."

Notably this show included Russell's first abstract Synchromy, *Synchromy in Violet*, which he had dedicated to Gertrude Vanderbilt Whitney, no doubt to encourage her to continue her financial support.

The controversy over Synchromism reached its peak the following winter when Morgan Russell exhibited his colorful *Synchromy in Orange: To Form* at the Salon des Independents. Some twelve feet high, the painting was too big to ignore. Critic after critic denounced the canvas either for being completely incomprehensible or for plagiarizing the work of the Orphists. The pair achieved a kind of high point of negative publicity when the president of the French Republic, Raymond Poincaré, who visited the exhibition, personally took umbrage at the piece.

In fact, while art historians have often treated them slightingly, Russell and Macdonald-Wright achieved quite a number of notable firsts. They were the first American painters to create a new modern artistic movement of any sort; they were the only Americans to contribute to the development of modern art in Paris; and they were the first artists of any nationality in Paris to exhibit truly abstract paintings, in which clear references to a particular subject had disappeared. Moreover, although this has not yet been fully recognized, the work of the Synchromists was not a dead end but a beginning—for their originality was not simply on the surface but in the intelligence with which they addressed fundamental questions of art-making and visual expression. The alternation of hollow and bump, the rhythm of the human figure, the sense of human identity reaching out for some larger truth associated with the cosmos as a whole—these are all concerns that would find echoes in the work of Thomas Hart Benton and Jackson Pollock, though admittedly in a radically different visual form. Regrettably, many of their most exciting ideas were not well described in their manifestos and were missed by most contemporary critics.

And one more thing—something not to be overlooked, at least as regards their influence on Benton and Pollock—Russell and Macdonald-Wright were the first American artists to rewrite art history by composing a manifesto. They showed that being a great artist was not simply a matter of making pretty paintings but of seizing a place in history, and of staging a grand performance that confronted and challenged the assumptions of the audience.

Part Four

The Other Wright Brothers

Were realism the object of art, painting would always be infinitely inferior to life—a mere simulacrum of our daily life, ever inadequate in its illusions . . . Our minds call for a more forceful emotion than the simple imitation of life can give. We require problems, inspirations, incentives to thought.

—*Willard Huntington Wright, 1916*

8

Band of Brothers

The phenomenon of creative pairs is a recurrent theme in the history of modern art during times of particularly bold and significant creative breakthrough. Impressionism, for example, developed through the partnership of Monet and Renoir, when they worked side by side on paintings of a suburban dance hall outside of Paris, La Grenouillère; Cubism through the partnership of Braque and Picasso in their run-down "Washboat" studio in Montmartre. This makes sense. Heading off into the unknown is a lonely and psychologically daunting enterprise. It helps to have a partner to provide an audience, even if it is an audience of only one. Synchromism fits neatly into this common pattern. It seems unlikely that Russell would have moved forward as quickly as he did without Macdonald-Wright's creative partnership and support, let alone without Macdonald-Wright's money, which paid for the posters, catalogues, and gallery space at the first two Synchromist exhibitions.

Nonetheless, during its first phase, Morgan Russell played very much the leading role in the Synchromist endeavor. He produced the largest and most ambitious paintings, and he was always just a little ahead of Macdonald-Wright in making innovations of technique, subject matter, or advances into the realm of abstraction. On the whole, Macdonald-Wright seems to have played a game of follow-up: to the extent that we can identify his distinctive contribution, it seems to have resided in the skill and sensitivity with which he explored color scales and chords, since even at this early stage he handled brushwork and gradations of tone and

color with more nuance and delicacy than Russell did. Around 1913–14, however, the balance between Russell and Macdonald-Wright started to shift, and the latter began to play the leading role. In part this was because Macdonald-Wright introduced a new strategic approach.

Up until 1913 the Synchromists tried to promote their work in Europe, but although they were successful in stirring up publicity and controversy, they never managed to generate any significant sales. Late in 1913 Macdonald-Wright conceived the plan of moving the battle to the United States, where there was less competition, where their American citizenship would be an asset, where there was a vast potential market that was still largely untapped, and where there were no serious rivals to question their claim to being the foremost masters of modern art. During this period Russell mostly stayed in Europe and was less active as a painter. In April 1914 he abandoned Synchromism altogether. While Russell occasionally returned to Synchromist effects for brief periods, most of the remainder of his career was devoted to classically inspired figure paintings, including numerous self-portraits in which he wears a dress.

One could argue that Macdonald-Wright's most important contribution to Synchromism at this juncture was less in the arena of painting than in that of marketing and promotion. Today we are accustomed to the notion that painting needs to be buttressed by art history and art criticism; that great painting plays a role in history and should represent some sort of creative new idea. In 1913, however, this notion was very new. While a few French artists such as Rodin or Picasso had gathered a circle of friendly writers—Rodin's secretary was the great poet Rainer Maria Rilke, and most of Picasso's closest friends were poets and critics, such as Guillaume Apollinaire—no American painter had ever really fully grasped the close relationship between artistic innovation and artistic criticism. They might be friendly with a writer or critic, but in a casual social way. It never occurred to them to form a working alliance and to create an advertising and publicity department, like those used to sell other products. Macdonald-Wright demonstrated that becoming a great artist depended not only on visual achievement but on generating publicity through outrageous statements and manifestos and rewriting art history to spotlight the originality of one's work. The techniques he introduced changed the whole game of achieving success as an artist in America.

But Macdonald-Wright was more than just a windbag. He also produced the best paintings of his lifetime in this period—including some that are arguably the greatest achievements of the Synchromist movement. Remarkably, he did so while in almost constant motion, as he shuffled back and forth between Paris, New York, and London, perennially out of money, perennially moving to ever more shabby apartments, as his financial situation grew increasingly desperate.

Notably, Macdonald-Wright's shift in direction was closely associated with a shift in social relationships. In the period from about 1910 to 1913 his closest friend and associate was Morgan Russell. From 1913 to 1916 he formed an equally intense partnership with his older brother, Willard. This in part explains his new interest in critical theory, for while Morgan Russell was an artist, an instigator of pictorial innovation, Willard was a journalist, well placed to serve as a standard-bearer for Synchromism and as a mouthpiece for Stanton's ideas. In addition, however, this was also the period in which Macdonald-Wright reconnected with the friend of his early days in Paris, Thomas Hart Benton. Indeed, Benton functioned as a kind of shadow member of the Synchromist team during the period when Willard wrote his most important art criticism and Stanton produced his best paintings.

They looked rather alike, Stanton and Willard, with prominent sloping foreheads, weak chins, and sensuous lips. As if aware that they had something to cover up, they both tended to decorate their faces with rather silly-looking mustaches and goatees: while neither was exactly handsome, they both carried themselves with such panache that they often conveyed that illusion. They were both at once grandiloquent and sarcastic, with strong opinions about everything; they were both shameless spongers and promiscuous skirt-chasers; they both made up outrageous lies about themselves that often deflected attention from their actual achievements; they were both multiply gifted, in writing, painting, music, and many other avenues of activity, from gambling on horses to raising tropical fish.

They were so similar in most ways that in tracing their lives it often becomes hard to remember which was which, since they not only shared interests and friends and frequently lived in the same places (often in the same apartment) but often also often collaborated on projects, with each claiming credit for the other's work. They even sometimes shared the same mistresses.

Today most people are familiar with the names of the Wright brothers, the two bicycle fixers from Dayton, Ohio, Orville and Wilbur, who pioneered the game of flight. Sober-looking chaps, who seemingly had their feet solidly planted on the ground, they nonetheless shattered a boundary that men had dreamed about breaking through for centuries, the gravity that ties us to the earth, enabling mankind to soar with the birds. In doing so they provided a model for other futurist dreamers: Picasso and Braque, when they were devising Cubism, jokingly called themselves "Orville and Wilbur" in the hope that they could do something as inspiring and revolutionary as these two tight-lipped, church-going, bachelor mechanics from Dayton.

Today most people are *not* familiar with the other Wright brothers, Willard and Stanton, who brashly set out to revolutionize the worlds of literature and painting. Their victory was not so complete. Their dreams were greater than their achievements, and their achievements, such as they were, were tarnished by their pretentiousness and their many false claims about themselves. Perhaps the most powerful of all forces in history is the law of unintended results, and it is ironic that for all their self-serving propaganda, for all their reckless boasts, neither Willard nor Stanton ever fully understood the true significance of what they did. Like artistic cat burglars, they set out to steal modern art from the French. Amazingly, they helped pull off a successful heist, although they themselves did not end up with most of the loot. Benton, who drew extensively from their ideas, became more famous than they did, although his fame was always clouded by bitter controversy. Jackson Pollock, who likewise owed them a debt, went on to become the most celebrated figure in American art. Today both these Wright brothers remain largely unknown outside specialized circles. Yet in the end they helped alter the course of modern art and change the face of American culture.

Willard Wright

While Stanton had been struggling to conquer the world of modern art, Willard had been making a similar attempt in the field of modern literature and journalism. His first steps were not auspicious. After attending four colleges without graduating from any of them, making a hasty marriage, and failing in several businesses (including a sad stint at the Cheer-ee

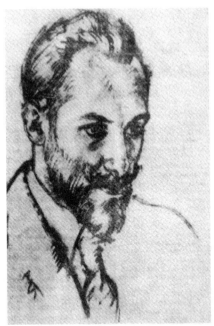 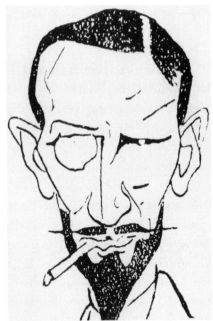

Willard Wright as sketched by Benton (left) and by Wright himself. (*Left: Portrait Sketch of Willard Huntington Wright* (1916, now lost), Princeton University Library, Department of Rare Books, Special Collections, Willard Huntington Wright scrapbooks. *Right: Self Portrait*, first published in the *Chicago Tribune*, 1927, from John Loughery, *Alias S. S. Van Dine: The Man Who Created Philo Vance* [New York: Charles Scribner's Sons, 1992].)

Beverage Company, financed by his father, which he quickly pushed into bankruptcy), Willard moved in with his parents in Santa Monica and took a job as a ticket-taker on a commuter railroad. Improbably, this led to his big break. A chance meeting with John Daggett, a reporter for the *Los Angeles Times*, resulted in an interview with the paper's managing editor and a trial spot as a reviewer and reporter.

Willard took to his new duties with ferocious enthusiasm and quickly became the principal book reviewer, in part due to his false claims that he had matriculated at Harvard and had spent a year studying art and literature in Europe. Appalled by the sentimentality of most of the fiction he was given, Willard sought out more worthwhile writings. Perhaps his most impressive achievement was a literary supplement he brought out every six months, which contained twenty pages of book reviews and essays and, equally notable, a list of the year's best books that seems impressively cosmopolitan and well informed, even today. He also

became a much sought-after lecturer, with the unusual specialty of argu-
ing the case against suffrage for women to women's groups, a topic that
always led to lively discussion.

His notoriety soon attracted the attention of a New York business-
man, John Adams Thayer, who had just purchased a magazine with slip-
ping circulation, the *Smart Set,* and was hoping to reinvigorate it.
Impressed by Willard's remarkable (and largely untrue) claims about
himself and his educational background, and at the recommendation of
H. L. Mencken, he hired Willard as editor.

At the time there was no lively American journal of culture and the
arts. *Scribner's, Harper's,* the *Century,* and the *Atlantic Monthly* were
notoriously staid and old-fashioned in their taste. The *Dial,* the *New
Republic, Seven Arts,* the *American Mercury, Vanity Fair,* and the
New Yorker were yet to come. What Willard had in mind was a journal
that would combine gossip, sexually provocative material, and fine writ-
ing by the major figures of the avant-garde. The first step was to become
scandalous. Willard immediately set out to horrify "the old maids of
both sexes" with muckraking stories of prostitutes, abortions, and
sexual scandal by figures such as Theodore Dreiser or Albert Payson
Terhune.

But his most successful move was an unorthodox one: Willard per-
suaded Thayer to send him to Europe for a month to drum up new mate-
rial, and there he made contact with the poet Ezra Pound. Pound was at
the height of his prowess both as a poet and as a spotter of new talent,
and the meeting immediately produced remarkable new material for the
magazine: a group of poems by Pound, a poem by Yeats, a story by Ford
Madox Ford, and several poems and two short stories by D. H. Lawrence.
In a stroke, Willard had lifted the *Smart Set* from being a good magazine
to being a great one.

Equally significant, over the course of this trip, Willard discovered
modern painting, meeting up with his brother Stanton in Munich, just in
time to see the opening of the first Synchromist exhibition at Der Neue
Kunstsalon. Under Stanton's guidance, he launched a new career as an
explicator of modern art, making a seemingly instantaneous shift from
ignoramus to expert.

Just a few months before, Willard had ridiculed the Armory Show.
As his wonderfully insightful biographer John Loughery has noted, the

postcards of works from the show that he mailed to his wife in California are straight out of Babbitt. On the back of one reproducing Souza Cardoso's *Parade* he scrawled: "This is not a plate of tripe but a street parade as seen by a Futurist. There are a hundred like it at the exhibit." Of Duchamp's *Nude Descending a Staircase* he wrote: "The most talked of picture in New York. It's too deep for me." On the card reproducing Picabia's *Dance at the Spring* he declared: "The cubist's idea of art. Picabia is one of the leaders. Can you see the dance or the spring? This has sold for an enormous price."

The change came about almost overnight, in June of 1913, when he met up with Stanton in Munich. At that point the fact that most people ridiculed modern work became part of its appeal for Willard: it fueled his sense of superiority to the masses. His first assumption of this new persona was an essay titled "Impressionism to Synchromism," which was published in a New York magazine, the *Forum*, in December 1913. (While signed by Willard, this must have been written at least in part by Stanton, since it casually refers to some exhibitions that Willard had never seen.) Over the next four or five years, Willard was to become America's leading literary explainer and advocate of advanced modern painting, and he and Stanton operated in a close if frequently acrimonious partnership.

Lost in Translation

Willard returned to New York early in 1913, to continue with his duties at the *Smart Set,* and Stanton followed shortly thereafter. The Munich exhibition had been costly to mount, and Stanton had covered these expenses personally. When both it and the Paris show produced no sales whatsoever it created a crisis. By this time, Stanton had run through Ida's money, so he turned to his parents for support. "All I need is another year and a half of quiet study and I will take care of myself O.K," he wrote to them optimistically. He then purchased tickets on a ship that sailed for the United States on November 25, presumably so that he could travel on to California, meet with his parents, and beg for funds. His schemes were upset when he learned of the demise of his father, who died on September 12, 1913, after a brief illness, at the age of sixty-three.

Both Willard and Stanton had assumed that they would each inherit a quarter of their father's estate. Instead, to their distress, he left them only a dollar apiece and left the remainder of his estate to his wife, Annie. Evidently he was skeptical that either of his sons was ready to spend his money wisely or to care for their mother in old age.

Stanton arrived in New York early in December. He was no longer interested in Ida. After landing, they separated, and she went to live with relatives. Always submissive and docile, she apparently was ready to rejoin Stanton if he summoned her, but he did not. They would see each other only once again. For the next three years, Stanton would depend chiefly on Willard, for both financial help and emotional support.

Completely broke, Stanton moved in with Willard for five months, while he tried to figure out what to do next. After five years in Paris, it was a shock for Stanton to return to the United States, and equally a shock to become a partner in Willard's extravagant lifestyle. Stanton later recalled his experience in 1914 in New York as "a sort of hotel life in overheated rooms, plushily furnished," with bevies of well-dressed girls in silk and furs, fancy restaurants, parties, opium, and a general air of artificiality, vivacity, and cynicism. Both Stanton and Willard engaged in aggressive womanizing in this period, which apparently included exchanging sexual partners with each other. They were often joined by Thomas Hart Benton, who was at the lowest point of his career, living from hand to mouth, and who often moved in with them, sometimes for weeks at a time.

Without Ida's support, Stanton was penniless. To his distress, he found that none of the established galleries were interested in Synchromist work—they thought it was too risky. He eventually found a new gallery, the Carroll Galleries, just off Fifth Avenue on East Forty-fourth Street, that agreed to put on the display but was not willing to cover all the costs of doing so. Willard seems to have put up most of the money required to stage the show. When the show opened on March 2, 1914, it included a small catalogue with a statement jointly written by Russell and Macdonald-Wright in which they wrote up a new manifesto about Synchromism, declaring that they conceived space itself as "having a distinct plastic significance which is expressed by color." Willard timed a puff piece about Synchromism in the *Forum* magazine to coincide with the opening of the show.

Unfortunately, due to artistic rivalries, the show opened to an undercurrent of ill will. Andrew Dasburg and Arthur Lee, who were in New York at the time, and who had known Morgan Russell in Paris, wrote letters to Russell charging that Stanton was taking all the credit for inventing Synchromism and was seeking to diminish Russell's role. When Russell wrote an angry letter of complaint, Stanton wrote back to reassure him that his paintings were hung with care in the best places and that his role would be acknowledged. But the harm was done.

Willard Wright took upon himself the role of publicity manager for the project. Benton was still going around in his French artist's clothes, with a black cape and gold cane, and Willard decided to introduce him

to the press as "a young Parisian artist." To maintain the illusion, he asked Tom and Stan to converse with each other only in French. Unbeknownst to them, he also spread the rumor that Tom was a Parisian gangster in flight from the police, who went by the name of Kiki le Souris (Kiki the Mouse). Needless to say, the fiction was soon discovered, raising questions about everyone's integrity and artistic seriousness. As if this were not enough, Willard's arrogant dismissal of other American painters as stupid and insignificant led to bad feelings all around.

Stanton clearly hoped that New Yorkers, who had little knowledge of his rivals in Paris, would be amazed by the paintings and swept away by the *Forum* essay and the little catalogue and would view him as a major figure of modern art. The good news was that the American public's knowledge of his rivals was just what he hoped. Even supposedly well-educated people had never heard of them. The bad news was that they also had no knowledge or interest in modern painting at all. Judging from the reviews, most New Yorkers were simply mystified by the strange spectacle of Synchromist rainbows. The *New York Press*, for example, divided the paintings in the Carroll Galleries show into two types: those that were conventional but "badly drawn and painted," and those that "resemble the sort of thing we have grown to call Cubist or Futurist art" and were "no easier to understand."

Unfortunately, none of the commentary was particularly heated—the show had failed to hit a nerve. While a review in *Town Topics* made reference to the "gullible followers" of the Synchromists, the followers were scarce, and fewer still had an open checkbook. The exhibition was supposed to earn the fortune denied to Stanton by his father's unfortunate will. Instead sales were sparse, barely covering the costs of mounting the show, let alone providing something to live on.

In the end the most significant thing about the Carroll exhibition was its influence on other artists—particularly Benton, whose career had been at an all-time low point when Macdonald-Wright returned from France. There's no doubt that Macdonald-Wright's arrival rejuvenated him. As Benton recalled:

> I used to go around there every day. After all, this was part of the smell of Paris and I was interested. I began to meet artists there. Quite a number of them came in to see that. It never got any *reclame*

at all or much attention, but a lot of artists did come in to see that exhibition.

Indeed, for Benton the exhibition marked a moment of artistic awakening. As will be discussed shortly, for the next decade he would struggle with the issues of color and form that it presented. One could argue that from this moment Benton became a Synchromist for life. The issues posed by Synchromism laid the foundation for his own artistic style, and most of what he passed on to Pollock was in one way or another based on Synchromist ideas.

Willard Gets Fired

Willard was at the height of his form as a writer and editor in this period. While its quality was always somewhat uneven, in the period after his return from Europe the *Smart Set* showed signs of becoming a truly remarkable magazine unlike anything that had existed before in America—or has existed since. The key to its success was its unlikely mix of ingredients: tough-minded writing dealing with social problems, such as prostitution; modern poetry and modern fiction; and gossipy editorials by the likes of H. L. Mencken. Even at its worst, the magazine was provocative and stimulating.

Willard's reckless departures from conventional taste, however, made his employer, John Adams Thayer, extremely nervous. Like a broker fingering a ticker tape, Thayer followed the ups and downs of circulation with vigilant attention, seemingly unaware that many of these fluctuations were simply seasonal. He failed to recognize that establishing a distinctive identity for a magazine is a long-term process, which may initially alienate some readers. Most crippling, Thayer feared offending stodgy advertisers, one of whom, National Cars, specifically advertised that it manufactured "for conservative people." The *Smart Set* advertised itself as "The Magazine of Cleverness," and Thayer wanted more cleverness and less of life's miseries. He was growing tired of "whores and horrors."

The end unfolded quickly, impelled by Willard's strange machinations, which amounted to a kind of death wish. By November, Thayer had become seriously distressed about rising expenses and had convinced

himself that a poem by Ezra Pound that Willard had just published was sheer modernist lunacy. To hold Willard in check, Thayer insisted on keeping an assistant editor, Norman Boyer—who had resigned from the magazine after fighting with Willard but then returned on Thayer's urging. When Willard was sick for a few days, Boyer was placed in charge and took advantage of the position to reject a story by one of Willard's favorite authors of tales of sex and misery, Albert Payson Terhune.

At this delicate moment, Willard dreamed up a new uncensored, even more radical magazine that he would coedit with Mencken and Nathan and that would be titled the *Blue Review*. Willard seems to have conceived it as something more radical than the *Smart Set*, on the model of the European magazines edited by Ezra Pound and Ford Madox Ford. With amazing recklessness he decided to produce a dummy issue and charge the printer's bill to the *Smart Set*. Unfortunately, Thayer discovered the unauthorized expense and immediately called in lawyers. By New Year's Day, Willard was out of work. Thayer promptly sent out postcards to the subscribers, informing them of Willard's departure and also announcing a change of literary approach. Henceforth the magazine would assume a more cheerful tone, and "sex stories . . . and stories of gloom and hopelessness" would no longer be welcome. Modernism was out: shallow wit and society gossip were in. One of Boyer's first actions was to reject three now famous short stories that James Joyce had sent in for consideration, all three of which later appeared in *Dubliners*.

While his salary had been impressive, by the time he had paid his lawyer, his landlady, his laundry service, his tailor, and many others, Willard was almost flat broke. With Mencken's help, Willard got a position writing columns for the *New York Mail*, but the stress of constant writing was too much for him, particularly given his understandable nervous exhaustion, and in March he quit. At this point his fortunes became even more closely tied with those of Stanton. Both brothers were adrift, with no one but one another to fall back on.

Back to France

They both decided to wave good-bye to New York. On March 28, 1914, Willard and Stanton sailed for Europe on the steamer *Olympia*. How they got money to pay for passage is unclear. In a letter to Morgan Russell,

Stanton implied that it was by less than honest means. "I'm glad to be near Stanton," Willard wrote to his wife, Katharine, although he objected to traveling second class. "I suppose paupers shouldn't kick," he noted philosophically. By this time, Stanton was ready for a fresh start. Around the time of their departure, he wrote to Russell, "I shall start life all over again," adding that "to everybody but you and Dracopoli (the only two friends I want or have) I'm permanently incarcerated in a bughouse."

On arriving in Paris, Stan and Willard moved in with Morgan Russell at the rue Vercingetorix in the Quartier du Maine. Stanton later remembered this period as a sluggish period during which he "desultorily painted and drew." But over the course of five months, he did some of the best work of his career, producing his *Abstraction on Spectrum* and starting his *Conception Synchromy*.

This state of affairs ended abruptly with the outbreak of World War I. In August of 1914, as the Germans pushed almost to Paris, the brothers made a hasty departure for London, where they found cheap and filthy accommodations in Fitzroy Square. Soon after their arrival they were visited by detectives from Scotland Yard who wanted to question Willard about his interest in Nietzsche. Because of their haste, they left many of their books and paintings behind in Paris, but Willard was only mildly distressed. "The old world was an anachronism to me," he wrote to his wife. "I and my beliefs were out of place. I belong to the new era and was born to be one of the pagan leaders of it."

Morgan Russell had stayed behind in Paris. In the period before the Wright brothers departed he made some of his most remarkable paintings, including *Synchromy in Orange: To Form* (1914). The trauma of the war, however, and of Wright's departure, seems to have deeply affected him. His artistic progress slowed, and in 1916 he abandoned Synchromism, writing to Andrew Dasburg in that year, "I'm through with Synchromism."

In London, the Wright brothers soon ran out of money and pawned nearly everything they owned. Willard supported himself playing the piano in a movie theater for seven dollars a week, while Stanton found a job as a waiter. Despite their dire financial straits, Willard was exceptionally productive, writing a draft of his novel *The Man of Promise*, publishing detective stories in the *Forum* under the pen name of Albert Otis, and writing long letters to their mother, in an effort to wheedle

money from her. Stanton found it more difficult to make progress, since there was no room to paint in their flat.

Modern Painting: Its Tendency and Meaning

Since London offered no prospects, in February of 1915 Stanton and Willard headed back to New York again on the *Lusitania*, both virtually penniless. "I had hoped never to see America again," Stanton wrote shortly after landing. Willard seems to have felt the same way. "The only intelligent people are the Germans," he wrote around the same time. Willard seems to have been suffering from drug withdrawal and later described himself as "full of hallucinations and phobias." With money borrowed by Willard from an acquaintance, they moved into an apartment on Kelly Street in the Bronx.

In October 1915 Willard published *Modern Painting: Its Tendency and Meaning*, arguably his most important book. For all its faults, the book was a landmark in the early writing on modern art, the first serious attempt to trace an evolution for modern painting based not on biographical anecdote, literary content, or moral values but on aesthetic principles. While Willard was listed as author, Stanton later claimed, "I wrote most of it." So far as ideas and phrases are concerned, this is probably largely true. Never meek about expressing his opinions, Thomas Hart Benton surely chipped in some ideas as well.

Willard's basic historical framework is now familiar to us, since, with modest revision, it has been repeated in many textbooks, and it roughly corresponds with the layout of the Museum of Modern Art. Essentially Willard saw the history of modern art as the progressive advancement of methods, toward ever more creative and liberated mastery of color and form, and the progressive abandonment of literal dependence on nature, to become instead an art of pure and abstract formal relationships, in a fashion somewhat analogous to music.

Unfortunately, the book was skewed by the fact that Willard was really writing not an objective history of modern art but a crypto-manifesto for Synchromism, intended to single out the unique importance of his brother Stanton's work. Perhaps the weakest link in the chain of his argument was his insistence that the development of modern art had reached its culmination with the work of the Synchromists and that a

point had been reached when "research is at an end" and "no more innovatory 'movements' are possible." Willard's error was not unlike that of those religious prophets who insist that the Last Judgment or the Second Coming will occur on a certain day. When that day passes uneventfully, their credibility suffers. Since modern art has continued to develop and move forward, despite Willard's insistence that it had irrevocably come to an end, *Modern Painting* has come to seem increasingly a period piece, no longer relevant to the history of modern art.

In addition, on a key point of artistic expression, Willard took a tack that differs from that of later writers. He felt that painters should organize forms in depth, in a three-dimensional space—that the best modern art represented an enhancement of tactile and sculptural sensations. Many of the next generation of art writers took an exactly contrary view. For example, Clement Greenberg famously insisted that modern painting was headed in the direction of ever greater flatness.

For all its peculiarities, the book soon developed a cult following. Artists such as Georgia O'Keeffe and Marsden Hartley admired it, as did Alfred Stieglitz; and e. e. cummings (who was a painter as well as a poet) regarded it as a sort of Bible. André Tridon in the January *Forum* noted that Willard was "America's first aesthetician," H. L. Mencken declared that Willard was "one of the heralds of the new era," and the book was also praised by James Huneker, Antony Anderson, and Mitchell Kennerley. Others were less convinced. Leo Stein in the *New Republic* headlined his review "An Inadequate Theory" but praised Willard's appreciation of Cézanne. Frank Jewett Mather of Princeton University declared that Wright's book was "brilliant and perverse" and that "a ray of sunlight, a single impulse of humor, would shatter the entire dream fabric."

While no longer much read today, the book was a major influence on later writers, although in curiously contrasting ways. Alfred Barr, the first director of the Museum of Modern Art, took the extreme personal bias out of Willard's account and developed the textbook history of modern art and of its formal progressions. On the other hand, Clement Greenberg, the critical champion of Jackson Pollock, was inspired by precisely the feature that annoyed Barr. Willard showed him that the history of art could be employed in a partisan, polemical way to draw attention to a favored group of new painters.

Conception Synchromy

Unfortunately, the fraternal dialogue that inspired the creation of *Modern Art* gradually progressed from heated to openly unfriendly. Willard and Stanton—and Benton, who joined them—were fiercely opinioned. Each was convinced that his way of thinking was the only correct one. As it happened, their girlfriends were equally argumentative and self-righteous, and things came to a head when Stanton's paramour, Edith, fought with Willard's girlfriend, Claire. Willard didn't mind giving handouts to Stanton but objected to supporting Edith, "that damned no good bitch." A break was necessary. Consequently, Willard moved to a new apartment on Fifty-eighth Street in Manhattan, which he shared with his mistress, and Stanton retreated to a roach-infested studio at the Lincoln Arcade, which he abandoned after a few weeks when he found a still cheaper place to live, the top floor of a "miserable" apartment in Hell's Kitchen, which had no heat and no bathroom. To clean up he and Benton used to frequent the showers of a public swimming pool.

With his typical insouciance, however, Stanton continued to indulge his whims like an aristocrat. He bought a dog and a monkey and spent a good deal of money on opium. Such extravagance forced him to desperate measures. To support himself he made pen-and-ink illustrations for fly-by-night magazines, which he signed with the pseudonym Ray Van Buren; made posters to support the war effort; and taught art part-time in 1918 for the Young Women's Hebrew Association, a post that he probably obtained through his friendship with Benton. He occasionally sold a painting through the former saloon keeper Charles Daniel but had difficulty collecting his money.

Yet strangely, over the course of this unsettled period, the constant movement and the constant financial problems of the years from 1914 to 1916, Macdonald-Wright produced what are arguably the finest paintings of his career—works that stand among the best and most innovative modern paintings ever produced by an American artist. They fit loosely into two types. The first are essentially figural paintings, although they stand in something of a middle zone between the realistic and the abstract. At first what we take in seems like a formless shower of luminous color, an explosion of prismatic hues, but as we look more closely, figural shapes gradually emerge, not, as with Michelangelo, from a block

of stone but from a rainbow. The distribution of color is a little surprising, since often the blue (receding) color rests upon a near surface and the red (forward-pulling) color on one that is further away. As we grasp the nature of the figure, however, what is striking is how the push-pull of color interacts with the twists and turns of the anatomy, to create a lively sense of movement, muscular tension, and visual rhythm. Many of the compositions are loosely based on Michelangelo—on the recumbent figures in the Medici Chapel or the unfinished figures for the tomb of Pope Julius II. But it's also clear, from the vividness with which they are observed, that the figures were studied from life. In fact, there seems to have been a specific catalyst for these paintings. Macdonald-Wright had begun drawing from the nude model alongside Thomas Hart Benton, and this surely encouraged him to observe the human figure, and all the hollows and bulges of its musculature, with a new intensity.

The second group consists of floating arrays of color discs, such as *Abstraction on Spectrum* or *Conception Synchromy*. Again, I think it likely that Benton was to some degree associated with the creation of these paintings, although the evidence is circumstantial. In this period, Macdonald-Wright was explaining to Benton how the color wheel was organized and how its colors could be organized into scales and sequences. Presumably, Macdonald-Wright began by showing him various color wheels. These paintings of color discs essentially take such a didactic procedure one step further and organize clusters of colored discs to make a full-scale composition. That Benton was on hand when Macdonald-Wright made these paintings is suggested by the fact that Benton's one surviving Synchromist abstraction, *Bubbles*, follows the compositional formula of Macdonald-Wright's floating-disc paintings very closely.

In short, Macdonald-Wright must have been both learning from Benton and showing off to him the various modernist tricks he had learned that Benton did not know. Both impulses pushed him toward a new peak of artistic intensity. And it was at this point that Wright's development started to race ahead of that of Morgan Russell, who had until then been very much the leader of the pair. Russell at this stage seemed to run out of new pictorial ideas, whereas Macdonald-Wright's mind was flooded with them. What is more, Macdonald-Wright was a more skillful and evocative painter.

To a large degree the remarkable impact of these paintings by

Macdonald-Wright, and their advance over Russell's accomplishment, can be attributed to a matter of technique. Morgan Russell's application of paint tended to be flat. One could come close to many of his designs by pasting bits of colored paper to a canvas. Macdonald-Wright, on the other hand, had a remarkable touch, handling his brush with a skill almost unequaled in the history of American art. Specifically, Macdonald-Wright understood how to play with the contrast between a clear, sharply defined edge and a fuzzy one that gently fades into the background almost as if the pigment were sprayed on with an airbrush. In many instances he managed to blend these two effects, with a brushstroke that shifts from sharp to blurry or vice versa over the course of its arc. One could protest that this was merely a technical trick, essentially a gimmick, but in fact, in Wright's paintings of this period it goes deeper in its expressive significance and touches on one of the essential mysteries explored in the art of painting—the difference between the solid and the evanescent, the real and the illusory. In his greatest paintings of this period, Wright's brush was a metaphysical instrument, exploring the interplay between substance and void.

Viewed in their own terms, Wright's paintings of these years are magnificent achievements. But they are fascinating as well because in many ways they laid the foundation for what Pollock would achieve thirty-five years later. Put an early Pollock such as *Birth* beside Macdonald-Wright's *Conception Synchromy*, and it's not hard to see that they follow similar principles of organization and design. Indeed, their influence runs deeper. As will be seen, much of Macdonald-Wright's philosophy of art, admittedly refracted and perhaps even distorted by Benton's strong personality, would shape Pollock's fundamental conceptions of art. It would even guide the creation of Pollock's great drip paintings, as will be examined in due course.

The Forum Exhibition

At this financially desperate moment, Willard and Stanton joined forces again and conceived one of their greatest achievements, the Forum Exhibition, which ran for thirteen days, from March 13 to 25, 1916, at the Anderson Galleries, in the Kennerley building on Madison Avenue.

The Armory Show of 1913 had stimulated interest in European

modern art, particularly the work of the French artists. A mammoth exhibition, with over a thousand paintings, including works by Picasso and Matisse, it had introduced the American public for the first time to radical European modern art. The display created a media frenzy—most of it ridiculing the work on view—and even Teddy Roosevelt had stepped in to provide commentary about the work. In Chicago, art students had burned Matisse in effigy.

Willard and Stanton were eager to stir up similar interest and hoped that their display would swing the pendulum back and place Americans in the spotlight. The "explanation" for the show that they placed in the catalogue specifically laid out these intentions, declaring that the project was intended to show the "very best examples of the more modern American art" and to "turn public attention . . . from European art." As a consequence, Europeans were kept out and only Americans were included.

As with everything the brothers did, it is hard to determine whether they were motivated by idealism or simply hoped to get rich quick. An impulsive letter to Morgan Russell in Paris supports the latter conclusion. In it Stanton boasted that the Anderson Galleries, where the show was to be staged, had the Rockefellers, Harrimans, and Morgans as clients and that their support was "as good as cash." "Of course we will hang ourselves in the best space there!" he concluded.

Yet while their main goal was to showcase themselves, Willard and Stanton quickly realized that it would be politic to include other artists, and the project rapidly developed a life of its own. It soon grew into a sizable undertaking, with 193 works by seventeen American artists, including a number of figures from Stieglitz's stable such as Arthur Dove, Marsden Hartley, and John Marin. Despite resistance from some quarters, one of those included was Thomas Hart Benton, who was vigorously supported by both Stanton and a member of the organizing committee, the Marxist John Weichsel.

With all these contributors, it was hard to maintain a clear party line that focused all of modern art toward Synchromism, as its crowning development, but Willard and Stan worked hard to fulfill this goal. Man Ray later complained in his biography that Russell and Macdonald-Wright had hogged the best places in the show. In his enthusiasm, Stanton stretched and framed canvases that Russell had shipped to New York and even somehow found the money to get Russell passage to the United

States so that he could be present for the opening of the exhibition. The catalogue was a virtual Synchromist manifesto. Willard contributed two essays based on his *Forum* articles and included a bibliography of useful books. The centerpiece was Willard's essay, "What Is Modern Painting," which argued that painting should be based on purely aesthetic values, obviating the need for representation. (Interestingly, Alfred Barr later stole Willard's title verbatim for a best-selling brochure put out by the Museum of Modern Art, popularly known by the staff as *WIMP*.) Stanton's statement was notable for the force with which he argued that painting should become nonobjective. As he declared, "I strive to divest my art of all anecdote and illustration, and to purify it to the point where the emotions of the spectator will be wholly aesthetic, as when listening to good music."

The other artist's statements were heavily edited by the Wright brothers to showcase their own interests and to push forward the idea that modern art was moving toward pure abstraction. Willard deleted more than half the statement that Morgan Russell wrote for the catalogue and extensively altered what was left. In the case of Benton's statement, he added a paragraph that had no connection with what Benton had written, to stress the importance of abstract art. In the case of Andrew Dasburg, he pretended that the statement was drawn from an interview with the artist but apparently never bothered to talk with him. The one artist who did not get a statement of any sort was Marguerite Zorach, the one woman in the show. Ironically, Stanton was named for an important pioneer feminist, Elizabeth Cady Stanton, his mother's close friend. But with characteristic male chauvinism, he and Willard seem to have felt that a woman would have nothing of value to say about her work.

Despite the misrepresentation that resulted from such high-handedness, the Forum exhibition is now viewed as a landmark in the history of American art—the first survey of the work of American modernists, and a surprisingly complete one given the haste with which it was pulled together. Without much question it was the most important group show of work by American modernists until 1942, twenty-six years later, when John Graham staged a show at the Macmillen Gallery juxtaposing young American unknowns, such as Pollock and Lee Krasner, with famous European figures, such as Picasso and Matisse.

The significance of pioneering exhibitions of this sort, however, is

generally more apparent in hindsight than at the time. Most of the contemporary critical response to the Forum Exhibition was predictably dismissive, since Willard's attacks on other critics in his recent writings set the stage for negative reactions. For the Wright brothers the greatest disappointment was surely that the show produced little in the way of income, even though prices were low. The drawings ranged from $10 to $150, the paintings from $35 to $1,050, with most of them going for a few hundred dollars. Nonetheless, few of the works sold. Morgan Russell, who had no money and could not afford either to store his paintings or ship them home, literally gave away his work after the exhibition, presenting Willard with two major paintings, *Au Lait*, now lost, and *Cosmic Synchromy*, which remained in Willard's possession until his death and is now in the Munson-Williams-Proctor Institute in Utica, a recognized classic of modern art.

Murder for Profit

Shortly after the Forum Exhibition closed, Willard published a book dedicated to Stanton, *The Creative Will*, his fifth book since leaving his post at the *Smart Set* just two years before. Once again, the book was largely based on conversations with Stanton, and after Willard's death Stanton tried to claim it as its own. Written in aphoristic style, no doubt partly inspired by the writings of Nietzsche, the book was another defense of Synchromism and again disparaged the idea of art as a documentary medium. Essentially, it argued that great art was based on an elaboration of fundamental "abstract" principles, above all on an understanding of the rhythms of the body. Our innate sense of balance, coordination, and movement provides the basis for our love of the symmetrical and dynamic in art, and the rhythms of the body should determine the development of the visual rhythms of paint upon the canvas. Many years later, Willard's musing would bear fruit: these are all themes that would later play a central role in the art of Jackson Pollock. At the time, though, the book created little stir. It was only summarily reviewed, although somehow it did capture the attention of a small cadre of intensely creative people, notably the novelist William Faulkner, who later referred to his reading of it as one of the crucial influences on his early development.

Georgia O'Keeffe also admired the tome and recommended it to her friends. In 1916 O'Keeffe wrote to her friend Anita Pollitzer:

> Been reading Wright's 'Creative Will'—Have you got it? If you haven't I want to give it to you—It has been great to me—that's why I want to give it to you . . . He gets me so excited that sometimes I think I must be crazy. Have been reading Clive Bell again too. He seems stupid next to Wright.

In June of 1917 O'Keeffe wrote again to Pollitzer to praise a painting by Stanton Macdonald-Wright that she had seen at Stieglitz's gallery.

> He has a new Wright and I saw another one—both Synchromist things that are wonderful—Theory plus feeling—They are really great.

She then added some description of Stanton:

> I met him too. He is a little over medium size but looks glum diseased—physically and mentally.—I'd like to give him an airing in the country—green grass-blue sky and water—clean flowers—and clean simple folks.

Like Willard, Stanton was at his peak, but he was also growing "tired of chasing art up back alleys." In a letter to John Weichsel he complained about "America the damnable" and noted that painters in America were treated like whores—"but the obvious preference is for the whores. At least they travel in automobiles and have charge accounts!"

In the fall of 1918 Macdonald-Wright left for California. As he groused in a letter, he had tired of "the rancor and pettiness of the 'art world' antagonisms, the playing to the gallery, the near-epigrammatic conversations and the superficial literary efforts for posterity." For Thomas Hart Benton, who for years had depended on Stanton's guidance and his friendship, his departure was a shock. "I had a sincere regret when he departed for the nut state," he later commented. With his departure, Stanton largely stepped out of the history of modern art and ceased to produce paintings of major importance. While his talent remained evident

for the remainder of his career, what he produced became increasingly facile, and his later paintings increasingly came to look like designs for beach towels.

Willard likewise abandoned Synchromism, although by a more tortuous route. In the seven years after the Forum Exhibition, Willard's life went straight downhill. He was fired from newspaper jobs, dropped by mistresses, exploited by loan sharks and drug dealers, and at one point even arrested as a German spy. And then, rather astonishingly, he achieved the popular success he had always dreamed of—though not for literature or art criticism but for popular writing that clearly pandered to popular taste.

At the lowest point in his descent, Willard conceived the idea of writing a mystery series featuring a sleuth named Philo Vance, who effortlessly solved mysteries that had baffled the police. While Edgar Allan Poe invented the detective story, American writers had failed to keep pace with British writers in developing the genre. Willard Wright changed that. He gave detective stories a snobbish appeal, enlarged the audience for them, and ended the British monopoly on the genre. For all his self-indulgence, Willard could be impressively diligent when he chose. After receiving a small advance, he dutifully sat down and completed the first mystery, leading a reclusive life and seeing few people except for his mistress Claire and a single friend, Thomas Hart Benton. He finished the first mystery in June 1925, exactly on schedule.

Willard's friendship with Benton during this difficult period is intriguing. Throughout his life, Benton was a powerful anchor for those who were in trouble: his willingness to put up with people who were genuinely desperate, such as Willard Wright, was as notable as his talent for ridiculing fops and snobs. His students, and not only Pollock, looked up to him as a sort of father figure, a rock of strength. But Benton also had a curious sixth-sense ability to notice that something significant was happening in a place where most people would never think to look. At some level he seems to have sensed that Willard (like Pollock later) was up to something interesting and that there were things he could learn by spending time with him.

Vance, who was clearly modeled on Willard himself, was unlike any earlier detective in American fiction, a debonair art connoisseur, a cynical aesthete, who lived in luxury, had a formidable vocabulary, and had

inherited enormous wealth from his aunt Agatha (perhaps a humorous reference to Agatha Christie, or then again, to the novels of P. G. Wodehouse). Vance purchased Cézanne watercolors, visited Stieglitz's gallery, collected rare Chinese ceramics, had a vast library with books on strange and esoteric subjects, read Freud and Spengler, and worked on an apparently never finished translation of Delacroix's journals. In many ways, Vance was a pretentious pain in the ass. Heywood Broun pronounced Philo Vance "that most tiresome person in modern fiction," and Ogden Nash wrote that "Philo Vance deserves a kick in the pance." But for some reason the public was fascinated.

In October 1926 Scribner's released the first book, *The Benson Murder Case*, with an energetic promotional campaign that included thirteen hundred postcards designed to resemble a New York Police Department crime report, providing the circumstances of Mr. Benson's death and the name of the investigating officer. The book was well received and sold fifty thousand copies, despite a carping review by a cocky young freelancer named Dashiell Hammett, who pointed out that the identity of the murderer was obvious from the start and that Philo Vance had "the conversational manner of a high school girl who had been studying the foreign words and phrases at the back of her dictionary." (Willard later repaid the favor, dismissing Hammett's "tough guy" detective mysteries as "all booze and erections.")

If *The Benson Murder Case* was successful, *The Canary Murder Case*, the story of the murder of Margaret Odell, with five lovers who made likely suspects, proved a smash, selling more than twenty thousand copies in its first week, over sixty thousand in the first month, and breaking every sales record in the genre by the end of the year. *The Greene Murder Case*, the third book, while arguably less well written, did even better. It sold sixty thousand copies in three weeks. Along with the mysteries of each story, the public was encouraged to speculate about the identity of the author, since the books were released under the pseudonym S. S. Van Dine, and Willard did not reveal that he had composed them until after the third had appeared.

Shortly after confessing to his role as author, Willard told interviewers that he was going to write only six Philo Vance stories and would then move on to more serious literary ventures. But the serious literary ventures never materialized. In the end, Willard followed his first

three mysteries with nine more. The later books tended to focus on the author's extravagance of the moment: breeding and training show dogs, exotic fish, gambling, horse racing, and so forth. Several were turned into movies. The most serious effort to make something artistically competent was *The Canary Murder Case*, which Paramount filmed in 1928 with the dashing William Powell in the role of Philo Vance and Louise Brooks, with her wonderful art deco looks, as the showgirl. Unfortunately, serious trouble ensued when the film was nearly complete and sound technology suddenly became the new rage. The producers realized that they had to add dialogue to a film that had been originally conceived as silent. To get the dialogue to fit, the original sequence of scenes was scrambled, and since Louise Brooks had already taken on new commitments, her voice was dubbed by another actress. What had once looked dramatically promising became a creative mishmash.

Miraculously, the film made money in any case and inspired further movie-making ventures, but the quality of the films went down steadily from there. The unwanted task of directing *The Dragon Murder Case* fell to H. Bruce Humberstone, at the insistence of Jack Warner, who told him: "You're going to make this picture. Do you think it matters that it's lousy? That picture, with my theater chain, is going to make me fifty thousand dollars, good story or not. So you're going to make it for me. Or you're never going to direct another picture in this town." The logic of this was irrefutable. Humberstone agreed to make the film.

Willard's new wealth allowed him to live well. He dumped his girlfriend and acquired a wife and a two-floor penthouse at 241 Central Park West, on the corner of Eighty-fourth Street, overlooking the park. The place had servants' quarters; the staff included a cook and a butler. There was space in the study for sixty-eight aquaria, built to hold more than two thousand exotic fish. The living room held a grand piano. Floor-to-ceiling shelving housed Willard's huge collection of books as well as expensive Chinese ceramics. He also had a blackjack table and a roulette wheel for guests who were interested in gambling. He kept a car and a chauffeur. And he spent every penny that he earned from his books, including the advances. His restaurant and clothing bills were astronomical.

But wealth did not bring happiness. By 1938, at the age of fifty-one, Willard looked exhausted, had a beard that was almost white, and was often taken for a man in his sixties. In April of that year he appeared in

ads for Hiram Walker gin looking shockingly aged, as if he were sixty-five or seventy rather than merely fifty.

Willard wrote the last of the Philo Vance murder stories, *The Winter Murder Case*, purely for the cash—the generous sum of twenty-five thousand dollars provided by Twentieth Century–Fox, who planned to make a movie based on it. Two days after completing the story, Willard suffered a mild heart attack at home. At first he seemed to recover. After a stint in the hospital he returned home and even worked a little more on the manuscript. But on Tuesday, April 11, 1939, as he relaxed in bed after lunch, with his wife still in the room, he slid back onto his pillow and closed his eyes. A few moments later he was dead. On his desk was the typed first draft of the mystery—"complete to the last comma," his editor Maxwell Perkins later commented. In his last meeting with Perkins, Willard had summed up his life with the comment: "I've enjoyed the brandy. I only regret that I didn't drink more of it."

While they were successful in the twenties, Willard's detective stories are no longer widely read. Their whole style and mode of presentation has become dated. Thomas Hart Benton included a volume by S. S. Van Dine in the background of one of the scenes of his mural *America Today*, but most people today probably don't even recognize the name, let alone grasp Benton's amused delight in the ironic fact that one of the most highbrow and snobbish of American art critics had ended his career as a writer of pulp fiction for a mass audience.

Part Five

The Painter of America

In college we never grasped the idea . . . that an artisan knowing his tools and having the feel of his materials might be a cultured man; that a farmer among his animals and his fields, stopping his plow at the fence corner to meditate over death and life and next year's crop, might have culture without even reading a newspaper. Essentially we were taught to regard culture as a veneer, a badge of class distinction—as something assumed like an Oxford accent or a suit of English clothes.

—*Malcolm Cowley,* Exile's Return

A Modernist in New York

Perhaps the most remarkable thing about Synchromism was its sheer audacity. The Synchromists wanted to capture the art world; they wanted to be the leaders of modern painting; they wanted to push outside the usual confines of technique into light shows and other extravaganzas; they wanted to change art history and art criticism. While they made a point of being controversial and rude, they also wanted everyone to love them: and they wanted not simply to be esteemed by the cognoscenti but also to earn popular fame and wealth. While their presumption was almost unbelievable, they did, in fact, accomplish quite a number of their goals. By synthesizing the accomplishments of such figures as Cézanne, Matisse, and Picasso, they introduced a new movement of modern art and created some truly remarkable paintings. As has been indicated, they were the first to exhibit purely abstract paintings in Paris; they startled New York with their radical artistic ideas; they were the first Americans to write an artistic manifesto; they wrote the first history of modern art to trace its formal development; they organized the first major exhibition in the United States of the work of modern American painters; and one of the circle, Willard Wright, achieved considerable financial and popular success, though not in the realm of serious writing but in the openly commercial genre of the popular detective story.

Impressive feats! Yet despite all this, somehow the Synchromists never achieved the grand triumph that they hoped for. The French did not like their work because they were Americans; Americans were puzzled

because it looked too French. While they produced some truly remarkable paintings, they never quite secured either popular fame or a solid art historical niche. Today most people, even most art historians, have never heard of them.

Nonetheless, the Synchromists had a student who was taking in what they did and would push it on to a new level: Thomas Hart Benton. To be sure, Benton's direct involvement with Synchromism was very brief. But it occurred at a particularly exciting moment, when Macdonald-Wright was making his best paintings, organizing the Forum Exhibition, and (with his brother) writing his seminal history of modern art. From the Synchromists Benton learned to think of a painting in terms of visual rhythm, as an organized sequence of forms; he also learned to promote his work through controversial statements and manifestos. For the rest of his life Benton would design like a Synchromist, although he did so with interesting twists. From Benton's standpoint, Macdonald-Wright's art fell short in notable ways: it was too esoteric, too highbrow, too European, and too lacking roots in the dirt and grit of American culture. Benton wanted to Americanize modern art and to translate it into terms that an ordinary man could understand—to produce, as he once declared, an art that "was arguable in the language of the streets." While Macdonald-Wright was content to import French modernism to America, Benton wanted to make art with an American accent.

One might say all this more succinctly in a different way. In 1930 Jackson Pollock lived seventy-five miles away from Stanton Macdonald-Wright's home and studio in Pacific Palisades. Yet instead of studying with Wright, he chose to travel with his two brothers to New York, twenty-seven hundred miles across the country, to study with Thomas Hart Benton. What was it about Benton that could pull three working-class boys from California to move to New York with the hopes of becoming great painters under his guidance? How had Benton changed the rules of modern art? What was his appeal to young American men? A few adjectives are hardly sufficient to answer this question, for what was unique about Benton was the sense that he had suffered and lived life to the full. Indeed, in the end, his mesmerizing power over Pollock was the product not only of the forcefulness and inventiveness of his art but of some peculiar affinity between their two personalities, some underlying

commonality of energy, insecurity, desire to display manliness, and grandiose artistic ambition.

Benton Adrift

The period that followed Benton's return to the United States was one of the most confused of his entire career. For seven months he hung around Neosho, unclear what to do next. Things finally came to a head because of an affair he was having with a local girl, Fay Clark. One day her father came to call on Benton's father, M. E., to ask about his son's intentions. M. E. replied that his son had no intentions, had never shown any sign of practical sense, and showed no signs of being able to support a wife. To prevent the situation from going further, Benton's parents agreed to give him a small sum of money to get started and shipped him off to become a portrait painter in New York.

He arrived in the city in early June of 1912. For the next ten years Benton would live as a near-starving artist in the city, struggling to survive, struggling to find an artistic direction. His progress during these years was so erratic that at times it feels painful even to retrace his steps. Though he was only twenty-three, those who met him at the time sensed that he was in some way damaged or shell-shocked. Thomas Craven later commented of his appearance at this time that "he looked old and sad and I cannot remember that he ever laughed. He was, I felt, the victim of some strange irregularity of development."

Shortly after his arrival, Benton took a studio at the Lincoln Arcade, a rambling, seedy rabbit warren of studios located on the site where Lincoln Center stands today. There he slept on a cot whose legs were placed in pans of water for protection against the swarms of bedbugs. A daily morning ritual was dumping out the insects that had drowned during the night.

Benton managed to survive during this period largely through his friendship with two more prosperous individuals who took care of him: Ralph Barton and Rex Ingram. Ralph Barton was a little man with a big head, whom Benton met shortly after his arrival in New York. Their friendship was cemented when it turned out that one of Benton's ancestors, Thomas C. Rector, had killed one of Barton's ancestors, Joshua

Barton, in a duel.* Unlike Benton, who couldn't adjust to commercial work, Barton immediately began selling drawings to popular magazines such as *Puck* and *McCall*'s and achieved instant commercial success. For much of the next decade he allowed Benton to work in his studio and even, when he was traveling to Europe, as he often did for months at a time, to stay in his apartment.

In addition, Benton enjoyed the friendship and support of Rex Ingram, a handsome Irishman with considerable charm and a hint of a brogue. In 1911 Ingram entered Yale to study sculpture under Lee Lawrie, best known today for his Atlas figure, which adorns Rockefeller Center in New York. Since Lawrie had a studio in New York, Ingram rented a studio at the Lincoln Arcade, where he soon met Thomas Hart Benton and befriended him. Though accomplished in sculpture, Ingram soon took his talents in another direction. A classmate at Yale introduced him to Charles Edison, son of the great inventor, who had his own film company. Edison offered Ingram a job, and the sculptor was soon engrossed in acting, scriptwriting, and directing. Though handsome enough to become a star, Ingram soon discovered that his real gifts were shown when he stood behind the camera. With his background in painting and sculpture, Ingram showed a gift for thinking of film as a visual composition. He was at his best in spectaculars, such as *Ben-Hur, The Prisoner of Zenda*, and *Scaramouche*. A master of photographic technique, who used specially treated film stock to create rich tonal effects, he also understood the principles of organizing crowd scenes as a visual design, carefully calculating distances, perspectives, and rhythms of movement.

Benton served as Ingram's set designer during his early period of filmmaking in New York. At the time the movie business was very loosely run, and Benton became friendly with early silent stars such as Rudolph Valentino and Clara Bow, the "It Girl." The crew would meet in the evening at Luchow's restaurant to figure out what they were going to do the next day. There they would agree on what scenes they needed, whether a

* This was not Benton's only ancestor who was pugnacious. The artist's namesake, the senator, killed Charles Lucas, who had insulted him, in a duel on Bloody Island, off St. Louis, and also nearly murdered Andrew Jackson in a street brawl, lodging four bullets in his body that were never removed. Remarkably, Jackson and Benton subsequently became friends and political allies, forming common cause against the East Coast politicians led by John Quincy Adams.

Moorish palace or an Irish castle, and after a bit of research in the library Benton would work up a distemper painting, doing it in black and white since movies were not yet in color. Professional scene painters would then enlarge it to full scale, and it generally looked surprisingly real when placed behind the actors. On one occasion, Benton even tried acting, playing the role of a drunk in a barroom brawl, much to the distress of his father back in Neosho, who worried that his son's theatrical antics were destroying his own good reputation.

Benton's closest friend of this period was the poet Thomas Craven, who shared his financial miseries. Like Benton, Craven came from a midwestern background: he had grown up in Kansas on a farm that had once been robbed by Jesse James. Like Benton, he had a varied job history: he had been a newspaper reporter in Denver, a schoolteacher in California, and a night clerk for the Santa Fe Railroad in Las Vegas, and he had sailed before the mast in the West Indies. Later in life he liked to play up the racy side of these experiences. In Las Vegas, for example, he was the friend of roustabouts and prostitutes, and he had lived for a time in Paris, where he scribbled romantic verse and kept a mistress.

Craven arrived in New York to take the city by storm. Shortly after arriving in New York, he sold two poems to the *American Mercury*, edited by H. L. Mencken, but for the next eight years he was unable to sell a single manuscript. In order to survive, Craven often spent the winter in Puerto Rico, teaching Latin and English in a private school. Periodically he would reappear in the city, move in with Benton or next door to him, and take on a role similar to that of a wife. As Benton recalled:

> We frequently lived together or in adjoining apartments. He was a good cook. He'd cook and I'd wash the dishes. So we did that. They used to think we were a couple of homosexuals because we were always together. But it was for the convenience. I've always liked the association of males anyway.

Richard Craven, Thomas's son, has commented, "I would say my father and Tom were as close, as inseparable, as two men could be with one another." The bond was not unlike that of two brothers, and in fact Craven would eventually become an art critic and play the same role in boosting Benton's work that Willard Wright did for his brother, Stanton.

Despite these friendships, Benton's career floundered until he reconnected with Macdonald-Wright in 1914. Stanton would later declare that Benton had given up painting and that he deserved credit for reviving his career. This seems a bit exaggerated and is out of line with other accounts, but there's no question that Stanton's influence at this time played a key role in Benton's artistic development.

Benton achieved his first notable artistic success two years later, when he was included in the Forum Exhibition through his friendship with Stanton. Specifically for the show, Benton created a group of paintings in a Synchromist style, including a large abstraction. The most elaborate of them, now known only from a black-and-white photograph, was based on Michelangelo's early relief *The Battle of the Lapiths and Centaurs*. While the color palette was similar to that of Russell and Macdonald-Wright, the colors were not diaphanous but hard and firm, as though the figures had been dipped in vats of paint. As Benton told Paul Cummings:

> They were spectral. I just simply did Renaissance compositions with spectral color. That's all it was. But it looked strange at the time. I did exactly what you see in those drawings of Jack Pollock's only with bright color . . . I had already done spectral painting under the influence of Paul Signac. But I never had monkeyed with it in large planes or with the idea of using it compositionally.

In fact, Benton had come up with something new. While Russell and Wright had explored the muscular tensions and spiral rhythms of Michelangelo, their paintings generally focused on a single figure. On those rare occasions when they tried to go further, their compositions fell apart. Benton had introduced the notion of a multi-figured design, in which the rhythm jumped from one figure to the next. In a fashion that has interesting affinities with Pollock's later work, the rhythm was not confined to a single section of the design but expanded over the entire composition, running under and over other forms but never leaving the canvas. Ironically, in the end Benton got more publicity than almost anyone else in the exhibition since the art critic for the *Herald Tribune*, Royal Cortissoz, singled him out for praise. "I didn't stay with it," Benton later commented

of his foray into Synchromism. "After that exhibition I never did another one. But the influence stayed."

What stayed was the idea of rhythmic organization—of organizing a composition that led the eye through the entire composition, weaving in and out of deep space. Essentially, Benton had decided to devise a form of Synchromism with less emphasis on color but even more on complex rhythmic sequences of form. And this was the theme he focused on a year later, in March 1917, when he held an exhibition of his work at the Chelsea Neighborhood Association, complete with a little brochure. The paintings were Michelangelesque figure compositions but less brightly colored than those in the Forum Exhibition, with brushwork reminiscent of Cézanne. Notably, the show provided the basis for the first full-scale article on Benton's work, which Willard Wright contributed to the *International Studio*. Willard praised the show as "the most important modern exhibition of the month" and singled out Benton's interest in visual rhythms, declaring that "when an artist at times actually achieves rhythmical line sequences, then a vital aesthetic force has been set in motion."

One could hardly say that Benton had "arrived," but he was starting to become a figure worthy of notice, someone to talk about: granted that much of the talk was hostile, since Benton's idea of organizing visual rhythms, of basing a design on abstract principles, grated on the nerves of conventional realists. Around this time, when someone mentioned Benton's work to Robert Henri, the leader of the Ashcan School, he responded, "It's too Michelangelese," and quickly changed the subject.

Designing with Clay

In the early 1920s Thomas Craven published a novel, *Paint*, whose artist-hero is closely based on Thomas Hart Benton. In the book, the Benton character dies in 1920. Ironically, it was right around this time that Benton emerged from his decade of floundering and developed a mature and recognizable style—one whose themes were ultimately based on what he had absorbed from the Synchromists but that treated Synchromism merely as a point of departure.

In 1917 and 1918 Benton had made a series of abstract still-life

paintings, which were painted from models he made out of paper, wood, and wire. This process seemed to give his compositions a new clarity and intensity. These experiments were interrupted by a brief stint in the navy, where he worked with camouflage and documented the ships and equipment of the naval base at Norfolk, Virginia. But after his release from the navy he went back to his model-making and began to think about how this approach could be applied to the human figure. In the fall of 1919 he came upon an article on Tintoretto that described his procedures for the church of Santa Maria della Salute in Venice. In order to plan his compositions for the church, Tintoretto had created models out of wax and then experimented with their placement and lighting until he found an arrangement that suited him.

As Benton examined Tintoretto's paintings, with their dramatic sculptural qualities, he became convinced that they had all been planned in this way and decided to try to reconstruct his methods. In the back of Benton's mind was one of the key experiences of his career: the moment when he walked into Morgan Russell's studio in Paris and saw his sculpture. The experience had shown him that sculpture and painting could play off each other in a mutually beneficial fashion.

When he first took up sculpture, Benton modeled his figures in full relief, but he soon realized that full relief was not the best approach for coming to a pictorial form of organization since a very slight shift in viewpoint would throw off the entire composition. Consequently, he shifted to deep relief, using as his model both the doorways of Gothic cathedrals and Ghiberti's famous doors for the Baptistery in Florence, of which he obtained photographs.

As Benton progressed, he further modified Ghiberti's approach and began to work with a tipped-back plane, a kind of compromise between sculpture and painting, with deeply modeled figures in the foreground and shallower relief as one moved back. "You have to have a certain knack to make them," Benton later commented in an interview. "Even some sculptors can't make them if they don't have a sense of perspective in drawing."

This unique method made it possible for Benton to create the rhythmic feeling that is the most notable feature of his mature style. Developing such a rhythm through drawings would be an arduous process that would require hundreds of sketches. In clay he could instinctively create a sense of flow and movement and with a few bends and pinches could

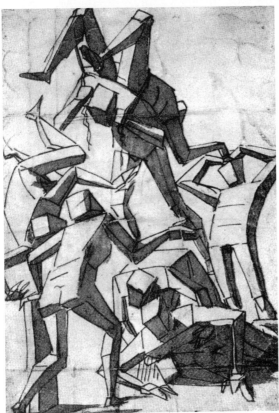

Benton's cubic studies (c. 1919–21, top) were inspired both by Cubism and by the drawings of the sixteenth-century Italian master Luca Cambiaso (bottom). *Top: Compositional Study for "Palisades."* (The Benton Trust, UMB Bank, Kansas City, Missouri, original art © T. H. Benton and R. P. Benton Testamentary Trusts/UMB Bank Trustee/Licensed by VAGA, New York, NY. *Bottom: Study of a Group of Figures*, the Uffizi, Florence.)

modify and intensify the sense of rhythm. After 1919 Benton used this method of clay models for every painting that he made.

He would then make sketches from his statuettes, sometimes filling up an entire sketchbook with studies. Some time before, John Weichsel had lent Benton a German book that reproduced drawings by Luca Cambiaso, a sixteenth-century Italian master, which reduced figures to cubic shapes. Benton recognized that this method made it easier to think about the volumetric form of a composition, and consequently he began making studies of this type. Such cubic drawings are surprisingly difficult to do. You can't make them by copying the outlines on the surface; you need to draw a clearly conceived concept of the form. That is, you need to conceptualize how the form rests in space and then make a drawing based on this information.

Throughout his career, Benton made many drawings that analyze famous paintings. A good example is his study of the famous *Assumption of the Virgin* by El Greco on the main staircase in the Art Institute of Chicago, which is particularly interesting because Pollock made a drawing of this same masterwork, and it's fascinating to set the two drawings side by side. But Benton also used this method for designing new compositions. Indeed, from this time on he never went forward with a major painting or mural without subjecting the design to this sort of treatment.

Albert Barnes

At this time, Benton finally began to get serious recognition as one of the leading American modernists. One person who helped Benton a great deal at this juncture was the talented modern painter Arthur Carles, a gaunt, hollow-cheeked figure with a dusty beard, whom Benton had known slightly in Paris. Like Benton, he was an enthusiastic talker and drinker. Carles had some power at the Pennsylvania Academy, and in 1922 he organized a show of modern art on the model of the Forum Exhibition, to which Benton contributed. Carles helped him make sales to three wealthy Philadelphia collectors—quite a coup for an artist who had lived from hand to mouth for a decade, either selling nothing or parting with pictures for derisory sums. One of those who purchased his work was the notorious Dr. Albert Barnes, perhaps the leading collector of

modern art in the United States. The sale led to an intense if short-lived friendship.

Barnes was a hulking man with a chip on his shoulder who had made a fortune of some twenty million dollars by developing Argyrol, a cherry-red disinfectant then used in clinics and hospitals around the world. Something of Barnes's temperament is suggested by the fact that his business partner, Herman Hille, who invented Argyrol, sold out to the doctor because he feared that Barnes might murder him.

Once he became rich, Barnes began collecting modern art, in part because he had played baseball as a boy with William Glackens, the Ashcan School painter. He quickly developed a fondness for modern painting, perhaps in part to set himself apart from high society Philadelphia, which he loathed and which tended to favor conservative forms of art. In Paris he visited the Steins and got to know the leading dealers, such as Paul Guillaume. He rapidly became a self-taught expert, convinced of the superiority of his own ideas and taste to those of everyone else.

Today the Barnes Foundation, located in Barnes's mansion in Merion, just outside of Philadelphia, has probably the greatest collection of Post-Impressionist painting in the world, with some one thousand masterpieces including 180 Renoirs and 69 Cezannes. No other figure in the United States had such a seemingly unerring eye for the best in modern art, or such a large checkbook to indulge his enthusiasm. For an ambitious modernist painter like Benton to connect with Barnes was rather equivalent to an oilman hitting a gusher. Or at least, so it seemed for a time. When they first met, Barnes and Benton hit it off. Barnes could hardly have been more enthusiastic about his work. In a note for the show organized by Carles, Barnes said of one of Benton's pictures (which he had just purchased):

> Corot has never revealed to me a composition as satisfying to a critical analysis as is the composition in a painting by a young American, Thomas Benton. But to compare Corot at his best with Benton would be an offense to the exquisite sense of values, the fine intelligence which created the forms in Benton's picture.

This was the period when artists and art historians were developing the theory that the significance of great art lay not in representational

tricks, subject matter, or storytelling but in formal values—what the English critic Clive Bell termed "significant form." Barnes was a subscriber to this doctrine. What is more, having been trained as a scientist, and being a man of strong and fiercely held opinions, he believed that through careful analysis one could devise exact and definite criteria to explain why a work is beautiful, and therefore art, and another, just slightly different, is not. To demonstrate his theories, Barnes hung his galleries in a thoroughly eccentric fashion, not according to artistic schools but according to the formal relationships he discerned. Alongside the paintings he displayed antique door latches, keyholes, keys, household tools, and objects of furniture, which supposedly had geometric lines similar to those of the paintings.

Benton, of course, had spent a decade analyzing the formal qualities of works of art in a somewhat similar fashion. After Barnes invited Benton to his home, he was so impressed with his intelligence and artistic insight that he invited him back several more times and the two began a lively correspondence. On the last visit Benton brought along Thomas Craven, and Barnes enjoyed their company so much that he suggested they come back every weekend. He noted that he was looking for a writer for a book on the formal qualities of painting. Perhaps Craven could take the project on. He might also employ Benton. Indeed, with his encouragement, Benton began work on a long essay on the mechanics of formal organization in painting.

Benton was never quite sure why Barnes turned on him. "Barnes was a poor talker in man-to-man discussion," he later commented. "But he brooded on his deficiencies and exploded in his notorious letters." Benton always suspected that Barnes reacted to his comments about Impressionism, which he did not much care for at the time and which Craven loathed. Benton was showing Barnes his method of analyzing the composition of old master paintings with cubic drawings. When Barnes asked him to discuss the structure of some Impressionist works, of which Barnes owned boatloads, Benton carelessly replied, "Well, that's kind of difficult, there isn't much form there."

Despite this untactful comment, Benton's last meeting with Barnes was extremely cordial. Barnes provided no clue that something was amiss. Shortly afterward, however, Barnes made a trip to France, and from Paris he wrote a letter in which he denounced Benton with heated

invective. "Barnes was an amateur psychologist," Benton recalled, "and he really could be devastating. Briefly, what he said was that my cockiness with regard to the arts derived from the fact that I was only a runt anyhow, and runts like me are always combative. He was a vicious bastard, but he did love art."

Ethel and Denny

It is prophetic that the patronage that Benton found around 1923 to replace Dr. Barnes came from characters of an altogether different type. At the time an actress named Ethel Whiteside was purchasing hats from Benton's wife, Rita. Ethel had a popular show called *The Follies of Coontown* in which she sang "darkie songs" with a group of African American musicians. She lived with a criminal lawyer named Denny, who had become prosperous defending pimps and prostitutes and other unsavory types. The pair lived in a lavish apartment on Riverside Drive with brocade walls and held parties that went on until the late hours of the night almost every evening. Benton and Rita got in the habit of attending.

At some unconscious level the weird assortment of guests—actors, judges, aldermen, and lawyers, perhaps even the occasional gangster—seems to have reminded Benton of the political gatherings he had known as a boy with his father. While a painter was a bit out of place in such a setting, he was forceful enough to hold his own: one evening he chewed out a portly, jowly judge who made fun of him for being an artist, doing so with such eloquence that he gathered a crowd. Before long Denny and Ethel became patrons. In fact, they purchased the largest and most ambitious of his beach scenes, although the formal title, *People of Chilmark*, was too much for them. Denny christened it *Basketball in Hell*.

In Denny and Ethel, Benton had found supporters of a new sort: not exactly aesthetic sophisticates, they were nonetheless wise to the ways of the world and wonderfully, unaffectedly enthusiastic about life. Benton was beginning to look for some "robust fellows" to connect with, and he was becoming interested in making art that would communicate to them.

A Wall to Paint

In the early 1920s Benton began to apply his new technique of planning with clay models to representations of the American scene. He worked at this process from different directions, and his first attempts were somewhat groping. Initially, much of his effort was concentrated into two loosely defined projects: one a series of portraits of "American characters," the other an ambitious mural of American history that he called *The American Historical Epic*. The idea was to create a history of the United States, stretching from first settlement to the present day. Since Benton couldn't find an architect or patron to provide him with a commission, he decided to make a mural series of his own, creating a series of larger mural-like canvases that could be arranged in groupings, or "chapters," to create a unified effect on a wall. He originally planned to create some seventy paintings, although in the end he finished only eighteen before abandoning the project.

Thus, by the early 1920s Benton was well on his way to developing a style that applied modernist techniques to American subject matter. The final push that made this happen, one of the most momentous events in the artist's life, occurred in 1924. At that time, for more than a decade, Benton had been completely estranged from his father, who after his political defeats had been pursuing a lackluster legal career in Neosho. Then his father developed throat cancer, and Benton went back to Missouri to sit by his bedside for three months while he watched him die.

The experience brought about some strange emotional transformation. As Benton later wrote:

> I cannot honestly say what happened to me while I watched my father die and listened to the voices of his friends, but I know that when, after his death, I went back East, I was moved by a great desire to know more of the America which I had glimpsed in the suggestive words of his old cronies, who, seeing him at the end of his tether, had tried to jerk him back with reminiscent talk and suggestive anecdote. I was moved by a desire to pick up again the threads of my childhood. To my itch for going places there was injected a thread of purpose which, however slight as a far-reaching philosophy, was to make the next ten years of my life a rich texture of varied experience.

The period after his father's death was one of enormous restlessness for Benton. In 1926, with some money he had saved up from decorating a sportsman's den, he made a trip out to Arkansas and southwest Missouri, roughly the same region he had visited as a small child with his father, and spent several weeks roaming through the most isolated section of the Ozarks, sketching farms, ramshackle villages, and local people, engaged in their country customs. This was followed by a quick jaunt out to the boomtown of Borger, Texas. What struck him was the richness and variety of subject matter that had never been painted before. As he wrote to Charles Pollock in September 1927:

> I become more and more in love with America the more I get out in it. It offers so much that art has never touched. As for its being stereotyped and built upon the same pattern everywhere that is only a blanket which our intellectuals throw over their incapacity for sensitive observation.
>
> Most of our critics judge America from the lobbies of its first class hotels or from the drawing rooms of people already corroded with cultural aspirations . . . Naturally their judgments are cockeyed. To see America you have to get down in the dust, under the wheels, where the struggle is. From such a position the notion of a stereotyped land and people is ludicrous.

Encouraged by what he had accomplished, he planned a much more elaborate trip in 1928, setting out in an old Ford, which served as both bedroom and studio, and taking with him for company a young student, Bill Hayden, the alcoholic scion of a wealthy Chicago family. Earlier American painters had sometimes painted American subjects, but no painter had ever attempted, as Benton did, to grasp all regions of the United States and to combine their qualities into a single work of art. Like Jack Kerouac a quarter century later, he sensed that there was something worth capturing out of the bewildering rush of sights and experiences on the road.

He started in Pittsburgh, where he sketched smokestacks and steel mills, and then made his way down through the Appalachians of West Virginia and Tennessee, visiting a lumber camp, where he made a series of detailed drawings, and also sketching factories, coal mines, and country farms. Moving farther south to Georgia, he drew poor white farmers and African American workers in the cotton fields. From there he headed west: visiting New Orleans, with its markets and nightlife; exploring the tributaries of the Mississippi, with its riverboats; and finally heading west to Texas and New Mexico, where he recorded the cowboys and Indians, as well as ranches, shantytowns, and oil fields. Then he headed back through the Midwest, sketching the world of agriculture—farms, tractors, grain elevators, and so forth.

Trips of this sort were rugged in the 1930s. Company guards chased him away from mines and mills and confiscated his sketches, often with the assistance of local police. Suspicious shopkeepers deliberately gave him wrong directions, sending him off into cul-de-sacs. On one isolated Ozark trail, a grizzled farmer picked up his gun and held it ready as Benton passed by him, presumably because he was making illegal moonshine and thought that the artist might be a revenue agent. To get the sketches that he wanted, Benton breakfasted with lumberjacks, exchanged banter with African Americans in the cotton fields, and partied for three days straight with some inebriated cowboys in an isolated cabin in New Mexico. In order to record the cotton packet *Tennessee Belle*, Benton and Hayden camped out on a riverbank in Arkansas for three days and nights, in sweltering heat.

The drawings that Benton made are of a part with these experiences. The materials he used were cheap and simple. The drawings themselves

are often smudged and stained; they often contain passages that look rushed and a bit awkward. We can sense that they were made on the spot: they convey a sense of effort and sweat; they are filled with short-cuts and cartoony exaggerations. The anatomy of the figures is often rubbery and the features of faces reduced to a kind of shorthand, in which a single wiggling line will express an eye or mouth. The shading is not carefully modeled but often rendered with a hasty and scratchy line. They have little of the refinement we associate with notable artistic accomplishment. I must confess that when I first encountered them I didn't like them very much, and then, for some reason, my viewpoint turned by 180 degrees and they became just about my favorite American drawings.

For all the seeming roughness of Benton's draftsmanship, the drawings reveal profound understanding of form and record spatial relationships with impressive mastery. Given a Benton drawing, it would not be hard to make a clay model of the scene he represents. Even more significant, in some peculiar way, Benton's drawings bring to life an impressive range of American characters with the depth and richness of a great novel. There's Slim, the drunken cowboy he sketched in a shack in New Mexico; or Tex, the poker-playing broncobuster, who later went to jail for committing a murder; or Dudley Vance, the Tennessee fiddler, who remembered the old way of playing country tunes and felt that the new-fangled musicians just didn't play them right. Benton had an instinctive sympathy for the poverty and plainness of their lives as well as for their touchy pride.

Finally, there was an aspect of the adventure that went beyond a mere collection of drawings. Traveling around the United States in this way gave Benton a sense of the bigness of America—of the vastness of American space. Benton himself wrote eloquently of this:

> For me the Great Plains have a releasing effect. They make me want to run and shout at the top of my voice. I like their endlessness. I like the way they make human beings appear as the little bugs they really are. I like the way they make thought seem futile and ideas but the silly vapors of the physically disordered. To think out on the Great Plains, under the immense rolling skies and before the equally immense roll of the earth, becomes a presumptuous absurdity. Human effort is seen there in all its pitiful futility. The universe is

unveiled there, stripped to dirt and air, to wind, dust, cloud, and the white sun. The indifference of the physical world to all human efforts stands revealed as hard inescapable fact.

In a passage of writing like this, we get a glimpse of a quality that Benton introduced into American art, one that Pollock later emulated. Their art feels like a great shout against the immensity of the universe.

America Today

Viewed in retrospect, Benton's efforts as a mural painter during the twenties such as *The American Historical Epic* feel unsure and tentative. In 1930, however, he finally pulled together all the disparate elements he had been struggling with—modern forms, Marxist theory, and American subject matter—into a single powerful statement, his panorama of *America Today*. The mural changed the direction of American painting in fundamental ways and set in motion controversies that raged fiercely through the remainder of the 1930s and beyond.

During the late 1920s Benton had showed his work at the Delphic Studios, run by Alma Reed, the mistress of the Mexican muralist Orozco. Ever since she had first teamed up with Orozco, Alma Reed had been eager to find him a wall to paint. In 1930, when she heard that the New School for Social Research was being constructed, she went to the director, Alvin Johnson, and offered Orozco's services free of charge. Johnson promptly accepted and arranged for Orozco to paint a mural in the school's cafeteria.

Word of Orozco's success soon got out, to the annoyance of Benton's friend Ralph Pearson, a hulking six-footer who had headed a collective devoted to the arts and crafts for which Benton had designed some rugs. In fury, Pearson confronted Johnson and hotly complained that an "alien" had been commissioned to create a mural, when Thomas Hart Benton, a 100 percent American, whose ancestor had nearly killed Andrew Jackson and had caused him to limp for life, was unable to get a space. Johnson promptly agreed to give Benton a wall as well, but under the same terms he had offered to Orozco: no pay except for materials, mostly the eggs that went into his recipe for tempera paint. The next day,

Benton dropped by to cement the agreement. As he told Johnson, "I'll paint you the mural, if you'll give me the eggs."

The project moved forward rapidly. On returning from his trip of 1928, Benton had filled a bureau with hundreds of his sketches. His first step in designing the mural was to arrange them into categories. Once he had done so he worked to arrange them into rhythmic visual sequences. Everything in the mural was something that he had observed firsthand. Benton completed the project in a mere nine months, devoting two-thirds of his time to planning the scheme and making clay models for study purposes. He executed the paintings in just three months, devoting just a little over a week to each of the nine large panels, each one about eight feet high and twelve feet wide and packed with dozens of figures. When the panels were completed they were lowered from the twelfth-story loft where they had been painted and transported to the New School. In addition to posing, Jackson Pollock helped with the moving and installation.

Books do a poor job of conveying what Benton's murals are about: they flatten them, and they transform their scale. In fact, *America Today* creates not a discrete, narrowly framed space but a complete environment, in which the figures seem life-size and in which, for all the peculiar spatial properties of Benton's imaginary realm, it feels as though one could easily step out of the room into the world of the painting. To phrase this in slightly different terms, Benton was creating not simply a framed view but a kind of environment, a work of art that surrounds us on all four sides. This gives the painting peculiar properties, since we are not capable of taking in the whole scene at once. We are overwhelmed by it, at the same time that we can sense that it contains some sort of grand intellectual order. Indeed, a good part of the experience of taking it in is to mentally compare what we are looking at with the equally complex and vivid scenes that are happening behind our back.

In short, we largely experience *America Today* not through direct sight but through peripheral vision and peripheral awareness. Thus, it hits our emotions in a way that touches powerful prehistoric instincts. Peripheral vision is our early warning system and connects with the early history of mankind. It tells us to be mindful of things we can't yet fully discern or understand. Notably, the things we see out of the corners of

our eyes seem to summon emotions, whether of danger or awe, with more intensity than things we see right before us. Not simply as a design but as a physiological experience, as an all-enveloping visual sensation, *America Today* was unlike anything achieved in American painting before.*

Two themes run through the mural, providing a kind of dramatic tension through their competition with each other. One is the wonder of new forms of technology. *Instruments of Power,* with its compendium of machines and vehicles, announced this theme, and the remaining panels continued it, with an inventory of old and new forms of machinery, from old steamboats and threshers to modern power plants, steel mills, oil derricks, and pile drivers.

The other main theme is the exploitation of the worker, who becomes increasingly a slave of machinery rather than its owner and master. *Coal* shows a slumped-over coal miner, emaciated from black lung disease; *South* a worn-out farmer; *Steel* a series of exploited steelworkers. Some of these scenes allude to the race problem in the United States. *South,* for example, shows a white sharecropper and a black cotton worker facing each other, with a chain gang of black convicts guarded by a gun-toting white man standing between them. Thus, Benton's subject matter sets up a distinct emotional tension between the exhilarating force, energy, and exuberance of American industry and the social exploitation that it was based on.

In much of the writing about him, Benton has been dismissed as a conservative or reactionary figure, who advocated a conservative form of realism, but if we actually look at *America Today* we can quickly see this is not the case. In actual fact, his realism bears very little relationship to the work of any earlier American painter, or to realistic painting in any normal sense. It's a way of looking at the world that is highly peculiar and very modern.

* While for the sake of immediacy I've placed this in the present tense, in this paragraph, I write of the original effect of the mural. *America Today* is no longer in its original location at the New School for Social Research, and in its present location at Equitable Life Assurance on Avenue of the Americas, it is displayed not as an enveloping room but as a line of discrete panels. The one Benton mural of the 1930s that still remains in its original form and its original setting is *A Social History of the State of Missouri* in the Missouri State Capitol in Jefferson City. This is well worth visiting to get a sense of the sort of all-encompassing surround that Benton originally achieved in all his murals of the 1930s.

Nothing is quite as we would normally see it. Arms and legs seem to stretch if they are making a forceful gesture; railroad trains become rubbery and bent because of the velocity with which they are moving forward. Many of these effects resemble the work of the sixteenth-century masters whom Benton had studied, such as El Greco and Tintoretto, but the degree of the bending and stretching and the velocity of the visual movement have a very twentieth-century energy and go beyond their Mannerist sources. In fact, Benton does weird things with space that have no real prototype in Mannerist work but are closer to the strange dislocations of Cubism. There are expansive areas, where the space widens out into seemingly infinite vistas, and narrow apertures, where space is compressed, rather like the rabbit hole that took Alice into other worlds. As you go through these apertures the place that was once West Virginia is transformed into Brooklyn, or the place that was once Georgia becomes Louisiana. In short, space seems to expand or shrink to emphasize particular things, and objects are organized in visual pathways with such an insistent rhythm that the eye never seems to rest but instead is pushed round and round the composition in a series of loops, not unlike Celtic interlace or the figure of the Ouroboros, the dragon that is swallowing its tail.

Notably, this peculiar visual patterning is tied in some way to the subject matter: the eye is forced into unexpected juxtapositions, which seem to have different levels of significance, not unlike a well-written sentence in which symbolism and wordplay enhance and disrupt the usual flow of sense and lead the mind in multiple pathways. The stooped coal miner leads our eye to the barge carrying coal; the white sharecropper leads our eye to the gun-toting guard watching a chain gang of black prisoners; the burlesque scene leads our eye to the lovers necking on a park bench. Benton's visual language allows images to be lined up in sequences rather similar to sentences and also allows these strings to be organized in a similarly flexible way, to stress elements of similarity or difference, or simply free association, based on some peculiar sort of psychological connection not easily accessible to ordinary logic. In short, Benton's paintings capture the flow of experience in a fashion less like the creations of most painters and more like the free-flowing imagery of a writer such as James Joyce. No doubt this is realism of a sort, but realism of a very specialized sort: more like a novel or a film than like most canvases, since

we can flow from one image to the next without the usual interventions, in a sort of stream of consciousness.

When we look closely at the individual objects, we discover that they are also rendered in a way that is peculiar. Unlike in most paintings, there is almost no atmosphere in a Benton painting, nothing that disappears into mist or fades and softens as it slides into the distance. Everything is clear and hard because everything is experienced at the same peak of high intensity. Visually, this creates a somewhat paradoxical effect, which confuses our sense of spatial relationships, and Benton accentuated this confusion in other ways as well. While he enjoyed creating tunnels of space that instill almost a sense of vertigo, there's also a sense that everything in the painting is pushing toward the viewer and the surface. (A few years later, when Benton completed his Missouri mural in the house lounge of the Missouri State Capitol, the legislators complained that the figures were jumping out at them from the wall and that the room was no longer restful.) The objects thus at once seem to close in on the spectator and to shoot outward as if from the force of an explosion.

Even in reproductions of *America Today*, in which we look at the panels one by one, this effect is very powerful, but it was truly overwhelming when all ten panels were placed in their original setting, a not-very-large room in which the panels, with their life-size figures, surrounded the spectator on all four sides. The result was a kind of compression chamber. Benton was at once making all of America close in on the viewer and placing the viewer in the center of it all, in an almost God-like position, as if all the fury and tumult of the American continent were revealed to one powerful omniscient gaze. In many ways Benton's effects are similar to Cubism's, but Benton's sheer profusion of subject matter creates a statement that has a very different flavor. One aspect of this is that it's more American in feeling—bigger, brasher, more vulgar. It's also more like a movie.

Surely Benton's work as film-set designer affected his accomplishments as a muralist. It taught him how to work on a big scale; it taught him to plan a composition in powerful patterns of light and dark, black and white, an exercise he went through even for paintings in color; it taught him the fashion in which seemingly rough brushwork and flat paint handling can create a powerful illusion from a distance; and from

watching the cinematographer Rex Ingram at work Benton also learned to orchestrate figures and crowds into a unified rhythm, an effect that is particularly noticeable in his Indiana mural. Interestingly, the very flimsiness of stage design seems to have affected Benton's thinking, since it taught him to design much of the architecture of his murals as cutaway, in which walls are magically removed to make things visible and the eye soars above the scene, like a camera on a crane.

At some level, the rapid rhythm of cuts in film also seems to have affected him. One of the notable features of Benton's murals is the way the scenes flow into each other in a series of fast cuts, like successive scenes in a movie. Benton's murals are fast-paced, modern, and film-like, in their pace, their cutting from scene to scene, their grand vision of life. Even the use of stereotypes in filmmaking—the glamour girl, the cowboy, the farmer, the city slicker—taught him how to create figures whom one can read at a glance in a large, complicated composition. In a stroke Benton had completely shifted the nature of American painting by producing a work that was larger, more powerful, more exciting than anything yet made by an American—more modern in its visual form, more controversial in its subject matter. He made the work of most previous American realists seem small and limited in its expressive ambition; he made most modernist painting seem weak and irrelevant, divorced from real life. His achievement had a bigness altogether unlike the typical easel pictures of the period—it had the grandeur and complexity, the rich cast of characters, the interweaving of memorable themes, that one might expect from the Great American Novel. In fundamental ways he changed the rules by which American art had been judged, challenging the supremacy of easel painting and proposing that American subject matter could give birth to new forms of arrangement and composition.

Paintings of the 1930s and early 1940s have a different quality from those of other periods of American art. An incident from my own life suggests the very particular nature of their pull. The summer after I graduated from high school, I hitchhiked from Albuquerque, New Mexico, to Chicago with two friends, often sleeping by the roadside, with the goal of seeing two paintings from this period, Grant Wood's *American Gothic* and Edward Hopper's *Nighthawks*. In retrospect the whole episode seems slightly odd, and it's curious to reflect on why these two paintings held such a powerful attraction for us. As I ponder the question

in hindsight, it seems to me that a large part of their appeal was that they stood outside the usual territory of art. At its heart our youthful journey was a quest to discover America, and these particular paintings were part of the very landscape and country we aspired to grasp. Figures like Rembrandt or Picasso might be great painters, but they stood outside real American life in some special, slightly esoteric realm of cultural affairs. By contrast, Grant Wood's tight-lipped farm couple and Hopper's slightly sinister, hawk-nosed, caffeinated denizens of the night, while they had ended up in a museum, were not highbrow or pretentious or European. They spoke the language of America, the language of the American people and of the American highway. In some very special way they were part of the same landscape we traveled through, with its gas stations and diners and lonely farms and its decaying main streets of small towns.

By that time, of course, the art of the 1930s was hardly new, its language hardly a surprise. How much more powerful it must have been for Jack Pollock to arrive in New York and suddenly be confronted by *America Today*—the painting that exuberantly trumpeted the arrival of a new kind of American art, one based on real experience of American life. Indeed, Pollock was not confronted simply with the painting and its forceful visual impact but also with the overpowering, crusty personality of its maker, Thomas Hart Benton, with his impressively tousled hair and wrinkled face; and with the experience not simply of watching Benton paint but also of installing the mural and of posing for it—so that Pollock learned, in a literal sense, what it meant to be *inside* the painting. Not surprisingly, Pollock devoted the next five years of his life to struggling to master this experience.

The most immediate result of *America Today* was that it introduced a new mode of mural painting into American art, one that celebrated American life and the activities of the working man. It provided the principal impetus for the Works Progress Administration (WPA) mural program of the 1930s, with its hundreds of large-scale projects for post offices, courthouses, and schools, as well as for literally thousands of easel paintings produced over the course of the 1930s, which examined the sort of imagery that Benton had introduced. Even those who didn't like Benton's work, such as Stuart Davis, were forced to revise their artistic position to counter what Benton had accomplished and to devise new

techniques and new explanations to show that abstraction could have an American quality and could become something more than a faint imitation of European art.

But the strong nationalist rhetoric that accompanied Benton's accomplishment has to some degree obscured the remarkable originality of what he accomplished in visual terms. For Benton was a visual innovator, a boundary crosser, who challenged the restrictions of the normal easel painting and introduced something more expansive and difficult to take in at a single glance—something more complex, more overwhelming, more powerfully pulsing in its visual rhythm. He developed a form of painting experientially different from anything seen in America before. The painter who fully seized upon this aspect of Benton's work was Jackson Pollock, and surely it was this specific mural, *America Today*, that largely laid the foundation for his later achievements. It's no accident that essentially Pollock's career started at the moment when he came to New York and witnessed the creation of the mural, for Benton had developed exactly the sort of "all over" composition later taken up by Pollock, in which muscular gestures are densely scattered across the picture surface.

For that matter, Pollock was also influenced by the crowing nationalism of Benton's achievement. Not least, Benton showed Pollock that American art could achieve greatness on its own terms. Later in life, when asked why he didn't go to France to learn how to make great art, Pollock replied: "It's here. It's not in Paris. It used to be with Benton but now it's with me."

Pollock in the Thirties

The present order is the disorder of the future.

—*Louis Antoine Léon de Saint-Just*

The Happiest Time

Benton's murals were all based on materials gathered on long sketching trips. In imitation of these adventures, Pollock made three cross-country journeys in the 1930s. The first of these, made in 1931 when Pollock was just nineteen, was the roughest and most dangerous. For the first part of the journey he traveled with his high school friend Manuel Tolegian, picking up rides in delivery trucks as far as Cleveland, where it became hard to get a ride because of the hordes of other hitchhikers on the road. Around Indianapolis, he split with his companion.

We know the rest of the trip in fragments. Somehow Pollock made his way to Terre Haute, Indiana, where he saw miners and prostitutes and is said to have had some kind of run-in with the police. He then hitched rides to southern Kansas, where he managed to hop a freight train that took him through the Texas panhandle. At some point he hopped off and began hitchhiking again. Amazingly, he met up again with Tolegian for the last part of the trip, when they were both picked up by a gentleman in a stolen car. A letter to his brother Charles makes clear the degree to which the trip was conceived in emulation of Benton, since everything is described in terms that evoke a Benton sketch or painting. The letter reports that Jackson saw "negroes playing poker, shooting craps, and dancing along the Mississippi" and miners and prostitutes in Terre Haute, which he sarcastically noted provided "swell color." Appropriately, Pollock spent much of the rest of the summer working in a logging camp—another Bentonesque experience, for

Benton had stopped off at a Tennessee logging camp on his cross-country trip of 1928.

Pollock made a second cross-country trip the next summer, in a bit more comfort since this time he rode in a 1926 Packard accompanied by his brother Frank, Frank's girlfriend, Marie, and two other young artists from the League, Palmer Schoppe and Whitney Darrow, the future cartoonist for the *New Yorker*. Darrow, who had attended Princeton and had never been west of Geneva, New York, was making the trip for the sheer adventure of it. After a few weeks in Los Angeles, Pollock made the return trip with Darrow, in a Ford that Darrow bought for a hundred dollars, taking a southern route, and seldom stopping except to camp. The route was close to the one that Benton followed on the latter part of his trip in 1928, and they saw many scenes similar to what Benton witnessed on that journey: oil derricks in the Texas panhandle, plantation workers harvesting cotton, black workers unloading bananas and cotton bales onto the boats tied along the Mississippi. Once again, it appears that much of the purpose of the trip was to be like Benton. "Jackson was always doing the Benton thing," Darrow later recalled. "We were out west and he wanted me to know how good he was out there. We tried chewing tobacco even, but when we spit it out the car window, it blew back in our faces.'

Pollock's third trip, which he made in midsummer 1934 with Charles, was even closer to Benton's, so much so that it seems that the brothers were probably deliberately tracing the same route that Benton had traveled in 1928 with Bill Hayden. Like Benton, they packed bedrolls and folding cots and brought cooking utensils to save money on food. They started in southwestern Pennsylvania, went on to Harlan County, Kentucky (the site of a recent miners' strike), on to Memphis (with its bars and clubs on Beale Street), on to New Orleans (where they cruised the red light district), and then west to Texas. This was exactly the part of the country that Benton had traveled, in the same order, though probably not precisely the same roads.

Unlike Benton, however, in the course of all this traveling Pollock did very little drawing. Whitney Darrow recalled that he made some quick sketches of the sunset when they were crossing the desert with Chinese crayons that he wet with spit. But rather than literally recording the scene, these seem to have been expressionistic affairs, filled with flame-like swirls. Not a single travel drawing by Pollock survives from the

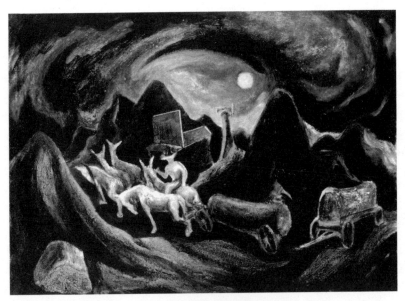

Pollock's early painting *Going West* (1934–8, top) was inspired by one of Benton's illustrations for a 1932 Marxist history of the United States, *We, the People*, written by Benton's friend Leo Huberman. (*Top*: Smithsonian American Art Museum, Smithsonian Institution, Washington, D.C., gift of Thomas Hart Benton. *Bottom*: Art © T. H. Benton and R. P. Benton Testamentary Trusts/UMB Bank Trustee/Licensed by VAGA, New York, NY.)

1930s, and the works in which Pollock recorded the American scene turn out to have been directly copied from Benton. Thus, for example, a small oil painting by Pollock titled *Camp with Oil Rig* turns out to be a faithful copy of a sketch that Benton made in Borger, Texas, in 1926. A pen and wash sketch that scholars have romantically titled *Cody, Wyoming*, after Pollock's birthplace, turns out to be a free copy of a sketch that Benton made of the market in New Orleans in 1928. In short, for all his efforts to emulate Benton, Pollock does not seem to have been capable of mastering his methods.

Murals

Along with making cross-country journeys, the other thing one had to do to be like Benton was to make a mural—preferably a very big one. Benton in this period was churning out murals at an almost incredible pace: *America Today* was followed by four more murals in the space of just five years, since the flurry of media attention around his work had started to lead to large-scale commissions, although the amount of money he earned was generally very modest. Each of them contained hundreds of figures and took up impressive volumes of wall space—the Indiana mural, for example, was 14 feet high and 250 feet long, as long as a city block. Jackson clearly wanted to make something as big and impressive as what Benton was doing, but as with the travel drawings, he fell short in practice.

Pollock himself made just two ventures in the direction of mural painting in the 1930s, both in different ways somewhat pathetic. The first came early in 1934, when Pollock was recovering from a drinking binge. Charles tried to help get his life in order by suggesting that they should collaborate on some murals for Greenwich House, a settlement house where Jackson sometimes took art classes and where he worked for a time as janitor. Charles's design showed a pushcart man being run down by a large truck (apparently it was intended as a comment on how capitalism mows down the proletariat); Jackson's design (which had no political implications) showed a group of five musicians and was clearly inspired both by Benton's musicales with the Harmonica Rascals and by the various music scenes Benton had painted in the early 1930s, for two of which Jackson had posed. Charles eventually showed a group of his

drawings in a small exhibition at Greenwich House, although he never was commissioned to actually make a mural. Jackson's design never got beyond a rough sketch on brown paper.

The second mural would hardly be worth mentioning if it did not anticipate some of Jackson's later paintings. Around 1934 Jackson and his brother Sande lived for a time in a loft-like commercial space with no heat. Maria Piacenza, Rita's niece—who visited them there with a friend named Madeline, with whom she worked at Klein's department store—recalled that the two painted "murals" on the walls that were "kind of naughty. There were guys peeing all over, that sort of thing. Madeline and I tried very hard not to notice them." No photographs exist of these "murals," and needless to say they no longer survive, but from the description it seems likely that their raw, graffiti-like character anticipated some of what Pollock later did on canvas.

While Pollock was seemingly the master's favorite student, Benton did not appoint him as an assistant when he created his Whitney mural. An assistant's major responsibility was to transfer Benton's design from his squared-up sketches to the actual wall panels; the whole process of transfer and enlargement required patience and precision, and Benton later commented that Pollock would have been poorly suited for that sort of work.

Jackson did finally get to function as a mural assistant in 1935, while working for the WPA, although not for Benton himself but for one of his students, Job Goodman, who was creating a mural, *The Spirit of Modern Civilization*, for Grover Cleveland High School in Queens. Jackson helped out both on the site and in Goodman's studio on Sixteenth Street. A kind of Benton martinet, Goodman followed Benton's procedures very faithfully. The most interesting aspect of the project was that, like Benton, Goodman designed his compositions with clay models, so Jackson got some practice making maquettes in clay.

Pollock's most successful exercise in "being like Benton" came in October 1932, when Benton, as a kind of atonement for not asking Jack to assist with the Whitney mural, appointed him his class monitor. This entailed hiring the models and setting the poses, although it wasn't particularly complicated to do so since Benton had a set of favorite models, who knew exactly what they were supposed to do. Among them were Ed Bates, a black man whom Mervin Jules found through his brother, a

bouncer at the Apollo Theater, and the muscular Hank Clausen, the well-read son of a Danish symphony conductor, who had compensated for a sickly childhood by taking the Charles Atlas body-building course and who added to his income as a professional wrestler by moonlighting as an artist's model. One of the requirements was that you couldn't be too ticklish. "Benton was a muscle and bone man," Whitney Darrow recalled, "and I remember Pollock poking and pinching the models to show the other students where the muscles were and how they felt. The models were a little squeamish sometimes. I don't think models would allow that today."

By this time Jackson's skills seem to have improved somewhat. As Whitney Darrow recalled, "Pollock drew with a real Bentonesque hollow-and-bump muscularity—always with frenzy, concentration, wild direct energy . . . His approach was very much Benton's." Along with making drawings, he produced clay and plasticene models, painted black and white to suggest the fall of light, which he brought to the League for Benton's criticism. Whitney Darrow remembered them as "swirling objects, objects with interesting curves and strong forces."

Martha's Vineyard

On the whole imitating Benton was a strenuous affair, but there was a notable exception to this—the summer visits with the Bentons on Martha's Vineyard. It was Rita who had originally dreamed up the idea of spending the summer on the island. In 1920 she arranged a vacation there with Benton and Thomas Craven and one of her friends, Lillian Hoffman, a schoolteacher from the Bronx. Lillian, a city child, lasted just two days in the primitive conditions—they had no phone, no electricity, and no car, and she was spooked by the strange country noises—but the other three stayed. Rita slept in a little bungalow, and Benton and Craven camped in the barn belonging to Ella Brug. It seems to have been on Martha's Vineyard that Tom and Rita's relationship grew sexually intense, for at the end of the summer Craven ceased to be Benton's roommate in New York. Craven moved to a rented house in Long Island, which he shared with the painter William Yarrow, and Rita moved in with Benton. Whatever the reason, whether romantic associations or something else, Tom and Rita both fell in love with the island and visited

Sea, clouds, and cliffs form shimmering, jagged patterns in Benton's early woodcut of the southwestern shore of Martha's Vineyard. (*The Cliffs of Gay Head, Martha's Vineyard* [c. 1922], collection of Art and Pam Haseltine, Springfield, Missouri. Original art © T. H. Benton and R. P. Benton Testamentary Trusts/UMB Bank Trustee/Licensed by VAGA, New York, NY.)

it every subsequent summer for the remainder of their lives. "Martha's Vineyard had a profound effect on me," Benton later wrote. "The relaxing sea air, the hot sand on the beaches where we loafed naked, the great and continuous drone of the surf, broke down most of the tenseness which life in the cities had given me."

Today Martha's Vineyard conjures up images of wealthy socialites, but in the 1920s and early 1930s it was still remote and simple. Many of the inhabitants were still farmers, descendants of people who had lived there since the eighteenth century. Because of inbreeding it had an unusually high percentage of deaf-mutes. Much of the land that is now solid underbrush was then pasture and farmland, and there were sweeping vistas down to the beach and ocean. Spiritually the island resonates with two great figures in American culture, the painter Albert Pinkham Ryder and the writer Herman Melville. For the Vineyard stands just across the water from New Bedford, where Ryder spent his childhood and where Melville set the opening chapters of *Moby-Dick*. The whaleship *Pequod* must have sailed right past Martha's Vineyard as it set out on its quest for the white whale, and one of the major characters in the book, the harpooner Tashtego, came from Gay Head on Martha's Vineyard, located just a short walk from the Benton home.

"Rita and I lived in the Vineyard like a couple of savages," Benton recalled. "We swam, gathered berries and mushrooms . . . We hardly ever put on respectable clothes and when our son, T. P., was born, he ran naked over the dunes and was sunburned to the color of mahogany." Over the course of several summers—1934, 1936, and 1938—Pollock joined in this primitive lifestyle.

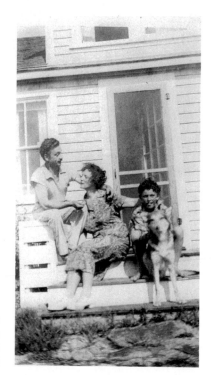

Thomas Hart Benton, Rita Benton, and their
son, T. P., by the doorway of their home on
Martha's Vineyard, early 1930s. (Photographer
unknown. Courtesy of Jessie Benton.)

With Benton he put a floor down in the chicken coop and cut a window in the north wall so that it could serve as his studio. To provide a place to sleep they constructed a bunk bed on one of the outer walls, giving it a roof to keep the rain out but leaving it open on the side, like a sleeping porch. They christened the result "Jack's Shack." (When I first visited the Benton place on Martha's Vineyard, Jack's Shack was still standing, though much of the wood was rotten. It has since been torn down.)

The routine of the day corresponded with the hours of light and began very early, at 4:00 A.M. The structure was loose, but with a few fairly firm markers. After breakfast Jackson carried out chores for an hour or two such as gardening, house painting, and chopping firewood. Around noon they would go picnic on the beach, carrying a hamper stuffed with things Rita had prepared to eat, with Jackson often carrying T. P. on his shoulders. After lunch they would often swim in the nude and then lie naked in the hot sand to dry off. Jackson spent the remainder of the day as he chose—digging clams and picking blueberries, going on

walks, decorating ceramics, and making paintings. Eight-year-old T. P. taught him to sail. The day ended about 9:00 P.M. when the light faded.

A number of Tom's friends lived nearby: Caroline Pratt, the founder of the City and Country School, and her companion, Helen Marot; Max Eastman, the former editor of the radical socialist rag *The Masses*. A cluster of interesting people was associated with a sort of vacation commune, the Barn House, which included Benton's red-bearded friend Boardman Robinson, then world-famous for his radical political cartoons and his daredevil exploits while traveling as a journalist in czarist Russia. Drinks and dinner in the evening was often the occasion for a gathering of friends. "We had many ardent discussions at our table with dinner guests," Benton later recalled. "Jack never entered these. He had no verbal facility. He had read too little anyhow to be at ease with the subjects discussed. In all the time of our Vineyard intimacy I never saw him with a book in his hands, not even a whodunit." Benton later wrote that the happiest times of Pollock's life were the stays on Martha's Vineyard:

> It is quite possible that the only really happy times of his life were had there, taking his end of a two-handled tree saw, swimming in the surf, gathering clams for chowder or wild berries for pies— times when alcoholic stimulation was unnecessary.
>
> His Western boyhood had given him a penchant for all the spooky mythology of the West with its visions of wild stallions, shadowy white wolves, lost gold mines, and mysterious unattended campfires. When, as a young man, he talked at all it was about such things. We received early reports of them from our admiring son and about the imaginary hero Jack Sass, who had explored, solved, or conquered all these mysteries. Jack Sass was, of course, Jack Pollock without the frustrations.

While Benton is remembered as a talker, during the early part of the day he was generally quiet and usually disappeared into the studio, where he worked alone. As a result, Jackson spent most of his time with Rita, who not only supervised his chores in the morning but often worked alongside him later in the day when he was decorating ceramics. Some of Jack's most notable creations of this period are the ceramics he made with Rita Benton, dribbling glazes through his hand onto the

curved surface of the bowl. The task of decorating such a shape gave a new twist to the usual Benton game of creating a rhythmic composition, since the shape itself curved in fascinating ways, so that the "hollow and bump" of the design interacted with the hollows and bends of the surface itself. On some of the plates Jack dripped and splattered colored glaze, his first known use of the technique that would later make him famous.

The Dark Side

When he was with the Bentons, Pollock was gentle and well behaved, but there was also a darker side to his life. For Pollock, as has now become legendary, was a troubled personality, and his emotional conflicts mirrored those of Benton in a complex fashion. Some of the very things that made Benton so captivating to Pollock—his foul language, his love of bourbon, his brusque behavior to women—mirrored elements in Pollock's psyche that were emotionally confused.

While Benton served as a father figure and taught Pollock a sort of artistic discipline, he was also a model of how to behave like a bad boy. Thus, for example, *Time*'s art critic in the 1930s, Alexander Eliot, once told me that one of Benton's little games was to speak to reporters in a string of four-letter words—knowing that the newspaper etiquette of the period prevented them from repeating or even mentioning them. And he liked to provoke people on a first meeting with a string of obscenities. No doubt in part because of his exposure to Benton, Pollock developed a similar practice, which some of his friends described as "the shit test"— that is, using the word "shit" and seeing if his listener was shocked.

While sometimes offensive, this sort of misbehavior was essentially childish. Other aspects of Pollock's behavior were more deeply troubled, even dangerous.

Soon after his arrival in New York, Pollock began to exhibit a serious drinking problem. In the winter of 1931, for example, he went through a phase of depression and stupor during which he would sit with his head in his hands, unable to work, for days at time. During this period he went out on drinking binges with friends like Joe Delaney, Bruce Mitchell, and Nathan Katz. Once he touched liquor, he became wild and uncontrollable. On Christmas Eve of 1931, after getting extremely

drunk, he followed a procession into a church, went up to the altar, and began knocking over the cross, the candles, and other things. Someone called the police, and he was arrested, although when he was arraigned he was released without being charged—somehow his brother Charles got him off. Pollock was arrested again in midwinter 1933, when he went on a rampage in a nightclub and attacked a policeman. Once again, he was let off with a mere reprimand. On still another occasion he got in a fight with a well-dressed man on Fifth Avenue who was walking his dog. Apparently Jackson got the worst of it. He was arrested, taken to St. Vincent's Hospital for head injuries, but then released, perhaps out of sympathy for his injuries. This was clearly not the only time when he chose to pick a fight over how well a dog was treated. As has already been mentioned, Becky Tarwater witnessed an episode of this sort, and very likely there were others.

Very often, when he attended parties, Pollock first became drunk and then became wild and violent. Axel Horn remembered him chasing a woman down a corridor at a party in 1933. At a benefit for the Art Students League held at the Palm Garden in 1935, Jackson got in a fist-fight with another artist, Harold Anton, and then, as the melee expanded, started slugging people indiscriminately. Not long afterward, Pollock started a fistfight at a party that one of Benton's former students, Amy Spingarn, held for the Harmonica Rascals. On still another occasion, he started a fight at a Puerto Rican dance hall, but when someone pulled out a knife and threatened him he retreated.

Sometimes he got in fights with friends that started as play and then turned nasty and scary. Maria Piacenza, Rita's niece, recalled a spaghetti dinner on the roof of her apartment building for Jackson and Manuel Tolegian in which the two got into a wrestling match. As they struggled, they rolled out to the very edge of the roof, which had no wall or railing. Maria was terrified that they would go over and end up as splatter on the sidewalk. In December 1936, at a party to honor the muralist Siqueiros, who was leaving New York to fight in the Spanish Civil War, Jackson got in a fight with him under a table and started to strangle him. "He was killing him," Axel Horn later recalled. The fight ended when Sande knocked out Jackson with a right to the jaw. At one point, Manuel Tolegian told friends that he once woke up from sleep and saw Jackson standing over him with a knife, although he later recanted the story.

Car wrecks sometimes played a role in these dramas. In the summer of 1932, when Jackson and Manuel Tolegian were working together at a lumber camp, the two got in a heated argument while Tolegian was driving, and Jackson became so angry that he pushed a saw blade against Tolegian's throat until he crashed into a wall of rock. Fortunately, Tolegian steered into a mountainside; on the other side was sheer precipice. In August 1936 Jackson hit another vehicle while driving, not only totaling his own Model A Ford but having to pay eighty dollars for the damage he had done to the other car.

While he sometimes attacked others, Jackson also often engaged in self-destructive or even suicidal behavior, such as punching out windows with his fist or running out into the street and daring cars to run him over. At a League party on a night boat up the Hudson, he jumped up on on a railing and threatened to jump off until his friends wrestled him back. On another occasion he jumped into the Hudson River and his friend Tolegian had to dive in to save him. Within a year or two of his arrival in New York, Nathan Katz has stated, "it was common knowledge that Jackson was suicidal."

While there were many earlier episodes, things seem to have gotten dramatically worse after Benton left New York in 1935. Pollock's drinking became compulsive, and according to Tolegian he often spoke of suicide. By 1937 his drinking had become a form of self-annihilation. Reuben Kadish recalled that "he was going berserk every time he drank . . . and doing awful things, getting himself in intolerable situations." Periodically the drinking bouts were followed by days in which he lay in bed or sat motionless in a chair, overcome by remorse.

Even a brief inventory of these episodes makes it clear that Pollock's infractions were not isolated events but followed patterns that were repeated more than once: smashing or breaking things; chasing, abusing, or threatening women; getting in fights at parties; getting in fights with friends that turned ugly; attacking people who were walking their dogs; hitting policemen; crashing cars; and threatening suicide.

What's not so clear, since the record is far from complete, is the timing of these episodes. There does seem to have been some sort of cyclical pattern, since there are periods where he seems to have been perfectly well behaved for several months at a time. Whitney Darrow, who traveled with him for about three months in the summer of 1932, never saw

him drunk and never experienced any behavior that was violent or even unpleasant. Asked about Jackson's drinking, Darrow commented: "I remember we bought a cold bottle of milk at a country store in the desert. Our drinking problem was finding something to quench our thirst. We never drank alcohol the whole trip." As for Pollock's famously tormented personality, he remarked: "He was a very likeable, warm person. I don't remember ever having any contretemps with him, or any unpleasantness."

Generally, Pollock's violent episodes seem to have followed periods of lethargy and deep depression. In addition, the episodes seems to have become more frequent over the course of the 1930s: in other words, the space between cycles of depression and drinking seem to have become shorter and shorter as the decade wore on. In the early 1930s those who knew Jackson seem to have seen the drinking bouts as a surprising lapse on the part of someone who was generally sweet-tempered and nice. By the time his brother Sande dropped him off at the Bloomingdale Asylum in 1936, he seems to have descended into an almost unbroken bout of drunkenness and bad behavior.

This pattern, of course, is one that is characteristic of bipolar illness, which eventually enters a phase known as hypercycling, in which the episodes of depression recur more and more rapidly, frequently resulting in suicide or death. In many instances Pollock's depression and drinking seems to have been set off by an event, such as Becky Tarwater's rejection of his marriage proposal or Tom and Rita's departure from New York. To a large degree, however, it was probably something caused not so much by external circumstance as by the natural cycle of a disease.

Oddly, while Pollock's illness has often been described, none of his biographers has ever provided a medical diagnosis, and many of the statements imbedded in the literature on his work are misleading. This is largely because of the fact that in Pollock's lifetime understanding of mental illness was still in its infancy. As a consequence, his symptoms were often misdiagnosed, and these errors have been perpetuated in literature on him, up to the present. Specifically, while doctors and scientists now recognize that bipolar illness (formerly known as manic depression) and schizophrenia belong to separate families of illness, in Pollock's lifetime disorderly thought patterns of almost any nature were

often labeled "schizophrenic." Not surprisingly, the label was applied to Pollock's case. Thus, for example, Pollock's analyst Joseph Henderson concluded that he suffered from a "schizophrenia-like disorder," while his subsequent analyst, Dr. Violet de Laszlo, determined that Pollock was suffering from a "schizoid disposition" and wrote a letter to Pollock's draft board providing this diagnosis to get him registered 4-F.

In fact, it is quite clear that Pollock was not schizophrenic but bipolar and that his bipolar illness was linked, as is often the case, with alcoholism. Pollock's mood swings and the dramatic alternations in his artistic productivity, between impulsive production and complete creative drought, are classic indicators of bipolar illness.

What was Benton's role in this? One might easily suppose that Benton played a role in feeding Pollock's alcoholism, as the remark he made to Leonard Lyons seems to boast. But the truth is odder and more complicated. Benton's fondness for bourbon and branch has always played a large role in his persona, although as many who knew him have pointed out, if he had really drunk as much as legend reports, he could never have executed so many paintings. In fact, Benton generally remained upright and lucid when liquor was served, although this was not necessarily true of his guests: Bill McKim once described to me a party in Kansas City at which Grant Wood and Clarence Decker, president of the University of Missouri–Kansas City, passed out together on the floor of the Bentons' kitchen. The period when Pollock arrived in New York was one of particularly hard partying and hard drinking. As Benton later wrote:

> The New School murals put my reputation up. If I wasn't famous in the way the critics thought I ought to be, I was at least notorious. The value of my paintings took a jump, and Rita, always a good hand at the selling business, disposed of the better part of our stock of pictures. I had a dealer at the time but it was Rita who did the real selling. She and I began to live higher than we had since the days of Denny and his gang. We rented a swank apartment and gave parties. I improved my brand of whisky. The freedom with which it was served became famous and Rita and I, taking stock one early morning of our more or less inebriated guests, discovered we had never met a damned one of them before. After that we shut down on the parties.

How did this affect Pollock? Amazingly, from all reports, Pollock did not drink when he was with the Bentons. In a memoir of this period, Benton recalled that while Pollock was a constant presence, at parties and family gatherings, he was a silent presence and "though drinks were occasionally available, [he] rarely touched them." In short, Pollock the drunk was some "other self" than the one that connected with Tom and Rita. On the face of it, this seems almost incredible, but in fact, as was just mentioned, we have the testimony of Pollock's friend Whitney Darrow that Pollock often went for long periods without drinking alcohol of any sort, and when he was sober he was the sweetest of companions.

In short, Pollock had two quite distinct personalities, which largely remained separate from one another—one exceptionally gentle and kindly, the other alcoholic, raging, and self-destructive. While Jackson's brothers and many of his students knew by the early 1930s that he had a problem, Benton and Rita did not grasp this fact until Pollock's visit to Kansas City in 1938. Only at that time did they realize that Pollock's drinking was an illness and that he needed medical help.

Why didn't Pollock drink when he was around the Bentons? If we conclude that Pollock drank as a response to severe depression, it suggests that when he was with Tom and Rita he did not need to drink, because when he was with them he was not depressed—or at least not seriously so. The point is fundamental to understanding Pollock not only during the 1930s but throughout his career. It explains why Pollock's personal bond with Benton remained in place when their artistic styles had seemingly drifted apart and when Benton and everything he stood for had become anathema to Pollock's wife and friends. For Pollock, Tom Benton and Rita were emotional healers.

Jackson's relationship with Rita was particularly powerful since he seemed incapable of sustaining a romantic relationship. "He bragged about a lot of conquests," one classmate recalled, "but it was pretty evident that they didn't culminate to the extent he claimed they did." "He was handsome and good-looking as any movie actor," Elizabeth Pollock, the wife of his brother Charles, recalled. 'But I never saw him with a girlfriend. I never *could* understand why he was so terrified of women."

Such relationships as Jackson had were very brief. In 1932 he had a short affair with an intensely lonely Jewish girl, Rose Miller, who bailed

out of the relationship after a few days. "There's no question in my mind," Jack's brother Frank later commented, "that *she* seduced him." In August 1936 he had some sort of romance with a very plain girl named Sylvia, who also seems to have taken the lead. For a brief time Jackson had the romantic and thoroughly unrealistic notion that he and Sylvia would live together in bliss in a small isolated cottage in Bucks County, but the relationship ended after a few weeks. In 1935, when Benton left New York, at which point all his brothers had gotten married, Jackson didn't even have a girlfriend.

At some level, in his contacts with women, Jackson seems to have courted failure. Much of the time, he approached women so aggressively that they immediately rebuffed him. According to one classmate, "He'd walk up to a woman at a party and stick his big face in hers and say something in a rough threatening way." "He made women afraid," Philip Pavia recalls. His first approach to Lee Krasner, in the mid-1930s, was a move of this sort. At a dance he stumbled up to her, pushed away her partner, and began drunkenly dancing with her. His first words were "Do you like to fuck?" Naturally enough, she then slapped his face and pushed him away. They did not make contact again until five or six years later. "He would come on very strong," Peter Busa recalled. "He approached women almost like a dog, bending down and smelling them. He could tell by the smell if a gal had her period, and if she did, he would tell her so."

Sometimes he approached women with pure hostility. Elizabeth Pollock once introduced him at a party to an attractive single woman in her late thirties. Rather than conversing, Jackson retreated to a corner, where he sulked, drank, and became intoxicated. Then, seemingly without warning, he crossed the room and told the woman, "You are the ugliest god damned old bitch I ever saw." Over the course of the 1930s, such episodes occurred with increasing regularity. Axel Horn recalled that at Art Students League parties "he would start chasing women, he would throw things around, yelling and challenging everybody." Most frightening, Jackson's groping and crude language often veered into physically violent behavior. In 1932, for example, in a party at the Tenth Street apartment, Jackson began manhandling a girl who was a friend of Marie, Frank's girlfriend. Afraid that he would hurt her, Marie tried to push

Jackson away, at which point he grabbed an axe from beside the stove and held it over her head. "You're a nice girl, Marie, and I like you," he said. "I would hate to have to chop your head off." After a few ominous seconds he smashed the axe down on one of Charles's paintings, splitting it in half.

Part Seven

Going Too Far

The trick of audacity is to know how far is too far.

—*Jean Cocteau*

Negroes in the Library

While Pollock was still struggling to master Benton's style, Benton had moved from being famous to being notorious, the subject of constant attacks and protests. The reason for this has always somewhat mystified me but is clearly deeply bound up with notions of social class and of what constitutes proper etiquette in making a work of art. At some level Benton wanted to turn his back on all his sophisticated knowledge and make paintings for people like his father. He liked the idea that people who usually didn't know or care about art and who thought, as his father did, that artists were fairies and sissies, would like his paintings. And, as I've witnessed many times, his paintings still conjure up an almost magical intensity of response from people of this sort.

One incident springs to mind. In 1989 one of Benton's major murals, *The Arts of Life in America*, was hauled to the museum in Kansas City for a big show of Benton's work. When the shipment arrived at the loading dock, I went out to greet it and was met by two drivers from Mineral Wells, Oklahoma, who sported ten-gallon hats, big belt buckles, and cowboy boots and who looked like they had just stepped out of the very mural they had been hauling in their truck. To my amusement, they both immediately began to lecture me about how much they liked the painting. "It's really incredible—you should see it!," one of them commented. While they carted art all the time, they made it clear to me that most of what they handled excited them no more than a bale of hay. But Benton's work directly touched them.

Of course, not everyone has shared Benton's desire to communicate to truck drivers and cowboys—to hold the mirror up to ordinary American life so that working-class people can see themselves reflected there and seize a vision of their place within the rhythms of a grand American composition. As his student Earl Bennett once remarked:

> Hell, Tom Benton went out and looked at America like nobody did. He knew where America was and what America was because he went out and mixed with the people, slept with the people, ate with the people, drew the people, won their confidence and he didn't give a damn about high society. Now that irritated a lot of people.

A major turning point occurred in 1933, when Benton managed to alienate a large group of his early supporters. The controversy began with what was surely intended as a joke, although it badly backfired.

While it brought him considerable attention, Benton's *America Today* mural was widely condemned as vulgar and tasteless, both for its brash visual form and for its working-class subject matter. Annoyed by the criticism, in his next mural, for the Whitney Museum of American Art, Benton decided to turn up the volume, filling it with large-scale figures of thoroughly vulgar working-class Americans engaged in daily amusements, such as dancing, playing music, pitching horseshoes, and going to church. One scene showed bootleggers, a cocktail hostess, and a woman singing on the radio; another, cowboys in a frontier setting; and one of the largest panels showed African Americans, or "Negroes" as they were then called, singing, dancing, playing craps, and attending church. This was the very mural I went out to greet at the loading dock in Kansas City. I've mentioned the enthusiasm of the two truckers for this piece, but in the 1930s well-bred New Yorkers reacted with horror—much as if live people of this sort had been allowed to step into this sanctum of high culture. Paul Rosenfeld, for example, complained that Benton had portrayed "cornfield Negroes" from "the primitive fringe of American life" and that the effect was "crude, gross and ungracious."

It seems clear that Benton intended his painting as an act of inclusion: as a reminder that much of America consisted of people who didn't live in New York, who often were poor, and who nonetheless found ways to bring fun and entertainment into their lives. By the time the battle was

over, however, this message had been fundamentally reversed. Benton was widely pictured as a bigot and racist, and those who wanted to keep Negroes out of the library as socially enlightened.*

Today criticism of Benton usually focuses on the contention that he was opposed to abstraction and modern art. But this was not the issue that concerned people in the 1930s. Instead, Benton's work came under attack from two seemingly quite different groups: those who defended traditional academic history painting, and those who supported revolutionary Communist ideology. What is surprising is that both sides were offended by essentially the same thing. Both camps focused on subject matter and on Benton's alleged breach of artistic decorum in his choice of it. Both conservatives and Communists were distressed by Benton's vision of American history and by the fact that he presented what he had actually seen and what had actually happened, rather than presenting an ideal.

Contrary to the generally accepted view of things, Benton was far more committed to free expression than his opponents, although as the battle continued, he was pushed into increasing conservatism and isolation. This struggle was to prove of long-term significance for the course of American art, since through a complex concatenation of circumstances, Benton's effectual defeat on this issue of freedom of expression set the stage for the collapse of Regionalism as a viable artistic movement and the eventual triumph of abstract painting.

Academic history painting in the nineteenth and early twentieth centuries tended to push history into the realm of the ideal. Historical events were presented in a prettified form and in fact, toward the end of the nineteenth century, were frequently pushed into the realm of allegory, with the result that a rendering of a woman in a white dress holding

* While the Missouri of Benton's childhood was obviously not free from racial prejudice, it's surely psychologically significant that Benton grew up in very intimate contact with African American people. Indeed, as a small child, Benton was largely raised by an African American woman, the most respected midwife in Neosho, Aunt Mariah Watkins, a remarkable woman who also played the role of foster mother for another notable figure in American culture, the great African American scientist George Washington Carver. At some level Aunt Mariah clearly served as an important model for Benton, showing what a self-confident, powerful woman could achieve. It's striking that Rita Piacenza, the wife he chose, was not lily-white, snobbish, helpless, and given to fainting spells, like his mother, but somewhat dark-toned, gregarious, unsnobbish, forceful and capable in practical affairs, rather like Aunt Mariah.

some attribute could stand for almost any historical circumstance. With very few exceptions, muralists avoided the so-called lower class and concentrated on heroes. When they did show workmen or modern industry, as John White Alexander did in Pittsburgh, they felt obliged to add allegorical flying figures, in order to raise the scene above the level of real life.

To those accustomed to this kind of sanitized history painting, Thomas Hart Benton's work came as a very brutal shock. Benton did not focus on heroes but presented a true people's history, like that of Charles Beard or Frederick Jackson Turner. Indeed, Benton enjoyed thumbing his nose at the sort of front-parlor manners that academic history painting glorified. His murals are filled with impolite reminders of the seedier aspects of American life, such as bootleggers and gangsters, train robberies, holdups, barroom shootouts, lynchings, chain gangs, Ku Klux Klan rallies, and even, in his Whitney panorama, the first garbage pile in the history of mural painting. What made this even worse was that Benton rendered such scenes with gusto and clearly based his murals on what he had seen in real life.

In the course of his long trips around the United States, Benton had developed the ability to make life drawings with phenomenal speed. Because they were executed very rapidly, these drawings often possess a cartoon-like quality, and indeed Benton took a certain pleasure in reducing a scene to its expressive essentials. From his friendship with Ralph Barton, Benton had grown to appreciate the power of caricature. When he made use of these drawings for his murals, he did not attempt to cover up their distortions but retained all their simplifications and exaggerations. Rather than attempting to polish them up to an academic standard of realism, he concentrated his effort on integrating them into the complex three-dimensional rhythms of the design. To do this required a special kind of virtuosity, for even a small section of a Benton mural may contain figures sketched years apart, in disparate locations. In his Whitney mural, for example, the drunken, unshaven cowboy Lem, whom Benton sketched in a shack in New Mexico in 1928, plays cards with the broncobuster Tex, whom Benton sketched at a rodeo in Saratoga, Wyoming, in 1930. In the nearby music scene a fiddler sketched in Tennessee joins the guitar player Wilbur Leverett, from Galena, Missouri, while Jackson Pollock adds to the harmony with his harmonica.

Benton's technical virtuosity was lost, however, on those accustomed to the nineteenth-century manner of mural painting, who expected a more academic and more idealized approach, not unlike that of a re-touched photograph. Thus, even in the Midwest and in rural places, where Benton enjoyed much popular support, his art was also quite con-troversial, as was reflected in the many attacks on Benton's Indiana and Missouri murals on the part of proper-minded local painters, historians, civic boosters, and members of the chamber of commerce. These people complained that Benton's cows and hogs looked too skinny, that his fig-ures had hands and feet that were too large, that his subject matter was sordid rather than heroic, and that in general Benton's work represented "a low type of painting," unsuitable to a public building. "I wouldn't hang a Benton on my shithouse door," commented one such viewer, Matthew Murray, the Missouri state engineer.

Today, of course, the academic approach toward history painting is virtually dead, and few people would attack Benton's work from this standpoint. By contrast, the Marxist attack on Benton is still alive, even though the political viewpoints that generated it have long since been discredited. This criticism of Benton, in fact, was largely a reflection of a short-lived Stalinist phase of the American Communist movement, which briefly attracted the support of American artists. The attack on Benton was led by supporters of Stalin and precisely coincided with the moment when Stalinists played a major role in the American Communist Party.

This assault took several years to gain force, for the Marxists did not publicly take issue with Benton's first mural, *America Today*, which re-ceived mostly favorable reviews in the press. When Benton completed his next mural in 1932, for the Library of the Whitney Museum of Ameri-can Art, the leftists attacked him with full force. The *New Republic* published an editorial denouncing it; a petition was circulated at the Art Students League to have it destroyed; and when Benton delivered a talk defending his work at the John Reed Club, an outraged party member threw a chair at him. In fact, Benton's Whitney mural was not markedly different in its subjects and themes from *America Today*. What had changed was the political situation, both in America at large and within the Communist Party.

As several writers have noted, one thing that had changed was the intensity of the Depression. Millions of Americans were out of work,

and most artists were in an embittered mood. In addition, there had been recent internal changes in the leadership and the political programs of the American Communist Party. Because of these changes, Benton and his art were no longer acceptable.

The Communist Party in the United States was formed surprisingly late, in 1919, and its early years were troubled ones. Because of factional differences, for several years there were two rival Communist parties, with different leaders and slightly differing programs; and the party was hit hard in 1920 by the notorious Palmer raids, orchestrated by J. Edgar Hoover, in which thousands of alleged Communists were arrested or deported. By the late 1920s, however, the Communist movement had become more unified, and it had begun to attract support among impoverished writers and artists.

Through the 1920s, Benton was extremely close to the Communists and actually considered himself one of them. One of his best friends, Boardman Robinson, had traveled with John Reed in Russia; Benton voted the Socialist ticket, headed by the imprisoned activist Eugene Debs; and he once hosted a meeting of the outlawed Communist Party in his apartment. As late as 1933 Benton showed his work at the John Reed Club, and in that year he also made the illustrations for a Marxist history of the United States, *We, the People*, written by his friend Leo Huberman. Throughout the 1930s Benton advocated collective ownership of the tools of industrial production, an essentially Marxist or socialist idea. Even at the height of the attacks on his work, Benton remained surprisingly good-natured in his statements about the Communists. "Don't get the idea that I have any hatred for Communists," Benton stated in 1935. "I used to be one of them myself ten years ago, and I am still a collectivist."

Benton's break with the Communists, it is clear, was due not so much to a change in Benton's message as to a shift that occurred in the Communist movement at just this time. Up through the 1920s, the term "Communism" applied to a rather loose spectrum of political ideas somehow associated with the notion that the wealth of the United States should be distributed more equally and that the workers, the proletariat, should achieve some form of control over the instruments of production.

About 1933, however, the Communist movement became increasingly dominated by the Russian Communism of Stalin, and in fact Stalin

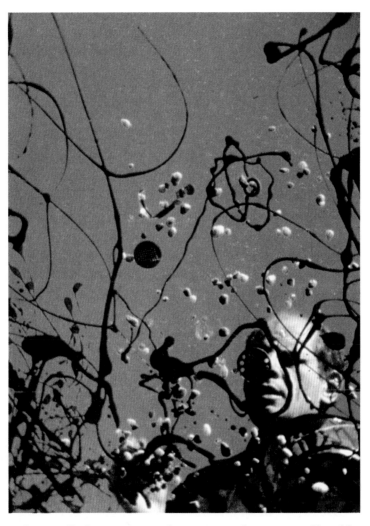

Jackson Pollock painting on glass in November 1950, as filmed by Hans Namuth. Frame from a color film by Hans Namuth and Paul Falkenberg.

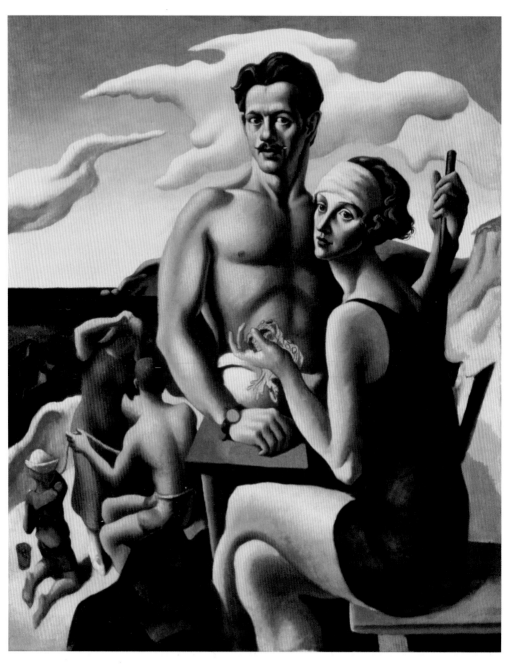

In 1922 Pollock's teacher, Thomas Hart Benton, portrayed himself in swim trunks with his wife, Rita, on the beach at Martha's Vineyard—probably the first bare-chested self-portrait in American art. National Portrait Gallery, Smithsonian Institution, gift of Mr. and Mrs. Jack H. Mooney. Art © T. H. Benton and R. P. Benton Testamentary Trusts/UMB Bank Trustee/Licensed by VAGA, New York, NY.

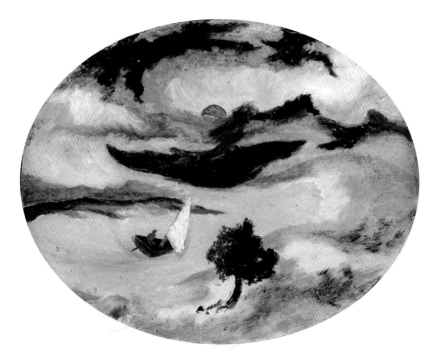

When I first hung Jackson Pollock's early painting *Menemsha Pond* (1934) in my office at the Nelson-Atkins Museum I thought it was completely inept. Over time I changed my mind.

Jackson Pollock posed for several of Thomas Hart Benton's major paintings, including *The Ballad of the Jealous Lover of Lone Green Valley*, where he plays the kazoo beside a Tennessee fiddler.

In the spring of 1914 Morgan Russell's *Synchromy in Orange* created a sensation at the Salon des Independents in Paris and was even denounced by the President of the French Republic, Raymond Poincaré. Like most of Russell's Synchromist paintings, it is an abstracted representation of Michelangelo's *Dying Slave*. Albright-Knox Art Gallery, Buffalo, New York, gift of Seymour H. Knox, 1958.

Stanton Macdonald-Wright made some of his best paintings, such as the one below, around 1916, when he was drawing from the model alongside Thomas Hart Benton (sketch above). At the time, he introduced Benton to Synchromist ideas. Top: *Michelangelesque Drawing*. The Benton Trust, UMB Bank, Kansas City, Missouri. Art © T. H. Benton and R. P. Benton Testamentary Trusts/UMB Bank Trustee/Licensed by VAGA, New York, NY. Bottom: *Sunrise Synchromy in Violet*. Carnegie Museum of Art, Pittsburgh, Living Arts Foundation Fund and Patrons Art Fund.

The Synchromist approach ranged from quite recognizable figure paintings to abstractions such as Stanton Macdonald-Wright's *Abstraction on the Spectrum* of 1914. Nathan Emory Coffin Collection of the Des Moines Art Center, purchased with funds from the Coffin Fine Arts Trust.

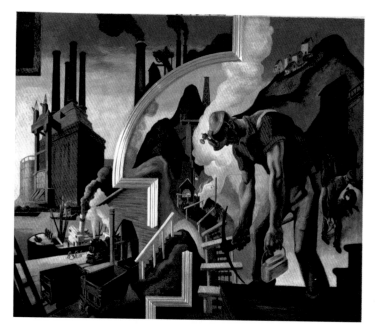

In the strange world of Benton's mural *America Today* (1930), space becomes malleable. West Virginia is sucked into New Jersey, and a locomotive, an airplane, and a blimp explode from the heartlike throb of an internal combustion engine. AXA Equitable Life Insurance, Seventh Avenue, New York.

Jose Clemente Orozco's image of *The Table of Brotherhood* (1930, top), in his mural for the New School for Social Research, probably was the inspiration for several paintings in which Pollock placed a rectangular table in the center of the design. One of the most famous of these is *Guardians of the Secret* (1943, bottom), in which Pollock seems to probe memories of his childhood, with his dog Gyp beneath the family dinner table. Top: Alma Reed, *Jose Clemente Orozco* (New York: Delphic Studios, 1932). © Artists Rights Society (ARS), New York/SOMAAP, Mexico City. Bottom: San Francisco Museum of Modern Art, Albert M. Bender collection, Albert M. Bender Bequest Fund Purchase, © Pollock Krasner Foundation through the Artist's Rights Society (ARS), New York.

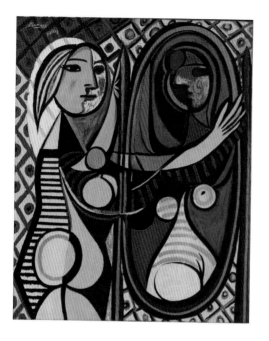

Pollock's *Birth* (c. 1939–41, right) recomposes Picasso's *Girl Before a Mirror* (1932, top left) into the pattern of a Synchromist abstraction, such as *Cosmic Synchromy* (1914, lower left) by Morgan Russell. Right: The Tate Gallery, London, © Pollock-Krasner Foundation through the Artist's Rights Society (ARS), New York. Top left: Museum of Modern Art, New York, Gift of Mrs. Simon Guggenheim, © 2009 Estate of Pablo Picasso/Artists Rights Society (ARS), New York. Bottom left: Munson-Williams-Proctor Institute, Utica, New York.

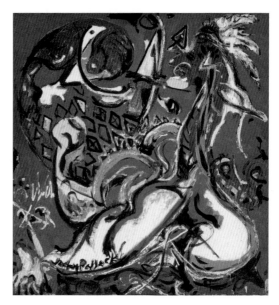

Top: The circling rhythms of Benton's *Organization* of 1944 are surprisingly similar to Pollock's *Moon Woman Cuts the Circle*, painted around the same time. Left: The Benton Trust, UMB Bank, Kansas City. Art © T. H. Benton and R. P. Benton Testamentary Trusts/UMB Bank Trustee/Licensed by VAGA, New York, NY. Right: Musée nationale d'art moderne, Centre de Creation Industrielle, Centre George Pompidou, Paris, donated by Frank K. Lloyd, Paris, 1979, © Pollock-Krasner Foundation through the Artist's Rights Society, New York.

Pollock scored one of his first major successes in 1944 when Peggy Guggenheim sold *The She-Wolf* to the Museum of Modern Art. The Museum of Modern Art, © Pollock-Krasner Foundation through the Artists Rights Society (ARS), New York.

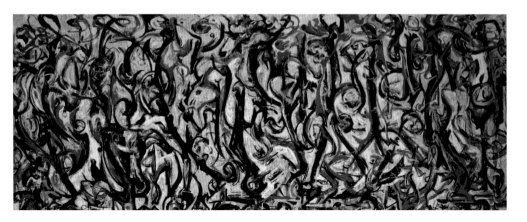

Pollock constructed what is generally regarded as his first masterwork, his *Mural* for Peggy Guggenheim (1943-44), from the letters of his name. University of Iowa Museum of Art, gift of Peggy Guggenheim, © Pollock-Krasner Foundation through the Artist's Rights Society (ARS), New York.

The principles of camouflage that Pollock employed were first elucidated by the American academic painter Abbott Thayer, based on his study of the concealing coloration of birds and animals. *Peacock in the Woods*, 1909 (assisted by Richard S. Meryman). Frontispiece of Gerald H. Thayer, *Concealing Coloration in the Animal Kingdom* (New York: The MacMillan Co., 1909).

The Synchromists sought to create an abstract visual rhythm based on the turns and undulations of the human body. The idea is nicely demonstrated in Macdonald-Wright's painting *Arm Organization* (1914), as well as in Thomas Hart Benton's diagram showing how an arm changes shape when the muscles are flexed. Top: The Museum of Fine Arts, Houston. Bottom: Diagram (redrawn by Lloyd Goodrich) from "The Mechanics of Form Organization in Painting," part IV, *Arts* magazine, February 1927. Original art © T. H. Benton and R. P. Benton Testamentary Trusts/UMB Bank Trustee/Licensed by VAGA, New York, NY.

Pollock's *Portrait of H. M.* of 1945 is filled with stick figures similar to those that Benton employed for his compositional studies, such as the one at top for *America Today*. Top: The Benton Trust, UMB Bank, Kansas City, Missouri. Art © T. H. Benton and R. P. Benton Testamentary Trusts/ UMB Bank Trustee/Licensed by VAGA, New York, NY. Bottom: University of Iowa Museum of Art, gift of Peggy Guggenheim, © Pollock-Krasner Foundation through the Artist's Rights Society (ARS), New York.

The earlier paintings of Pollock's mature career, such as *Troubled Queen* of 1945 (below), tend to use jagged shapes like those of the earlier diagrams in Benton's article on composition. Top: Diagram (redrawn by Lloyd Goodrich) from "The Mechanics of Form Organization in Painting," part I, *Arts* magazine, November 1926. Original art © T. H. Benton and R. P. Benton Testamentary Trusts/UMB Bank Trustee/Licensed by VAGA, New York, NY.

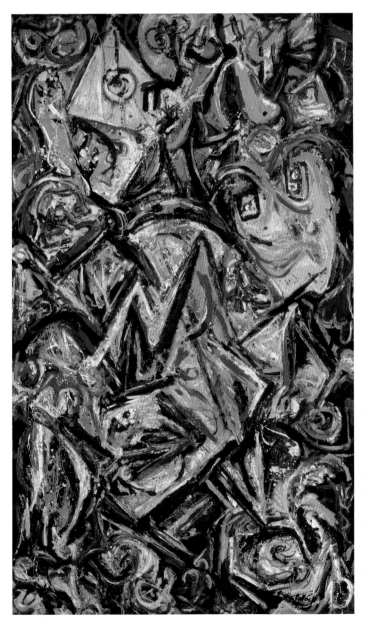

Jackson Pollock, *Troubled Queen*, circa 1945, oil and enamel on canvas, 74 x 43 inches. Museum of Fine Arts, Boston, Charles H. Bayley Picture and Painting Fund and gift of Mrs. Albert J. Beveridge and Juliana Cheney Edwards Collection, by exchange, © Pollock-Krasner Foundation through the Artists Rights Society (ARS), New York.

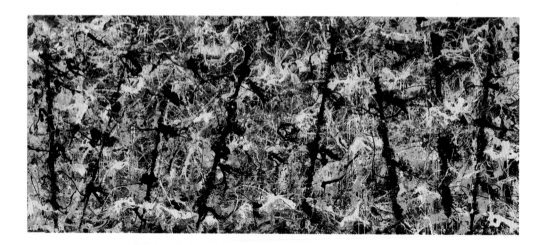

The composition of Pollock's famous *Blue Poles: Number 11, 1952* is pulled together through the use of vertical poles, and follows the principles that Benton laid out in his articles on abstract composition. After Pollock's death, when Benton heard of the sale of the painting to the National Gallery of Australia, he commented to a friend, "I taught Jack that!" Top: National Gallery of Australia, Canberra, © Pollock-Krasner Foundation through the Artist's Rights Society, New York. Bottom: Diagram (redrawn by Lloyd Goodrich) from "The Mechanics of Form Organization in Painting," part I, *Arts* magazine, November 1926. Original art © T. H. Benton and R. P. Benton Testamentary Trusts/ UMB Bank Trustee/Licensed by VAGA, New York, NY.

made a conscious attempt to gain leadership over the American Communist Party. To an increasing degree the Communist Party became concerned not with reaching out to American workers but with purging dissidents from within its own ranks.

One of the symptoms of this ideological shift was the creation of the John Reed Club, which was founded in October of 1929 by the American Communist Party as an extension of the International Union of Proletarian Writers and Artists, which had its headquarters in Moscow. The club adopted a manifesto based on the guidelines established for the arts at the International Congress of Proletarian Culture, held at Kharkov in the Soviet Union. The essence of this six-part program was opposition to the decadent capitalist notion of art for art's sake, that is, of art that was essentially formal or decorative in its appeal. The club's manifesto declared that the purpose of art was to further the struggle against capitalism: specifically, to fight against imperialist war, against fascism, against white chauvinism, against the influence of middle-class ideas, and against the persecution of revolutionary writers and artists.

In 1934 the First All-Union Congress of Soviet Writers made Social Realism the official style of Soviet art and prohibited all other forms of artistic expression. In the United States, however, Moscow adopted a less stringent approach and encouraged the creation of so-called popular front movements, such as the American Artists' Congress, the American Writers' Congress, the United American Artists, and the Artists' League of America. Hitler's rise to power in Germany in 1933 gave added strength to the Stalinist movement. Communism was widely held to be the most potent alternative to Fascism, and any "middle-class ideas" that represented an alternative to Stalinism were equated with the Fascist threat.

Curiously, the leader of the attack on Benton, Stuart Davis, was both a Communist and an abstractionist, and therefore something of an ideological oxymoron. In his attack on Benton, however, Davis avoided the issue of artistic style but focused on political content. The artists whom Davis singled out for praise were not modernists but Stalinist Social Realists, such as the now-forgotten American painter Jacob Burck, who executed murals in a thoroughly boring, literal, and humorless Social Realist style and whom Davis termed "one of the outstanding revolutionary artists." Davis was never a card-carrying member of the Communist Party,

perhaps out of fear of future Palmer raids, but there can be no question that he was a defender of Stalin in this period and allied himself with Stalin's minions. Thus, for example, Davis signed a group statement declaring that Stalin's Moscow trials, in which scores of Russian intellectuals were condemned to death, were morally justified.

Davis engaged in deceit in his campaign against Benton. He enlisted some friends to entice Benton into giving an interview, which he would never have done if he had known that Davis was behind the project. He then ran Benton's remarks, which by themselves would not have seemed particularly inflammatory, alongside a series of articles accusing him of racism, Fascism, and other misdeeds. It seems obvious that Davis was intensely jealous over the publicity that Benton received in this period, particularly after an article in *Time* magazine raised his fame to a new level. His attack on Benton came within days of the *Time* article.

Benton always believed that the ultimate cause of Davis's fury was a personal slight suffered more than twenty years before. The two first met in 1912, in the studio of Samuel Halpert at the Lincoln Arcade, where Davis was showing Halpert a group of his figure drawings, executed in the fashion of the Ashcan School and his teacher Robert Henri. Something about Davis's cocky manner set Benton off. Having just returned from Paris, where he had learned about Fauvism and Cézanne, Benton told Davis that his drawings were terrible and that he should go to France to learn something about modern art. As it happened, it was good advice, but Davis never forgave the insult.

When one reads through Davis's assault on Benton, one can't help sensing that Benton's belief that Davis held some form of personal grudge must have been correct, for one of the odd features of Davis's diatribes is his repetitious claim that his grievance against Benton is not personal, a phrase that invariably precedes either crude bathroom humor or some slanderous personal remark. At the time, Benton specifically complained that Davis did not concentrate on political issues but "dropped back to the level of a personal attack."

On the surface, however, Davis attempted to make a political case and relied heavily on the support of his hard-line Stalinist friends. At least his central complaint was that Benton's ideology was not socially progressive and not in harmony with Communist doctrine. Davis's language,

however, while remarkably heated, was also somewhat cryptic, for his summary of Benton's position was often so grotesquely twisted, and so far from Benton's actual statements, that the real cause of his fury remains unclear. Davis, for example, maintained that Benton thought political ignorance was preferable to knowledge and that "social understanding usually hurts the artist"; but this was a ridiculously and deliberately inaccurate summary of Benton's position, namely, that for numerous pragmatic reasons, the Russian version of Communism was not suited to American workers and would never be embraced by them.

Davis, in short, constructed imaginary positions for Benton so that he could easily destroy them, with the result that the true cause of his anger remains elusive, and his specific responses to Benton's paintings somewhat baffling. For example, it is difficult to understand why Benton's Whitney mural was so much more offensive to Davis and the leftists than *America Today*.

In fact, it appears that the central grievance of Davis and his allies was remarkably similar to that of the academic critics, although presented from a different political standpoint. They objected that Benton painted America as he found it, rather than as they believed it ought to be. They were deeply distressed that Benton did not present proletarian heroes but instead painted ordinary American people doing ordinary American things.

Benton's *America Today* mural was apparently acceptable from a revolutionary standpoint, if only barely so, for it showed poor Americans, some of them black, hard at work, busy being exploited by capitalism. The Whitney mural, however, was not acceptable, for it showed poor people, including poor black people, actually having fun, singing gospel songs, going to church, feeding the baby, playing cards, and roping horses, seemingly unaware that they were the miserable victims of the capitalist system.

In a sense, Benton was thumbing his nose at the leftists, because it seems fairly self-evident that the sort of working-class Americans he painted were not waiting with bated breath for the latest proletarian position paper from Kharkov. Indeed, to underscore this message, Benton later repeated one of the vignettes in the Whitney mural, portraying a tenant farmer sitting on the hood of an old car in the middle of nowhere,

in a lithograph that he titled *Waiting for the Revolution*. The clear implication was that this poor hick was going to have to wait a very long time—until Doomsday, in fact.

In April 1935, in an interview with a reporter for the *New York Herald Tribune*, Benton nicely summed up the position that so outraged Davis and the Communists. As he stated:

> If the radical movement is to get anywhere in this country it has got to drop Marxism as an outworn historical and economic notion and rely wholly on a pragmatic observance of developing facts. You can't impose imported ideologies on people. The point I wish to make is that social revolution has got to come from the grass roots. But the way the Communist intellectuals are going about it—never! Communism is a joke everywhere in the United States except New York.

Not everyone, of course, could keep up with these ideological shifts. Thus, although Stuart Davis angrily denounced Benton's mural as "Fascist or semi-Fascist," Henry McBride, the genteel art critic for the *New York Sun*, accused Benton of "being a Communist." By the time of the Whitney mural, however, the political tide had turned. While his own attitudes had changed little if at all, Benton from that time onward was regarded as an adversary by the denizens of the radical left.

Not surprisingly, since many of Benton's antagonists were Jewish, over the course of these fights Benton was often accused of being racist or anti-Semitic. Indeed, when I moved out to Kansas City to work at the art museum there, with the knowledge that I was obliged to put on an exhibition of Benton's work, I shared this common view, only to be somewhat startled by the large number of Benton's close friends in Kansas City who were Jewish, many of whom regarded him with the warmth and affection they would feel for a family member, as if he were an eccentric but lovable uncle.

Notably, during the very period when Benton was being most heatedly denounced as an anti-Semite, he was vigorously praised by the future Abstract Expressionist Barnett Newman, a Jew, who, after a visit to Martha's Vineyard in 1938, wrote glowingly of Benton as "a constantly active bundle of energy, informal and straightforward, who transmits to

all who meet him his boundless courage, the courage of a man who has spent his life fighting for ideas and ideals."*

As it happened, Benton's distrust of Stalinist orthodoxy was simply a few years too soon, for after 1939 even Stuart Davis came to share it. The Hitler-Stalin nonaggression pact, which was signed in August of 1939, and which was followed by the Soviet invasion of Finland in November of that year, led to the rapid collapse of the American Artists' Congress. The popular front suddenly became unpopular. Some supporters, such as Meyer Schapiro, resigned with considerable public fanfare; and even Stuart Davis realized that he had been mistaken in his admiration for Stalin and quietly withdrew from political activism. While full knowledge of Stalin's activities would take years to emerge, it is now well established that he was one of the greatest murderers in human history, responsible for slaughtering about twice as many people as Hitler. When interviewed late in life, in a gambit reminiscent of some modern politician under investigation, Davis claimed complete amnesia about his political activities in the thirties. Asked about the causes he campaigned for at the time, he declared:

> I'd forgotten all about that—thank God. You know, there were so damn many things going on. You just can't keep all that crap in your head. The only reason it went on was because nobody had anything else to do, and the fact that they were able to do something in concert was very important. It didn't make any difference whether the people who instigated it were communists, or whatever.

* The role of racial issues in Benton's art and in the attacks against him is too large a subject to deal with adequately here, and it's certainly true that Benton's art is often impolite and not in "good taste." It is worth noting, however, that in several interviews and written statements Benton explicitly denounced racism. For example, in 1940 he declared: "We in this country put no stock in racial genius. We do not believe that, because a man comes from one racial strain rather than another, he starts with superior equipment. We do not believe this is true in any field; but particularly in the field of creative endeavor do we repudiate it." Interestingly, Benton's paintings of African Americans are now avidly collected by wealthy African Americans. Oprah Winfrey, for example, owns two major paintings by Benton, one in a place of honor in her home in Chicago, the other similarly featured in her retreat in Hawaii. It is evident that she looks at Benton's representations of African Americans on a near daily basis and derives inspiration from them.

It's surely ironic that within a few years Stuart Davis was presenting himself as a high-minded advocate of individual freedom and artistic self-expression. This, of course, was in direct contradiction to his position of the 1930s, when he had urged vigorous suppression of political viewpoints that differed even slightly from the party line. By 1939, however, Benton had left New York, and it was too late to take full advantage of the changed climate of political debate.

Rudderless

Throughout this period, Pollock remained at the center of Benton loyalists. In January of 1933, when Benton gave the talk at the John Reed Club that ended in a chair-throwing brawl, Jackson was one of the group who jumped onto the stage to defend him. But just at this point, Jackson lost both his real father and Benton, his surrogate father, with devastating effect on his emotional stability. In December 1932 Benton accepted a commission from the State of Indiana, and hurriedly left New York for Indianapolis where he worked frantically on the project for eight months. Initially, Jackson Pollock reacted enthusiastically to his teacher's success. As he wrote to his father on February 3, 1933:

> Benton has a huge job out in Indianapolis for one of the state buildings—two hundred running feet twelve feet high. The panels are to be exhibited at the Chicago World Fair when finished in May. After a lifetime struggle with the elements of every day experience, he is beginning to be recognized as the fore most American painter today. He has lifted art from the stuffy studio into the world and happenings about him, which has a common meaning to the masses.

Benton's departure, however, left Pollock alone, without his most important mentor, and largely rudderless.

What is more, only days after Benton left, Jackson received news that his father was having severe heart problems. On March 4 Franklin Roosevelt gave his famous inaugural address, which Roy Pollock listened to with approval and enthusiasm, sensing that a new age was coming for downtrodden common men like himself. By the next morning he was in severe pain, and by early evening he was dead. For Jackson, his father

had been only a distant presence for years. Because money was so tight, he didn't travel to California for the funeral. "I always feel that I would have liked to have known dad better," Jackson wrote to his mother in a note of condolence shortly afterward.

Jackson seems to have regularly responded to stress or bad news by going on drinking binges. Not long after his father's death he was arrested for going on a rampage in a nightclub and hitting a policeman. He was arraigned the next day but let off with an admonishment. In an effort to get him to straighten out, Charles brought Jack to live with him in the Eighth Street apartment, despite the objections of Charles's wife, Elizabeth. By the next winter, however, Charles wasn't willing to house Jack any longer. For a few months, Jack lived by himself in a shabby apartment on Houston Street. That summer, Sande lost his job doing layout work for the *Los Angeles Times*. He landed in New York that fall, having hitchhiked from Los Angeles, arriving with thirty-four cents in his pocket and wearing his California clothes—not even an overcoat. He moved in with Jack in October, taking over Charles's role as his brother's caretaker.

Once Benton left for Indiana, Pollock was clearly at a loss about how he should continue his artistic studies. He signed up for John Sloan's drawing class, but unlike Benton, Sloan was neither patient with slow learners nor tolerant of divergence from his own approach. After less than a month, Pollock dropped the class in disgust. Interestingly, when he did so, he abandoned drawing and painting altogether to concentrate on sculpture, studying stone carving in a class at Greenwich House and modeling in clay at the Art Students League. His fellow students thought his work was a joke. "He just wanted to make small figures like the ones he did for Benton's murals," Philip Pavia commented. "He was just imitating Benton. There we were, serious sculptors, and he was doing these little Bentonesque figures." For all that, Pavia had to confess that Pollock did have a remarkable grasp of rhythm. "Pollock had the rhythm down," Pavia later recalled. "He really had a feeling for it."

By the autumn of 1933, Jackson's drinking seems to have become less desperate, due both to the attentiveness of his brother Sande and to the fact that the Bentons were both back in New York and providing him with a home-like framework. In September of 1933 Benton returned to New York and moved into an apartment on Eighth Street, across from

the Brevoort Hotel. Pollock promptly resumed his visits, and his drinking tapered off. While he had stopped taking art classes at the Art Students League, he regularly attended the Monday night evenings of the Harmonica Rascals, and he also posed for one of Benton's most remarkable paintings, *The Jealous Lover of Lone Green Valley*, in which he plays the harmonica in the company of another Benton student, Glenn Rounds, and a Tennessee fiddler.

With help from the Bentons, Sande and Jackson both found a job at the City and Country School on West Thirteenth Street. They cleaned the five-story school every night and swabbed it down once a week, for which they received five dollars apiece. Not long afterward they both joined the newly formed government art program. Rita also managed to sell some of Jack's ceramics and paintings from a space that she had fixed up in the basement of the Ferargil Galleries. An aggressive negotiator, at one point she exchanged one of Jack's paintings with a tailor for a suit of new clothes; and she also sold a painting on approval to the actress Katharine Hepburn, although Hepburn returned it after a few days. With Tom and Rita in New York to care for him, Pollock's emotional life seemed to be stabilizing and his career gaining momentum. But then he lost Benton once again—this time a break that was never fully healed. Something happened that neither could have predicted: Benton became famous beyond his wildest dreams.

Fame and Flight

Fame caught up with Benton during this slow phase of his career. The stage for this had been set by his friend and former roommate Thomas Craven, who had become a partner in his ventures, much as Willard Wright had for his brother, Stanton. By the late 1920s Craven had stopped writing for the *Dial* and shifted to more popular journals, such as the Hearst newspapers. Around 1929 Craven began launching a direct attack on French influence in articles with titles like "The Curse of French Culture." He regularly cited Benton as a leader of the battle against the decadent modernist styles that were being imported from France. In the spring of 1931, just after Benton had completed his *America Today* mural, Craven published *Men of Art*, a survey of painting from Giotto to modern times, which became a Book-of-the-Month Club Selection and the bestselling art book of the decade. Though most of the text was devoted to the old masters, the final chapter described Craven's "Hopes and Fears for America" and praised the increasing desire of American painters "to throw off the European yoke." Needless to say, Benton was cited as the most important leader of this tendency.

In 1934 Craven published *Modern Art*, a direct assault on modern painting; filled with attacks on such Europeans as Picasso and Matisse and on such Americans as the photographer and art dealer Alfred Stieglitz, and once again hailed Benton as the savior of American art. The heat of the invective resembled modernist diatribes, such as "The Futurist Manifesto" or the statements that Morgan Russell, Stanton

Macdonald-Wright, and Willard Wright had penned on behalf of Synchromism, with their cheerful denunciation of everyone but themselves. But the target had changed. A modernist tactic was being used to challenge the dominance of French modern art.

Thanks to Craven, Benton began to achieve fame as a champion of American values, although he did so at the expense of the reputation as a leading American modernist that he had gradually arduously built up over the course of the teens and early 1920s. Moreover, Craven's savage invective against other artists created a long string of lingering animosities. While Craven denounced anti-Semitism as a bourgeois vice, many believed that his attacks on Stieglitz were anti-Semitic and that Benton was at least partly responsible. Around this time, many of Benton's more thoughtful defenders, such as Lewis Mumford, withdrew their support.

Craven, however, played no role in the curious set of circumstances that launched Benton's reputation as the most famous American artist of his time. Two figures played a role in this: Maynard Walker, an art dealer, and Henry Luce, the publisher of *Time* magazine.

The man who dreamed up Regionalism was Maynard Walker, who had grown up in the Midwest, in Garnett, Kansas, and who joined Fred Price as a partner at the Ferargil Galleries in the early 1930s. Given Benton's well-known homophobia, and the fact that Regionalism was always promoted as an antidote to effete European styles, it's rather ironic that Walker was a homosexual, as I learned from an interview with the painter Vincent Campanella, whom he once tried to seduce. In 1933 Walker organized an exhibition of thirty-five American paintings from the gallery at the Kansas City Art Institute. It was titled "American Painting Since Whistler," but in his statements about the show, Walker focused on three painters from the Midwest—Benton, John Steuart Curry, and Grant Wood. Walker seems to have devised this scheme in the hope that people in the Midwest could be cajoled into buying the work of native sons. In this hope he was disappointed, for midwesterners generally viewed the work of Benton, Wood, and Curry as vicious satire, and Walker sold nothing from his exhibition. But his sales pitch had a result he could not have anticipated. In 1934 improvements in color printing made it possible for *Time* magazine to illustrate an inside story with color. Henry Luce began looking for an art story for the Christmas Eve issue, and after a chat with Maynard Walker he decided to focus on

this new group of painters from the Midwest. The result was the story "The U. S. Scene," written by Alexander Eliot, which appeared on December 24, 1934, and circulated to half a million Americans. Benton's self-portrait was featured on the cover, the first time that such treatment had been awarded to an artist, and Benton, Wood, and Curry were presented as the new heroes of American art.

Benton, Curry, and Wood all accepted their newly created roles, posing for photographers in farmers' overalls and doing what they could to live up to their image of wholesome midwesterners. Almost by accident they established a new promotional strategy for American artists—that of bypassing art critics, museum curators, and art dealers and boosting their work directly through stories in the popular press. Indeed, Grant Wood, the most isolated of the Regionalist trio of Benton, Curry, and Wood, became nationally famous at a point in his career when he had yet to be picked up by a dealer and had hardly shown his work outside of Iowa. In significant ways, however, this new fame pushed the Regionalist trio into compromising some of the key features of their art.

Before the *Time* story, the art of Benton, Curry, and Wood was generally viewed as satirical, in a manner similar to the novels of Sinclair Lewis or the short stories of Sherwood Anderson. After it appeared, they all came to be viewed as champions of American values, and the complexity and subtlety of their art was no longer recognized. In some cases, this persona associated with Benton has led writers to describe his work in a manner completely at variance with visual fact. For example, Benton's farm scenes have often been described as idealized, when in fact they vividly portray the hardships of life during the Depression.

Finally, the emphasis of the *Time* story and Maynard Walker's propaganda led Benton and Curry to feel that they should disassociate themselves from New York and urban life and become true midwesterners. Before 1934 Benton concentrated equally on urban and rural subject matter. Indeed, in *America Today* his view of rural life and the West is generally more pessimistic than his view of urban New York. After the story in *Time*, however, Benton came increasingly to concentrate on rural subject matter and increasingly to focus on one region, that of rural Arkansas and Missouri. In 1935, during a lecture tour of the Midwest, Benton received two tempting offers from his home state of Missouri: a contract to paint a mural for the state capitol and an invitation to become

head of the painting department at the Kansas City Art Institute. Life in New York had become increasingly unpleasant because of the jealousy of other artists and the controversy over his Whitney mural. Consequently, he accepted both offers. In the spring of 1935, with Pollock's help, Tom and Rita packed their belongings into a truck and left New York. Jack and his brother Sande moved into their former apartment on Eighth Street.

15

Jack Falls Apart

With Benton gone, Jackson once again began to behave strangely, drinking too much, totaling his car, and getting in fights. When he didn't come home at night, his friends and Sande would often go look for him in the bars on Thirteenth Street, Fourteenth Street, and Sixth Avenue and drag him home. Sometimes they found him lying on the sidewalk or the street. In January 1937 Sande decided that Jackson was "mentally sick" and should see a psychiatrist. As he wrote to Charles, "Troubles such as his are very deep-rooted, in childhood usually, and it takes a long while to get them ironed out."

In 1938 Pollock visited the Bentons on Martha's Vineyard for the last time, and it was on this visit that his problems with alcohol first came to their attention. After getting off the ferry, Pollock purchased a bottle of gin. He seems to have intended this as a gift to the Bentons but could not resist taking a few sips, then taking a few more. When he had downed the entire bottle, he drunkenly climbed on a bicycle and wobbled down the street, shouting and chasing girls. Eventually he became too drunk to keep his balance and fell in the street, scraping his hands and knees. At this point the police picked him up and locked him in a jail cell overnight. There Tom, Rita and their son, T. P., picked him up the next morning. No charges were filed, and Benton seems to have regarded the episode as quite humorous. Once at the Bentons', Pollock seems to have done no more drinking. During this visit, Pollock made a number of

paintings, including a little oval picture of T. P's sailboat that he gave to Tom's visiting nephew.

In December 1938 Benton came to New York to receive an award and commission from the Limited Editions Club, and at a reunion of the Harmonica Rascals in the Eighth Street apartment he invited Jackson, Sande, and Manuel Tolegian to come visit in Kansas City over Christmas. Sande eventually dropped out, as did Tolegian, whose car was supposed to provide the transportation. Consequently, Pollock came alone, riding the bus for thirty-eight hours to get to Kansas City. During the stay, at Rita's urging, Pollock painted four small winter landscapes, which Rita sold and which paid for his bus fare home.

What happened during this visit is not very clear, although we know that Pollock drank very, very heavily in a way he had never done around the Bentons before. "He began escaping with alcohol quite early," Benton later wrote, "though my wife and I did not recognize this as a disease until he visited us in Kansas City." During a party on New Year's Eve, Pollock got very drunk and blockaded the painter Fred Shane in a bathroom. Shane escaped by taking the hinges off the door. At some point during the visit, probably a little later, Pollock stayed out all night and returned the next morning in a seriously wasted state. Rita took him to a doctor who confirmed that his alcoholism had become a disease. They had apparently already picked up some stories to this effect. As Benton later wrote:

> Although in our company Jack was quiet and reticent, rumors would occasionally reach us that he was not always so. Tales, emanating from student parties in New York, revealed a quite different person. Give him sufficient alcohol, it was said, and he became loud, boisterous, combative, and sometimes completely unmanageable.

In addition to drinking during this visit, Pollock is said to have proposed marriage to Rita Benton. At least this is the claim made by Steven Naifeh and Gregory White Smith in their biography of Pollock, apparently based on the statements of Lee Krasner. Their paragraph making this claim is worth looking at closely:

On the eve of his departure, made bold by liquor, he finally poured out to Rita the feelings that had been secreted in his imagination for so long. Seven years of forbidden longings and private looks, of envying her husband and caring for his child; seven years of watching her sunbathe nude on King's Beach or probe the bottom of the pond with her foot in search of clams, and finding one, throw her head back and shake with laughter; seven years of maternal affection and sexual enticement were crowded suddenly into a few brief moments of breathtaking openness. He told her that he loved her and that he always had, that she was his ideal woman, the only one he had ever loved. Then in a final spasm of fantasy, he asked her to marry her.

This is certainly floridly written. At the same time, the basic claim seems plausible. From statements he made on other occasions, we know that Pollock loved Rita and viewed her as the ideal woman. And Pollock was surely capable of making spur-of-the-moment marriage proposals, since he made one to Becky Tarwater after knowing her for a few days. Very likely, at some point in this visit he did indeed declare his love for Rita, and from what happened afterward it seems clear that she rejected him.

How much Benton knew about all this is not clear. But shortly before Pollock left Kansas City, apparently because he felt it would help Jack get a grip on things, Benton invited him to come along on a sketching trip that was scheduled to begin on May 28. This would have been the first time that Pollock accompanied Benton on one of these adventures.

Pollock never made the trip. By March and April, Pollock was drinking very heavily and often missing his deadlines to deliver paintings at the WPA. Perhaps for this reason, the WPA denied him permission to go on leave in May. Pollock's response was a four-day drinking binge. On June 9 he was formally dismissed from the project for "continued absence." Pollock responded by drinking even more. Clearly things were getting out of hand. On Monday, June 12, 1938, Sande drove him to the New York Hospital in White Plains, New York, known as the Bloomingdale Asylum, to begin treatment.

The Bentons followed this decline from a distance, and in letters from Kansas City they expressed their deep concern. Benton supplied a bit of "tough love," declaring, "I am very strongly for you as an artist," but then adding, "You're a damned fool if you don't cut out the monkey business and get to work." Rita followed up with some words of affection: "I was worried about you for 4 months, and can't tell you how relieved I was to hear from you. We all hope & pray that you settle down & work—& we mean *work hard paint hard*—so few have the ability to say something thru their work—You have—Tom & I and many others believe in you." Pollock's stay in Bloomingdale marks a major juncture, a turning point in his life. From this point onward he and those around him recognized that his drinking and unhappiness represented some sort of illness. The rest of Pollock's life would be devoted to trying to identify the true nature of this illness and find a cure.

Bloomingdale Asylum, 1938

Treatment at Bloomingdale started with simple rest and nutrition, followed up with occupational therapy and counseling, largely focused on building up self-esteem. Jackson was treated by James Hardin Wall, a specialist in the newly established discipline of alcoholism and its treatment. Today alcoholism is recognized as a disease that has a large genetic and biochemical component, but Wall approached it from a different standpoint. A confirmed Freudian, Wall believed that unhealthy family dynamics were the fundamental trigger for alcoholism. Pollock fell perfectly into the pattern that he believed was characteristic of alcoholics: he had an overpowering mother, who was "the spoiling, pampering and protective type of mother," while the father took no part in disciplining his offspring and in fact deserted the family when the children were young. Indeed, Jackson's father perfectly fit Wall's paradigm of "a weak individual who set a poor pattern for his son to follow." In Wall's view, alcoholics were fundamentally afraid of women as a result of having been overpowered by their mothers. Drinking served as a substitute for sexual prowess.

In later years Wall recalled Pollock as "a lovely person" and "an intelligent and cooperative patient" and noted that he "made real progress fairly soon." Pollock was released after just three and a half months,

having promised never to drink again. Nonetheless, despite his seemingly positive response during his sessions with Wall, Pollock started going on binges within days of his release.

The Bloomingdale episode marks a major turning point not only in Pollock's emotional life but in his artistic growth as well, for it was at exactly this point that Pollock finally mastered Benton's drawing techniques and started to move away from and beyond them. Benton often repeated the comment that Pollock never learned to draw, and through most of the period when he worked with Benton this seems to have been the case. But two fascinating sketchbooks, now in the Metropolitan Museum of Art, belie this assertion. Executed with colored pencils, they are filled with copies of old master paintings, analyzing their compositions according to Benton's methods and exploring the work of exactly those masters whom Benton advised his students to study most closely: Signorelli, Michelangelo, Tintoretto, Rubens, and particularly El Greco. The analytic procedure, with its careful analysis of surface lines, of cubic volumes, and of patterns of light and shade, precisely follows Benton's directives: on one sheet, Pollock even sketched a vertical pole with circling arrows that closely resembles one of the diagrams in Benton's articles on abstract composition. Pollock clearly made the drawings from black-and-white illustrations in books. Katherine Baetjer at the Metropolitan Museum has identified the very monographs that he consulted. Significantly, the drawings are very accomplished, showing a confident grasp of anatomy and a wonderful sense of visual rhythm. Far from slavish, they often add elements not included in the reproductions, to strengthen the rhythm and enhance the qualities of a design. Circumstantial evidence makes it very likely that these drawings were made at Bloomingdale during Pollock's recovery there, for one of the drawings is a copy of the cover of *Life* for June 6, 1938, just a week before Pollock checked in; most likely Pollock based the drawing on a copy of the magazine that he picked up in the waiting room of the asylum. In short, by the time he enrolled at Bloomingdale, Pollock was a confident master of Benton's techniques.

But by this time, Pollock was also struggling to come up with some form of original expression that went beyond Benton's example. Not too surprisingly, he started with the work of Benton's friends. Pollock's major creation of this period was a ceramic bowl decorated with swirling

Over the course of the 1930s, Pollock learned to analyze old master paintings into cubic blocks and fluid linear patterns, in a fashion modeled on the work of his teacher, Benton. (Jackson Pollock, *Figure Studies,* from *Sketchbook I* [c. 1938], page 7, Metropolitan Museum of Art, New York.)

figures, which he titled *The Story of My Life*. To date scholars have failed to recognize the source for this piece, an illustrated book by Benton's colleague at the Kansas City Art Institute, Ross Braught. The choice of source sheds some light on Pollock's gradual move away from Benton, which began at this time.

Not many people outside of Kansas City have heard of Ross Braught: I first came upon the name when I worked at the Nelson-Atkins Museum of Art. On those evenings when I didn't leave until near midnight, I heard stories about him from the night guard, who had studied painting under him at the Kansas City Art Institute. A distinctly spooky figure, and a dead ringer for Boris Karloff, Braught generally wore a black suit with a black cape and startled the sober citizens of Kansas City by bringing a skeleton with him in the evenings on the streetcar, so that he could draw from it at home. Periodically he would disappear for months or years into some exotic locale, such as the jungles of Suriname or the Badlands of South Dakota, eventually reemerging with a rich trove of paintings and drawings. Many of Benton's students found Braught extremely strange. Jim Gantt, for example, complained that Braught paid no attention to such mundane things as anatomical knowledge or the use of chemically sound pigments. Instead, "he lived in imaginary landscapes that resemble a tub full of pig entrails or the human brain with the skull removed. It was different." But oddly, despite their very different temperaments—Benton was down-to-earth whereas Braught was a mystic and a visionary—Benton and Braught became good friends. It was common to see the two strolling together across the campus of the Kansas City Art Institute, lost in conversation about art.

Pollock's bowl was clearly based on a book illustrated with twenty-two lithographs by Braught, *Phaeton*, which was published in 1935 in Kansas City in an edition of one hundred, one of which Benton owned. The text, drawn from Joseph Addison's translation of Ovid's *Metamorphoses*, tells of Phaeton, who foolishly persuaded his father, Phoebus Apollo, to allow him to drive the horses of the sun. Unable to control them, he drove the sun chariot recklessly close to the earth, scorching the landscape, until Apollo, knowing no other way to halt the disaster, blasted him from the chariot with a thunderbolt. For Pollock the story served as a metaphor for reckless aspiration to scale the heavens and for catastrophic failure—in other words, a metaphor for his own lofty artistic

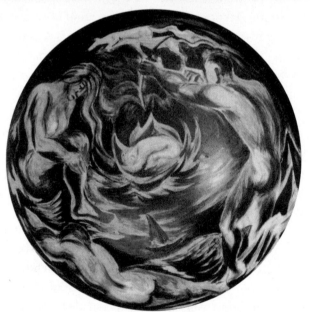

A group of lithographs (top left and right) by Ross Braught for the book *Phaeton* (1935) served as the inspiration for Jackson Pollock's 1939 *The Story of My Life* (bottom). (*Top: Nude Woman Beside a Tree* and *The Horses of the Sun*, printed by Emmet Ruddock, from *Phaeton* [Kansas City: Lowell Press, 1935]. *Bottom:* Jackson Pollock, *The Story of My Life*, enamel on Limoges porcelain bowl, c. 1939, 11 1/8 inches diameter, 5 inches depth, present collection unknown. Reproduced from *The Jackson Pollock Sketchbooks in the Metropolitan Museum of Art*, by Nan Rosenthal, Jackson Pollock, Katherine Baetjer, Lisa Mintz Messinger [New York: Metropolitan Museum of Art, 1997].)

ambitions and his failure to achieve them. More generally, perhaps, it served as a metaphor for the highs and lows of manic-depressive illness.

Pollock's bowl has three main groupings of figures:

1. On the right an archer is taking aim at a horse in the sky. This is clearly Apollo taking aim at Phaeton. (In Pollock's version of the myth he has a bow and arrow rather than a thunderbolt.)

2. On the left is the sorrowful figure of a crouching woman, who perhaps is giving birth to a baby in fetal position in the center of the bowl.

3. At the bottom of the design is a sleeping figure and a Ryder-like presentation of a boat on restless seas, very similar to Pollock's painting of T. P.'s boat on Menemsha Pond.

With the exception of the boat, all these images are quite similar to illustrations in Braught's book. Naifeh and Smith have described the bowl as "an impenetrable allegory," but in fact, once its source is identified, the meaning of the imagery is not hard to construe. Loosely speaking, it can be divided into three themes: the agony of birth, the voyage on pathless seas (which seems to be also a voyage into the unconscious mind of the sleeping figure), and, finally, Phaeton's attempt to drive the horses of the sun, only to be shot down by his father. Clearly Pollock identified his struggle to be a great artist with Phaeton's attempt to drive the horses of the sun. Like Phaeton, he had great aspirations but lacked skill. Consequently, he was shot down. Interestingly, the myth has oedipal themes, for in many versions of the story it is Apollo, the sun god, who shoots down his own son. Can we suppose that Benton was the archer whose arrow Pollock feared?

What clearly appealed to Pollock about Braught's work was a visionary quality, reminiscent of William Blake. Unlike Benton's, which seem rooted to the earth, Braught's figures are weightless, and he portrayed not the external world but that of inner feeling or the mysterious primordial state of chaos evoked in the opening passages of the poem. Notably also, in Braught's work objects always seem to be in a state of being transformed into something else: natural forms, whether rocks or trees and branches, often have a human or biomorphic quality, while human forms are strangely vaporous and cloud-like, even abstract. In short,

Pollock's shift from modeling his work on that of Benton to drawing on that of Braught marks the beginning of a shift away from Regionalist American subject matter toward myth and allegory and from the external world to that of myth and the unconscious. At the beginning of this shift, however, he drew on an artist, Ross Braught, who was close to Benton, both artistically and personally. In fact, during this period Benton also was flirting with allegory. In 1939, for example, Benton produced one of his most remarkable paintings, *Persephone*, in which he set a Greek myth in a midwestern setting, making the sensuous forms of the woman serve as metaphor for the richness and fecundity of the surrounding landscape. Somewhat precariously, his work and that of Pollock were still in tune. Over the next few years, however, Pollock's sense of harmony with Benton's goals would become increasingly tenuous, and he would move farther and farther from the kind of art that Benton made, or of which he in any way approved.

Without question, Pollock's greatest influence during this period of moving away from Benton was the work of Benton's friend Orozco. During his American sojourn, the art of Orozco had grown more mystical in its approach, in part due to his association with his paramour Alma Reed. Reed shared an apartment at 12 Fifth Avenue, looking out on Washington Square, with Eva Sikelianos, the daughter of an extremely wealthy New York philanthropist, Courtland Palmer. With her husband, the Greek poet Angelos Sikelianos, Eva had dedicated herself to the revival of the ancient Amphictyonic League, based in Delphi, which they envisaged as the first League of Nations. They aspired to gather together "the intellectuals, the great ones, the true elite of the earth in order that they might pool their genius for the advancement of mankind." With this end in mind, their apartment served as a gathering place for a picturesque group of idealists, from India, Greece, Mexico, and the Middle East, including poets, painters, educators, journalists, musicians, dancers, philosophers, actors, and religious teachers—figures such as the singer and poet Madame Sarojini Naidu, an important supporter of Gandhi, or the Syrian poet and artist Khalil Gibran, whose bestselling book *The Prophet* had already been translated into twenty-two languages.

Under the influence of such figures Orozco became a painter not simply of the Mexican revolution but of windswept visions of the spirit

of modern man. His work became less literal, more symbolic, with a mode of imagery that was increasingly mysterious, cryptic, and fragmentary. In one of his last murals, for example, the 1938 *Man of Fire* in Guadalajara, disembodied hands and heads swirl in the central dome, surrounded by floating representations of heart, liver, and other internal organs. In short, by the late 1930s Orozco's art had developed a mystical, inward-looking quality in tune with Pollock's artistic direction—more so than that of his principal teacher, Benton.

A number of scholars, notably Ellen Landau, have traced Pollock's extensive borrowings from Orozco during this period. Pollock's third extant sketchbook of the 1930s, probably dating from the last two years of the decade, contains eighteen well resolved, artistically ambitious colored pencil drawings, the majority of which are semi-abstract explorations of Orozco's Dartmouth mural, *Epic of American Civilization*, completed in 1934. Less literal than Orozco's earlier murals, the imagery at Dartmouth often suggests a kind of train of mental associations that eludes ordinary logic and draws in some way on the unconscious. Even for Orozco, the imagery is remarkably grisly. One scene of Aztec sacrifice shows masked priests tearing out the living heart of their captive victim. Perhaps the most memorable scene, *Still-born Education*, shows American educators as grinning skeletons in academic caps and gowns who tenderly deliver a dead embryo to its mother—a female skeleton prostrate over a rack of guns that turn into books. Although he had visited the mural, most likely Pollock was working from reproductions in a book or magazine. In his sketches he often turned one of Orozco's elements to a new orientation and then mixed it with other motifs. One page, for example, shows a three-dimensional cross lifted from Orozco's depiction of the triumphant, resurrected Christ, but turned. The other elements—Christ's legs, a skeleton, a figure brandishing a stick—can all be found in Orozco's mural, but in different configurations. Scenes of birth are not very common in Western art, though Pollock later represented this subject quite frequently. While his treatment was quite different, very likely Orozco's unforgettable rendering of *Still-born Education* played a role in inspiring him to take on this theme.

One of Pollock's most significant borrowings from Orozco, however, has not been noted. When Pollock arrived in New York, both Benton and Orozco were working on murals for the New School for Social Research.

To Orozco's bitter disappointment, his mural was not well received by the New York critics, but Benton admired it, and apparently Pollock did as well. The central panel of Orozco's design showed a "table of brotherhood," around which figures of different races were seated. Edward Alden Jewell of the *New York Times* found this scene particularly dismal and noted that the "unhappy beings" seated together looked "as if they were sorry any such notion as universal brotherhood had ever been hatched." Pollock, on the other hand, was clearly mesmerized by the visual daring of Orozco's design, in which a bizarrely foreshortened table boldly fills up the whole central portion of the composition. One of the themes to which Pollock repeatedly returned is that of a table in the center of the design, so foreshortened that it reads as a flat rectangle, flanked by figures. Orozco's mural was surely the major inspiration for this idea.

Pollock must have immediately sensed that two things about Orozco's design were visually exciting: first, making a table read as a flat rectangle, and second, making the center of the design essentially empty, with the dramatic energy of the painting concentrated on either side. In an interesting instance of a visual device suggesting a narrative theme, Pollock clearly recognized that Orozco's design could be turned to new uses, and that such a divided composition could be employed not to signify brotherhood but to become some sort of metaphor for the emotional divisions within a family or even for the divided self.

Significantly, during this period Orozco's emphasis on anguish and his almost cartoon-like exaggeration often come close to the expressionistic work of Picasso during the 1930s, with its emphasis on weeping women, mangled horses, and the horrors of war. In fact, it's clear that Orozco served for Pollock as a kind of bridge to the work of the Spanish master. What's striking is how similar these borrowings from Orozco are to Pollock's just slightly later borrowings from Picasso, once he came under the influence of John Graham.

Part Eight

Breaking the Ice

The art world works at many levels. Most of them are not publicly acknowledged.

—*Jasper Johns*

A Museum for Modern Art

When Benton left New York, Pollock's persona and approach to art went through a fundamental shift, at once a breakdown and a re-formation. While he always retained some of Benton's macho qualities, he ceased to dress and act in a way that resembled a hillbilly in a Broadway musical with boots and cowboy hat. Instead, he adopted a less regional, all-American look, more in the abrasive, alienated mode of actors like Marlon Brando or James Dean, with T-shirt, jeans, a scowl, and the brooding aura of a rebel without a cause. He also shifted his artistic alignments, from Regionalism to modernism, in a sense traversing Benton's pathway but in reverse, in a direction that brought him back to many of the abstract tenets of Synchromism. This was partly a personal journey but also an instinctive response to changes in the New York art world. For precisely during the period of Pollock's breakdown, the New York art world was undergoing a fundamental shift. Pollock was one of the first artists to respond to this fact, to recognize that the rules of the art game had changed. "There's no doubt," Gerome Kamrowski has commented, "that Jackson had a sense of where his career should go. He joined Benton when Benton's star was on the rise, then jumped to Picasso when Benton began to fade."

While the 1930s is often viewed as a decade hostile to modern art, that judgment oversimplifies the actual situation, for it was also the decade during which modern art first achieved a solid foothold on American soil. This came about not through an artistic movement but through

the creation of a museum, the Museum of Modern Art (MOMA), the first museum of its type in the world, which opened in 1929. In a surprisingly short time this new institution fundamentally transformed not only public attitudes toward viewing modern art but the whole process of art-making in the United States.

Alfred Barr Jr., the first director of MOMA and the chief figure in shaping its character, grew up in Baltimore, where his father was the minister of the First Presbyterian Church. From an early age, Barr had the natural instincts of a cataloguer. His chief interest as a child was paleontology and evolution. He collected leaves, fossils, and butterflies, which he carefully organized to demonstrate the morphology of their development. He began to shift his interest from fossils to art when, as a prize for outstanding academic achievement, his Latin and Greek teacher gave him a copy of Henry Adams's *Mont-Saint-Michel and Chartres*. What fascinated Barr in Adams's book was the idea that art expressed the spirit of an age and that one might trace the evolution of art in a fashion similar to that of fossils. Perhaps what Adams did for the Middle Ages could be done for modern times as well.

After graduating from Princeton, Barr went on to study art history at Harvard, where his chief mentor was Paul Sachs, the first Jew to receive an appointment in art history at an American university. Sachs's most remarkable class was a course in "museum studies," the first such class ever offered in this country. Barr greatly impressed Sachs with his knowledge of contemporary painting and then went on to a teaching position at Wellesley, where he taught the first college class on modern art ever offered in the United States. In short, Barr had made quite an impression on Sachs by the time that three New York society ladies contacted him for advice about a new museum of living art they hoped to form.

The person who first came up with this idea was Abby Aldrich Rockefeller, wife of John D. Jr., the heir to America's largest fortune. As a tribe, the Rockefellers were famously stiff and austere, and not much interested in art. They preferred to focus on prayers and rapacious business activities. To the extent that John Jr. indulged in collecting, his taste veered toward things that were rather lugubrious, such as Gothic tapestries. Abby has been described as "a much-needed ray of sunshine" in this ménage, and she liked art that was cheerful—folk art (she founded a

folk art museum at Colonial Williamsburg), for instance, or vibrant canvases by living painters, such as Arthur Davies, who made good company at a party. She clearly thought that a museum of modern art would inject an element of fun into her life. As partners in her enterprise, Abby enlisted two of her friends, Lillie Bliss, a wealthy art collector and gardener, whose great estate Dumbarton Oaks now belongs to Harvard, and Mary Sullivan, the wife of a prominent New York attorney. Once this core of founders was in place, all that was needed was a director. For this the ladies turned to Harvard, and to Harvard's expert on art museums, Paul Sachs. Sachs told them to interview Alfred Barr.

The ladies did so and were impressed by Barr's wide-ranging knowledge of modern art, but they were concerned about his youth and unimpressive appearance (he was only twenty-seven years old). At the time, Barr had never administrated anything and had never worked in a museum. They went back to Paul Sachs to ask whether there was anyone else they could consider, someone a bit more commanding, a bit more experienced, a bit more mature. Sachs assured them that there wasn't, that Barr's knowledge of modern art and passion for the subject were unique. After hesitating a moment, they took his advice and made the hire.

It was to prove an inspired decision. Barr became not simply a good museum director but a figure who transformed American culture. He has often been termed the greatest museum director in human history. Unlike his major American predecessor in promoting modern art, the art dealer Alfred Stieglitz, who operated on a shoestring, in a tiny space, Barr benefited from lavish funding provided by the Rockefellers and other immensely wealthy American families. Since there was surprisingly little competition from other museums, many of which were specifically prohibited from acquiring work by living artists, in the space of a few decades he was able to put together the finest collection of modern art in the world.

Earlier American museums had been conservative and largely static; Barr conceived an enterprise that would thrive on provocation and controversy. In essence, Barr used the strategy that Whistler and others had devised for the modern artist in the mid-nineteenth century, namely, to use scandal and negative publicity as a marketing tool. While artists had used such strategies before, no museum had done so. Many of those who

attended shows at the Museum of Modern Art disliked and even ridiculed what they saw. But the displays also won converts, and the controversies between converts and skeptics made the museum a lively place, a centerpiece of cultural excitement and debate.

Unlike any museum director today, Barr essentially functioned as chief curator, playing a key role in every purchase and not simply conceiving but fussing over the details of every major exhibition. Earlier American writers on modern art, such as Albert Barnes or Katherine Dreier, focused on its expressive qualities. Barr, on the other hand, was obsessed by the task of organizing the history of modern art into a scheme of sequential movements and styles. In his writings he included diagrams of these evolutions that were often quite complex, with bubbles of different shapes and sizes and arrows pointing in different directions. But in his museum he was forced to organize the history of modern art in a fashion that was much simpler than that proposed in his books. Since his rooms proceeded in a line, he devised a scheme that moved forward in a strictly linear sequence.

Barr was committed to a museum that would always stay modern, so his scheme introduced the need to find new artists to extend the line that had been created so far. There was always an empty room at the end of the line waiting to be filled, always a new movement in art waiting to be invented. By the time the museum moved into an impressive new building in 1939, this had created an obvious opening for young American artists. In essence, Barr provided American artists with a place in history that they needed to fill. While Pollock is often viewed as an outcast, a rebel, his emergence as a major modern painter precisely coincided with the emergence of the Museum of Modern Art as a major institution. And he made the shift from being a Regionalist to being a modernist just at the time that the Museum of Modern Art opened its new building in 1939.

17

The Man with Many Lives

Pollock's development at this point is usually charted through a progression of styles, as he progressively mastered the idioms of Picasso, Miró, the Surrealists, and others. While useful in some ways, such an approach also runs the risk of turning his art into a sort of dictionary of artistic influences without grasping his underlying motives in emotional terms. To understand more profoundly what was going on, it is probably even more instructive to look at the figures who served as mentors, guides, or helpers at this phase of his life. Pollock was never much of a reader or even much of an intellectual in the normal sense. His mode of absorbing things came about not so much through reasoning as through an intuitive process of picking up vibrations from the people who surrounded him. His artistic style was largely pulled from them, and when we look at his development in this light we can often see beyond the surface traits of his paintings and grasp deeper expressive principles.

Pollock's analyst Joseph Henderson once commented: "Basically uneducated, he took in a lot and his intuition was highly developed . . . His imagination was turning over ninety miles a minute." Henderson's successor, Dr. Violet de Laszlo, commented that Pollock was "highly intelligent, much more so than he appeared, but it was all intuitive. His inability to express ideas went both ways—he couldn't absorb words and he couldn't use them, but he picked up the subtlest nonverbal signals."

The figure who pulled Pollock away from Benton's orbit, and enabled him to integrate the themes of Jung, Mexican mural painting,

John Graham played a central role in pulling Pollock away from Benton's orbit toward Picasso, Jung, and other modern influences. (Photographer unknown. John Graham papers, Archives of American Art, Washington, D.C.)

primitive art, and Picasso, was one of the strangest and most amazing characters of this period, John Graham. Like Benton, Graham was not simply a painter but a theorist. His ideas about the meaning of modern art enabled Pollock to take what he had learned from Benton and push it in a new and surprising direction. Interestingly, Pollock sought out Graham rather than the other way around. After coming upon Graham's article "Primitive Art and Picasso," Pollock arranged to visit his studio, and the two immediately formed a mutual admiration society. Graham became an enthusiastic promoter of Pollock, who got his work into exhibitions and put him in contact with other artists. Equally significant, to a degree that has still not been fully appreciated, Graham schooled Pollock in the art of making a modern painting.

The adjective "amazing" hardly does justice to Graham. One gets an interesting picture both of Graham's charm and of his strangeness from the account of one of his last girlfriends, Isabelle Colin Dufresne—later to become one of Andy Warhol's superstars, Ultra Violet. She had gone to an opening at the newly created Leo Castelli Gallery, and they met in the elevator. He was seventy-one, she was twenty-two, and he struck her as "a diabolical-looking man" with "a shaved head, a Cossack mustache, and pointed ears." His eyes were piercing, and the electricity was instantaneous. Although she was on her way up and he was on the way down, Graham reversed course and escorted her to the show and through it, with eager explanations. He then invited her to drop by his basement

lair. The place was dazzling, with works of art scattered around everywhere: Greek statues, a bronze horse that he said was by Donatello, precious and semiprecious jewelry, magic wands, crystal balls, and enough Egyptian artifacts to fill a tomb. She later learned that he had file cards on each, with the provenance and history of every object. The walls were covered with mirrors of all shapes and sizes, from different countries and centuries; convex, concave, unframed, framed in gold and framed with ornate carvings. "Of all objects, mirrors have the best memory," he told her.

They conversed mostly in French (she was from a conservative and aristocratic French family), although it quickly became apparent that Graham knew, or claimed to know, about twenty languages, including Aramaic. At some point Graham began kissing her feet, and this progressed into making love. She had intended to stay an hour or so but ended up staying two weeks; and thus was initiated an intense off-again on-again relationship, with many stormy breakups and contrite reconciliations, which lasted for two years, until Graham's death from leukemia in a London hospital in June of 1961.

This was the late John Graham. Who was the John Graham whom Pollock knew? The answer to this question is not easy, for John Graham was strangely chameleon-like, a figure of many guises and contradictions. When Ultra Violet met Graham, he was producing strange portraits of cross-eyed women covered with wounds and had passionately turned against modern art. But when Pollock knew him, he was its enthusiastic advocate. No one has ever compiled a fully trustworthy biography of Graham (though the late Eleanor Green has established the main outlines of his life), since no one has ever been able to separate actual fact from the wonderful legends he created around himself. Even in a dry summary—for secure facts are hard to come by—Graham's life story provides a dizzying succession of abrupt changes of places and personal relationships, and of continual reinventions of his personality. By the time Pollock met him, he had already lived in five or six different countries, changed his name half a dozen times, shifted his artistic and political allegiances as often as he moved, gone through three marriages and many other affairs, and sired at least six children (with all of whom he had largely lost contact), four from former wives, two from hastier liaisons.

John Graham, of course, was not his real name: it was a creation. He was originally named Ivan Dambrowski, and his birth certificate establishes that he was born in January 1887 in Warsaw, Poland, which made him six years younger than the age he usually claimed and the one reported in his obituaries. His father was a bureaucrat and landholder. While Polish by background, he generally described himself as Russian and seems to have grown up largely in Kiev in the Ukraine. He was baptized in Kiev in 1891; he graduated from the University of Kiev in 1909; and he received a law degree from the University of St. Vladimir in Kiev in 1913.

In 1915 he attended the Nicolaiev Cavalry Institute in Petrograd and became a commissioned officer in the Russian army. It was presumably at this time that he began to acquire his remarkable riding skills and knowledge of horses; a year before his death, for example, when riding in the Bois de Bologne, Graham startled his son David by first standing up on his saddle while at full gallop and then doing a series of somersaults and turns. In 1916 Graham fought with the Russian army in Archduke Nicholas's "Wild Brigade" against the Bolsheviks, and he was decorated for his valor with the Cross of St. George at least once—according to some of Graham's accounts, decorated three times. At dinner parties, later in life, Graham liked to act out the technique he allegedly employed for decapitating people while riding at full gallop.

Graham's first marriage took place in 1912 at the age of twenty-five, when he was living in Petrograd, and resulted in two children. In 1918, however, he married a young woman of twenty-three, Vera Aleksandrovna, apparently without bothering to divorce his first wife. The marriage took place in Moscow. Two years later, apparently for political reasons, Graham left Russia with his new bride and hastily fled to the United States. On arriving in America, he changed his name from Ivan Dambrowski to John Graham. He later asserted that this was because his mother's name looked like "Graham" when written in Russian. In fact, the name seems to have been inspired by his father's first name, Gratian, which does indeed look like "Graham" when written in a mixture of upper- and lowercase Cyrillic letters.

Shortly after their arrival in America, the Grahams were hired by a wealthy Long Islander, Samuel Thorne Jr., who employed Vera as a governess and Graham as a riding instructor. Graham's place in this arrange-

ment, however, did not last long. Thorne and Vera began an affair: they eventually married, and Thorne adopted Vera's son by Graham. Consequently, Graham moved out, supporting himself by taking a job at the New York Public Library.

In December 1922 Graham began taking classes at the Art Students League. He soon began courting one of his fellow students, Elinor Gibson, whom he married in 1924. The marriage ended in 1934 because of an affair Graham had had with an undergraduate at Wells College in Aurora, New York, where he had been teaching. In 1936 he married for a third time to Constance Wellman, a secretary at *Vanity Fair*, whom he described in a letter of this time as "a Park Ave girl, 21 years old." The two had separated by 1942, and in 1945 Constance received a Nevada divorce from Graham on the basis of "extreme cruelty, mental in nature." During this period, Graham later confessed that he also had two illegitimate sons, both the result of short-lived relationships, one in Mexico and the other in France.

While his actual biography was remarkable, Graham was never willing to be confined to its real facts. Throughout his life, in ever-changing ways, he invented amazing fables about himself. For any reasonably intelligent person, it was not hard to figure out that much of what he said was not trustworthy. There were too many discrepancies from one telling to another, too many chronological and factual inconsistencies. Moreover, some of the events were clearly preposterous, such as Graham's claim that he was sired by Jove in the guise of an eagle, or that his parents discovered him as a newborn baby, planted on a rock in the Black Sea, and then adopted him. As Graham's biographer Eleanor Green has noted, John Graham was an "invented person"—a person whose personality was invented for the occasion.

Nonetheless, some of Graham's stories were given wide credence and have been credulously repeated in most narratives of the American art world in this period. When Pollock knew him, Graham enjoyed a legendary reputation as a link between the great avant-garde French painters such as Pablo Picasso and the young American ones such as Jackson Pollock and Willem de Kooning. Graham claimed to have had an active career in the French art world before he came to America, and throughout the 1930s he related colorful anecdotes of his interaction in Paris not only with all the major modern painters but also with major

French poets and writers such as Paul Eluard, André Breton, and André Gide, all of whom he claimed to have known intimately. In many cases he claimed to have played a key role at some critical juncture of their career. In general surveys of American art, in studies of modern painting, and in monographs on major painters of this period such as Pollock and de Kooning, these claims have been almost endlessly repeated.

Astonishingly, none of this was true. A variety of travel documents establish with certainty that Graham did not spend time in Paris when he left Russia but traveled directly from Germany to Holland and then took ship for the United States. It is quite likely that at the time that he first began spreading these stories he had never even visited Paris (although it is remotely possible that he did so early in life, in his high school or college years). Nonetheless, throughout the 1920s and 1930s Graham brazenly maintained his persona as a familiar of great French artists. On July 4, 1928, for example, Graham wrote from Paris to the collector Duncan Phillips in the United States reporting that he had just been invited to pay a visit to Picasso in his Paris studio. In actual fact, Picasso was in Dinard at the time. It clearly did not occur to Phillips that Graham would simply make up a story of this sort.

Graham was able to get away with his fictions largely because he came from a part of the world little known to Americans. Even when there were major factual and chronological discrepancies, his listeners did not have a fact base against which to gauge his fabulous stories of his wartime exploits, his encounters with Russian collectors of modern art, and his close friendship with members of the Russian royal family. In addition, Graham's linguistic skills opened up to him a world of fascinating information not available to most people. At various times he claimed to be fluent in nine, twelve, and twenty languages. This was surely an exaggeration, but he seems to have been fairly fluent in at least four—Russian, German, French, and English—and to have picked up a smattering of words and phrases from other tongues, such as Latin, Egyptian, or Aramaic, when they related to his interests. Graham used these foreign texts as the springboard for fancies and stories that he invented about himself, working in a fashion rather like a novelist, except that the fictional persona that he created was not a literary character but himself.

One of the things that we still do not know is when and where Graham learned to paint. He must have done something in Russia, but his

first documented artistic training started in December 1922, about two years after his arrival in the United States, when he enrolled at the Art Students League under John Sloan, for whom he later served as a class monitor. Few pieces survive from this period, although they already show exceptional skill, and he impressed his classmate Alexander Calder by the fact that he was ambidextrous and could draw with equal facility with either hand. By the time we have a substantial body of work to go on, that is, by around 1930, Graham had become an accomplished modernist, producing work that showed an informed awareness of the latest work of Picasso, as well as of other leading French artists. Presumably he learned about these painters from books and from the rare examples of their work that could be seen in America. Over the course of the 1920s he seems to have perfected his stories of his early career in Paris, so that by the 1930s they formed a wonderfully convincing persona.*

Since picture-making provided only a modest income, Graham largely supported himself through selling art and advising collectors in New York, and by the late 1930s this activity entailed frequent trips to Europe, particularly Paris, where he knew all the leading dealers. While his tastes ranged very freely, Graham's special expertise, and the source of most of his income, seems to have been in African art, a field that was new and daring at the time and where standards of taste were just being formed. The most notable of his clients was Frank Crowninshield, the editor of *Vanity Fair* (and a patron of Benton's friends Miguel Covarrubias and Ralph Barton), for whom he assembled a magnificent collection of African masks, totaling hundreds of pieces.

In addition to his artistic activities, Graham dabbled with Jungian theory, psychoanalysis, yoga (visitors sometimes encountered him standing on his head), and a variety of occult systems and healing practices.

* It is striking that during this period Graham formed a close friendship with another remarkable and pathetic fabulist who was also a gifted painter (far more gifted, in fact, than Graham)—an Armenian born to the name of Vosdanig Manoog Adoian, who presented himself as a Russian, Arshile Gorky, the cousin of the famous writer Maxim Gorky. Arshile Gorky not only lied about his name and nationality but gave an incorrect immigration date to lend credence to his claim to have studied with Wassily Kandinsky in Russia from 1920 to 1922. Even Gorky's love life was based on fabrications: he copied his love letters verbatim from H. S. Ede's biography of the modernist sculptor Henri Gaudier-Brzeska. As in the case of Graham, Gorky's obituaries were largely devoted to the myths that he had created about himself. "Gorky's experiences away from the easel were all made up," his biographer Harry Rand has noted.

By the early 1940s he had entered analysis himself, although we do not know the name of his doctor or doctors, and in one of his letters he boasted that he himself practiced psychoanalysis.

Not long after meeting Graham, Pollock began Jungian analysis with Joseph Henderson, and this helped cement the friendship. Graham was also a Jungian, and his ideas harmonized with the theories that Henderson expounded. What was new about Graham, however, was that whereas Henderson thought in terms of verbal concepts and gave long-winded verbal explanations, Graham thought viscerally in terms of magic-laden works of art. For Pollock, Graham's teachings showed how to translate Jungian therapy into art-making. Or to put this in another way, Graham gave art a magical aura, since he proposed that great art was a road to healing.

Graham's Theory of Art

What Pollock learned from Graham is largely distilled in Graham's "Primitive Art and Picasso" the article that led Pollock to seek out his acquaintance. While Pollock was not much of a reader, the piece is only three pages long, so he surely was able to absorb it, and of course its lessons must have been reinforced by his extensive conversations with Graham. What's more, it is clear that Pollock looked carefully at the illustrations, for he made paintings based on every one of the objects and paintings reproduced in the article. In fact, it's useful to regard Graham's provocative essay as a sort of how-to-do-it manual that showed Pollock how to move from Regionalism to modern art.

Essentially, the article makes two arguments—both of them intellectually shaky but creatively stimulating. First, it asserts that primitive art is based on a direct connection with the unconscious and thus, unlike most later art, directly connects with the wellsprings of human knowledge and feeling. Second, it maintains that a few modern artists, most notably Picasso, in large part through their interest in primitive art, have also connected with the unconscious and created art of extraordinary artistic power.

For Graham, the power of reasoning was "essentially a limited power." The highest power that humanity has developed is "the power of vision, divination, evocation, revelation, *power unlimited*, power procreative,

power advancing directly from point to point without the tedious proce-
dure of logical argumentation, the power of the unconscious organized."
As he wrote:

> Primitive races and primitive genius have readier access to their un-
> conscious mind than so-called civilized people. It should be under-
> stood that the unconscious mind is the creative fact and the source
> and the storehouse of power and of all knowledge, past and future.
> The conscious mind is but a critical factor and clearing house.

Very significantly, Graham proposed a rather simple mode of gain-
ing access to this world of intuitive, magical thinking. A notion of great
significance for Pollock, for example, was Graham's contention that chil-
dren lose contact with their unconscious at age seven.

> Most people lose access to their unconscious at about the age of
> seven. By this age all repression, ancestral and individual, has been
> established and free access to the source of all power has been
> closed. This closure is sometimes temporarily relaxed by such expe-
> dients as danger or nervous strain, alcohol, insanity, and inspira-
> tion. Among primitive people, children and geniuses, this free
> access to the power of the unconscious still exists in a greater or
> lesser degree.

For Pollock this claim seems to have been hugely influential. From
the practical standpoint, looking into one's archetypal Jungian uncon-
scious is not easy to do—there's too much rational thinking and con-
scious consciousness that filter it out. Graham proposed an easy way
around this problem. Just go back to memories that occurred before the
age of seven, and you can bypass the debilitating restrictions of adult
consciousness and go back to the magical, primordial unconscious mind
in its pure, uncontaminated aspect. Of course, one may well question
whether this is really true and whether memories of early childhood can
be equated with "the mythic unconscious" as described by Jung. Pollock,
however, clearly believed that this was the case, and it provided a work-
able way of generating images to put on canvas.

Unlike many individuals, whose memories blur together and who

cannot recall their age when a particular event occurred, Pollock was able to neatly distinguish the memories he had at different ages, since they happened at different places as his family moved. His earliest memories were those of the family farm in Phoenix, which he left when he was six, exactly the age at which, according to Graham's theories, he was losing touch with his unconscious. In other words, by going back to his memories of the Arizona farm, Pollock could achieve a connection with his Jungian unconscious.

One of the things that is striking about Pollock's art is the degree to which his major paintings seem to refer back to his memories of his childhood in Arizona. Pollock's biographers Steven Naifeh and Gregory White Smith have worked hard to identify the subjects of Pollock's major paintings, and while some of their conclusions are arguable, it is certainly striking how often Pollock's paintings seem to contain images that hark back to the period when he lived in Phoenix as a child of four or five: renderings of roosters, the family dinner table, the family dog Gyp, tea with a neighbor girl Evelyn Porter (with her dog Trixie looking on), and the landscape of the family farm. Significantly, this tendency to paint his memories predating the age of six seems to start precisely around the time when he was associating with Graham. In short, Graham provided Pollock not only with a style but with a set of artistic subjects and a method for generating them.

One of the most notable things about "the Primitive" as Graham conceived it was that, by drawing on the powers of "the Unconscious," it liberated the artist from the formal constraints of conventional picture-making and encouraged a play with form that was spontaneous, child-like, and endlessly inventive. As Graham wrote:

> Two formative factors apply to primitive art: first the degree of free-dom of access to one's unconscious mind in regard to observed phenomenon, and second, an understanding of the possibilities of the plain operating spaces.
>
> The first allows an imaginary journey into the primordial past for the purpose of bringing out some relevant information, the second permits a persistent and spontaneous exercise of design and composition as opposed to the deliberate, which is valueless.

Graham was particularly fascinated by the way in which primitive art contained visual puns, that is to say, forms that have multiple meanings. As he wrote:

> These capacities permit the artist to work freely within the pure form, shifting at will, assembling and disassembling the character-features of form. For example, in treating a face the artist assembles the features in order to bring out the character or plastic meaning of the face, grouping the eyes and nose close together in a poignant form or dispersing them or rearranging them at will in order to fit a preconceived composition.

Significantly, Graham did not merely describe this process but gave a specific example of it, a photograph of an Eskimo mask. Graham's caption to this illustration describes quite specifically the artist's technique:

> There is typical primitive insistence that nostril and eye are of the same origin and purpose. Two similar orifices seem to say, two eyes or two nostrils. It indicates a master artist's freedom of speech.

Significantly, around this time Pollock made a painting that explores exactly this idea, as if laying out the fundamental grammar of ambiguous forms. The painting *Head* (1938–42) is a collection of orifices that resemble eyes, mouth, nostrils, ears, or even sexual parts. They are loosely configured in the pattern of a face, with a mouth surmounted by a nose surmounted by two eyes, although the final effect is a bit strange, since there's an extra eye in the center of the forehead. But what's even more frightening is that everything seems to be on the verge of becoming something else; the mouth wants to become a nose or a vulva; the eyes are turning into beaked birds, and of course the birds have eyes, creating an image of an eye inside an eye. Pollock, in short, took Graham's description of the technique of the Eskimo mask and created a new image based on the same principle.

Notably, this same process of transformation is what Graham admired in the work of Picasso. During this period, Graham's admiration for Picasso knew no bounds. In 1937, in *System and Dialectics*, Graham

declared: "Picasso is so much greater than any painter of the present or the past times that it is probable he is also the greatest painter of the future. He has painted everything and better; he has exhausted all pictorial sources . . . Picasso is devastating, he picks out an object and discloses its actual reality, germination and destiny . . . Picasso drops a casual remark and a score of artists make a life's work of it." In fact, Graham's own work of this period consists largely of pastiches of Picasso.

According to Graham's interpretation, Picasso's power lay largely in his understanding of primitive art, which in turn gave him access to the powerful forces of the unconscious. As he wrote:

> Picasso's painting has the same ease of access to the unconscious as have primitive artists, plus a conscious intelligence . . . He delved into the deepest recesses of the Unconscious, where lies a full record of all past racial wisdom.

Indeed, Graham implied that Picasso's merit was even greater than that of primitive artists, since whereas their link with the unconscious was essentially childlike, Picasso combined the mind of a child with a more mature awareness. Again, Graham provided two illustrations by Picasso to illuminate what he was talking about, *Woman Seated in the Atelier* (1931), in which the head is two-dimensional with two or three eyes on one side of the face under one another, and *Woman at the Mirror* (1932), in which Picasso "uses arbitrary contortions of features in two-dimensional spatial arrangements."

Pollock's "John Graham Phase"

The fact that Pollock's paintings of this period deal with the theme of transformation makes it difficult to describe his imagery in a straightforward way, for one thing is always turning into something else. Men turn into women, dogs turn into bulls, images from Picasso turn into images drawn from primitive art, and so forth. If we use Graham's little article as a guide, however, it turns out that Pollock's paintings were the product of a surprisingly logical and relatively simple process. Essentially, he combined Picasso, primitive art, and Jung. Picasso and primitive art often become conflated with each other, and he drew from the "Jungian

unconscious" in two slightly different ways—on the one hand, using standard Jungian symbols, such as mandalas, which Jung himself had described in his writings, and on the other hand, creating images based on events that occurred before he was seven years old, when, according to Graham's somewhat idiosyncratic interpretation of Jung, his mind was still in its primitive, intuitive, creative, prerational phase.

Many of his major paintings of this period were based directly on the illustrations in Graham's article. For example, one of his most memorable paintings of this period, *Birth*, was produced by simply combining two of Graham's illustrations, Picasso's *Girl Before a Mirror* and the Eskimo mask. The general technique, with its bright colors, black outlines, and ovoid forms, is right out of Picasso's *Girl Before a Mirror*, although rather than forming breasts, belly, and buttocks, Pollock's circular forms are a pig-pile of anguished heads—all variations of the ambiguous Eskimo mask that Graham reproduced in his article. Notably, the idea of using such a primitive mask pays tribute to Picasso's most famous painting, *Les Demoiselles d'Avignon*, in which the faces of a group of prostitutes become savage masks from the jungles of Africa. Pollock substituted an Eskimo mask for an African one. It's obviously unlikely that Pollock remembered his own birth, but he surely knew from his mother that it had been a difficult one and that he had nearly strangled in his own umbilical cord. At some level he surely believed that this experience had traumatized him and that it was related in some way to his battles with depression. The painting can be seen as an attempt to capture this preconscious Jungian memory.

In *Guardians of the Secret*, Pollock similarly mixed Picasso, primitive art, and themes drawn from the Jungian unconscious. The flanking figures of male and female figures are a conflation of Picasso's figures in *Three Dancers* and the totemic figures of Navajo sand painting. The subject, the family dinner table, with male and female figures on either side and a dog underneath it, is drawn from his memories before age seven and thus expresses the Jungian unconscious, at least according to John Graham's theories.

If we look closely at another painting of this period, *The She-Wolf*, it turns out that the original concept must have been quite similar, although the final result is quite different. As in *Guardians of the Secret*, there's a rectangular form in the center of the painting, which must have

initially represented the family dinner table. But in the process of paint-ing, Pollock transformed the table into a dog—perhaps the dog Gyp—who then in turn became transformed into a much stranger creature: a composite of a bull with horns, reminiscent of many of Picasso's im-ages, and a She-Wolf like the one that suckled Romulus and Remus. Turning all this into a coherent narrative isn't easy, but the emotional message is not difficult to grasp. Both bull and wolf clearly symbolize the violent, brutish side of human nature. Evidently Pollock saw the family dinner table as a locus of violent (if suppressed) emotional conflict, saw the mother figure as wolf-like, and saw himself as an orphan suckled by a wolf.

In retrospect, Pollock's process of drawing so directly from the illus-trations in Graham's essays seems almost naively simple, but at the time to put these things together took an act of daring. While Picasso's work was starting to be talked about in New York, only a few American paint-ers were beginning to model their work on his. Those that did had not yet made the additional creative jump of drawing as well on primitive art and Jungian theory. In some ways it stands out as odd that Graham, who thought up much of Pollock's procedure, did not himself make paintings of this sort, but Graham was more of a talker and a proselytizer than a painter. While he did ultimately make a few paintings of this sort, they were made later than those of Pollock, were clearly modeled on Pollock's work, and were considerably less ambitious. Pollock's genius—if we choose to call it that—was simply that he went straight to the heart of the issue. He grasped the big issues of his moment and then expressed them with an almost childish directness. What is more, despite the obvi-ous combination of sources, Pollock's paintings have a visual rhythm quite distinct from that of Picasso or primitive art, a swirling, energized quality. In fact, what Pollock did, almost unconsciously, was to Benton-ize his sources—to start to reshape them as a pattern of swirling forces revolving around vertical poles.

One final aspect of Graham's influence should be noted—one that goes beyond the text of his article. In addition to his interest in psycho-analytic theory, Graham was a devotee of mystical practices, such as as-trology and numerology, as well as of learning obscure languages, such as Egyptian or Norse, that involved runes or hieroglyphs. Writing is at once one of the most direct ways of communicating meaning and one of

the most peculiar, for the letters of our alphabet, or any alphabet, are essentially arbitrary: while most forms of writing began as pictographs, they ultimately evolved into abstract signs whose meaning can be imposed at will.

Graham's interest in alphabets and symbols led him to evolve his own imaginary forms of symbolic writing. In this period Graham made paintings that are simply imaginary alphabets of letters or signs. In some cases they seem to have been based on astrological symbols, but in a way so free that they can't be reduced to any straightforward scheme of meaning. Graham was not unique in this interest, for other artists in this period, such as Adolph Gottlieb, made similar experiments. Notably, occult practices often involved not only a study of ancient scripts, such as runes or Egyptian hieroglyphs, but also techniques, such as the Ouija board, for drawing messages from the spirit world or the unconscious. Graham's paintings with "symbolic writing" seem to have combined these two ideas, since he seems to have used ancient scripts as a starting point but then altered them according to principles of free association.

Graham seems to have passed on this interest to Jackson Pollock, and in many of Pollock's paintings of this period, such as *Guardians of the Secret* or *Stenographic Figure*, passages of indecipherable writing or symbolic gestures run across the surface of the canvas. He seems to have liked this device not only because these symbols have a mysterious quality that hints at some deep esoteric meaning but also because they become a device for flattening the pictorial space and bringing the image up to the pictorial surface.

In short, Graham seems to have explicated to Jackson the idea of "automatic writing," that is, of gestures that were not rationally motivated but directed by the unconscious mind. A few years later, this interest would be reinforced by Jackson's contact with the Surrealists.

Women with Wounds

For Pollock his period with Graham marked a kind of prelude to far greater achievements as a painter. In fact, while the works he made in this period are quite good, at the time he broke off all his ties with Graham he had yet to produce a single drip painting, the work on which his popular fame rests today. With Graham it was the opposite. Right around

the time when Pollock began producing his greatest work, Graham went through another one of his turnabouts, rejecting modern art, repudiating the great New York artists he had discovered, such as Pollock, Arshile Gorky, de Kooning, and David Smith, and denouncing Picasso as a fraud.

At this point Graham began creating paintings that were consciously *retardataire*—enigmatic portraits of women in a Renaissance Revival style, often based on Renaissance paintings or on photographs. Graham added peculiar twists, however. The women are generally cross-eyed, which gives them a slightly demented appearance. Most disturbing, the women are often covered with wounds, which Graham seems to have added and erased as he worked on these images over a period of years. Describing one of his drawings, he noted that "on the left side of her neck is: a *wound*, not lips . . . I personally like many wounds on women." "I find cruelty has beauty," he declared in his last interview, for *Newsweek* in 1960.

Writers on Graham have been extremely evasive about the reasons for this fundamental shift in views, from America's foremost advocate of modern art, the first to make a link between Picasso and Pollock, to becoming the foe of modern art and Picasso, the painter of portraits of cross-eyed women, the master of esoteric knowledge and the occult. The clue, I think, lies less in tracing the logic of Graham's artistic theories than in noting that he also went through many other equally abrupt personality shifts, as he shifted from woman to woman, or from one political ideology to another—from czarist to Marxist, for example, and then back again. Most accounts of Graham stress his haughty assurance, his claims to occult knowledge or to being the son of Jupiter or to being the greatest painter in the world. But there was another side of his personality that was equally striking, a frequent retreat into lassitude, monasticism, and depression. At the point when one of his marriages was collapsing, for example, he retreated to a monastery in New York, where he lived with little food and no heat, with a bowl of snow sitting on his table. When visited, he seemed meek and hesitant. In other words, Graham's grandiose moods seem to have alternated with depressive ones—he seems to have gone through violent mood swings. It is curious that no writer on Graham has drawn what seems to be the obvious conclusion, namely, that Graham suffered from bipolar illness. No doubt

Graham learned to play up his grandiose statements as a way of getting attention and notoriety, but many of them were probably symptoms of a disease.

In fact, many of Graham's utterances have a quality of clinical paranoia. For example, consider the following statement, one of many similar examples that might be cited:

> I ask nothing of man, except an implicit obedience. When men criticize my work and attack me, I know how to answer in a most devastating way. When they are indifferent, I like it the best. But when they praise me, or my art, their insolent pretensions to be able to understand me make me furious, for they are trying to drag my work down to their level. And if they like it, it is always for the wrong reason.

What seems evident is that Graham suffered from an illness that sent him on a trajectory from charming brilliance, when creative ideas crowded in on him from every direction, to wild grandiosity, and then at some point from grandiosity to paranoia, which then turned downward into depression, and then, after a period of listlessness, on an upward trajectory again into another superheated and grandiose mood. The cycle repeated itself over and over again, and most likely there were cycles within cycles—a short monthly or bimonthly cycle of mood shifts and then a larger cycle measured in years. Many of Graham's personal peculiarities, such as his compulsive sexuality, could have been linked with manic depression, for sexual activity is a natural drug that counteracts depression. (Compulsively sexual people, who have dozens or even hundreds of sexual partners in a year, generally fall back to a more normal pattern if they take antidepressants.) Many of Graham's seemingly peculiar interests—psychoanalysis, yoga, the occult, tarot, astrology, and so forth—were connected in some way with the arts of healing or of prognostication. They were an attempt to stabilize his moods, or at least to predict and anticipate their strange pattern. Graham's sickness, in fact, was very similar to Pollock's, though lacking the element of alcoholism: both exhibited manic-depressive symptoms. This shared sickness (admittedly in somewhat different guises) was surely a major reason why they shared so many interests.

The Influence of Jung

One reason that Pollock was so receptive to Graham was that many of Graham's theories overlapped with those of Pollock's Jungian analyst. Oddly, it was through the Bentons, or at least through their circle of acquaintances, that he was pushed into the Jungian world.

Although Benton has often been accused of misogyny, two of his closest friends on Martha's Vineyard were a female couple, Carolyn Pratt and Helen Marot. Benton was most closely attached to Pratt, who was the principal of the City and Country School, which Benton's young son attended. In some utterly unself-conscious way, she and Benton had souls that were completely in tune. They both liked to talk a lot and battle for things. They even looked remarkably like each other: Pratt might have been Benton's twin, as one can see from Benton's likeness of her in his painting *City Activities*. Pratt's influence on Benton was considerable, an issue that deserves to be the topic of a full-scale study. Through her experience in teaching woodworking to small children, she had become interested in the role that play and toys perform in learning. She was the one who introduced Benton to Dewey's ideas of "learning through doing," and the toys she devised for children, modeled on the cars, trucks, ships, trains, and airplanes that supplied the modern city, surely provided one of the key sources of inspiration for Benton's landmark mural of *America Today*.

While Benton bonded most closely with Pratt, Pollock gravitated toward her companion, Helen Marot, a woman of utterly different carriage

and appearance—slender, fine-boned, and quite good-looking in a Kath-
arine Hepburn sort of way. The scion of a wealthy and progressive Phila-
delphia Quaker family, as a young woman Marot served as the secretary
of the Women's Trade Union League. She was the principal leader and
organizer of the first major strike by female workers in the United States,
the 1909–10 strike of shirtwaist makers and dressmakers. In the end, the
strike and the controversy that surrounded it had considerable influence
on changing the American workplace and bringing about social reform,
but it did not achieve its immediate goals. After many months of hard-
ship and sacrifice, the strikers were brutally defeated.

After the disappointing failure of that effort, Marot turned inward,
ceased to work for political causes, and pursued a course of self-study in
psychology and healing. While not a trained therapist, Marot became
intensely involved with stabilizing Pollock's emotional life from about
1935 to 1940, the troubled period after Benton left New York. Never one
to keep a regular schedule, he often appeared at her apartment late at
night, for long talks about his troubled emotional state. She on her part
became convinced that he was an artist of genius—she and Benton seem
to have been the first two people to use the word "genius" in relation to
Pollock's work. When Marot died suddenly and unexpectedly of heart
failure on June 3, 1940, Pollock was devastated and went on one of his
most intense drinking binges. Some scholars have suggested that Pol-
lock's *Portrait of H. M.* of 1945, which has been frequently viewed as a
tribute to Herman Melville, was actually a tribute to Marot. Quite likely
it is a tribute to both, and Pollock chose to use initials so that he could
symbolically merge the two figures.

Marot's own approach to psychology was influenced by nineteenth-
century writers on self-improvement and uplift, such as William James,
Sir Charles Scott Sherrington, and James Bryan Herrick. But she moved
freely in psychological circles in New York and had friends who were pi-
oneering followers of Carl Jung. Underlying her pronounced practical
ability were an interest in spirituality and a touch of mysticism.

It was Marot who steered Pollock into counseling with Dr. Joseph
Henderson, an analyst in his mid-thirties who was just starting his pro-
fessional career. Born in Elko, Nevada, where his family played a promi-
nent role in politics and business, Henderson had studied at Yale with
the novelist and playwright Thornton Wilder and then had moved to

Switzerland to study with and be analyzed by Jung. Henderson worked with Pollock for a year and a half and then moved to San Francisco, where he practiced as a therapist until the age of 102 and founded the C. G. Jung Institute. He died in December 2007 at the age of 104, when I was about midway through writing this book.

As it happens, an acquaintance of mine, the painter Stephanie Peek, attended a Jungian Society lecture on Pollock delivered by Henderson in the early 1960s, which took place in an old Victorian house in the Pacific Heights neighborhood of San Francisco, in a front parlor, which had been equipped with about thirty folding chairs. After talking about Pollock for a while, Henderson passed around a group of Pollock's drawings, un-framed and unmatted, for the audience to hold and examine. At the time, she was not very impressed with Pollock's drawings, which seemed crude, but something about Henderson's manner was so authentic and penetrat-ing that it inspired her to read through the entire body of Jung's work, in the collected edition of his writings published by Bollingen.

Jungian theory ignored the past and focused on the future: its goal was to forge a connection with the innermost self. Jung believed that the human mind contained archetypal symbols that were part of the "collec-tive unconscious"—that is, part of the universal inheritance of human-kind. In one's struggle to realize one's inner potential and to achieve "individuation," one should search for archetypes within the collective unconscious and raise them to conscious recognition. Jung conceived the collective unconscious as a kind of inner universe—as a realm of experi-ence that mirrored the structure of the cosmos as a whole, though it was structured in a peculiar layered fashion and was filled not with material facts but with evocative symbols.

Unlike Freudian psychologists, Henderson had no interest in exam-ining family history or sexual experience. For that matter, while Jung's ideas later inspired the creation of Alcoholics Anonymous (which was founded in Akron, Ohio, of all places), Henderson did not directly con-front Pollock's alcoholism. Instead, Henderson aspired to dig down to a still deeper level of experience: he believed that dreams and symbols could provide a point of connection with the archetypal wisdom of the unconscious and that connecting with them would provide psychic inte-gration. Since Pollock was appallingly nonverbal, it was difficult to get started. Pollock sat speechless, and the therapy was stalled until he began

bringing in drawings that Henderson would interpret for him. Each week, as Pollock sat with him, largely silent, Henderson interpreted the drawings for him, devising elaborate readings based on Jung's theories. Pollock then went home and made further drawings, inspired by the symbols and messages that Henderson had explained. Needless to say, the process was not pure. As Pollock became engaged in the process, his drawings began to reflect not only his unconscious feelings but also his desire to illustrate Jungian themes according to Henderson's interpretations and suggestions.

Pollock went through Jungian analysis with Henderson for eighteen months, or about seventy-two weeks, and during this period he produced sixty-nine drawings and one gouache—a total of eighty-three images, since thirteen sheets had drawings on both sides. The fact that the number of the drawings (sixty-nine) and the number of the weeks (seventy-two) is very close can hardly be coincidence, and this brings out a very significant point about this series that scholars have failed to note. The numbers strongly suggest that Pollock was bringing in his drawings at the rate of one a week, with little deviation from this schedule. Thus, the drawings form a regularly kept visual diary that records Pollock's artistic thinking over the course of a year and a half. Henderson explained that the process of bringing in drawings only started after several weeks of failed attempts at establishing verbal dialogue. Using the number of drawings as a benchmark, this suggests that they tried conversation for about three weeks and that from then on Pollock submitted drawings with perfect or near-perfect regularity, on a weekly basis. More research needs to be done to place these drawings in their correct chronological sequence. But if nothing else, the realization that these drawings are a sort of visual diary produced over an extended time period should encourage us to look at them with renewed interest. Pollock did not simply dash them off. Each one was the summation of a week's artistic effort and distilled feelings.*

* In *Jackson Pollock: "Psychoanalytic" Drawings* (1992), Claude Cenuschi has skillfully organized these drawings into a series of groupings of works that are closely related to each other, and are clearly close in time, based on their style and various forms of physical evidence. Cernuschi's overall sequence, however, moves from works that look like Picasso to works that look like Orozco, whereas it seems evident that during this period, for the most part, Pollock's work developed in the opposite direction. I think what threw

One of the most vexing questions about these drawings is how we should regard them: as documents of Pollock's therapy or as artistic statements. The fact that they are generally known as the "Psychoanalytic Drawings" has led them to be viewed as essentially therapeutic, as probings of the unconscious, but Dr. Henderson's statement about them suggests otherwise. As he wrote in a letter to one of Pollock's biographers, B. H. Friedman:

> It sounded as if I had set Pollock the task of portraying the unconscious in these drawings. This was not the case. He was already drawing them, and when I found it out, I asked for them.

What this would suggest is that this group of drawings should be viewed not as a special assignment but as a cross-section of the sort of work that Pollock was producing in this period. Of course, in practice, distinctions of this sort are never entirely simple, particularly given the strange dualism of Pollock's nature. Counterbalancing the drunken, rude, brutal side of Pollock was a very different personality: a pleaser hypersensitively responsive to the feelings of the people he was with. Some of the drawings illustrate Jungian concepts so clearly and literally that it seems evident that Pollock was simply responding to Henderson's directions or suggestions. Others look like they were inspired by artistic sources, such as the work of Picasso or Orozco. Overall what's striking is how these two goals became intertwined.

In a fashion that was creatively stimulating but far from systematic, Jung had provided an alphabet of symbols, alleged "archetypes" that could be combined to create sentence-like statements. The mandala represented psychic integration; the Chinese tao sign the union of opposites; the snake the unconscious; the pelvic base birth, sex, mother, or all three. Curved lines and rounded forms expressed a feminine impulse; straight and jagged lines a masculine one. Jung proposed that there were four major personality functions, intuition, thinking, feeling and sensation, and that they were symbolized respectively by the colors yellow, blue, red, and green.

him off is a large painting showing the influence of Orozco that Pollock gave to Henderson at the very end of their sessions, but which was surely made earlier. If we read Cernuschi's book from back to front it makes a more plausible chronological sequence.

Pollock seems to have quickly mastered elements of this language and to have made drawings that represented the personality he wished to have. To assert his masculinity, for example, he drew extremely angular figures and jumbles of jagged lines. Pollock's dilemma was one that he struggled with throughout his career. Images drawn from the unconscious don't seem to be clearly formed or visually arresting or to have the kind of pictorial organization that makes a memorable painting. The artist's challenge thus becomes finding images that have a rawness that seems to draw from wellsprings of primal feeling but that also possess some of the other qualities we expect in great works of art. To get the "art quality" he wanted, Pollock not only had to dig into his unconscious and his deepest feelings but had to borrow liberally from artistic sources. Essentially what Pollock did was to merge this system of archetypes and symbols with the artistic influences that he was struggling to absorb, such as the work of Orozco and Picasso. His drawings were a product of this mix.

While working with Henderson, Pollock developed a repertory of motifs and symbols that recur for the remainder of his career. One of the most significant of these was that of the "Moon Woman"—represented either as a crescent or as a full circle. Indeed, some of the very last series of paintings of Pollock's career, a set of circular heads created with black drips, seem to be expressions of this motif. Pollock's mood swings seem to have followed some sort of monthly cycle, and thus it's not surprising that he was fascinated by the moon, a body that traditionally has been associated with shifting moods and "lunacy"—that is, mental instability caused by lunar influence.

A number of other motifs that he later used repeatedly also crop up in the drawings he gave to Henderson. They include the skeleton (as a symbol of suffering and death), the horse (as an expression of anguish, a motif that Pollock borrowed from Picasso), the totem (the enigmatic, vertical figure, to which male and female sexual organs could be attached), and pictographs and shields, generally pre-Columbian or American Indian in character (expressions of a cryptic, mystical language of archetypal meanings of an ill-defined sort). Essentially, with a bit of guidance from Jung, Orozco, and Picasso, from Henderson and Graham, Pollock was devising a personal language of emblems and symbols that could serve as a base, as a foundation, for his later language of gestures.

Along with introducing a set of Jungian images and symbols, another aspect of Jung's approach had a profound influence on Pollock at this time, tied in interesting ways with the issue of rhythmic connection that he had absorbed from working with Benton. Jungian theory placed great emphasis on dreams as a route to the unconscious, and one of the peculiarities of dreams is how quickly one image transforms into another. Scenes shift with a peculiar rapidity, and in many instances a person or thing morphs into something else as the dream develops. While Pollock's paintings are not strictly "dream pictures," in the sense that, let us say, Salvador Dalí tried to create a photographically real and convincing image of the subconscious, Pollock's images do reflect a process of visual metamorphosis similar to what we encounter in dreams.

Henderson's special contribution was to encourage Pollock to conceive the dream-like images he created as something with deeper meaning, as messages from the depths of the unconscious, and thus as things that connected at a primal level with both the collective wisdom of mankind and with the fundamental nature of the universe itself. In his readings of Pollock's drawings, Henderson frequently proposed that some fundamental division of the psyche, such as that between male and female qualities, was being transformed into a sense of wholeness and unity, whether through upward movement or by the way in which disparate forms fused together into the form of a mandala. In short, through the influence of Jung, Pollock was encouraged to create images that are in a constant state of visual and symbolic transformation, in which unities break apart into dualities, and dualities merge into unpredictable unities.

A Collision

John Graham not only influenced Pollock's work. He was the first to organize an exhibition that brought together avant-garde American and French painting—to hang work by figures such as Pollock and Lee Krasner in the company of work by Picasso and Matisse. To be sure, at the time, January of 1942, it would have been easy to miss the event. McMillen & Co., where the show occurred, was not so much an art dealer as a decorating firm; the show did not generate great sales or great publicity; and the quality of the examples was frankly somewhat uneven. The dangers of being an art critic are suggested by the fact that one of the few writers who took note of the display at all, James Lane, declared that a now completely obscure painter, Virginia Diaz, "walked off with the show." Pollock's contribution, *Birth*, received not a word of critical comment, although today it hangs in London's greatest museum of modern art, the Tate Gallery, and is universally regarded as a masterpiece. Hastily pulled together, the show was uneven and not very well focused. But for all its shortcomings, Graham's exhibition introduced a theme that has since become canonical in histories of modern art—that the Americans were the true heirs of the accomplishments of the French.

The show also brought Pollock into contact with a figure who would play a central role in his life, Lee Krasner. The Krassners (Lee later took one of the *s*'s out of her name) were Russian Jews who, like hundreds of thousands of others, came to the United States in the early years of the twentieth century to escape economic hardship, military conscription,

Lee Krasner, about 1938. (Photographer unknown. Lee
Krasner Papers, Archives of American Art, Smithsonian
Institution.)

pogroms, and religious persecution. Perhaps because of its background,
the family was suspicious of outsiders. At the same time, the atmosphere
inside the family was also not harmonious or friendly, and Lee grew up
thinking of herself as "an outcast" and "an oddball." Her father was
remote, spending more time at the synagogue than at home or at work,
while her mother, who handled most practical affairs, was argumenta-
tive and superstitious. The girls were viewed as less important than
Lee's older brother, Irving, the only male in the family, who treated her
rather sadistically, with contemptuous superiority, and Lee was treated
less fondly than her younger sister, Ruth, the baby of the family, who was
regarded as prettier. Not surprisingly, Ruth and Lee did not like each
other; in fact, they barely communicated. "We had nothing in common,"
Ruth later commented.

Later in life, Lee often spoke of "colliding" with people, and she
developed an approach to relationships that was at once combative and
insecure. Afraid of criticism, she responded by going on the attack. "You
couldn't just have a conversation with Lee," Ruth remembered. "Oh, no!
She'd bite your head off even before you had a chance to say hello."
Throughout her life she formed relationships with men who were at
both remote and abusive, and she was always ambivalent about her role
as a woman, fiercely struggling to assert her identity as an artist at a time
when women were not taken seriously, and at the same time fearful that
a woman alone, not a wife and not a mother, had no existence. Insistent
on independence, she was curiously lacking in basic practical skills. When
Pollock met her she did not know how to turn on the stove to make a cup
of coffee, and she did not learn to drive until she was over forty.

One of the mysteries about Lee Krasner is why she became an artist, since she received no encouragement from her family or anyone else, and she seemingly showed little talent. In some complex way the decision doubtless reflected an early desire to escape the confines of her culture and her family. Traditional Jewish culture was bound by the biblical injunction against graven images, but in American culture, by the turn of the century, the arts were widely viewed as a realm in which women could achieve self-expression and even pursue a professional career. At some visceral level, Krasner seems to have sensed that art provided a means of escape.

At the age of fourteen she applied to Manhattan's Washington Irving High School, the only high school in the city that allowed girls to major in art. Her application was rejected, but she reapplied and was accepted. Once enrolled in the school, not only did she get poor grades, but art was her worst subject. Nonetheless, she persisted. After graduating she attended the Women's Art School of Cooper Union, on the edge of Greenwich Village, where she was trained in a thoroughly traditional way, including much copying of plaster casts, and also took some classes at the Art Students League. Ambitious to get better training, she applied to the National Academy of Design and was accepted although her academic record was far from exemplary. But she did not submit gracefully to the regime of copying plaster casts and painting photographic likenesses of the model, instead becoming a rebel who painted Impressionist studies outdoors and visited shows of modern French painting.

Krasner's first serious relationship was with a dashing fellow student at the National Academy, Igor Pantuhoff, a six-footer with a golden baritone, a slight Russian accent, and movie-star good looks, who claimed to be a White Russian of noble ancestry. He was also an alcoholic. For several years she set aside her painting career to cater to his needs, but in 1937 she decided to go back to painting and enrolled in Hans Hofmann's school at 38 West Ninth Street. In 1939 Pantuhoff walked out, leaving Lee devastated.

Not long afterward she took up with Pollock, apparently picking him out as an achievable target and then establishing a relationship despite his passivity and reluctance. While not a White Russian like Pantuhoff, to Lee he undoubtedly seemed exotic—a 100 percent American whose ancestors had lived in this country for five generations or more.

In later life, Lee Krasner often related the story of how she first met Jackson Pollock, describing how when she stepped into his studio and saw his paintings the sight "overwhelmed her," how she felt the floor beneath her sinking and "felt the presence of a living force that [she] hadn't witnessed before." In actual fact, as we know from her friends at the time, there wasn't much electricity to their first meeting. Jackson was sitting in the front room, head in hands, recovering from a binge the night before, and their conversation was minimal. Nor did she particularly like his work. Nonetheless, something about his looks and character impressed her. Lee apparently got Pollock to promise to visit her studio, but it was weeks before he showed up. She asked if he wanted a cup of coffee, and when he said yes she headed back to the hall to get her coat. When he looked confused, she explained that she didn't know how to make it—they needed to go to the local drugstore.

She came into his life just at the right moment to fill a gap. For six years Jackson had been cared for by his brother Sande, but on November 9, 1941, Sande's wife, Arloie, had a daughter, Karen, and having Jackson around, getting drunk, became untenable. Sande's son Jason believes that Arloie got pregnant to get rid of Jackson. Whether or not this was the case, at this point it became clear that Jackson needed to move out. In early 1942 Jackson began spending the night at Lee's studio, and when he returned to Eighth Street during the day to paint or sit around, the common door was kept locked. Shortly afterward, Sande left New York, leaving Lee to take care of Jackson.

Once Jackson moved in, Lee threw herself into the role of perfect wife, learning to cook, shifting from bohemian attire to that of a proper housewife, making his phone calls, handling his correspondence, and, since he was so silent, even speaking his thoughts. "He couldn't do anything for himself," Clement Greenberg once observed of Pollock. "If he went to the train station to buy himself a ticket, he'd get drunk along the way." For the second time in her life she largely stopped painting. Lee would later refer to this as her "blackout period." She talked about his paintings but not about her own. There was one painter who mattered, and that was Jackson. Intensely possessive, Lee took steps to eliminate any possible competition. For example, in the summer of 1942, shortly after Jackson had started living with her, he ended his sessions with the Jungian therapist who had succeeded Joseph Henderson, Violet de Laszlo, on Lee's insistence.

Krasner's artistic influence on Pollock was by no means straightforward, since their relationship was far from harmonious. Indeed, on fundamental issues of artistic expression they were completely out of sync. Pollock didn't care for Cubism, which Krasner revered, regarding it as the foundation of modern art; Krasner had no interest in Jung, who provided practically the foundation for Pollock's sense of self. Pollock was not much interested in Matisse and Mondrian, whom Krasner admired; she reviled Siqueiros and did not understand how anyone "could take Benton seriously as a painter." While they both admired Picasso's *Guernica*, Lee admired its formal properties, Jackson its emotional intensity. Once when she had the temerity to pick up a brush to show him how to paint something, he became so angry that he stormed out of the room and remained sullen and resentful for months afterward. Eventually, on visits to museums and galleries, they learned to avoid conversation and communicate through brief nods and grunts. "I practically had to hit him to make him say anything at all," she once commented. "We didn't talk art. We didn't have that kind of relationship at all."

Yet in some subliminal way, Krasner had great influence. At the time that Pollock met Krasner, he was surprisingly naïve, since to a large degree he had absorbed his ideas from a single source: most of his views about art were still those he had absorbed from Benton. Krasner quickly straightened this out and gave him a new canon of whom to admire and whom to dislike.

The art critic Barbara Rose, reflecting a widely held view, has declared that Krasner helped Pollock escape "Benton's narrow provincialism" and develop "a more international, sophisticated view of art." In many ways this is getting things backward. Benton, for all his gruff pretensions, was a thoroughly cosmopolitan figure. He could read books in foreign languages; he had lived in Europe; he had traveled widely in the United States; his friends included leading intellectuals and artists, not only painters but poets and musicians; he read philosophy and aesthetics; and he had studied art history from top to bottom, including things that are often left out, such as Persian miniatures and Hindu sculpture.

Krasner, on the other hand, had read little and had hardly been outside New York; she did not know how to drive a car or even how to turn on a stove; her group of friends was narrow. What she introduced Pollock to was not so much a range of ideas as a limited set of them, an

ideological stance. Krasner's strength, in fact, was that she was willing to disregard and plow through so many things that others held dear—things like history, or the figural tradition of Western art, or good manners, or other people's feelings. One can call this intelligence in the sense that the strategy in many ways was remarkably effective. But if we look to nature for insight, we learn that the creature most dangerous to man is not some reasonably brainy primate but the slithering crocodile, with a brain the size of a poker chip, which because it has few thoughts is singularly successful in turning thought into action. Krasner's strength—and one could say this of Pollock as well—was not sophistication but a more primitive instinct.

Hans Hofmann

To the extent that Krasner influenced Pollock's artistic style, it was to expose him to the theories of her teacher Hans Hofmann, who (largely through Krasner) was also to greatly influence the art theories of Pollock's critical supporter Clement Greenberg. Hofmann had gone to Paris in 1904 and stayed there for ten years, associating at least casually with the major figures of French art, such as Picasso, Braque, Matisse, and Derain. When war broke out in 1914 he went back to Munich and opened a school based on the one Matisse had established in Paris. Shortly before the start of World War II, he came to the United States and quickly established a reputation as a leading teacher of modernist ideas, a figure who could answer the great questions of modern art.

He was an effusive, garrulous, enthusiastic teacher, who took on the role of a guru of modern art and basked in the admiration of his mostly female students. Steve Wheeler, who studied with him, recalled Hofmann as "pompous, blustering, and egocentric," but others adored him. Lee Krasner had a love-hate relationship with him, at once deeply resenting when he took the charcoal from her hand and marked up one of her drawings, or even tore a drawing she particularly liked into four pieces and rearranged it on her easel, but at the same time loving the attention and the sense of mystery that surrounded association with a guru, a master.

Pollock's relationship with Hofmann was strained by several episodes in which Jackson behaved with drunken violence. But Hofmann

was quick to recognize that there seemed to be two very different Jackson Pollocks trapped in one body, one sweet and the other quite menacing. As Hofmann noted in the fall of 1944, in a postcard to Mercedes Matter (written in English accented with traces of his native German):

> Jackson is highly sensitive, he is a wonderful artist, he is in reality good natured, but his companionship is hard to stand when he is off the normal. Lee will have a hard time with him, but she stays with him and I respect her for this. Lee says over: it is easier to have 5 children as to be married with an artist. When he is talented then you can dopple [*sic*] or triple this number.

While Jackson never formally studied with Hofmann (he seems to have largely absorbed his ideas through Krasner and Greenberg), Hofmann certainly contributed to a loosening of his approach and a move to a greater sense of weightlessness.

Until the development of photography, the goal of painting had been to imitate nature as closely as possible. After the invention of the camera, however, it came to seem rather pointless to devote great effort to do something that could be done better by a machine. Rather than killing painting, this challenge ended up giving it a new life: to a large degree, this battle with the camera produced modern art, which abandoned illusionism and perspective and increasingly acknowledged the fundamental character of painting as the application of color on a flat surface. The challenge of modern art, however, was to create a new set of standards and rules. What should a painting set out to do? What was the connection between one brushstroke and the next? How should brushstrokes relate to each other? How could one tell when a painting was finished or whether it was good or bad?

In somewhat murky language, Hofmann had an answer to all these questions. As a child, Hofmann had played with electrical inventions, and perhaps in part because of this experience, his art theories abandon the usual Renaissance space, in which forms have weight and gravity, and posit a free-floating electrical field. Essentially, Hofmann posited painting as a field of interactions, ruled by the dynamic push-pull of opposing forces. He proposed that force-field tensions are created from the moment of the first brushstroke: tensions between the stroke and the empty

canvas, tensions between one brushstroke and the next. He was particularly fascinated by the oppositions of color: warm color and cool color, advancing color and receding color, luminous, translucent color and solid, weighty color. Similarly, he saw tensions that are created by line: tension between inside and outside, solid and void, direction and stability.

How should one put these things together? Part of the fascination of Hofmann's theories is that they were not quite logical. He insisted on creating dynamic tensions of spatial push and pull and at the same time argued that a painting should be flat, that the forms should float toward the surface, and that the space should contain no holes. If it was just flat it didn't have "push and pull," but if it had too much push and pull it didn't harmonize and the space had holes. "Do not make it flat! But it must stay flat!" he exhorted, to the bewilderment of some of his students, to the delighted wonder of others.

The General

Perhaps even more significant than her discipleship with Hofmann was Krasner's friendship with a figure who must have seemed thoroughly insignificant at first, an aspiring poet and cultural critic, Clement Greenberg. Greenberg had been close to Lee's first boyfriend, Igor Pantuhoff, who introduced him to Lee and Hofmann. In large part out of pure misogyny, Greenberg never took Lee very seriously as a painter, but they established an odd, somewhat prickly friendship, based partly on their similar Jewish and Eastern European heritage, partly on their shared commitment to radical forms of modern painting, and partly on their mutual love of gossip, the more malicious the better. Greenberg's art criticism was surely greatly influenced by his long conversations with Krasner, as well as by ideas and phrases that he picked up from Hofmann's lectures and classes.

For a person of the twenty-first century, reading the reviews of Clement Greenberg is a little like studying the exploits of some eighteenth-century general, whose tactics and quaint weaponry, while innovative for the time, seem almost prehistoric today. No one today could capture the citadel of modern art using Greenberg's techniques. But in their time and place they were stunningly effective.

In a painting of 1984, *Triumph of the New York School*, Mark Tansey portrayed the triumph of New York over Paris. Figures dressed in World War I and World War II uniforms are grouped around a treaty table against a battle-scarred landscape while smoke from bombs and shellfire

Clement Greenberg, about 1940. (Photographer
unknown. Private collection.)

rises in the distance. As we look more closely we note that Pablo Picasso, General of the School of Paris Army, is surrendering to Clement Greenberg, General of the New York School Army, as Henri Matisse, Jackson Pollock, Harold Rosenberg, and others look on. While the painting is surely whimsical, Greenberg's prominence is no accident. In a very real sense, he was the central figure in the triumph of the New York School over the French. As late as March 1946 the editor of *View*, John Bernard Myers, was startled by Greenberg's comment that Paris had been "limping along" since the 1930s and that the art world needed a new center.

"How is that possible? . . . What would that center be?" Myers spluttered.

"The place where the money is, New York," Greenberg replied.

When expressed so baldly, the artistic triumph of New York after World War II seems all but inevitable. At the time, however, Greenberg was one of the few who saw what was happening.

Greenberg grew up in the Bronx, the son of a Jewish immigrant, Joseph Greenberg, who had fled poverty and discrimination in Europe to come to the United States, where for years he worked at low-margin businesses for low pay. Eventually Joseph became wealthy, although never fabulously so, and he always felt envious of those who had a big break of some sort that he was denied or who made similar amounts of money with far less effort. Autocratic in approach, he wanted everything done his way and did not appreciate questions. Greenberg's relationship with his father was never an easy one. "I've been in rebellion all my life," he once commented, "rebellion against him."

After graduating from Syracuse University, Greenberg made a brief

attempt to go into the wholesale necktie business with his father but soon grew disgusted and quit. Moving to the West Coast, he made a hasty marriage and supported himself as a translator while struggling to write poetry. His one published poem became a source of later scandal and embarrassment, since it turned out to be substantially plagiarized from the work of another author. Within a few months he had abandoned his wife and child and moved back to New York, where he supported himself first by working for the Veterans Administration and then for the U.S. Customs Service, Port of New York, in the Appraiser's Division of the Department of Wines and Liquors. Still eager to make a mark as an intellectual or a critic, Greenberg moved into the artistic and bohemian section of Manhattan, Greenwich Village.

At this time he got to know Harold Rosenberg, then concentrating on poetry, who would later become an intense rival as an art critic but at that time played the role of mentor, as well as Lionel Abel, who was on his way to becoming a well-known playwright and literary critic. All three were Jewish and shared many similar values. Leftist in their ideals, they had turned against Stalin after the Moscow trials and were enthusiastic Trotskyites, although they recognized that their political stance was completely ineffectual. They fretted that art was in decline and wondered why the 1930s had produced no novelists of a stature comparable to those of the 1920s.

Through Rosenberg and Abel, Greenberg became involved with the *Partisan Review*. Founded in 1934 as the mouthpiece for the John Reed Club, an organization officially sponsored by the Soviet Union, it folded after two years and then was reborn as an anti-Stalinist publication. The stance of the *Partisan Review* always contained a fundamental contradiction, since while it was supposedly Marxist in slant—that is, dedicated to the welfare of the proletariat—it promoted literature and art that were modernist and highbrow. Inside the group, the atmosphere was ferocious. There were constant arguments about the political positions that the magazine should take, and nearly every article gave rise to a dispute of some sort. Since artistic judgments not only were matters of aesthetic whim but also played some ill-defined but important role in the Marxist revolution, even small differences of taste could have weighty impact. In the hands of writers like Greenberg, art criticism turned into a polemic on the fate of civilization.

Greenberg's career as a critic began rather fortuitously. Dwight Macdonald, an editor at the *Partisan Review*, had liked a piece that Greenberg had written on the playwright Bertholt Brecht and encouraged him to write something more ambitious. The result was Greenberg's first big success, an article titled "Avant-Garde and Kitsch," which introduced the word "kitsch" into the lexicon of American criticism. Essentially, Greenberg was concerned with the issue of critical standards. How can you develop critical standards in a culture that has such varied forms of art, a culture that produces both sophisticated, challenging forms of art for the cultural elite and simple, sentimental forms for the populace as a whole? The opening paragraph of the essay is brilliant and beautifully phrased, posing a number of philosophically challenging questions in an easygoing prose that sounds like casual conversation.

> One and the same civilization produces simultaneously two such different things as a poem by T. S. Eliot and a Tin Pan Alley song, or a painting by Braque and a Saturday Evening Post cover. All four are on the order of culture, and ostensibly, parts of the same culture and products of the same society. Here, however, their connection seems to end. A poem by T. S. Eliot and a poem by Edie Guest— what perspective of culture is large enough to enable us to situate them in an enlightening relation to each other?

Greenberg's solutions to the questions he posed, however, were inventive, to say the least. While he claimed to be a Marxist and a socialist, Greenberg firmly believed that "good taste" was established by the educated and the elite, and he was opposed to kitsch, the vulgar taste of the masses. Greenberg argued that in previous cultures artistic taste had been imposed from above but that industrial culture had somehow subverted this process, with the result that bad taste was percolating up from below, rather like sewage from a blocked drain. In this perilous situation, the artistic avant-garde was a kind of holding action, dedicated to maintaining standards of "good taste" until the Marxist revolution occurred. At this point, there would be a new order in which social justice and great art would be reconciled—exactly how, he did not say.

In retrospect Greenberg's whole argument seems strange, for good taste has never been the private possession of the upper classes, and for

that matter, great art has often contained elements that violated standards of "good taste." What is more, as was typical of critics of this period, Greenberg never closely analyzed the links between art and social forces, contenting himself with grand pronouncements about what was bad and what was good, judgments that often seem extremely puzzling when viewed in critical hindsight.

Nonetheless, the idea that there is a distinction between high and low culture was new to this period, and Greenberg's essay was greeted as a breakthrough. The article was reprinted by Cyril Connolly in the British magazine *Horizon*, which put Greenberg's name in circulation on both sides of the Atlantic. One reviewer praised the piece as "the most important essay on the subject . . . after [D. H.] Lawrence's essay on Poe." Some of Greenberg's central ideas were even picked up by popular writers and presented in mass-market magazines. For example, Russell Lynes's well-known essay "Highbrow, Lowbrow, Middlebrow," published in *Harper's* in 1949, was a playful takeoff on Greenberg's ideas. With a single essay, Greenberg ascended to the role of a major public intellectual.

Greenberg went on to write "Toward a Newer Laocoön," which was published by the *Partisan Review*, after delays and revisions, in July–August 1940. Unlike the earlier venture, the essay was not well received. But in many ways it laid the foundation for Greenberg's career as a practicing art critic and explains the artists and stylistic trends he favored.

The article was a response to a famous essay by Gotthold Lessing, published in the 1760s, which dealt with the issue of the relation between one art form and another. It also responded to Irving Babbitt's *The New Laocoön: An Essay on the Confusion of the Arts*, published in 1910. Greenberg's idea was that certain art forms become particularly popular in a period and then set the pattern for other arts. For example, he felt that nineteenth-century painting and sculpture imitated literature because they told a story. Greenberg was interested in the idea that modern art had moved away from literature and instead was working in abstract terms more similar to music. He proposed that shifts of this sort were due to the imperatives of history, that in the modern age it was impossible to make representational art without making a "surrender to images from a stale past." In his view, "we can only dispose of abstract art by assimilating it, by fighting our way through it." To where? This was not

clear. With abstract art, "there is nothing to identify, connect, or think about, but everything to feel." Interestingly, when he wrote "Toward a Newer Laocoön," Greenberg seems to have been rather unclear about the visual form that this new abstract art should take. One of his first reviews was a lukewarm assessment of an exhibition by the American Abstract Artists, a group that fit rather neatly with his theories but that he sensed, at some visceral level, lacked emotional force. Only when he encountered Pollock's work did he discover a form of art that both fulfilled his theories, at least to some degree, and also answered his emotional needs.

Greenberg's sweeping judgments were very typical of his period. Readers of this time eagerly devoured Arnold Toynbee's glib summaries of "the lessons of history," pondered over Oswald Spengler's diatribes on "the decline of the West," and meekly accepted the judgment of the English critic F. R. Leavis that there were only four modern novelists whose work was worth reading. As a critic, Greenberg was particularly influenced by T. S. Eliot, who insisted that an artist is great not simply in his own right but through his grasp of tradition and his appropriation of the past. Eliot felt that a great writer needed to "surrender and sacrifice himself" to this great tradition to become truly great. No one had done for modern painting and sculpture what Eliot had done for modern literature. Greenberg set out to do so. Like Eliot, Greenberg liked to stand above the crowd, allegedly defending a concept of "high culture" that was beyond the reach of most people. But Eliot's defense of traditional values often contained a hostility to those who stood outside the canon of the Western tradition, such as Jews. Greenberg brought such newcomers into his canon by inventing a new kind of "high art" tradition, based on rebellion against bourgeois values.

While the issue is still sensitive to discuss, it's clear that Greenberg's Jewishness powerfully influenced his thinking. Being Jewish colors a writer's attitude toward a good deal of Western art, with its Christian subject matter—very often brutal martyrdoms and crucifixions. It's hard not to associate art of this sort with bigotry and anti-Semitism, with the blood and violence that has been so much a part of Christian dominance. Indeed, from the Jewish standpoint, at some level even the notion of representation, the basis of Western art since the Renaissance, seems a little suspect.

Jewish culture was intensely spiritual and intellectual, intensely fo-
cused on God, God's commandments, and God's word. The idea that
God and intellectual things are most important, are more important
than practical things, is one of the most fascinating aspects of Jewish
culture. Significantly, however, this focus on the divine worked against
the development of figural art. Indeed, in Jewish tradition there is a firm
proscription against making representations of God, particularly against
portraying God in human guise. At some level, Jewish culture entails the
understanding that concepts of the highest order, such as God or the di-
vine, should not be shown in human guise, indeed, are not even repre-
sentable but are abstract. While not religiously observant in any
traditional sense, Greenberg to some degree seems to have absorbed
some of these Jewish beliefs, these ways of considering the fundamental
nature of things. In Greenberg's writing, in fact, the idea of the abstract
takes on some of the aura of a secular religion. Something about the
abstract is mysterious and ineffable and exists in a realm above mere
physical things. For Greenberg the abstract was in some sense divine.

Does all this sound familiar? In fact, Greenberg's theory of art his-
tory was in some ways strikingly similar to that of Willard Wright. He
saw art as a historical progression toward greater abstraction. He saw
the task of the artist as one of grasping the achievements of past art and
creating a new synthesis. Like Wright, he was unapologetically partisan
in boosting the artists he liked and dismissive of those who were rivals, if
indeed he bothered to even acknowledge that they existed.

But Greenberg's writings had a clout that Willard Wright's had
lacked, since the Museum of Modern Art had changed the game of
modern art from something that was of interest to only a few to a well-
funded public contest, which carried publicity, money, and glory for the
winners. Which American artist would continue the tradition of radical
experiment that figures like Matisse and Picasso had initiated? Green-
berg set out to determine who this would be. A trait that Greenberg
shared with Pollock was a sense of almost unfocused rage. Girlfriends
often used the words "cruel" and "sadistic" to describe him. One of his
childhood playmates recalled that when he was five he once battered a
goose to death with the handle of a shovel. In the New York cultural
world he quickly developed notoriety as someone who went around
punching people. Unlike Thomas Hart Benton, a trained boxer, who

generally took on men who were considerably larger than he was and who were his friends, Greenberg liked to beat up people who were smaller and weaker than he was.

Some of his fights have become part of the legend of the New York School and have been viewed as indications of his toughness, his passion, his all-American virility. Thus, for example, Greenberg once wrote a review very critical of Max Ernst, accusing him of vulgarizing modern art and comparing his work to "scenic postal cards." Understandably displeased, at a party a little later Ernst overturned a loaded ashtray on Greenberg's head, crowning him "King of Critics." Greenberg responded by turning around and punching Ernst in the face, giving him a huge black eye. Despite the naughtiness of his own gesture, it had apparently never occurred to Ernst that Greenberg would respond so forcefully. And as usual, Greenberg had picked on someone weaker: Ernst was elderly, and physically no match for him.

For all its nastiness, Greenberg's action has been embraced as a metaphor for the defeat of the French by the Americans and for the notion that while the French might be the more sophisticated of the two, they were effete. As William Rubin, chief curator at the Museum of Modern Art, later noted: "Ernst was probably shocked beyond belief when, instead of a witty response, he got a sock in the jaw. It was the difference between French and American painting in the late forties and fifties, between the very elegant work of a painter like Mathieu and that done by Jackson Pollock . . . It's the difference between haute cuisine and meat and potatoes."

With the recruitment of Clement Greenberg, to play a role similar to that which Willard Wright had played for his brother, Stanton Macdonald-Wright, or that Thomas Craven had played for Benton, Pollock's little guerrilla troop for storming the Museum of Modern Art had notably gained in strength. As Reuben Kadish noted of Pollock during this period: "He had gotten the idea from Benton that you've got to get a group together . . . He knew that one single artist was not going to be able to operate on his own." At this point, two legs of the tripod of support Pollock needed were in place: a wife-helpmate and an art critic–promoter. Now all he needed was a patron.

21

Poor Little Rich Girl

There were few venues in New York for the kind of art that Pollock was making. In fact, at this time there was only one person in New York seriously supporting such radically avant-garde creations: Peggy Guggenheim. No other figure played such a central role in promoting the then dispersed and little-recognized painters whom we now neatly group together under the title of "Abstract Expressionists" and view as central figures of twentieth-century art: not only Pollock but Willem de Kooning, Mark Rothko, Adolph Gottlieb, Robert Motherwell, William Baziotes, and Clyfford Still.*

Most art historians largely skip over Peggy's wild behavior, which seems to make them uncomfortable, but in fact one of the most interesting and significant aspects of her character was her emotional desperation—and this was surely the essential point of contact between her and the artists she championed and represented. Clement Greenberg once remarked that Peggy Guggenheim's career was a response to the same stifling form of upper-middle-class Jewish culture that produced

* Peggy was one of three Guggenheims who have been major patrons of the arts: the other two were her uncles. Simon Guggenheim left money for artistic fellowships in memory of a son who collapsed and died after a track meet at the age of eighteen. Solomon, on the urging of his mistress Baroness Hilla von Rebay, became a major collector of modern art and established the Guggenheim Museum. Despite the considerable friction between her and the baroness, Peggy eventually left her collection in Venice to the Guggenheim Museum.

Gertrude Stein. Like Stein, she expressed her rebellion through art and became the center of a revolutionary artistic culture. But Guggenheim was a crazier version of Gertrude Stein: more reckless, more sexually promiscuous. While Stein achieved a kind of Buddha-like serenity, Peggy Guggenheim was always desperately unhappy.

How fitting, then, that her great discovery was an artist who was also desperately wild and desperately miserable, Jackson Pollock, and that she played a major role in exposing him to new influences, pushing his achievement to new heights, and making him famous. In later life, when Peggy was asked to name her greatest accomplishment, she would say, "Jackson Pollock," and then add that her collection was her "second achievement." Even Lee Krasner, who detested Peggy, always admitted that she played a major role in establishing Pollock's fame. Peggy did not mind appearing crazy. In fact, she was a shameless exhibitionist, and her memoir, *Out of This Century* (which her relatives unsuccessfully attempted to suppress), still makes rather startling reading. This, for example, is Peggy's account of an aunt:

> One of my favorite aunts was an incurable soprano. If you happened to meet her on the corner of Fifth Avenue while waiting for a bus, she would open her mouth wide and sing scales trying to make you do as much . . . She was an inveterate gambler. She had a strange complex about germs and was forever wiping her furniture with Lysol. But she had such extraordinary charm that I really loved her. I cannot say her husband felt as much. After he had fought with her for over thirty years, he tried to kill her and one of her sons by hitting them with a golf club. Not succeeding, he rushed to the reservoir where he drowned himself with heavy weights tied to his feet.

So it runs on for 365 pages—a litany of follies, sufferings, and escapades, not least those of Peggy herself, who left little to the imagination in recounting the unsuccessful operation to reshape her Jewish nose, her long string of lovers, or how she lost her virginity. Her life reads like a collection of tabloid headlines. She grew up in a grand mansion on East Seventy-second Street, near Central Park, close to the Rockefellers, the Stillmans, and President Grant's widow. It was an imposing place, with a

marble vestibule, a marble staircase, and a grand living room in Louis Seize style, with tapestries, a bearskin rug, huge mirrors, and a grand piano. But life was miserable in this gilded cage. If she had been poor she could have gone to school and played with other children. Since she was rich she had no friends, other than her two sisters, and was privately educated by humorless governesses and tutors. The relationship between her parents was strained. Her father kept mistresses (not very good-looking ones by her account) and was absent much of the time. Despite the traditions of the Guggenheim family, he was very poor at business and managed to lose a large part of his fortune. Her mother was a scatterbrain. Not surprisingly, Peggy's relationships later in life invariably disintegrated into resentment and infidelity. "My childhood was excessively unhappy," she later wrote. "I have no pleasant memories of any kind."

In 1912, when Peggy was thirteen, her father went down with the *Titanic*. When the ship began to sink he could easily have escaped in one of the lifeboats. Instead, with a perverse, quixotic courage not unlike that which distinguished Peggy's remarkable career, he stood back so that women and children could go in his place. He and his young secretary then dressed in evening clothes to meet their death. They wanted to die as gentlemen.

It was not very clear what a young female Guggenheim was supposed to do. After graduation from high school, Peggy worked for a time in the Sunwise Turn bookstore, run by Mary Mowbray Clark, where she met poets, novelists, mystics, and painters such as Marsden Hartley and Charles Burchfield. She had her first experience of modern art when she visited the gallery of Alfred Stieglitz, who showed her a work by his mistress, Georgia O'Keeffe. She was so puzzled that she kept turning it around and around, uncertain which way was up. Peggy then made her way to Paris, where she amused herself buying clothes and going to parties, and it was thus that she first came in contact with artists and writers, as well as other idly rich people like herself.

At twenty-three she lost her virginity, as she described with enthusiasm in her memoir, to a young American playboy, Laurence Vail, whom she married shortly afterward and by whom she had two children. In 1930, however, that marriage ended when she ran off with an Englishman, John Holms, who died a few years later during a routine operation to

reset a broken wrist, since he did not tell the doctor who sedated him that he had been drinking heavily the night before. Holms was followed by an English Communist, Douglas Garman, who added a pool and a cricket pitch to her English cottage and persuaded her to support Communist magazines. Gorman left her for a proletarian woman, so she became involved with Humphrey Jennings, a writer, painter, photographer and filmmaker, who encouraged her to open an art gallery in London.

She soon dropped Jennings but followed his advice and opened a gallery for modern art in London called Guggenheim Jeune. Then she closed the gallery in 1939, having decided to create a museum of modern art in London, which would display a collection of modern paintings that she planned to assemble. Shortly after getting started, however, she decided that she didn't want to live in London but rather in Paris. Returning to France, she began avidly buying modern paintings, often directly from the artist, averaging a painting a week.

In her enthusiasm for art, Peggy paid no attention to what was happening in the world at large. Consequently she was caught in France when the Germans invaded. Fortunately, she was an American citizen and also made it to the Vichy zone, which was nominally still under French rule, but being a Jew in German-occupied France was obviously risky. In July 1941, after many bureaucratic machinations, she finally managed to smuggle out her collection as well as to flee herself. Generously, she also subsidized the flight of a number of Surrealist artists, among them Max Ernst, who accompanied her out of the country and married her shortly after their arrival in the United States in July 1941.

About a year after settling in New York, she opened a gallery of modern art over a grocery store on Fifty-seventh Street, which she christened Art of This Century. Eager to make a strong statement, she hired Frederick Kiesler to design the interiors, and he came up with something utterly unlike anything seen before either in New York or anywhere else. He began by blocking out the windows, which created a disorienting effect. Then, in the main gallery, he stripped the paintings of their frames and projected them from the walls on what looked like baseball bats. The walls were made of curved canvas; the floors were turquoise. In other rooms the paintings were suspended from ropes or placed on a whirling Ferris wheel. Several Surrealist paintings were viewed through a peephole. As Peggy intended, when the gallery opened on October 20,

1942, the press denounced it as a circus, a delirium, a nightmare, and a hangover. It got extensive coverage not only in all the New York newspapers but in *Newsweek* and other national magazines.

Surrealism

Peggy's enthusiasm for Pollock derived in good part from his interest in the Surrealists, and, in turn, Pollock's association with Peggy and Art of This Century deepened his knowledge of Surrealism. Surrealism sought to capture the irrational world of the subconscious but went about this task in many different ways. Some artists, such as Salvador Dalí, tried to bring reality to the visions of the subconscious by picturing them with intense and disturbing realism. Others took an altogether different approach, seeking to release the unconscious through "psychic automatism," that is, through seemingly thoughtless, unpremeditated gestures of mark-making or writing that bypassed the conscious mind and supposedly drew on deeper forms of awareness. André Masson, for example, made drawings by moving his hand without conscious guidance across the paper, until images began to emerge. Or he spread glue upon the surface of a canvas, sprinkled it with sand, and then dusted away the excess, leaving only the sand that had stuck to the glue.

New York artists quickly took sides. Pollock's circle was dominated by those who favored abstraction, who were interested in experimental techniques such as automatism, and who viewed Salvador Dalí as a mediocre illustrator. For Pollock Surrealism had an obvious appeal, since its emphasis on the unconscious drew from the theories of Freud and Jung, which he had already embraced in an effort to cure his depression and alcoholism.

During World War II many of the French Surrealists, including the high priest of the movement, André Breton, fled to the United States. But for an American, becoming part of Breton's group was out of the question, since the French Surrealists were snobs who did not mix with Americans. The major bridge between the French Surrealists and the young Americans was Roberto Sebastián Antonio Matta Echaurren, generally known more simply as Matta, an effusive, persuasive personality whom Robert Motherwell once described as "the most brilliant young artist I've ever met." Born in Chile, Matta went to Paris to study art and joined the

Surrealist circle in 1937. In 1939, several years ahead of most European artists, he settled in New York and quickly made a name for himself as the only Surrealist there, even being granted a one-man show of his paintings at the Pierre Matisse Gallery. When Breton arrived in America, however, Matta was thrown into the shadows. As a sort of revenge, he decided to form his own rival group of young Americans, which would expose the French Surrealists as gray-haired, middle-aged men. He enlisted the young painter Robert Motherwell as his chief lieutenant, who in turn rounded up a group of aspiring young Americans including William Baziotes, Gerome Kamrowski, Peter Busa, and Jackson Pollock.

The group met occasionally at Matta's apartment, which, like Guggenheim's gallery, had curved canvas walls designed by Frederick Kiesler. In these sessions, Matta set homework assignments such as creating "new images of man" or "the hours of the day," and the rest tried to do them. Predictably, Pollock seems to have resented the assignments and generally didn't deliver, although he came to the meetings anyway. Among the games they played was "The Exquisite Corpse," in which each guest contributed a line without looking at what had gone before. The group did not last very long, and Jackson does not seem to have particularly enjoyed their amusements. Matta later described him as "*fermé*"—"a closed man," although he excelled at making automatic drawings with male and female symbolism.

Surrealism provided Pollock with some useful techniques, but it also presented problems of meaning and form that were not easy to resolve. The fact is that most of the time automatic gestures did not produce anything that was visually very interesting. Very often they devolved into monotonous circular patterns. How could one distinguish a mere scribble from a profound message stemming from the depths of the unconscious? What could one do to make such gestures visually exciting? Jackson's challenge was to find a way to turn automatism into something more than randomness, to find a way to give it visual and emotional strength.

Howard Putzel

While it sounds a bit awkward when boiled down to such a phrase, Pollock's appeal for Peggy Guggenheim was that he was a Surrealist but not exactly a Surrealist. When her gallery opened, Peggy Guggenheim was

pursuing Max Ernst and consequently focused largely on Surrealism. But like most of Peggy's relationships, that with the Surrealists ended in acrimony. She quarreled with Breton, and after marrying Max Ernst she split with him. Max had tired of her almost immediately and had rented a house on Long Island, where he met secretly with a beautiful young American Surrealist, Dorothea Tanning. Increasingly, he slept late and showed no interest in Peggy. By March of 1943 he had moved out. At this point Peggy's inner circle shifted. James Johnson Sweeney, who would soon become head of painting and sculpture at the Museum of Modern Art, became her major advisor. Howard Putzel replaced Jimmy Ernst (Max's son). Matta, the Surrealist turncoat, became the sole Surrealist she still consulted. All three pushed her in the direction of American artists whose work was in tune with Surrealism but different. The most notable of these was Jackson Pollock. The buzz about Pollock seems to have come from various directions. Herbert Matter, who was wildly enthusiastic about Pollock's painting, approached Sweeney, who didn't know quite how to respond but told Peggy that Pollock was "doing interesting work." Around the same time, Pollock's friend Reuben Kadish introduced Pollock to Peggy's assistant, Howard Putzel, and Putzel immediately concluded that he had discovered "an American genius."

For all her weirdness, Peggy Guggenheim had a talent for discovering smart art advisors and listening to what they said. For the most part she chose people with solid if somewhat eccentric credentials—illustrious masters of modern art, such as Max Ernst and Marcel Duchamp, or recognized scholars and curators, such as Herbert Read and Alfred Barr. Howard Putzel, however, the figure chiefly responsible for discovering Pollock, was something quite different—a seeming nonentity who had failed at almost everything he tried and whose own solo attempts at art dealing had ended in bankruptcy.

Putzel was middle-aged and overweight, with thin, slicked-back hair and round glasses. He smoked constantly, carrying a big cigarette holder that he would wave in the air to emphasize his points. He suffered from thyroid and heart trouble and was an alcoholic or near-alcoholic, with a fondness for too many martinis. Perhaps most debilitating, he was epileptic and had been traumatized by an overbearing mother, who was angry at him throughout his childhood for being sick and who would tell him that he was insane and a nuisance. She lived

in luxury in a Park Avenue apartment while her son struggled to make ends meet.

Peggy used Putzel as her errand boy, escort, shoulder to cry on, and confidante. As reward for his round-the-clock services, she abused him continually for trivial mistakes, paid him a pittance, and showed no mercy when he fell short on his bills. Putzel constantly complained to Pollock and Lee Krasner of Peggy's abuse, telling them, "I don't know how I can face another day . . . I don't know if I can continue working there." "Putzel was a fat, poor middle-aged homosexual," remarked Peggy's son Sinbad (the name, of course, was a pun on "bad sinning"). "She treated him like a slave." Nonetheless, Peggy also listened to him. Somehow, Putzel persuaded her not only to sign on Pollock and provide him with a stipend but also to stage shows of other unheralded, daringly abstract artists who would later become famous, such as Hans Hofmann and Mark Rothko.

Piet Mondrian's Support

Putzel's enthusiasm for Pollock received endorsement from the most un-likely possible source: the master of geometric abstraction, Piet Mon-drian. In 1942 Putzel arranged for a show of young Americans, to which anyone could submit, the work to be judged by a jury consisting of Peggy Guggenheim and five artists. Pollock, who had just gone through an explosively creative period, sent one of his most recent paintings, *Stenographic Figure*. Peggy Guggenheim's initial reaction was one of complete revulsion. Just at that point, however, Piet Mondrian, looking formal and professorial in horn-rimmed glasses and double-breasted suit, moved carefully down the row of paintings that had been arrayed along the wall.

As with many notable artists, it is sometimes hard to tell whether Mondrian was a genius or a candidate for psychological counseling. Mondrian had many of the qualities of the personality type known as a phobic, who compulsively performs obsessive-compulsive rituals. He felt the need to live in a world that was strictly rectangular. At restaurants he would avoid the window and seat himself facing the wall, since the dis-orderliness of nature made him uncomfortable. When checking into a hotel, he would insist on seeing the room before taking it, since he was

unwilling to take any room with irregular angles or in which it was not possible to arrange the furniture in a strictly regular configuration. His paintings never depart from shapes that are rectangular or square, and he broke off all contact with his follower Theo Van Doesberg when the latter had the temerity to introduce diagonals. For all its rigidity, however, Mondrian's world was anything but restful. Like many phobics, he was unable to leave things as they are: he needed to fuss. After covering a canvas with lines and right angles he could not leave it alone. He needed to go back and make changes and adjustments. Even after a painting was seemingly finished he would return to it and start making changes, sometimes reworking and altering the same canvas for decade after decade.

When Mondrian came to Pollock's work he stopped, seemingly transfixed. Peggy Guggenheim assumed that he disliked it. "Pretty awful, isn't it," she commented, and added, as Mondrian stood silent, "That's not painting, is it?" Mondrian still remained silent, so she chattered on: "There is absolutely no discipline at all. This young man has serious problems . . . and painting is one of them. I don't think he's going to be included."

"I'm not so sure," Mondrian replied. "I'm trying to understand what's happening here. I think this is the most interesting work I've seen so far in America . . . You must watch this man."

"You can't be serious," Peggy protested. "You can't compare this and the way you paint."

"The way I paint and the way I think are two different things," Mondrian replied.

The result was a kind of instant conversion. From that moment, as jurors entered the room, Peggy would pull them over to Pollock's work and say, "Look what an exciting new thing we have here!"

It seems mysterious that Mondrian of all people should have applauded Pollock's sprawling composition. There is no simple explanation for this, but surely it happened in large part because Mondrian saw that, like himself, Pollock was interested in capturing some sort of universal rhythm, which gave vibrancy to every sector of the canvas. Pollock rightly recognized the moment as a breakthrough. Reuben Kadish also later testified that Pollock was completely thrilled that Mondrian had liked his work—"he was excited like a kid." "Things really broke with the showing of that painting," Jackson wrote to Charles in July.

One-Man Shows and a Stipend

Although Pollock's painting did not sell, Howard Putzel continued to support Pollock's work and pressed Peggy to stage a one-man show. Eventually, she agreed to stop by Pollock's studio but she came away unimpressed, in fact offended, since Pollock had been at a wedding earlier in the day and was extremely drunk. Guggenheim was cautious and said that she would send Marcel Duchamp to look at the paintings. In early July Duchamp appeared at Pollock's studio, took a look around, and decided that Pollock's work was "not bad." With this lukewarm recommendation, Guggenheim decided to give him a show at Art of This Century in November.

Always somewhat stingy, despite her considerable wealth, Peggy agreed to be generous in a complicated way that ultimately left everyone in the transaction feeling slightly cheated. So that Pollock could make paintings for the show, she agreed to give him a stipend of $150 a month for a year ($1,800), an advance that would be deducted from sales along with a sales commission of one-third. In addition, at Putzel's urging, Guggenheim commissioned him to paint a "mural" for the entrance hall of her apartment. The agreement was unprecedented for the period but also left Pollock with barely enough money to survive.

Starting around August 1943, Pollock experienced another flood of productivity, during which he produced paintings at the rate of about two a week. By the time of his first show at Art of This Century, which opened on November 8, 1943, Pollock had fourteen new paintings, including several that have since become famous: *The She-Wolf, Male and Female, Guardians of the Secret, The Moon-Woman Cuts the Circle,* and *The Mad Moon Woman.* The critical reactions were very mixed. Not surprisingly, the European Surrealists tried to take credit for Pollock's accomplishment while denigrating its crudeness and lack of cultivation. Some of Jackson's friends, such as Reuben Kadish, felt that he had "cracked the whole thing open." Others felt: "This isn't painting. He just blew his top." The show was reviewed in the *New York Times,* the *Sun,* the *New Yorker,* the *Nation,* the *Partisan Review, Art News, Art Digest,* and *View.*

Over the next few months, Peggy managed to sell several paintings, although never for more than a thousand dollars. She sold *Guardians of*

the Secret to the San Francisco Museum and other paintings to Kenneth Macpherson, Joseph Hirshhorn, and Edward Root. Her greatest coup was to sell *She-Wolf* to the Museum of Modern Art, despite the reluctance of Alfred Barr. Pollock had a second show at Art of This Century in March 1945. After a long period of lassitude and inactivity, he created almost all the work a few weeks before the opening. A young sculptor who visited his studio at this time, David Slivka, recalled how furiously Pollock worked with a brush: "I had never seen anything like it. It was thrilling to watch." Blackness seemed to be the theme of the moment, and many of the paintings had the word "black" or "night" in their titles: *Horizontal on Black*, *Square on Black*, *The Night Dancer*, *Night Ceremony*, *Night Mist*, and *Night Magic*. Most of the reviews were negative, even mocking. Parker Tyler commented that Pollock "does not seem to be especially talented" and declared that his "nervous, if rough, calligraphy has an air of baked-macaroni." In *Art News* Maude Riley observed Pollock's "belligerence . . . toward all other things." Only Greenberg came wholeheartedly to his defense, insisting that Pollock was the strongest American painter of his generation.

Mural

The key painting of this period, however, was not any of the ones included in Pollock's exhibitions—it was the painting titled simply *Mural*, which Peggy commissioned him to make for the lobby of her apartment. Perhaps no painting in Pollock's oeuvre has generated so many misleading stories and interpretations. But by sifting through the various fables it has inspired, we can move toward an understanding of what the painting is actually about.

Working with both a stick and a brush, on a canvas roughly eight by twenty feet in size, Pollock created a swirling pattern of black lines and color patches—predominantly a weird harmony of yellow and turquoise. At first the effect looks abstract, but as we look further we can make out eight totemic figures who march across the canvas, seemingly in midstride. Then, as we look more closely we can also discern horses' heads on the right-hand side. In various conversations, Pollock indicated that these were inspired by a mustang stampede he had witnessed as a boy. In a general way the totemic figures resemble those in some of

Pollock's earlier paintings, such as *Male and Female* or *Guardians of the Secret*. But overall the painting has a different quality than anything Pollock had created before. What stands out as new is both the huge scale and the muscular, pulsing rhythm of the arcing forms—a rhythm which is never broken but binds all the elements of the design together into a visual unity.

Writers on Pollock, from Clement Greenberg to Kirk Varnedoe, have recognized the painting as a breakthrough of some sort—as a painting unlike anything that Pollock had made before. For Greenberg, in fact, it represented a turning point in his enthusiasm for Pollock's work. As he later declared, "I took one look at it and I thought, 'now *that's* great art,' and I knew Jackson was the greatest painter this country had produced."

Much has been written about the creation of the piece. The sheer size of the canvas made the project unlike anything that Pollock had attempted before. In order to work on such a large scale, Jackson tore out the wall between his studio and his brother Sande's former studio, which had been taken over by Lee. He then set up the blank canvas. "It looks pretty big," he wrote to Charles, "but exciting as hell."

And at this point we enter the arena of myth-making. For many years the story of the rapid creation of *Mural* has played an important role in building Pollock's legend: the tale has been widely repeated in biographies and has even been enacted in a Hollywood movie on Pollock starring Ed Harris. According to this account, Peggy had expected the painting to be completed at the time of Pollock's November show, so that it could be installed in time for a New Year's party she was holding early in January. But the November show opened and closed and the canvas was still untouched. The days of December ticked away, but by December 23 Pollock still had not started work. At this point, there was a further delay, when Jackson and Lee were pulled away to spend the holiday with Jackson's family. On their return to New York, Jackson locked himself into the studio, but when he occasionally emerged, Lee could see that he still had not started work. Eventually he asked her to leave the apartment, but when she returned the day before the deadline the canvas was still blank. Late that afternoon, a friend named John Little stopped by and found Lee pacing nervously. "Jackson's supposed to deliver that mural tomorrow," she told him. "He hasn't even started it."

Then, just after nightfall, Jackson began painting. He continued through the night, and by nine in the morning the painting was finished (although he did do a little touch-up later). When Little stopped by that day, Lee was in a cheerful mood. "You won't believe what happened," she told him. "Jackson finished the painting last night."

It's not surprising that for years scholars accepted this version of events. Krasner provided this story to scholars in a series of interviews; it was corroborated by her friend John Little; as early as 1946 it was written up by Peggy Guggenheim in her gossipy memoir; and it was widely repeated, with slight variations of detail, by quite a number of people who knew Pollock or Krasner in this period.

And yet, incredibly, as was recently demonstrated by the Pollock scholar Francis O'Connor, the central elements of this story are demonstrably untrue, as can be established by means of various forms of contemporary evidence. While some of O'Connor's objections may initially seem nitpicking, cumulatively they are damning. Specifically:

1. According to Krasner and the other informants, Pollock executed the painting within a day or two of January 1, 1944. But this cannot be correct since in a postcard written to a friend almost two months earlier, on November 12, 1943, Peggy Guggenheim mentioned that the painting had just been installed in her apartment. Most likely, in fact, *Mural* was in place in Peggy Guggenheim's hallway by the time of Pollock's exhibition at Art of This Century, which opened on November 9, just a few days before the postcard was written.

2. According to Krasner and the other informants, the painting proved too large for the space where it was placed. Consequently, six inches were cut from the right-hand side. Physical examination, however, shows no evidence that the painting was cut in this fashion.

3. Finally, the very notion that Pollock executed the painting in a single explosion of creative activity does not appear to be tenable. For one thing, in a letter of January 1944 to his brother Frank, Jackson Pollock declared that "I painted quite a large painting for Miss Guggenheim's house during the summer—8 feet x 20 feet." The reference to the Guggenheim mural is unmistakable, as is the declaration that he was working on it during the summer, a period when,

according to Krasner's account, the canvas still remained completely blank. It's also clear that if Pollock had actually created the painting in the first day or two of January, the paint would not have had time to dry in time for the installation, which supposedly occurred in time for Peggy Guggenheim's party just a day or two later. Obviously if the painting were installed while the paint was still wet, there would be smears, or retouched smears, but there's no evidence of this. Finally, some undated photographs of *Mural* show the painting in an earlier state than its present one, and reveal that Pollock went over it carefully, cleaning up splatters and paint trailings and making slight modifications to the design. Presumably, Jackson had the photographs made a few days after the painting was finished, believing it was done, but then went back and made a few more revisions and changes. To be sure, this process of photography and retouching could have been done in a few days. But the care and attention to detail that the photographs document doesn't seem consistent with Krasner's claim that the painting was created in a single night, and even a few days of such work would throw off her timeline.

Attempting to trace how this story got started and then collected further details as it grew is a complex process. As is typical of rumors, some slender foundation of fact seems to have been progressively embroidered and factually scrambled by successive narrators. We can trace this process to some extent by going through successive interviews by the individuals who recounted this story, as well as the successive printings of Peggy Guggenheim's memoirs, each of which became a little more colorful than the last. But Krasner was clearly the key figure in creating this legend. With regard to the crux of the drama, the claim that Pollock created the painting from scratch in a single night, the other narrators, such as John Little and Peggy Guggenheim, were clearly simply repeating what they heard from her.

How could she have disseminated such a whopper? The most plausible defense is that Pollock did not reveal much to her about his artistic process. For example, it is conceivable that Krasner never viewed Pollock's painting until it was finished, and leapt to the conclusion that he had made it in a few hours, since according to various reports he did not generally allow her access to his studio. But even if this was the case, it's hard to

escape the conclusion that there was a large degree of fabrication in her account, applied to the purposes of salesmanship and myth-building.

There's no doubt that Pollock, once he got started, worked more quickly than most artists, with more spontaneity and less reliance on preparatory sketches. "No sketches—acceptance of what I do," Pollock once declared. Krasner's story was clearly devised to turn this aspect of his working method into the stuff of legend. To create such a huge painting so quickly would be next-to-incredible: a secure proof of Pollock's artistic genius.

Notably, Krasner's amazing story has affected how scholars have interpreted the painting. Caught up in a sort of rapture, they have always emphasized the reckless spontaneity of the visual effect, at the expense of more sober analysis of its composition and imagery. A case in point is Kirk Varnedoe's discussion of the piece, in which he described the painting as a heroic feat that established Pollock as the world's leader of modern art.

> Before he made this picture, as of Christmas 1943, Pollock was a novice with a good gallery and some hot word of mouth behind him. Seen with the cooler eye of retrospect, he was then, and would remain for several years more, a provincial. Yet for a moment in January, when he put down the brush after the concentrated hours moving back and forth across the twenty feet of *Mural*, and painting from the floor to as high as his reach would stretch, this man stood alone at the head of his class, not just in New York but internationally. He had redefined not only the parameters of his own abilities but the possibilities for painting, at a moment when the fortunes of modern art—and the prospects for a continued liberal idea of modern culture—were at a nadir. There was nothing of this power and originality being made anywhere else in the war-plagued world that dim winter. And he had done it—doubtless somewhat in a spirit of desperation, having boxed out all other alternatives—by trusting himself, and leaving a lot of the inspiration that would come in the process of making.*

* Of course, as has been noted above, Varnedoe's date for the painting is incorrect. It clearly was not painted in January if it was installed in Peggy Guggenheim's apartment several months earlier. Most likely it was finished in mid October.

I must confess that I find this one of the most fascinating passages ever written about Pollock, since it so strongly insists on the significance of the painting without ever quite directly addressing the painting itself. The closest model for this sort of writing, in fact, is not art history but sports writing. In its literary style, Varnedoe's fuliginous paragraph is closer to "Win one for the Gipper" than to intellectual analysis. Indeed, as so often in writing on Pollock, part of the charm of a passage such as this is that rational reasoning seems to have utterly disappeared. We are induced, or at least invited, to set aside all rational inhibitions and enter into a state of enthusiastic flow, like that produced by drugs, love, or loud music. The stakes are gargantuan—nothing less than supremacy in the game of modern art—but the means to achieve this success are curiously simple, simply a bit of athletic stretch (it's as high as Pollock can reach to the top of the canvas), a good deal of passion (or at least enough anxiety to get one's heart to beat faster and to work up a sweat), and just enough awareness of modern art so that even if you're provincial, you're able to jump into the game.

There's a striking omission in Varnedoe's passage, and in nearly everything else that has been written about *Mural*. It's the recognition that for all its quality of creative frenzy, the painting has qualities of planning and order—that the process of creation was not straightforward and blindly emotional, but was a back-and-forth interplay between gesture, imagery, and larger principles of design.

All-encompassing principles of design are what make the painting work, and once we recognize this fact it also becomes not too difficult to grasp that what we see in the painting—more powerfully than in anything Pollock had made before—are qualities that go back to what Pollock had learned from Thomas Hart Benton. The basic compositional system of the painting—vertical poles, arranged in a lateral sequence, which serve as the locus of spiraling rhythms—derives from the methods that Benton laid out in his articles in the series "The Mechanics of Form Organization in Painting." For that matter, the general manner of creation—a period of brooding and planning followed by rapid execution—was one that was characteristic of Benton's murals. For years Pollock had been slowly drifting away from Benton's influence. In *Mural* he returned to the principles of his master, if not in terms of surface imagery, in terms of format, and compositional structure and fundamental expressive purpose.

In fact, when Pollock discussed the painting with the painter and sculptor Harry Jackson, around 1947, he was quite open about his attempt to emulate Benton. As Harry Jackson later reported of what Pollock said:

> He told me about a great piece of linen canvas Peggy Guggenheim bought for him to do a mural for her hall on. He had tried to paint a horse stampede on it and when it got beyond his control he got mad and started to sling the paint onto the canvas to create the driving, swirling action and thrust the composition and the heroic size demanded . . . He talked to me a great deal about that canvas for the hallway. He regretted that he was unable to make it a great figurative mural but he felt that the disciplines necessary for realizing such work had been lost to us. He admired Tom Benton and he wanted to be able to do what Tom dreamed of doing, that is, to make Great and Heroic paintings for America. He was painfully aware of not being able to do it the way he wished and he was determined to do it the way he could.

Of course, one would never confuse Pollock's final product with a Benton. The brushwork is too wild, the drawing too strange, the figures (if they are figures) too difficult to make out. But given these elements, which had also appeared in Pollock's earlier work, it is evident that Pollock was now starting to organize them in a different way. Paradoxically, in fact, the painting is at once wilder but also more disciplined than anything Pollock had ever done before. The wildness is in the imagery and brushwork; the discipline is in the composition, which is now unified, so that everything forms part of a web of visual movement. From this point onward, Pollock's paintings no longer look disjointed. By going back to Benton's principles he had found a way to be even wilder than before and yet to make paintings that held together.

One of Benton's central tenets was that one should start with a "grand design." Given all the ink that has been spilled over Pollock's work, it is odd that no one has ever noted Pollock's central step in mapping out the composition—one that combined ordering principles with a stark declaration of his expressive message. As should be evident, this was Pollock's chance to make a mural as big and splashy and important

as what Benton had done, something he had never been able to do, or even come close to, during his years as Benton's student. This was his chance to make a painting that shattered previous accomplishments and defined the character of a decade, as Benton had in *America Today*. Indeed, in oedipal terms he was carrying out a violent act, since he needed to slay the father, he wanted to lay Benton in the dust.

In fact, his decision was curiously logical and straightforward. He simply wrote the words "Jackson Pollock" very large across the canvas.* By a nice coincidence, both first and last name had the same number of letters, so it wasn't hard to make them fit. So as not to make the effect too obvious, he introduced some dazzle patterns, like those used to camouflage a ship, which makes the outlines a little difficult to read, but the "son" on the right is not too hard to make out, the big *J* on the right is quite clear when you know that you should look for it, and with a bit of examination it's not too hard to make out the other letters one by one. "Jackson" is written more clearly than "Pollock," but with careful looking that also becomes visible. This could hardly be random coincidence, since while some letters, like *O* form shapes that are easily found in most tangles of line, this is not the case with letters like *K* or *N*, and to find all these letters in the right order just by accident seems extremely unlikely. And it isn't possible to spell out any other names in the painting, so far as I can discern.

Indeed, the "Jackson Pollock" makes sense in relation to the meaning of the piece. The whole point of *Mural* was to declare that Jackson Pollock was a great painter—as great as Benton, as great as anyone. The painting is essentially a big billboard for Jackson Pollock. Once he had written the letters of his name, he then hung the imagery of the painting from them.

But of course, as has already been suggested, Pollock did not wish to be too obvious. Significantly, these letters are not easy to read, since Pollock disguised them according to principles of camouflage that he had absorbed from Benton and other artists in Benton's circle. While it's not hard to make out the letters one by one, it's extremely difficult to read

* Thanks to my wife, Marianne Berardi, who observed these hidden letters while she was looking at a reproduction of the painting with me. Curiously, at the time she was looking at the painting upside down.

the name as a whole. Pollock, in short, created a kind of imagery which is no longer possible to take in at a single glance. Like a Benton mural, we need to absorb it piece by piece, psychologically overwhelmed until we are caught up in the forceful rhythm that runs through every part and creates an almost miraculous sense of overall unity.

Scholars have generally traced Pollock's disruptive handling of form to cubism, but in fact his technique relies more on camouflage, a mode of painting that has a very different history.

Although it was one of the two or three most important innovations of twentieth-century art, camouflage has received little attention from art historians, no doubt in large part because it was developed not by a giant of modern art but by a turn-of-the century American academic painter, Abbott Thayer, who maintained a rambling complex in the artist's colony of Dublin, New Hampshire, in the shadow of Mount Monadnock. Thayer's interest in camouflage was an outgrowth of a fascination with birds that began in early childhood. By the time he was in his early teens, if he was given a feather, he could immediately identify the bird it came from. As he studied feather patterns he became convinced that they served a protective function, helping birds to blend inconspicuously into their environment. Types of camouflage have existed since ancient times, but Thayer was the first to systematically study the subject and reduce camouflage to a set of fundamental principles. In essence, Thayer recognized that bird feathers and animal skins are a sort of "abstract painting" of an animal's environment, mimicking the essential qualities of a background without reproducing it literally.

Thayer reduced camouflage to three basic principles. The first is the most obvious, that a camouflaged object should blend with the color of its background. Interestingly, however, if this is the only principle applied, an object is quite easy to discern. Successful camouflage depends on two other, less obvious, tricks. Thayer's second principle is that a camouflaged object should contain strong patterns that disrupt how one reads its form. This is counterintuitive, since we tend to think of camouflage as something that harmonizes and matches a form with its background. But in practice the bold patterns that disrupt our ability to read an object's silhouette make it merge into its surroundings. Thayer's third principle is that of countershading. Generally objects are top-lit by the sun, and consequently we expect them to be brighter on the top than on

the bottom. If one paints the top of an object a dark color, such as black, and the bottom a light color, such as white, it will throw off this expectation and make the object virtually disappear. In fact, countershading alone is a surprisingly effective form of camouflage, even when used with colors that don't match with the background.

During World War I Thayer's discoveries were adopted for military purposes, and in this way they were disseminated to a wide audience of American painters. As has been mentioned, Benton worked with camouflage in the navy, and his close friend William Yarrow (who also flirted briefly with Synchromism) commanded one of the U.S. Army's camouflage divisions, where he supervised the Ohio modernist Charles Burchfield. The elaborate compositional exercises that Benton gave to Pollock, with their systematic alternations of light and dark and of figure-ground relationships, essentially played with the ways in which a form could be asserted or concealed, emphasized or camouflaged.

In his Peggy Guggenheim mural, Pollock employed all three of Thayer's principles of camouflage. Symbolically, the technique allowed him to play with layers of meaning—to create shapes that dissolve into very different shapes, with different meanings, whose interplay suggests different layers of experience or consciousness. Visually, it allowed him to create patterns that were not static but continually energized and that form and re-form in endless visual combinations. In short, it allowed him to expand on what Benton had done in *America Today* and create an even more dynamic sort of visual field.

Is there a general subject or theme to the painting? In addition to the letters, the mural clearly contains figures—not simply the line of totem-like figures that establish the general rhythm but a rich assortment of heads and bodies and body parts, which morph strangely into each other. Thus, it's natural to ask just what these figures are doing, what sort of iconography the design contains. Unfortunately, Pollock left few verbal clues about the subject matter of *Mural*, although once, in discussing the painting with a friend, he mentioned a stampede of mustangs he witnessed as a teenager in the Grand Canyon. In fact, there are several horses' heads in the painting, on the right-hand side, which could well record this event.

To go further in decoding the subject, we must simply look closely at the painting itself. As several writers have noted, the row of totem-like

figures is similar to a photographic study of sequential motion, such as those made by Eadweard Muybridge of men and women walking, jumping, lifting, dressing, undressing, and so forth. Pollock was surely familiar with this sort of photograph, since his friend Herbert Matter made studies of this type, and such photographs were also featured in 1943 in an exhibition at the Museum of Modern Art, which he probably attended. Since many of Pollock's paintings of this period seem to be, at least in part, autobiographical records of childhood memories (such as the family dinner table when he was a child), my original thought was that *Mural* might represent the sequential stages of Pollock's life, going from childhood on the left to the wild stampede he witnessed as a teenager on the right. According to this view, the subject of the painting would be the stages of life, presented in autobiographical terms.

In part this may be correct. For example, I can make out what seems to be the figure of a child on the left, who is accompanied by an animal of some sort, perhaps a dog. But to a large degree the various heads and figures that are scattered through the painting don't seem to lend themselves to a unified narrative reading. In fact, my sense is that what Pollock did was to let the play of brushstrokes and shapes in the design conjure up images almost at random, in a fashion somewhat similar to the prehistoric cave painters, who often allowed the irregularities in the wall of a cavern to conjure up the image of an animal, which they would then "bring out" through a few deft lines. The process is a psychologically peculiar one, for as Picasso once pointed out, it is not so much one of imposing an image as of waiting until one can see the image that is already lurking on the wall of the cave and then accentuating it.

My belief, in short, is that while he may have been partly inspired by memories of a mustang stampede, to a large degree Pollock did not decide on the subject matter in advance but simply worked across the surface of the painting, looking for heads and figures that were suggested by the play of shapes. In practice, those shapes that he was most adept at producing were closely related to those he had produced in his psychoanalytic drawings a few years earlier. The horses, for example, may have been partly inspired by his childhood memory but also came into the painting because he had developed the skill of drawing horses as a result of making copies and free variations of Picasso's painting *Guernica*.

Thus, the process wasn't entirely innocent or pure, and the images

weren't solely the product of Pollock's unconscious (although he surely aspired for them to be that). Nonetheless, what was striking about Pollock's process was that except for the letters that established the framework of the design, the imagery was not imposed in advance but produced in response to the actual act of creating the piece. In short, unlike most of Pollock's earlier work, *Mural* did not have a single coherent story but was a far freer combination of imagery—deriving unity not from a coherent narrative program but simply through the discipline of fusing almost randomly generated elements into a rhythmically harmonious composition. In a sense, once a very general framework was laid out, the act of making determined the subject.

What Next?

Completing *Mural* marked a huge forward step for Pollock, but at that point his forward artistic momentum stopped. In a pattern that would be repeated even more dangerously later on, success for Pollock became a form of disaster: the pressure of shows and openings, his resentment over mixed reviews, and the fact that he had a bit of money in his pocket made him turn to drink, and this quickly made him unsociable and violent.

For a time Peggy Guggenheim seems to have tried to introduce Pollock to museum curators and prospective clients, but she gave up after a few horrific experiences. According to one account, though this has been challenged, at a party in Guggenheim's apartment, Jackson entered and crossed the room, unzipped his pants, and peed into the marble fireplace.

"He didn't help me sell paintings at all," Guggenheim complained, "because he was drunk all the time." At one lunch in the dining room of the Chelsea Hotel, he became so drunk that he vomited on the carpet. When he was not drinking he was "perfectly nice," in fact rather sweet, but these occasions were rare. Throughout the winter of 1944 he was rarely sober for long. Thus, for example, when Marie Piacenza invited him back to her apartment to see some paintings, he emptied an entire bottle of whiskey within minutes. When she brought him to a restaurant to get some coffee, he began to smash up the place, and they threw him out. The painter Steve Wheeler recalled finding him sitting alone on a park bench in the middle of Washington Square one morning, appar-

ently recovering from an all-night debauch. "He had very little to say," Wheeler recalled. "Just feints and grunts. So we went over to a bar and got tanked up."

As with Benton earlier, Pollock's splash of attention and publicity brought an end to many of his friendships. Balcomb Greene didn't like the work, finding it too uncontrolled. John Graham broke off contact, maintaining that Pollock had "betrayed" Picasso, even though he himself was also drifting away from modernist dogma. Like Benton, Pollock reacted to the rejection with an excessive boastfulness, bragging to everyone, even to young girls at parties, that he was a great artist. He grew increasingly intolerant of anyone who worked differently than he did. In May he burst into Louis Ribak's studio on Twenty-first Street and told him he shouldn't do representational work. When Ribak resisted, Pollock picked up a hammer and said, "I'm going to kill you."

As should be apparent from her biography, Peggy Guggenheim was utterly promiscuous. To make sex quick and easy, she did not bother to wear underwear. David Hare, who visited her country place around this time, recalled that she tried to seduce him but was not too distressed when he declined. Instead of having sex she got drunk. The next morning she could not remember whether she had slept with him or not.

Predictably, Peggy is said to have attempted to go to bed with Pollock, although there are contradictory stories about what happened. It's variously reported that Pollock went to bed with her wearing his cowboy boots, that he threw his underwear out the window, that he was too drunk to perform, that he passed out, and that he peed on the mattress. Whatever happened, it was evidently not a big success. While Guggenheim later spoke glowingly of Pollock's achievement as an artist, she was less flattering about his qualities as a human being, describing him as "a poor frightened animal that should have stayed in its burrow."

Although Pollock had essentially checked out of his career in an orgy of alcohol and misbehavior, the publicity machine moved forward with a momentum of its own. His paintings were included in shows that toured museums around the country and were shown in commercial galleries in New York and Washington, D.C. Robert Motherwell wrote about him in the *Partisan Review*. He made a number of major sales, including one to Thomas Hess, editor of *Art News*. Fame rushed forward, even though Pollock's ability to make paintings was faltering. As he

shifted his allegiance from Benton's Regionalist circle to the Peggy Guggenheim modernist group, Pollock began making nasty cracks about Benton in his interviews and statements. The first of these appeared in a carefully scripted "interview" published in February 1944 in *Art & Architecture*, about a year after his first show at Art of This Century. Pollock was asked how his study of Benton had affected him and replied:

> My work with Benton was important as something against which to react very strongly later on; in this way, it was better to have worked with him than with a less resistant personality who would have provided a much less strong opposition.
>
> *Do you think there can be a purely American art?*
>
> The idea of an isolated American painting, so popular in this country during the thirties, seems absurd to me, just as the idea of creating a purely American mathematics or physics would seem absurd.

There's some question about whether Pollock actually said these words, which are phrased in a way that hardly sounds like normal conversation. Some scholars think the whole interview was scripted by Robert Motherwell or Howard Putzel. But from this time onward Pollock repeated these ideas, with slight variations of wording, in many of his public statements. The notion that he had repudiated Benton became part of his rebellious persona, and no doubt a necessary ticket of entrance to the radical modernist group.

In their personal contacts with each other, however, the warmth and electricity between Pollock and Benton seems to have remained pretty much unchanged. In early June 1944, for example, five months after Pollock's jibes at him in *Art & Architecture*, Thomas Hart Benton came through New York on his way to Martha's Vineyard and ran over to Pollock's apartment to see him. He had read some positive reviews of Pollock's first show at Peggy Guggenheim's gallery and wanted to congratulate him in person. When he shouted up from the street, Jackson poked his head out the window to see what was happening and then ran down the stairs and greeted his old mentor effusively. With Jackson's encouragement, Benton asked to see Lee's paintings, but when she showed them to him he was silent, and she immediately concluded that

he felt that they weren't any good. A few moments later, the two men headed off to have a beer together, while she remained in the apartment. It was a moment for male bonding, and Lee immediately recognized that she was an outsider. Pollock later noted in a letter that Benton told him that his work was "good," although he questioned whether the compliment was sincere. From many later statements that Benton made, it seems likely that he complimented Pollock on his "color"—that is to say, the rich emotional quality of his paint textures—and probably tactfully avoided discussing Pollock's "drawing," which by Benton's standards seemed thoroughly inadequate.

This seems to have been the last time the two met face-to-face (Benton once specifically stated that he last saw Pollock in 1944), but in October 1947, after Pollock had moved to Springs, and ten months after he had started making his famous drip paintings, he asked Benton to write a letter on his behalf to the Guggenheim Foundation, in support of an application for financial support. Clement Greenberg and James Johnson Sweeney wrote the other two recommendations. "I believe the easel picture to be a dying form," Pollock wrote, "and the tendency of modern feeling is towards the wall picture or mural. I believe the time is not yet ripe for a full transition from easel to mural. The pictures I contemplate painting would constitute a halfway state, and an attempt to point out the direction of the future without arriving there completely." It seems unlikely that Benton thought much of this rather wishy-washy statement or was very clear about what Pollock was doing. But he loyally—and I believe sincerely—wrote a warm letter of support on behalf of his errant artistic son. Pollock fit his criterion of what being an artist was all about—he was real. "Very much an artist," Benton wrote. "In my opinion one of the few original painters to come up in the last 10 years. Gifted colorist. Whether or not he lives up to what he intends, money would not be wasted."

The Flight from New York

By 1945 Pollock had found the support of a major art dealer and had gained the attention of the Museum of Modern Art. His work was included in major traveling exhibitions, and he was getting a lot of press. Nonetheless, Pollock would probably be only a footnote in the history of modern art were it not for the works he produced after 1945—the drip paintings for which he is now world famous. Their creation coincided with a dramatic change in lifestyle. As Benton had done precisely ten years earlier, Pollock decided to leave New York City. The impetus for this decision came in the summer of 1945, when Jackson and Lee stayed with Reuben and Barbara Kadish at their beach house on the eastern tip of Long Island. Lee noted that while Jackson didn't do any work to speak of, he also stopped getting drunk. With fewer outside distractions, such as bars or friends dropping by, he was easier to keep in line. The notion occurred to her that it might be good to move out of the city.

As usual, with Lee and Jackson, the process of coming to a final decision was argumentative and difficult. When Lee first proposed leaving New York, Jackson was extremely resistant. After a while he became enthusiastic, but Lee in turn began to balk. Finally they both decided it would be a good idea.

Lee made all the arrangements and was the one who got in touch with a real estate agent. She quickly settled on a two-story, nineteenth-century farmhouse in Springs, near Amagansett, with a small barn and

some other sheds in the back. It had running water in the kitchen and electricity but no bathroom and no heat. The rent was forty dollars a month or five thousand dollars to purchase. They decided to rent for six months with an option to buy within that period. To come up with the money they wheedled a loan out of Peggy Guggenheim, to be paid for with the sale of future paintings. As usual when dealing with Peggy, she was generous in a way that made gratitude difficult: the terms were confusing and complicated.

On October 25, 1945, while these arrangements were moving forward, Jackson and Lee were married, in a hastily arranged ceremony with just two witnesses, strangely reminiscent of the marriage forty-three years earlier of Pollock's parents, Stella and Roy. Again, it was the woman who took the dominant role. Alma Pollock, the wife of Jackson's brother Jay, later commented that "the marriage did what it was supposed to do. It gave Lee more control." A few days later they left New York.

Springs was strikingly like the Benton place on Martha's Vineyard—in snapshots it would be easy to get the two places confused—and Pollock's barn, where he made his most famous paintings, was strikingly similar to the barns and sheds on the Benton compound. In fact, it was a slightly larger version of Jack's Shack. When Pollock arrived, Springs, just like the Vineyard, was still dominated by a handful of families—Bennett, Miller, King, Parson, Talmage—who had been there for generations and still made their living from the sea. The residents viewed Lee and Jackson with skepticism because of their different last names and because no one ever saw Pollock do a day's work. They were suspicious because he used a rope rather than a belt to hold up his pants, because he often didn't shave, nor did he dress up or go to church.

The period from 1946 to 1950 was the longest sustained period of productivity of Pollock's life. The move was something close to a new start. When they quit New York, they left all of Pollock's finished canvases at Art of This Century and took only sketchbooks, canvas, and artist's materials—a blank slate on which to begin afresh. Most of their New York friends were no longer welcome, at least as casual drop-bys, for Lee feared they would encourage Jackson to start drinking again. When the Kadishes dropped by to visit, Lee shooed them away. Jackson soon found a local bar, Jungle Pete's, but he seems to have kept his drinking

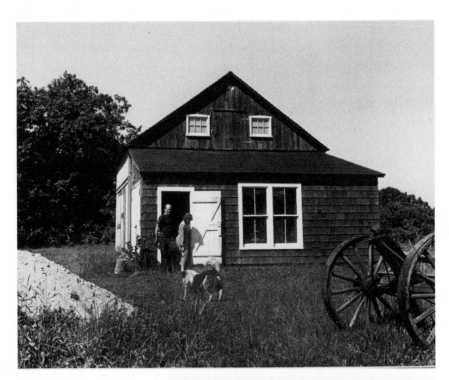

Pollock's house at Springs (top) looked very much like the Benton place on Martha's Vineyard. (*Top*: Photo by Hans Namuth [1950]. Estate of Hans Namuth, courtesy of the Center for Creative Photography, Tucson, Arizona. *Bottom*: Photograph by Fritz Menle. Courtesy of Jessie Benton.)

under control, in part because he didn't have a car and getting away from the house wasn't easy. For the most part his only excursion was to ride his bicycle to Miller's store to get groceries.

In New York Jackson had developed a schedule that was exactly the reverse of normal: sleeping all day and working through the night. At Springs he went back to a schedule that was a little more in tune with the pattern of the daylight, although he generally got up rather late, somewhere between ten and noon, and took an hour or two to get started while he sat quietly at the table, staring out the window and often nursing a cigarette or a cup of coffee. Lee, who got up earlier, cleaned the house and tended the garden while he slept. She kept the phone off the hook so he wouldn't be wakened.

Around one o'clock, Jackson went to the barn to paint, and Lee spent the afternoon making phone calls to dealers and collectors. She seems to have enjoyed the constant bargaining. Around five or six, Jackson would emerge from the studio, and they would have a beer or a walk on the beach. Then they would have dinner and spend the evening conversing with friends. On the weekends they generally had houseguests. Lee did most of the cooking, although sometimes Jackson would take on some special task such as cooking spaghetti and meat sauce according to a recipe he had learned from Rita Benton.

The winter of 1945–46 was particularly brutal, and Lee recalled it later as hell, with no fuel, hot water, or bathroom. They spent weeks cleaning up the house so that Jackson could paint in an upstairs bedroom and Lee in the living room. Always uneven in his work habits, Jackson did no painting until his mother arrived in January 1946 (Jackson and Lee came to Springs in November), when he painted four or five canvases, including one of a mother giving birth to a child—*The Child Proceeds.* He also did a painting called *Circumcision,* which might be seen as a reflection of fear of castration. In a letter to Louis Bunce in 1946 he noted that the move to Long Island had been difficult, that changing his space and light had thrown off his painting, and that there was still much work to be done to fix up the place. "Lee and I are trying the country life for a while," he noted. "[It's] a good feeling to be out of New York for a spell."

In April 1946 Pollock had another exhibition at Art of This Century, which was something of an anticlimax, since the work wasn't notably

different from what he had shown before and about half of the paintings had been executed before the move to Springs. Most of the reviews were reasonably favorable, no doubt because the critics had finally grown somewhat accustomed to his work and the show was somehow less frightening than earlier displays. As an event to talk about, it was completely overshadowed by the publication of Peggy Guggenheim's scandalous memoir, *Out of This Century*, which had been released in March and was still stirring up violent reactions. Pollock, however, got good exposure from that controversy as well, since one of his paintings was reproduced on the back cover of the book, his only book cover. The front cover was designed by Max Ernst.

When the weather warmed in spring, Jackson spent a great deal of time roaming around the property, planted a vegetable garden, and adopted a mongrel collie he called Gyp, after his boyhood companion. Lee did little painting at this time. In June he converted the barn into a studio and began painting there. His works of the summer and fall are Matisse-like and not particularly commanding.

Jackson continued to drink and was added to the local police list of drinkers who often needed a ride home, but he mostly drank socially and seldom became violent. Greenberg was impressed with a new painting, *Something of the Past*, and said to Jackson, "That's interesting. Why don't you do eight or ten of those?" Jackson followed his advice and began producing more radical, more agonized paintings, such as *Eyes in the Heat*, *Croaking Movement*, *Earth Worms*, and *Shimmering Substance*. When he finished *Eyes in the Heat* he told Lee, "That's for Clem." In 1947, as has been noted, even as the weather grew cold, Jackson continued to paint. It was at this point that he began to produce the drip paintings for which he is now remembered.

Curiously, in the period just before his greatest achievements, Pollock lost two of his early supporters. In 1944 the gifted but unfortunate Howard Putzel, who had tired of working for Peggy Guggenheim, started his own gallery, where he staged remarkable shows of cutting-edge art but quickly fell into desperate financial straits. He committed suicide in August of 1945, and thus did not live to see Pollock fulfill his artistic promise. Two years later, in 1947, Peggy Guggenheim closed Art of This Century, in part because of the departure of Putzel, who had

done much of the day-to-day work of keeping it going. She then moved back to Europe, settling in Venice, and largely abandoned her engagement with American art, staging a last show of Pollock's work from January 14 to April 1 of 1947. Ironically, she cut herself off from Pollock at the very moment when he moved to leadership of American art.

Heroic Gestures

If personality is an unbroken series of successful gestures, then there was something gorgeous about him, some heightened sensitivity to the promises of life, as if he were related to one of those intricate machines that register earthquakes ten thousand miles away. This responsiveness had nothing to do with that flabby impressionability which is dignified under the name of the "creative temperament"—it was an extraordinary gift for hope, a romantic readiness such as I have never found in any other person and which it is not likely I shall ever find again.

—*F. Scott Fitzgerald*, The Great Gatsby

The Hollow and the Bump

Since his traumatic visit to Kansas City in 1939, Pollock had been steadily moving away from the influence of Thomas Hart Benton. Speaking loosely, one might see this development in three stages. When he first began to move away from Benton, Pollock looked to artists who were Benton's friends, such as Ross Braught or José Clemente Orozco. Quite rapidly, however, he moved into what might be termed his "John Graham phase," when he moved to modern influences outside Benton's orbit, creating a synthesis of Picasso, primitive art, and images and symbols drawn from Jungian theories of the unconscious. Finally, through the influence of Lee Krasner, Clement Greenberg, and Peggy Guggenheim, he began to move into a still freer mode of modern expression, heavily influenced by Surrealism and theories of automatic gesture. Throughout this period, while from time to time one picks up an echo of Benton, his general movement was steadily away from Benton, both in subject matter and technique. In fact, he was clearly struggling to "break with the father"—to become separate from him.

But at the point when he began making the famous drip paintings, something fascinating and curious occurred. Pollock began to move back toward Benton's methods. At the beginning of this book I noted that there is a perfect correspondence between the compositions of Pollock's drip paintings and the diagrams in a group of articles that Benton wrote on how to create an abstract composition. This parallel has long been noted but has had surprisingly little influence on Pollock scholarship.

Kirk Varnedoe, for example, dismissed the connection as simply "mechanical" and quickly brushed past it, to focus on other subjects. Pepe Karmel, in a summary of recent scholarship on Pollock, has noted that this suggestion has had virtually no impact on anything written about Pollock for the last two decades. What would happen if we traveled a little further down this road to see if it is really a dead end?

In fact, two aspects of Pollock's relationship with Benton have never been carefully considered. First is the question of how Pollock drew on Benton's system of design mechanics when composing his paintings. In other words, given that his paintings look much like Benton's diagrams, what was the method that these diagrams seek to explicate, and how did Pollock draw from it? Second is the question of whether Benton's system sheds light on the ultimate meaning of Pollock's paintings and on his artistic intentions. In other words, was Benton's system completely mechanical, or was it based on deeper assumptions about form and expression that might illuminate the deepest meaning of Pollock's work? As we have seen, Benton's methods were largely drawn from those of the Synchromists, which in turn were drawn from figures such as Rodin, Cézanne, Matisse, Picasso, the Orphists, and the Fauves. Could it be that this way of thinking about form and expression in some fashion illuminates what Pollock's paintings are all about? Such a view goes against the prevailing doctrine of how Pollock fits into art history. They are normally seen as derived from Cubism and Surrealism. But what if they derived instead from Synchromism? In other words, let's explore the possibility that Benton taught Pollock a special method of achieving visual rhythm, and of reaching for cosmic connections, and that this method had a rich intellectual history.

In saying this I do not wish to discount the fact that Pollock's drip paintings are also influenced by the modernist sources already listed—Picasso, Jung, Hans Hofmann, the Surrealists, and so forth. But Pollock returned to some of Benton's fundamental harmonics in shaping these new influences. Thus he produced an art whose surface traits are utterly different from that of Benton but whose underlying principles are remarkably similar. And most significant, he made an art that has a new look, that moves beyond what other modernists were doing.

No writer on Pollock has ever explored his connection with Synchromism—has even mentioned Synchromism—but since Benton's

ideas were based on Synchromism, it can be illuminating to explore the ways in which Pollock's work connects with Synchromist art and theory. This is partly because Pollock was surely at least dimly aware of the work of the Synchromists. More profoundly, it reflects the fact that by putting Benton's techniques in reverse, as it were, and going back to a more abstract approach, he reconstituted many of Synchromism's goals, strategies, and techniques. Pollock often saw through Benton to what lay behind his achievements.

My point is not that Pollock's paintings are identical to those of Benton, but something just slightly more subtle and for that reason more difficult for most art historians to grasp: the notion that Benton's form of composition, his pattern of artistic creativity, and his concept of the artistic self, provided the essential reference point for Pollock's forward leaps. In his mature art, Pollock sometimes affirmed Benton and sometimes denied him, but Benton's frameworks were his starting point. And because Benton's ideas were unfamiliar to most of his contemporaries, this gave his processes a quality of mystery that was mesmerizing. Watching Pollock dance around his canvas, it was clear that he had some occult principle that determined his moves, if not altogether precisely, at least in a general sense. One could see that his splashings were not purely chaotic but determined by organizing principles. Benton's contemporaries, however, could not quite figure out what these principles were—and whether because he was secretive or simply inarticulate, Pollock did not tell them.

The Hans Namuth Photos

As many writers have noted, Hans Namuth's photographs and film of Pollock at work very quickly became as famous and widely reproduced as any of Pollock's actual paintings. While issues of flatness and spatial representation were frequently raised by critics like Greenberg, most of the public, even the educated public, had very little understanding of what Greenberg was talking about. In popular discourse, the wildness with which Pollock dripped paint, the fact that he dripped paint from cans, was the thing that stirred up immediate discussion and argument. For this period it was utterly startling that Pollock had thrown aside the usual tools of paintbrush and easel and was making paintings in a seemingly

"When I am in my painting, I'm not aware of what I'm doing," Pollock wrote. "I have no fears of making changes." (Photo by Hans Namuth [1950]. Estate of Hans Namuth, courtesy the Center for Creative Photography, Tucson, Arizona.)

wild and spontaneous new way. Some thought that this was wonderful, exhilarating; others thought that it was silly or crazy and that the result was not worth serious consideration as art. Namuth's film and photographs brought all this to life in a remarkable way.

Most painters are not particularly interesting to watch. The work moves too slowly—even a virtuoso like Sargent, a master of bold brushwork, took a week or more to finish a large painting. The process of sitting around watching such slow activity quickly becomes tedious: one might as well watch a writer sitting at a desk. Pollock was different. He worked rapidly, sometimes finishing a large canvas in an hour or two. His movements were varied, graceful, fascinating. One could even argue that witnessing the action of Pollock painting, as we do when watching the Hans Namuth film, is more exciting than viewing the final result, since the final painting flattens the arc of his graceful movement through three-dimensional space. Pollock was not on the whole a particularly athletic or graceful figure. He played no sports; he was a bad driver, prone to crack-ups; and despite his reputation for being a cowboy, he never learned to ride a horse. When he did move, he was rather clumsy, and a good deal of the time he didn't move at all but sat brooding or drinking: often his deep depression made him completely immobile. When Pollock painted, however, he became a different person both mentally and physically. He painted with his whole body—not simply with wrist movements but moving his torso and arms and legs; his body moves like a dancer's, thoughtfully but also with confidence and grace. What in the final painting is simply a splash or a drip becomes something still more complicated: each touch engages Pollock's body differently, in fascinating ways. Visual decisions are always more complicated than they appear, as anyone who has tried to place a desk and a bookshelf in a room can testify, both because the possibilities are very numerous and because each step limits what can happen afterward. Even "simple" solutions are curiously complex, since they entail organizing and sequencing so many variables. Where did Pollock's decisions come from? How were they made?

At first Pollock seems to move almost drunkenly across the picture surface, but as we watch further we sense some deeper underlying purpose behind the movement, a quality that Pollock defined rather ambiguously as "being in contact" with the picture. We instinctively sense that

Pollock's application of paint is purposeful and intelligent, but at the same time it's hard to predict what he's going to do and hard to explain his decisions, which, in any case, are made so quickly, with so little pause, that they clearly rely on some deep-rooted instinct, like that of a shortstop catching a baseball, and thus are hard to reduce to a set of clear-cut directions. Indeed, there's a trance-like quality to Pollock's movement that seems slightly out of touch with what's going on around him, not unlike the trance of a shaman, and it's notable that Pollock, who always spoke of the "openness" of his paintings, preferred to work in spaces that were closed, with no windows, no distractions. What's happening "out there" is clearly drawn from somewhere deep inside his head, somewhere perhaps not even fully accessible to normal consciousness.

For all their seeming freedom, Pollock's paintings clearly were based on following certain "rules," and while the basic rules were often simple, it was not easy to get them to work in accord with each other. Even a first-time viewer of the Hans Namuth film showing Pollock at work can begin to sense the problems he was struggling with. The shots showing him from underneath painting on glass are particularly interesting. The first splashes are invariably beautiful, as they trace a graceful arabesque across the surface. But as the paint becomes more layered, maintaining a sense of grace becomes more difficult. It requires not only making a pattern that is beautiful in itself but interweaving the design with the pattern that is already laid down. As more paint goes on, the sense of pattern starts to disappear, producing just texture or, even worse, just muckiness. In fact, at one moment in the Namuth film, Pollock stops, admits that he has "lost contact" with the painting, wipes the pigment off the glass with a rag, and starts over. The challenge of Pollock's technique was to go far enough to create a sense of richness, of complexity, of interweaving, as he did in his best paintings, such as *Cathedral* or *Autumn Rhythm*, but at the same time to stop before it got mucky; or, alternatively, even after he had created muck, to make a gesture so assertive that it restored the sense of pattern, as he did with *Blue Poles*—a painting that he nearly lost, which is generally regarded as less successful than his very best but which is nonetheless impressive and overwhelming in its impact. When everything worked properly, Pollock created a remarkable sense of rhythm, which holds all the accidents together in a precarious

visual harmony. In fact, Pollock clearly had some tricks for getting everything to work together.

The Traditional View

To understand Pollock's achievement, we first need to rid ourselves of some basic misconceptions about his work. In large part due to the influence of Clement Greenberg, for many years two false assumptions have dominated writing about Pollock.

For one thing, for decades the prevailing view has been that Pollock's paintings are flat—or at least that they create some hard-to-define state that glorifies flatness and does not conform to traditional Renaissance principles of perspective and pictorial illusion. For Pollock's defenders, insisting that he rejected Renaissance space became a matter of weighty consequence. First, they wanted to establish that he based his art on Analytical Cubism, the most esoteric and prestigious of modern styles, and thus that his paintings fit squarely within what one might term "the great tradition" of modern painting—the tradition of high European modernism represented by such figures as Matisse, Picasso, Miró, Mondrian, and so forth. Since Cubism does not portray a space that functions in Renaissance terms, clearly Pollock's paintings could not do so either. Second, they aspired to show that Pollock's art lifted the viewer into a paranormal realm, a kind of equivalent of the religious or the holy or the spiritual—although somehow it translated these qualities into "modern terms," similar to those of non-Euclidian mathematics and modern physics. If Pollock's art was to transcend normal principles of reality, clearly it could not conform to the rules of commonsense Renaissance space but must function differently.

Clement Greenberg, who first developed this argument, presented it somewhat cryptically, not so much through coherent exposition as through hints, innuendos, and occasional passing comments, such as his praise for the "rich fulginous flatness" of Pollock's work. But the notion of "flatness" gained in power when picked up and elaborated by two intellectual disciples, William Rubin and Michael Fried. Notably, while Greenberg was something of an outsider and amateur, without institutional backing or even a graduate degree, Rubin and Fried brought institutional power to their pronouncements. Rubin served as the chief

curator at the Museum of Modern Art, by then quite possibly the most powerful and prestigious art museum in the world; Fried was on the faculty of Harvard, then perhaps the top-ranked university in the world, with the oldest and most prestigious department of art history in the United States. Since the art world has always been keenly attuned to hierarchies, their words carried great weight. Moreover, both published their views in *Artforum*, at the time America's most prestigious magazine for modern art, and one that prided itself on the intellectualism of its content.

William Rubin, the more doctrinaire of the two, produced three weighty articles—the equivalent of a short book—in which he set out to fit Pollock into the history of modern art, that is, to demonstrate that Pollock fit into the chain of great artists on view in the Museum of Modern Art and that his genius was a reflection of this tradition. In his opening paragraphs he specifically dismissed the idea that anything outside this tradition was worthy of being considered, and throughout his essay he took swipes at ways of thinking that drew on sources even slightly outside the traditional modernist lineage, such as Jung or Oriental philosophy. Essentially, his article runs through a grab bag of work by the major masters of modern art—Claude Monet, Pablo Picasso, Joan Miró, the Surrealists, and so forth—searching for visual parallels of some sort that foreshadow Pollock's achievement.

This often entailed disregarding what we know of Pollock's taste. For example, in Rubin's scheme Pollock's art was directly based on Analytical Cubism, whereas in fact Pollock does not seem to have cared for this kind of painting, finding it unemotional and flavorless. It also often required stretching the bounds of credibility. For example, the paintings by Monet that Rubin cited as most strikingly similar to Pollock's work are paintings that came to light only after Pollock's death.

But the deeper problem is that after having gone through this laborious, long-winded exercise, the examples fall short: the most notable qualities of Pollock's art remain unexplained. Rubin himself confessed that there was some principle that he could not quite isolate by which Pollock incorporated seeming accidents into some scheme of pictorial order. At one point he provided a summary description of was constituted the greatness of Pollock's achievement, noting that "the precarious poise of an all-over, single image is achieved through the equally precari-

ous balancing of virtually endless symmetries." But how Pollock achieved this effect, which transcended any of his modernist sources, Rubin could not explain except to insist that in some mysterious way he was a "genius."

Michael Fried, on the other hand, who expressed himself more briefly, in a single essay, largely disregarded historical precedents and focused on the visual and emotional experience of a Pollock painting, which he described in terms that are essentially religious or mystical. In Fried's view Pollock had achieved some sort of almost nonphysical visual state that moved pictorial space into a realm never before achieved, some aesthetic equivalence to spiritual transcendence. In describing the experience of a Pollock painting, he wrote:

> There is only a pictorial field so homogenous, overall and devoid both of recognizable objects and of abstract shapes that I want to call it "optical," to distinguish it from the structured, essentially tactile pictorial field of previous modernist painting from Cubism to de Kooning and even Hans Hofmann. Pollock's field is optical because it is addressed to eyesight alone. The materiality of the pigment is rendered sheerly visual, and the result is a new kind of space.

Writing like this is hard to follow since it is religious rather than logical. What impresses one most forcefully is Fried's conviction that Pollock has created "a new kind of space," one that seems to transcend normal reality. But the description of this space and the claims made about it don't hold up well. In fact, Fried's exposition pushed forward several rather obvious misrepresentations.

For one thing, Fried insisted that Pollock's work is essentially linear, that it can be reduced to lines or a kind of "drawing," when it's obvious that his use of dripped paint was far more evocative and complex. In actual fact, Pollock's drips are closer to brushstrokes than to lines, although in some ways even more versatile, since they pool and layer and coagulate in fascinating ways. And brushstrokes don't serve the simple purpose of making lines. They can also evoke surface or mass; and somewhat paradoxically, they can wonderfully suggest vast expanses of empty space—a flat patch of blue, for example, can evoke the infinite

depth of the sky. Pollock's drips, in short, in a fashion somewhat like brushstrokes, are not a simple but a complicated tool, which serves a great variety of visual purposes.

Second, Fried presumed that line in traditional drawing is a mere device for rendering contours and shaping solid forms; thus, in going beyond these functions, Pollock did something fundamentally new. But this reductive view of the traditional role of line is incorrect. In rendering such things as foliage, for example, skilled artists employ a complex layering of lines that often don't clearly correspond to actual contours and can't be interpreted in that fashion but evoke the "texture" of what we see. In many respects Pollock's paintings have more affinity with this sort of academic draftsmanship than they do with the flat surfaces of modern abstractionists such as Mondrian, or even Picasso.

More profoundly, Fried's insistence on optical qualities seems to miss the real point of what Pollock's paintings are all about. Anyone familiar with the films of Pollock painting knows that he did not spend a lot of time looking at his canvas or, like an Impressionist, looking at the world around him and analyzing his visual sensations. His approach was more physical, gestural, and intuitive; it clearly stemmed from some realm beyond or different from that of mere sight alone. Indeed, one almost feels that Pollock could have been blind and have produced paintings quite similar to those he did, just as Matisse was able to produce sculpture while blindfolded. In short, Fried's analysis not only misrepresents the visual attributes of Pollock's work but fails to grasp its deeper emotional, expressive, and muscular qualities.

What is stirring about the statements of both Rubin and Fried is their intense appreciation of the visual excitement of Pollock's work. But neither argument is particularly convincing either as art history or visual description. Ultimately, the misconceptions go back to Greenberg, although personally I feel fairly charitable toward Greenberg's errors. New things are extremely hard to describe, and Greenberg was clearly groping. What's more, he was touching on feelings and emotions that he found it difficult to confront. His emphasis on theory was surely a form of repression, a way of putting a lid on feelings that could easily have boiled over and become quite untidy. What is odd to me is that Rubin and Fried did not have the critical perspicacity to see that some of Greenberg's statements didn't match with reality. Instead of dropping

"His spatter is masterful, but his dribbles lack conviction." (© 1961 by Peter Arno. Courtesy of the Cartoon Bank, Condé Nast Publications.)

them, they pushed them harder, with the result that their failure to pass a simple reality test becomes quite evident.

Looking Deeply

At the risk of seeming too focused on myself, too egotistical, let me fall back on personal experience—which, after all, is the ultimate pragmatic test. Scholarship usually consists of sifting through picky little details, but there are moments when things that have hovered for some time at the periphery of consciousness suddenly flood to the forefront of attention and produce a whole new pattern of meanings. For me a moment of this sort occurred a few years ago, at the Cleveland Museum of Art, when I recognized that much of what has been written about Pollock's work does not fit with my visual experience of the paintings. The catalyst was my son, Tommy, then just three years old. We were standing in the lobby of the museum (I had just picked him up from a painting class) when he announced that he wanted to give me a tour of the collection.

Pulling me in tow, he then marched up the stairs and through the galleries, looking neither to left nor right until we were standing in front of Jackson Pollock's *Number 5, 1950*. He looked up at it with delight. "Dad, I like this one," he announced.

When I was curator at the museum I had acquired a winter scene by Grant Wood titled *January*, showing corn shocks in the snow, of which I was rather proud. It had come from the collection of the great film director King Vidor. "Would you like to see a painting by Grant Wood?" I asked. "Dad, I'm feeling tired," he responded. "I want to go home." Pollock had won the day, and Grant Wood would have to wait.

I mention the experience for two reasons. The first is that I find it interesting that, given a museum full of remarkable works of art, a three-year-old should have singled out the work of Jackson Pollock as the painting he liked best, in fact the only thing in the whole museum that it was really important to see. Explanations of what Pollock was doing often depend on rather complicated theories about the inexorable evolution of modern art toward ever greater flatness, about how the Cubists handled space, about the physics and metaphysics of gravity, about Hegel and Marxism and late capitalism, about the cold war, about the clash of ideologies and symbols, and so forth. But a child of three who knew about none of these things could nonetheless respond to Pollock's work with immediate enthusiasm. In other words, the message of a Pollock painting is something quite fundamental and visceral. He packs a punch.

The second is something more personal: Tommy's enthusiasm affected how I look at Pollock and have seen his work ever since. When he stood in front of the painting I tried to imagine what a Jackson Pollock looks like to a three-year-old, looking at it without a knowledge of art history or even much of a vocabulary—looking at it, in other words, as a visual thing rather than as something defined by words. I tried to look at it (not that anything is ever entirely innocent) with an innocent eye. I imagined that I was very small; I tried to just look without falling back on what I had been told or what I had read. At that moment I saw Jackson Pollock's work with an intensity I had never experienced before. Clement Greenberg always insisted that Pollock's paintings are flat, but in fact the experience was anything but flat. The painting not only had depth, but it seemed to move and surge in space in a fashion that almost

made me seasick. It contained waves of movement and energy that rushed back into space and that also seemed to move forward, as if they were about to pour out over me from the canvas. Frankly, Pollock's paintings have always seemed to me very illusionistic and three-dimensional, but I had always pushed that thought to the back of my mind since I knew that I was supposed to see them as flat, and I knew that I was seeing something I was not supposed to see. At this moment the obvious truth that they have enormous depth came home to me forcefully and made me realize that much of the art theory attached to them has been incorrect.

Greenberg's idea, which in fact could be applied to any painting ever made, was that since Pollock painted with paint, what we see is the flat paint upon the canvas. Of course, this is true in a certain way. Any painting, when seen in a certain way, seems like mere paint upon the surface. But when we surrender ourselves to a Pollock, what we see is movement in depth. Far from being flat and contained, Pollock's paintings convey the sense of a vast universe of space. Were this not the case, why would viewers so often compare them to stars and comets and galaxies or view them as an expression of cosmic energy?

In fact, the crusty paint surface of a Pollock painting does not so much resemble modernist painting by figures like Cézanne, Matisse, or Picasso as it does that of the academic virtuosos of the late nineteenth century, such as John Singer Sargent, Giovanni Boldini or Antonio Mancini, who in turn derived inspiration from the vigorous brushwork of seventeenth-century Baroque masters, such as Frans Hals. (Mancini's thickly crusted surfaces are particularly similar. Like Pollock, he sometimes even left cigarette butts in his pigment.) Pollock's effect, in short, resembles what in the nineteenth century was known as *facture*, a French term devised to express the relationship between a paint surface and the artist's gesture. Essentially, *facture* was a reminder that a painting is made by human hands and that gesture has an expressive meaning—in general, bold gestures correlate with a more intense expression of emotion. When we look, we thus alternate between seeing the painting as an object made by human hands with paint and seeing it as a pictorial illusion. When we come close we see paint; when we stand back we seen an image with pictorial depth. As we move back from the canvas we have the curious experience of having one way of seeing mysteriously shift to the other.

This is flatness of a sort, but one very different from the flatness of a Cubist painting, which is created by providing clues that contradict pictorial illusion. In Cubist painting, our desire to understand where the objects rest in space is constantly subverted by things that go against normal principles of perspective or vision. Surfaces that should be solid are often transparent; surfaces that would normally disappear in flickering highlights are crisply defined and geometrically clear. Surfaces such as tabletops seem to be tipped; perspective lines get farther apart as they push into the distance rather than converging on a vanishing point; we seem to see things from different angles; objects in the distance come right up to the picture plane, whereas objects in the foreground seem to dissolve and become transparent. Artists such as Picasso, in short, created a contradictory space, which we cannot interpret according to the principles of Renaissance perspective.

Significantly, Pollock's space is structured entirely differently. Pollock's paintings produce a coherent deep space. In fact, unlike a Cubist painting, there's nothing about a Pollock that in any way contradicts the principles of Baroque or Renaissance perspective. Their use of deep space is essentially Baroque in feeling. In fact, what is fascinating about Pollock's work is that the space is not flat but expansive and cosmic.

From Rodin to Pollock

When I summarized Benton's teaching methods in the first chapter, they probably did not seem very radical or inspiring, but at this point let's look at them again. As should be apparent by now, while Benton has been castigated as conservative, as the foe of modern art, the key principles of his work grew out of Synchromism, which in turn had developed from the concepts and teachings of Rodin and Matisse. Benton's key phrase, "the hollow and the bump," which was repeated like a kind of mantra, can ultimately be traced back to Rodin, who once commented that "sculpture is quite simply the art of depression and protuberance. There is no getting away from that." While so far as I know Rodin did not use the phrase "the hollow and the bump," the poet Rilke, his secretary, used a phrase that was very similar, "lumps and holes," to describe Rodin's fundamental sculptural principle.

While seemingly obvious, this principle of "lumps and holes," or of

"hollow and bump," provided Rodin with a means of getting away from the banalities of conventional academic sculpture, such as the idea of symmetry or of "ideal" beauty, and of going back to more powerful visual essentials. One might compare his new method of modeling to the musical innovations introduced through jazz, ragtime, and the blues—musical forms that suddenly made it possible to produce syncopated as well as regular rhythms and to employ sequences of tones that did not strictly follow the Western scale. An old set of rules could be discarded. A whole new world of expressive possibilities had been opened up.

In this regard it's interesting to look at the most notorious and startling of Rodin's early sculptures, *The Man with a Broken Nose*, circa 1863–64, a work that, like Pollock's paintings, was widely dismissed as "ugly" and formless when it was first exhibited and now strikes most viewers as mysteriously beautiful, in some fashion that is profoundly in tune with modern life. The broken nose, of course, boldly declares a break from classical notions of regular, symmetrical form. But somehow Rodin uses this note of discord as the key to discovering a new, more modern principle of visual organization—one might even say a form of "harmony" that emerges from seeming mutilation and disorder. Yes, the interplay of shaded hollows and highlights is not regular but unpredictable. Yet, at the same time, there's a very strong sense of some sort of overall organizing rhythm, which, unlike the deadness of much academic sculpture, pulses with the force of life.

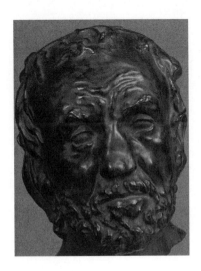

In *The Man with a Broken Nose* (cast of, 1878), Rodin pursued what the poet Rilke described as "lumps and holes," without regard for symmetry or conventional ideas of beauty. This new manner of organizing form, as passed on by Henri Matisse, Morgan Russell, and Stanton Macdonald-Wright, provided the basis for the key principle of Benton's teaching, "the hollow and the bump," which he passed on to Jackson Pollock. (Photo by Herve Lewandowski. Musee d'Orsay, Paris, France, courtesy Art Source, New York.)

Now let's imagine transforming this sculpture into a painting—one produced with drips and pourings of paint. While I don't wish to push the parallel too hard, in an intuitive way we can immediately sense that Rodin's rhythmic scheme, his overall visual effect, is rather similar in feeling to that of Pollock's drip paintings—which is not surprising, since ultimately Pollock's understanding of form can be traced back, through a series of artistic fathers and grandfathers, to Rodin.

From Rodin, this concept of "hollow and bump" was passed on to Matisse, to Russell, to Macdonald-Wright (and his brother), to Benton, and finally to Pollock. As it was passed from figure to figure, it slowly evolved, in part because it was extended from sculpture to painting and in part because it was transformed from an essentially technical trick to a cosmic and "abstract" principle, with metaphysical implications.

Most likely it was Macdonald-Wright, who had studied Oriental philosophy at the Sorbonne, who gave this principle a mystical flavor, by equating it with yin and yang. Yin and yang, of course, are the Chinese male and female cosmic principles. Presumably, Macdonald-Wright and Benton conceived the hollow as feminine, like a womb, the bump as masculine, like the male member. (Notably, some of Macdonald-Wright's paintings of 1916 are quite sexual in their imagery, with compositions that revolve around the genitals of a male figure.) Psychologically this is interesting, since it suggests that the idea of "the hollow and the bump" was not simply mechanical but involved a process of empathy and imaginative projection, of supposing that hollows and bulges were animate, energized, and sexual.

If we sum all this up and apply it to Pollock, it leads to three striking conclusions. First, the most notable feature of Pollock's work, its insistent but never quite predictable visual rhythm, is something that he learned from Benton, who in turn had absorbed the ideas of the Synchromists, Matisse, and Rodin. Second, this principle of "hollow and bump" was essentially sculptural—indeed, was based on extending notions of sculptural organization to painting. Third, while the principle began as a technical trick, it soon developed grander philosophical and metaphysical implications, since it provided a means of relating the rhythms of the figure to those of the cosmos as a whole.

Benton's Theories

While Benton did not personally like Morgan Russell, it's clear that one of the key moments of his career occurred when he visited Russell's studio in Paris and saw the sculpture that he had made. At this point it occurred to Benton that sculpture could provide a tool for thinking about pictorial form and for designing paintings. As has been discussed, he finally devised his own mature style about ten years later when he began to use clay models to work out pictorial designs.

One of the notable features of Benton's thinking about painting is how powerfully he incorporated issues that preoccupy sculptors, such as weight, gravity, the center of gravity, and what happens to forms when we turn them in space. And these are the issues that he explored in his five-part article on abstract composition, "The Mechanics of Form Organization in Painting."

The idea of balance is key to the creation of sculpture, not simply as a matter of visual expression but as a practical necessity. It's hard to make a sculpture of the human figure that will stand up without tipping over, and it's hard to make limbs and other extensions that won't break off. Sculptors soon learn to look at a lump of clay or stone and imagine the center of its weight, its center of gravity. They have to do so as a matter of practical necessity.

Good design, Benton noted, achieves balance, sequence, and rhythm. Moreover, pictorial design functions on two levels: as a design on a flat surface and as a design in sculptural depth. To diagram surface design and its flow of movement, Benton reduced designs to stick figures and to wavering lines that pass through the center of the surface form; to grasp its volumes, he reduced it to cubes. Benton got the idea for doing these cubic sketches both from the Cubists and from the drawings of the Italian Mannerist Luca Cambiaso.

Using these techniques, Benton and his students endlessly analyzed artworks of all types, including Chinese brush paintings, Persian miniatures, and the sculpture of India. But he was particularly attracted to Baroque and Mannerist painters. Jackson Pollock also made numerous analytical drawings of this type. Katherine Baetjer has identified the precise sources of Pollock's studies, and what is striking is that they focus on exactly the same artists whom Benton listed in "The Mechanics of

Form Organization": in painting, Signorelli, Tintoretto, El Greco, and Rubens, and in sculpture, Michelangelo.

Pollock's studies of the surface design of Renaissance and Baroque paintings often look surprisingly like his later "abstract" paintings. Indeed, Benton's analysis of such rhythmic relationships remained at the heart of Pollock's practice up to the end of his life. Thus, for example, Harry Jackson recalls an evening session he spent with Pollock, when he was at the height of his career:

> It's a lot of crap about Jack not talking much; he talked my goddamn ear off one long night, drinking beer in the kitchen. Jack brought out *Cahiers d'art* and analyzed Tintoretto in great detail, explaining the composition of this and that; what he was doing was bringing me pure Tom Benton: Venetian Renaissance to Tom Benton, Tom to Jack, Jack to Harry. He talked especially about composition that night, and Lee Krasner came down several times to say, "Jackson, come to bed—you're going to be so tired and you've got this and that to do." But we went on until dawn, with Jack describing Tintoretto and weaving a spell: "See, it goes back over there, and then over here, and it never goes off the canvas."

Pollock's lifelong interest in Tintoretto, of course, as I've already hinted, was very much a reflection of Benton's teaching. As Reginald Marsh once commented after a trip to Venice, "I never realized how much Tintoretto learned from Thomas Hart Benton."

Significantly, Benton used these same analytical tools, but in reverse, to design a composition. Thus, characteristically, he would begin a design with a stick figure drawing, such as his compositional sketch for *America Today* (see color plates), or he would analyze the design in terms of geometric volumes. Of course, Jackson Pollock absorbed these same techniques. Even late in his career Pollock's paintings often retain many of the features of Benton's preliminary sketches. The little stick figures scatttered over the surface of Pollock's *Portrait of H. M.*, for example, are exactly the same sort of stick figures we find in Benton's early sketches, such as his preliminary studies for *America Today*.

The Spiral and Rotating Forms

Thus, the Synchromists used Cubism as an analytical tool, as a method for disclosing what might be termed the "deep structure" of old master sculpture and painting. Like the Synchromists, Benton wanted to tie the parts of a composition together into an endlessly circulating visual pathway. His goal, in short, was exactly the thing that Pollock sought in his paintings: what Pollock expressed with the words "It ties together."

The most common form in Synchromist painting is the spiral, whether on a flat plane or in rotating blocks arranged like a spiral staircase. Benton was also most interested in circulating or spiraling forms. In a series of diagrams, Benton demonstrated different ways of organizing a composition, both on a flat surface and in depth. The most flexible and varied technique of organizing a composition, he proposed, is to distribute forms around a series of real or implied vertical poles. In his drawings Benton both diagrammed this system in old master compositions and used this principle to design original compositions of his own.

Benton passed on this concept of vertical poles to Pollock. Indeed, as has been mentioned, in one of his early drawings Pollock made a diagram of this principle on the side, to remind himself of the rhythmic principle he should use in the figure organization. This diagram is nearly identical to the sketch of forms rotating around a vertical pole in Benton's article. Not surprisingly, Pollock also used this method for his so-called abstract paintings. Generally speaking, Pollock's early works, such as *Troubled Queen* of 1945, tend to use more jagged, colliding shapes, which are similar to Benton's diagrams 22 and 23. The later works tend

In the margin of one of his early drawings (left), Pollock sketched Benton's system of arranging forms in a spiral around a vertical pole (right). (*Left*: Marginal drawing from Pollock's *Sketchbook I* [c. 1938], page 7, Metropolitan Museum of Art, New York. *Right*: From "The Mechanics of Form Organization in Painting," part II, *Arts* magazine, December 1926. Original art © T. H. Benton and R. P. Benton Testamentary Trusts/UMB Bank Trustee/Licensed by VAGA, New York, NY.)

In the 1920s Benton made many multi-sided designs, such as this one of 1922, which was executed on tile by his wife Rita. (Private collection, Cleveland, Ohio. Original art © T. H. Benton and R. P. Benton Testamentary Trusts/UMB Bank.)

to use more swirling forms and are more similar to Benton's diagram 24. Of course, Pollock's use of vertical poles reached its culmination in his famous painting *Blue Poles* of 1952. Benton was still alive in 1973 when Pollock's *Blue Poles* was sold to the National Gallery of Australia, and when he heard of the sale he commented to a friend, "I taught Jack that!"

An unusual feature of Pollock's work is that he painted on the floor, and his designs have an almost multi-sided quality unlike that of traditional paintings. This too harked back to his time as Benton's disciple. While working with Benton, Pollock spent most of his time not painting but making ceramics with Rita Benton, a process that entails pouring or dribbling glazes onto a flat horizontal surface.

Interestingly, in the 1920s Benton put a good deal of effort into creating multi-directional compositions for decorative objects such as tiles, rugs, cookie tins, and other objects. Indeed, Benton's student Ed Voegele recalled that "Tom said, if you have a good composition, hang the painting upside down, down side up, and on either side. The composition will still look good." A number of Benton's early abstract designs, such as the decorative tile above, work equally well from all four sides.

Extended Rhythms

Benton's art was distinguished by its peculiar sense of flow: by an effort to embrace the complete diversity of life within a unified aesthetic system. The fascination of his paintings is that they often seem on the verge of coming apart, of exploding, of showering fragments of this strangely

disjointed reality into the room, at the same time that they hold us with their magical sense of unity, one that is not easily knowable in a single glance but becomes apparent when our eye traces the elements of design in circular patterns that have a continuous unbroken rhythm and ultimately return us to our starting point, like the ancient dragon that swallows its tail, the Ouroboros—although often not before we have followed the design through thousands of objects and hundreds of figures, tracing both what is before and behind us, bouncing back and forth between foreground objects that seem about to press through the picture plane and background objects that are on their way to becoming vanishing points in the distance.

In one quite specific way, Benton came up with a new idea for organizing a composition. Russell and Macdonald-Wright had always worked on rectangular canvases that only slightly diverged from square. Benton, on the other hand, was interested in mural painting and consequently needed a form of composition that could be used on an expanse that extended laterally in both directions for a considerable distance. His solution to this problem was relatively simple: create a series of spiraling compositions, side by side, each organized around a visible or invisible vertical pole. As it happened, Jackson Pollock also liked to work on canvas that was wide and expansive, and his approach to composition was directly borrowed from Benton: a series of swirling forms, arranged around expressed or imaginary vertical poles. What was new was the openness of his approach, which went beyond even what Benton had tried. Lee Krasner once described Pollock's paintings as "sort of unframed space," and Jackson Pollock himself once remarked:

> There was a reviewer a while back who wrote that my pictures didn't have any beginning or any end. He didn't mean it as a compliment, but it was. It was a fine compliment. Only he didn't know it.

One of the most precise and eloquent descriptions of Pollock's approach was provided by Benton, who wrote:

> Although some of his rhythmic patterns, even to the end of his productive life, correspond to patterns I have myself used, it must be remembered that I did not invent these patterns. Their origins go

far back in the history of art. Jack's use of them became radically different from mine as he matured. My own rhythms are always closed, their peripheries are contained, turned inward, within a predetermined space. The fully developed Pollock rhythms are open and suggest continuous expansion. There is no logical end to Pollock paintings. Nor is there any need for any because, not being representations of the objective world, they are immune to the conventions by which we isolate these and make them function as a unified whole. The Pollock structures may defy the "rules of art," but they do correspond to the actual mechanics of human vision, which is also without closed peripheries. Jack Pollock's work represents, not the objects we experience in the act of seeing, but the way we see them, in continuing, unending shifts of focus. I had nothing whatever to do with this final and original aspect of Jack's art.

By contemporary standards Pollock's canvases do not seem enormously large, but by the standards of their time they were immense, completely out of line with the usual living room painting. *Autumn Rhythm*, for example, is about eleven times larger than *Nighthawks*, one of Edward Hopper's largest paintings. The size of Pollock's paintings, in fact, or at least the ones that stand out as artistic monuments, is very particular: intimate enough so that we still read the paintings in terms of our own bodies, and feel that the imagery is about the scale of a human figure; large enough so that the visual field becomes a sort of environment, rather than a self-contained little rectangle, and so that, as with a Benton mural, if we come near enough to examine the surface closely, we absorb the overall pattern in large part through our peripheral vision.

Michael Fried has proposed that one should see a Pollock canvas "all at once," but like the rest of his claims, this also is fundamentally incorrect. For one thing, the mechanics of vision make this impossible. While we're generally unaware of this fact, scientists have demonstrated that we see only in a narrow visual cone. We take in a scene through rapid eye movements that dart over a scene—or a picture—and it's our brain that organizes this amazing composite of impressions into a coherent image. It's simply not possible to absorb a painting in a single moment or a single glance, "all at once," as Fried insists.

More profoundly, this statement seems fundamentally untrue to

Pollock's artistic goals. In fact, what's striking about a Pollock painting is its endlessly shifting quality. The most exciting way to view a Pollock painting is to move back and forth between a distant viewpoint, where we take it all in at once, and a very close viewpoint, which creates a kind of visual envelopment. As we make the transition from far to close, passages that look flat from a distance become complexly layered and develop new movement and depth; or again, as we move even closer, these passages cease to be so deep and become somewhat more flat again as they are transformed from an illusion into mere drips of paint. From any distance the visual movement of a Pollock painting is also hard to hold stable. Our eye is pulled first in one direction, then in another, as it sweeps from point to point, discovering a seemingly endless pattern of movements and visual connections.

Admittedly, there are moments when the whole vision creates an almost psychedelic sense of visual overload, which hits us with a force like that of an electric shock and which creates a certain sense of visual "oneness"; but these moments alternate with episodes of looking at the painting in fairly manageable fragments, which we struggle to break down into understandable patterns. In other words, Pollock's paintings are hard to reduce to a single thing but rather express the mysterious tension between "the many" and "the one" that has always interested mystical philosophers, from Plotinus to Spinoza. They lead us from the specific to the cosmic. From the first, viewers have sensed that Pollock was trying not simply to reproduce some particular visual scene but to capture something mysterious and expansive, like the outer reaches of the universe. If there is a "oneness" to Pollock's work, it lies not in the fact that we can read the image "all at once" but in the fact that the successive glances with which we take it in, while each is unique, individual, and distinct from the other, have a somewhat similar quality of insistent visual rhythm.

What was Pollock doing? Perhaps the best statement of what was unique about his work was written by Julian Schnabel, who is not only a remarkable painter but a great writer. With a few deft words, he gets to the essence of Pollock's achievement:

> In Pollock's work every element of the painting is subordinate to every other element. As you notice one part, your perception of it is

immediately disrupted by its proximity to the next stroke. The relationship of the parts is such that you can't focus on just one part, making their cumulative ability to disrupt each other the generating element that comprises the vision of the painting as a whole.

Unlike the theoretical assertions of William Rubin and Michael Fried, this statement corresponds with the visual reality of Pollock's work. It succinctly identifies what is unique about Pollock's organization of the visual field. And it should also be apparent that the peculiar quality he identifies is one that has relatively little to do with the lineage that Rubin and Fried have identified, which seeks to establish the source of Pollock's work in the sort of paintings that Alfred Barr collected for the Museum of Modern Art. While doubtless figures such as Picasso or the Surrealist André Masson played a role in loosening Pollock's style, the unique element of what he did is obviously something taken from Benton, a kind of energized visual space in which each element leads on to the next, in a visual rush that rejects traditional visual hierarchies. Moreover, the sensibility at work, as Kenneth Clark sensed when he first encountered paintings by Pollock in Venice, is in many ways a distinctly American rather than a European one. Similar to the world vision expressed in the poetry of Walt Whitman, it's somehow connected with democratic values—and it democratizes the visual field. Notably, Julian Schnabel has lauded something akin to Whitman in the best Abstract Expressionist painting—"a Whitmanesque type of cataloguing," which provides "a nonhierarchical plane where all elements of differing kind can be declared to have the same value." But if Benton accelerated the energy of traditional painting, Pollock accelerated Benton. Indeed, in Pollock's work visual form blurs into a kind of energy—"energy made visible," to cite a phrase used by Pollock himself and selected by B. H. Friedman as the title of the first major biography of Pollock.

Benton's paintings in large part explore issues of flow and movement, but his representation of form is oddly hard and cement-like, something partly due to his peculiar working method, since he was not representing the actual world but the world he had re-created in clay models. Pollock recognized that visual flow could be accelerated by painting in a flowing fashion—that is, with flowing paint.

One of Morgan Russell's passing comments, in fact, is remarkably

suggestive of the direction that Pollock took. He commented that his objective was to express "palpitations and undulations" in his paintings, and that to do this he was willing to "sacrifice the fact." He also once declared that "the action of modern painting must necessarily be the placing of the looker into the middle of the 'whirlpool' of the picture." Essentially, Pollock took these goals and pushed them further. Everything in Pollock's work palpitates.

Images

Along with maintaining that Pollock's paintings were "flat," Greenberg, Rubin, and Fried also insisted that they were "abstract," by which they meant nonrepresentational and nonfigurative. In recent years, however, the view that Pollock's work was nonfigurative, or purely abstract, has become increasingly untenable. Quite a number of scholars have proposed that Pollock's paintings contain some sort of imagery, though imagery that was largely "veiled" in the process of making the painting. Indeed, Pollock's own statements suggest as much. "I'm very representational some of the time, and a little all of the time," he once commented. The clinching evidence that Pollock's paintings contain imagery has recently been put forward by Pepe Karmel, at the Museum of Modern Art, who used computer technology to look closely at Hans Namuth's photographs and film of Pollock at work. Namuth was able to photograph Pollock creating some of his most important paintings. Using computer technology, Karmel was able to take images that are extremely foreshortened and tip them up to a right angle, so that they become far more legible and we can easily compare them with the finished painting. In addition, he was able to merge details from different photographs, revealing just fragments of a painting, to create composite images that are far more informative. What emerged was quite surprising—at least to those who had conceived Pollock's paintings as abstract.

In nearly every instance Pollock's first layer of dripping—or drawing—revealed very recognizable imagery. *Number 27, 1950*, for example, started with two figures, whose heads, shoulders, arms, fingers, legs, and so forth are clearly indicated. He then delineated a dog similar to the one lying underneath a table in his earlier painting, *Guardians of the Secret*. *Autumn Rhythm* turned out to also contain figures, somewhat

more summarily indicated but with male and female characteristics reminiscent of Pollock's work of the early 1940s, such as *Male and Female*. Significantly, in developing these images Pollock does not work all-over but more in the fashion in which Benton designed his mural, starting with individual scenes, discretely placed, and then developing compositional means of linking them into a coordinated rhythm.

Interestingly, when it came time to link scenes, Pollock used a different mode of paint application. The initial drawing was done with line-like drippings, applied in a smooth, continuous arm movement. The linking lines are generally applied with a rapid flick of the wrist, to create blotches or splats that are less easily legible as drawing. In this process, the image itself would generally become less legible, although Pollock's final paintings invariably contain some hint of a figure or form that is struggling for release within the image. In cases where this image disappeared entirely, Pollock seems to have been displeased with the result. Consequently, he would layer over the paint with a light color, such as white, and start a new buildup of paint and imagery.

One could argue that Pollock's method was thus one of alternating "representational" and "abstract" brushstrokes, and this is certainly one way of explicating his method. But just such an element of "abstraction" also occurs in highly representational paintings, in which many areas, such as blue sky, for example, may well be represented with brushstrokes that are as flat as those of a housepainter. In such paintings, while an area may have representational significance, the brushstroke itself is essentially abstract.

While Pollock's general process is clear, there are still some questions about the balance between "representation" and "abstraction" in his work, in part because the layering of paint becomes so dense that individual configurations of line become difficult to discern. It's not clear, for example, when Pollock was "veiling" the initial image, whether his lines were "abstract" or whether these lines in turn contained some element of figurative drawing, perhaps with different imagery and subject matter than what he had initially laid down. The problem, simply put, is that Pollock seems to have sometimes started a motion with an image in mind but then have left that form so incompletely resolved that it is difficult to recognize. Indeed, he seems to have had techniques for creating images that were difficult to discern. Pollock's friend Nick Carone, for

example, has reported: "Jackson told me that he wasn't just throwing the paint. He was delineating some object, some real thing, from a distance above the canvas." Similarly, Lee Krasner once observed that he never stopped being a figurative painter, but his figures were ephemeral things that existed only momentarily, midair, and then disappeared. Lee described this process as "working in the air." Picking up at least a thread of this idea, the art historian Barbara Rose commented that "he is not drawing on the canvas so much as in the air above it." Similarly, the painter Paul Brach has declared of Pollock's work that he was "painting in the air and letting gravity make the picture."

One of the curious things about traditional representational drawing and painting is that the range of visual things it can successfully capture is rather limited, consisting mostly of those that have a clear outline or silhouette. It is extremely difficult—well-nigh impossible, in fact—to represent certain visual experiences that are extremely common in nature, visual patterns that have texture rather than a clear shape, such as the effect of standing in a forest surrounded by branches and foliage or of looking at a field of grass. In drawings, it is notoriously difficult to render foliage.

What is fascinating about Pollock's work is that while he did not literally represent such things, he created a visual effect that is strikingly similar. Pollock's *Blue Poles,* for example, with its range of visual vibrations, creates an effect curiously similar to that of standing in a forest, with a complex pattern of branches and leaves, and with patches of sunlight that unexpectedly illuminate different parts, at different levels of distance. It is as if, without representing any particular thing, Pollock had somehow penetrated the secret of nature itself, so that he could generate nature in his own terms.

When painters do achieve an effect that appears intensely "real," paradoxically they do not represent things in a hard-edged literal way but, in one or another fashion, through a form of rendering that injects a note of optical confusion. Objects in a realistic painting, for example, seem to pop into convincing realism when one softens some of the hard outlines, making the outlines fuzzy or even, in the passages of deepest shadow, completely blurring the separation between one object and the next. Similarly, our reading of color distance relationships is not entirely orderly. While objects generally get softer and less bright as they recede

into the distance, some patches of bright color jump forward in a surprising way, confusing our sense of relationships. Paintings that lack this sense of confusion do not seem entirely realistic or convincing.

One of Pollock's basic tricks was to exploit this device. Very commonly in his paintings a bright color, such as a patch of yellow or orange, will lie *behind a* darker color, creating a moment of visual confusion. The tension between the way it is set behind other forms and the way the color seems to jump forward creates an effect similar to what we know in nature—similar, for example, to the experience already mentioned, of a distant patch of light in the forest, which seems to visually jump forward. Most abstract artists paint in a way that seems quite flat and utterly different from the world of natural appearances. The total effect of a Pollock painting, on the other hand, is strangely like that of standing within the natural world and looking around, even though we cannot easily resolve the specific details into recognizable natural forms. In other words, while we can certainly describe them as "abstract," Pollock's paintings share some of the visual effects of the natural world and capture them more accurately than most so-called realistic paintings.

Scholars seem to agree that two influences were particularly significant to the mythic meanings of Pollock's art: the theories of Jung and Native American art—particularly totem poles and Navajo sand painting. The same scholars have generally assumed that Benton was not interested in these things and that Pollock's interest in them represented a turn away from Benton. In actual fact, however, while Pollock's use of these influences was quite original, the initial impetus to explore these avenues came directly from Benton. As has been discussed, it was Benton who steered Pollock into Jungian analysis when he learned of Jackson's problems with alcoholism. The key contact was one of Benton's closest friends, Helen Marot, who located Pollock's Jungian analyst, Dr. Henderson.

Interestingly, it was also through Benton that Pollock became interested in Native American art. Benton's father, a Missouri congressman, had served in the Bureau of Indian Affairs and gave his son a complete set of the Smithsonian reports on the American Indian tribes. After years of hauling these volumes from apartment to apartment, Benton got tired of moving them and donated them to the City and Country School. When Pollock was out of money, Benton got him a job as janitor at the

school; while working there, Pollock stole the volume on Navajo sand painting, which was still in his possession at his death.

At the risk of being simplistic, it seems to me that Pollock often combined Benton's compositional system with ideas that he drew from Navajo sand painting, to create a kind of Cosmic Synchromism, which combined Synchromist compositional structure with cosmic religious meanings drawn from Native American sources. Several of Pollock's paintings of the mid-1940s contain totemic forms, like those in Navajo sand painting, and such totemic forms, although less clearly drawn, also seem to appear in many of his famous drip paintings. In the early paintings the totemic forms serve as posts, almost like coat racks, on which to affix symbols, such as emblems of male and female characteristics. The swirling lines around these poles express a more general sense of cosmic motion and anxiety.

In Pollock's late drip paintings the delineation is less clear, and the two types of shape, the poles and the swirling forms, merge together. Of course, that is exactly the point. Pollock was interested in finding a cosmic connection between the totem figure and its universe, not unlike the harmony that Benton sought between the ripple and bulge of human muscles and the ripples and bulges of the natural landscape. In short, for Pollock, gestures that many viewers and art historians have viewed as abstract had a very particular representational and symbolic meaning.

There is an interesting corollary to this. Pollock forgeries generally look all right for a few minutes, but very quickly they become boring. We soon see that they are made up of repetitive gestures. They represent nothing of significance, and the gestures, while initially arresting, soon reveal themselves as superficial and tiresome. Look closely at a Pollock painting, on the other hand, and you will soon see faces and figures running through it—admittedly often densely enveloped in a film of swirling pigment and complexly fused into each other. In other words, Pollock's drip paintings at their most basic underlying level are ghost-like Benton figure paintings, which are then pushed to even a higher level of generalization. Because they have this imagery and meaning, even though it is difficult to fully discern, they are not dull and repetitive but are filled with inner life.

The larger reasons why Pollock employed these subterfuges will be discussed in more detail later, but an important impulse was clearly a

desire to make forms that did not so much represent specific things as capture their underlying rhythm and harmonize it with that of the composition as a whole. Thus, in a certain sense Pollock's paintings are "abstract," although in a sense quite different than that proposed by Greenberg, Rubin, and Fried. They are not nonfigurative. They do contain imagery. But the goal of the painting is not so much to represent a specific object or figure or form as to move out from that form and generate a unifying cosmic rhythm. For Pollock, in short, image and form were linked. The main significance of the image was that it established the rhythmic pattern of the composition.

Drawing from the Unconscious

One of Pollock's chief means of creating visual rhythm was through so-called automatic drawings—that is, by making free-form gestures supposedly drawn from the unconscious. Writers have generally assumed that Pollock learned about loose, automatic gestures from the Surrealists, and certainly the Surrealists encouraged this interest. But there was another earlier source for this approach, the sketching technique of Boardman Robinson—who, as I've mentioned, was the person who got Benton his teaching job at the Art Students League. A gifted teacher, it was Robinson who spurred Sandy Calder to make figure drawings with a single line, an exercise that ultimately inspired Calder's wire sculptures.

Robinson's forte was the life sketch, produced in a few seconds through a kind of automatic gesture. Robinson's most original work was produced in Eastern Europe during the First World War, while traveling with the leftist journalist John Reed. To avoid detection, Robinson drew in tiny sketchbooks and developed the ability to sketch while talking or performing some other activity. Interestingly, Robinson's technique was ultimately derived from the freely executed gesture drawings of Rodin, which he knew about because his wife, Sally Whitney, had studied sculpture in Paris with Rodin and knew Rodin and his methods very intimately. Today we recognize that what Robinson was doing was separating the operations of the left brain from the right brain and reaching deep into the unconscious to create his effects. His scribbles were a kind of automatic writing.

Robinson's student drawing exercises encouraged students to reach

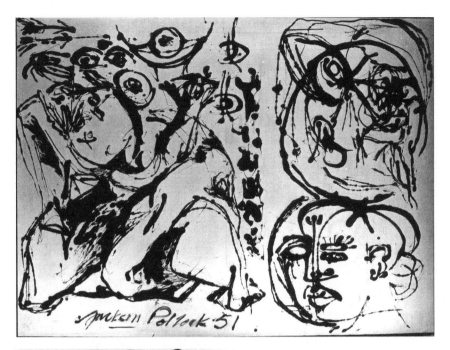

Jackson Pollock's last paintings (top) employ a mode of drawing similar to that of Benton's friend Boardman Robinson (bottom). (*Top: Number 27, 1951*. Private collection, Switzerland. *Bottom: Refugees, Serbia* [1915], pen-and-ink on paper, from Albert Christ-Janer, *Boardman Robinson* [Chicago: University of Chicago Press, 1946], page 34.)

to this deeper level, in a fashion that has some analogy to the breathing and spiritual exercises of Eastern mystics. Thus, for example, Robinson encouraged his students to draw with one hand while writing with the other; to write a sentence in normal script with one hand and to write the same sentence in mirror writing with the other, using both hands at the same time; to draw with the opposite hand from the one they usually used; to draw while talking; or to draw with both hands at the same time, simultaneously treating two different subjects. No doubt Surrealism affirmed Pollock's interest in automatic techniques, but the seeds of the idea were probably laid earlier, in a visual form that is closer to Pollock's mature work.

Empathy and Gesture

Gesture, of course, has a muscular element, and Pollock's work is remarkable not only for its design but for its powerful sense of gesture—the way in which his swirling lariats of paint evoke the movement of the human arm and body. In fact, a major theme of Synchromism was an interest in the effects of muscular tension. We often immediately respond to the alternating tensions and relaxations of a Synchromist painting and only gradually recognize that it contains a concealed human figure. The Synchromists (and Benton) believed that abstract form takes on the illusion of life because of its analogy with human muscular movement. While we may not recognize what the painting represents, we read it as living form, and it evokes an empathetic response.

Macdonald-Wright expressed this muscular principle particularly clearly in his painting *Arm Organization*. While initially this work looks abstract, in fact it is a diagram of the human arm and its alternating rhythm of tension and relaxation. As Willard Wright wrote of this piece:

> In his *Arm Organization in Blue-Green* one can discern near the centre a small and arbitrary interpretation of the constructional form of the human arm. The movement of these forms throws off other lines and forms which, through many variations and counter-statements, reconstruct the arm in a larger way. Again, these lines of the larger arm, in conjunction with the lines of the smaller one, evoke a further set of forms which break into parts each of which is

a continuation or a restatement of the original arm motif, varied and developed.

In his articles on the mechanics of form organization, Benton made a slightly more literal diagram of a human arm to illustrate the same principle that fascinated Wright. What is intriguing is how, depending on the patterns of tension and relaxation, the same object can take on a remarkably different visual form, though one still based on the interplay of tension and relaxation, hollow and bump.

Building on Synchromist ideas, Benton argued that we read even nonliving things, such as landscape, by comparing them with the curves and flexes of the human body. As Benton stated, "In the 'feel' of our own bodies, in the sight of the bodies of others, in the bodies of animals, in shapes of growing and moving things, in the forces of nature and in the engines of man the rhythmical principle of movement and countermovement is made manifest. But in our own bodies it can be isolated and understood."

To put this in a different way, Benton proposed that the interplay between relaxation and tension, hollow and bump, projection and recession, provided a means of moving from renderings of the human body to a more generalized abstraction of the cosmos. In other words, it provided a system for creating an "abstract" organization of form. As Willard Wright wrote:

> Macdonald-Wright, in interpreting the human form, makes use merely of the direction and counterpoise of volume; he does not indulge in the depiction of limbs and torso: the body is only his inspiration to abstraction. He changes and shifts its form out of any superficial resemblance to nature.

Jackson Pollock, of course, gave an additional force to this idea. Not only do the general shapes evoke dynamic, living things, but we also read his drips and splashes as the expression of the painter's own muscular gestures and movements—we translate the form into the living gesture of the artist.

It is unclear to me to what extent Pollock was aware of what the Synchromists had done and to what extent he simply reconstructed a very

similar set of intentions to theirs, by applying to the work of his teacher, Benton, the same contrarian logic that Benton had applied, a decade or two earlier, to the work of the Synchromists. In other words, Benton's work was a logical antithesis of the thesis of the Synchromists; Pollock's work was a forward step of synthesis, drawing on them both. In fact, the analogy between the fundamental artistic goals of the Synchromists and those of Pollock is virtually perfect. Both were interested in devising visual rhythms that never directly copied natural forms but abstractly captured their essence. In fact, Willard Wright's culminating statement in *Modern Painting* about the goals of the Synchromists could be applied, virtually without change, to the work of Pollock:

> They desired to express form which would be as complete and as simple as a Michelangelo drawing, and which would give subjectively the same emotion of form that the Renaissance master gives objectively. They wished to create images of such logical structure that the imagination would experience their unrecognizable reality in the same way our eyes experience the recognizable reality of life. They strove to bring about a new and hitherto unperceived reality which should be as definite and moving as the commonplace reality of every day, in short, to find an abstract statement for life itself by the use of forms which had no definable aspects.

I have said "virtually equivalent," for there are four words I have left out of Willard Wright's statement, which come after the word "express." In Willard Wright's formulation, the Synchromists sought to achieve their goals "by means of color." Pollock, on the other hand, like Benton, eliminated spectral color and concentrated on formal organization. To be sure, Pollock did use color to perform a constructive role. But this role is performed not through color sequences that are organized in chords or scales, in a particular prismatic sequence, but simply through the way in which colors are layered, one on top of each other, to define particular layers of depth in space.

Wright argued that art was a progression toward fuller realization of form, progressing in four stages, from "shallow imitation" to "qualities of solidity and competent construction" to "arrangement" of objects to

accentuate qualities of volume and, last, to the culminating phase of art history, the "abstract" treatment of form. He explained this last phase as follows:

Last, form reveals itself, not as an objective thing, but as an abstract phenomenon capable of giving the sensation of palpability. All great art falls under this final interpretation. But form, to express itself aesthetically, must be composed; and here we touch the controlling basis of all art: organization. Organization is the use put to form for the production of rhythm. The first step in this process is the construction of line, line being the direction taken by one or more forms. In purely decorative rhythm the lines flow harmoniously from side to side and from top to bottom on a given surface. In the greatest art the lines are bent forward and backward as well as laterally so that, by their orientation in depth, an impression of profundity is added to that of height and breadth. Thus, the simple image of decoration is destroyed, and a micro-cosmos is created in its place. Rhythm then becomes the inevitable adjustment of approaching and receding lines, so that they will reproduce the placements and displacements to be found in the human body when in motion.

There are some ambiguities in this statement, as well as some logical inconsistencies, although interestingly they are ambiguities that occur in Pollock's work as well. The central dilemma is that Wright wants painting to be "abstract" at the same time that he wants it to "reproduce the placements and displacements to be found in the human body when in motion."

Form in painting, like the eternal readjustments and equilibria of life, is but an approximation to stability. The forces in all art are the forces of life, coordinated and organized. No plastic form can exist without rhythm; not rhythm in the superficial harmonic sense, but the rhythm which underlies the great fluctuating and equalizing forces of material existence. Such rhythm is symmetry in movement. In it all form, both in art and life is founded.

Cosmic Synchromism

In fact, while Pollock's paintings do not use a Cubist space and are not truly "abstract," they do contain an interesting ambiguity: they are highly ambiguous in scale. Their scale, in fact, is fascinating. As in Benton's murals, the figure-like drawings in Pollock's paintings have a scale that seems the same as real life, with the result that we respond to them in an intense bodily way, as if they were actual creatures or human beings. At the same time, Pollock's paintings suggest two altogether different realms—that of outer space or the cosmos, and that of the mysterious world of the almost infinitely small, the world of atomic forces. As viewers noted from the time they were first exhibited, Pollock's paintings seems like representations of the universe and have striking affinities with the photographs of stars, comets, planets, and galaxies that were just beginning to enter the popular consciousness at this time.* At the same time, there's a sense that these images portray something inconceivably small, the world of protons, electrons, and other atomic particles, whirling around in their own universe of the inconceivably small. Finally, there's the sense that these images are not generated by the conscious mind but are drawn up from the unconscious, inner self. It's telling that Pollock considered Einstein and Freud the two most important figures of modern times: one delved into the structure of the universe, the other into the structure of the unconscious. The power of Pollock's great drip paintings is that they seem to explore both these mysterious realms.

In short (to cite metaphors that are often mentioned in early reviews of Pollock's work), we can imagine that we are looking at the incredibly small world of atoms and subatomic particles or that we are looking at exploding galaxies in outer space. And as has been described, we can also imagine human figures struggling to take form within the string-like skeins of paint. Indeed, far from representing nothing at all, at some level Pollock's painting seems to depict the fundamental structures of the universe and nature—perhaps the very process of creation. Thus, at many levels, Pollock created a metaphor for the task of making sense of

* Atomic theory was firmly in place by about 1930 and became a common subject in popular magazines after the dropping of the atomic bomb. Images of stars and galaxies in outer space also became popular in the late 1940s.

the modern world in which we are asked to grasp things, such as the atomic bomb or invisible rays that lie beyond the realm of normal vision or understanding. Personally I have always felt that Pollock's paintings are exciting because they are so cosmic—because they seem to capture and coordinate and unify the processes of nature as a whole.

As Julian Schnabel has noted, the excitement of Pollock's work has very little to do with the formal concerns espoused by Greenberg, Fried, Rubin, and others of their ilk. Indeed, it stems from something almost opposite, for rather than channeling thought in a fixed groove, the feeling of Pollock's paintings is exceptionally liberating and opens up a whole new world of thought, feeling, and potential connections between different things. As Schnabel has written:

> All paintings, in fact, are metaphoric. You look at one. It reminds you of something that you might have seen, a key to your imagination not dissimilar to seeing a slogan on a wall and being able to imagine somebody painting its letters, seeing the back of his head and the stroke of his arm in the night. To those who think painting is just about itself, I'm saying the exact opposite. The concreteness of a painting can't help but allude to a world of associations that may have a completely other face than that of the image you are looking at. The concept of Formalism imposes false limits on painting under the guise of esthetic purity, as if such a thing could exist in real life.

Intuition and the Universal Mind

At this point we enter a realm that is a little more speculative. Pollock was always attracted to mystical ideas, as is indicated by his early enthusiasm for the teachings of Krishnamurti. At some point he clearly learned about at least the rudiments of Asian art. Certainly it's striking that he put his paintings on the floor, as the Asians did, and some of his last paintings were produced with black ink and brush on rice paper, in a fashion clearly modeled on Oriental brush paintings. With these facts as hints, can we suppose that this interest in the Orient had a deep impact on Pollock's art and influenced his fundamental methods and goals? Could much of this Oriental outlook have come to him from Macdonald-Wright, as

transmitted by Benton and others? While much of the evidence is circumstantial, I find this supposition quite compelling.

Macdonald-Wright first became engaged with Oriental philosophy and art around 1910–12, when he attended lectures by Henri Focillon on the subject at the Sorbonne. From that time onward it was one of his major interests, and when he moved to California he began dealing in Asian antiquities and became recognized as an authority on the subject. Many of his later paintings resemble Chinese landscapes, and he consciously adopted some of the qualities of an Oriental sage. From 1920 onward Oriental thought permeated everything that Wright said and did. In the 1930s at least one of Wright's ideas seems to have made its way into the heart of Benton's teaching. When Benton described the significance of "the hollow and the bump," he compared them to the Chinese notion of yin and yang, the fundamental principles of the Chinese cosmos. In 1934 Macdonald-Wright included Benton in his Santa Monica mural as a kind of philosophical cowboy, lassoing the Oriental dragon of knowledge.

Throughout this period Benton and Wright remained in contact, and a number of Pollock's friends studied with or associated with Macdonald-Wright. Macdonald-Wright served as mentor to several of Pollock's artist friends from his high school days, such as Harold Lehman and Phil Goldstein, and some of Pollock's other acquaintances studied with both with Benton and Wright. Archie Musick, for example, studied with Benton in New York and with Wright in California and finally settled in Colorado, where he worked with Benton's friend Boardman Robinson. For Pollock, the most obvious source of information about Macdonald-Wright would have been Henry Clausen, with whom he worked closely when he became Benton's class monitor. An unlikely mix of professional wrestler and intellectual (in his later years he operated a rare-book store in Colorado Springs), Clausen roamed back and forth across the country, modeling for both Benton and Macdonald-Wright and becoming a boon companion of both of them.

While Wright never systematized his views on Oriental art, we can get a clear sense of his interests from a remarkable document: a copy of Osvald Sirén's *The Chinese on the Art of Painting* that he underlined and extensively annotated. When we follow these markings we discover remarkable parallels with Pollock's philosophical and artistic approach.

Two central ideas particularly interested Macdonald-Wright: first, that great art does not slavishly copy the surface of nature but probes beneath the surface and grasps fundamental principles; second, that the artist achieves this goal by entering a mystical state of mindless thinking, which eliminates the distinction between subject and object. Both these ideas correspond very closely with Jackson Pollock's artistic methods and intentions. Significantly, they also distinguish Pollock's work from that of European modernists, suggesting that he derived these ideas from some other source.

As Macdonald-Wright noted approvingly, all Chinese art criticism stems from the first principle of Hsieh Ho, the first notable theorist of Chinese art, that painting should achieve "Spirit Resonance (or the Vibration of Vitality) and Life Movement." In short, great painting is achieved not by mechanical imitation but by cosmic insight, by transforming one's inner consciousness and by releasing oneself from the imprisonment of surface appearances. The real subject of a painting should not be "outward likeness" but "the inherent reason or principle of things." Chinese critics constantly repeated that one should avoid "outward likeness." Macdonald-Wright scribbled "very good" beside a passage that reads:

Although painting is representation of form, it is dominated by idea. If the idea is insufficiently brought out, it may be said that the picture has no form either.

The goal of the great painter was to achieve a kind of intuitive freedom, which broke through the shell of appearances and captured the underlying essence. Thus, for example, a passage by Hsieh Ho praising the painters Chang Mo and Hsun Hsu declares:

Their style and temperament were divinely wonderful. They grasped the spiritual essence of things. They freed themselves from the bone manner (drawing in detail) and were no longer bound by the shapes of things. Their works were not remarkable for refinement and purity, but they contained something beyond the shapes and were satiated and rich. They may indeed be called subtle and wonderful.

In embryonic form, in short, the Chinese had developed a theory of abstraction. They felt that the greatest painting was not a representation of the outer surface of nature but captured spiritual essence. Just how to do this was not fully explained, although it clearly depended on grasping essential principles. The Chinese also recognized that representing the different forms of the natural world presented challenges of categorically different types. What was tricky is that some forms follow the same essential pattern from one object in its class-type to the next, while others are fluid but nonetheless not without a distinctive essence. Thus, for example, Su Shih declared:

> Often in talking about painting I have said that human figures, birds, buildings and utensils all have their constant form, whereas mountains, stones, bamboos, trees, waves, clouds and mist have no constant form but a constant principle.

Significantly, this process of grasping the "spirit resonance" of the subject must be achieved through a kind of release of conscious thinking and without intellectual deliberation. In the words of Confucius: "He who is in harmony with Nature hits the mark without effort and apprehends the truth without thinking." Indeed, as Siren insisted in his accompanying text, the goal of the painter is to eliminate the self to achieve "an identity between the knower and the known."

In short, a painter should aspire to a special kind of mystical state of mind: specifically the state explored in Ch'an Buddhism (known as Zen in Japan). As Siren explained, a person in this mind-set reaches for things "entirely beyond intellectual definitions" and aims for a mode of consciousness "where appearances and names are put away and all discrimination ceases." Interestingly, as Macdonald-Wright astutely noted, this mode of mystical practice has interesting parallels with Jungian psychology. Its goal is to go beyond the individual self and make connection with "Universal Mind," a concept that, as Macdonald-Wright noted in the margin, is strikingly similar to the Jungian idea of the collective unconscious. In other words, the goal of painting is not to control the universe but to merge with it, so that the painter becomes one with the forces of nature. When this merger has occurred, everything exists in a

profound cosmic unity, or, as Pollock once stated, "I don't use the accident, 'cause I deny the accident."

Pollock's interest in Asian mysticism can be traced back to his infatuation with Krishnamurti when he was in high school. Whether or not Macdonald-Wright was the source of these concepts, it seems clear that Pollock drew on principles of Oriental thought and developed a form of modernism that was based on different methods and spiritual ideals than that of European painters. These included a desire to connect with the infinite cosmos (and the void); a belief that the artist should capture the "spirit resonance" of nature rather than its external form, and thus should work abstractly, or semi-abstractly; and the conviction that achieving great art depended on a peculiar mental state, which was essentially intuitive, drew upon the unconscious and the "universal mind," and eliminated the ego. Ideally, the mystical state dissolved the distinction between subject and object, so that the artist could boast, as Pollock did, not that he painted nature but that "I am nature."

Macdonald-Wright was correct, of course, in sensing that this Oriental method had a kinship with the philosophy of Jung, which Pollock had absorbed, at least on some intuitive level, through his sessions with Joseph Henderson. As has been noted, while Freud focused on stages of sexual development (the anal, oral, and latent) and proposed a tripartite division of the psyche (the id, ego, and superego), Jung came to believe that solving psychological issues depended on going even further back into the deepest layers of the unconscious—into the foundations of human sentience, the collective unconscious, the deepest layer of human awareness, as it has developed in the human psyche over many thousands of years of evolution. In this collective unconscious were imbedded the experience, the myths, the archetypes, the spiritual truths that provide the key to human existence.

Jung believed that the unconscious mind was a highly evolved, unified structure whose *teleos* was to achieve greater and greater stages of spiritual harmony and integration. Ultimately, Jung posited that the unconscious provides a road to healing because it is a microcosm of the cosmic superstructure itself—that the psyche, at its deepest level of archetypes, provides a mirror of the universal order of the universe. Thus, finding God or finding the meaning of one's life is not so much a rational

process as one of exploring the depths of one's own being. We can best see the world around us by looking inside ourselves, by passing through the boundary at the frontier of normal awareness into the realm of the collective unconscious. From the Jungian standpoint, the ultimate value of Pollock's work rests on the fact that it seems to perform this process. We pass from normal reality to a kind of deepened reality that somehow connects the structures of the unconscious mind with those of the cosmos as a whole.

Altered states of consciousness, of course, have a quality akin to madness—are not always easy to distinguish from madness. Indeed, this link between madness and wisdom has always been one of the most potent themes of art. Shakespeare understood this well—think of his scenes of Hamlet mouthing rambling thoughts, King Lear ranting on the heath, and Macbeth losing his nerve and his grip on reality and giving voice to his guilt and deepest fears. Shakespeare moves us because he brings us to a state akin to madness, and Pollock's art captures our attention for the same reason. With his almost wild, sweeping gestures, we feel that he is on the edge of madness himself, just barely able to keep the chaos under control. But, at the same time, the emotional quality of Pollock's art is not easy to dismiss with a simple phrase, for it seems to express different poles of feeling simultaneously. It at once feels anguished, violent, crazy, and, in counterbalance to these qualities, strangely serene, rational, mentally controlled, as things large and small coalesce into a rhythmic harmony.

In summary, while Pollock has usually been seen as an artist who rebelled against his teacher Benton, in fact, the most original and significant aspects of his work were largely derived from Benton, who in turn provided a lens to look back toward Synchromism and the work of Matisse and Rodin, as well as the encouragement to delve into the teachings of Jung. Equally significant, for all their differences, Benton and Pollock had some special bond, one that would tie them together throughout their lives, up until the moment of Pollock's death.

How can we explain this? Artistry is most often linked with "genius," but alternatively, it has been suggested that the artist is simply a particular personality type. Some psychologists have proposed, for example, that artists are shaped by the rich sensuous experiences of earliest infancy and by the manner in which that magical world was shattered

when the child was first separated from the mother. Their artistry as adults was an attempt to regain the unity and wonder of that magical early moment. Such theories easily degenerate into psycho-babble, but they at least touch on the possibility that what makes a great artist may be something that has roots extending back into earliest childhood, even before the phase of the first conscious memories. What's striking is that Pollock and Benton shared some common identity as artists that created a powerful electricity between them and set them apart from most of their peers. Thus, rather amazingly, their bond endured, despite their clashing social allegiances and artistic styles, the geographical distance separating them, and the fact that both of the two, by any normal criteria, were impossibly difficult personalities.

Why, then, did Pollock return to Benton's techniques at this point, after publicly repudiating him as an artist and as an influence? That Pollock returned to Benton's methods cannot be denied. Why he did so is a more speculative question: explanations of matters such as this come after the fact; the variables are hard to isolate, and the field of variables is very large. To my mind, two directions of explanation can be proposed, though if we trace either of them the one soon leads to the other. One has to do with Pollock's technique of falling back on his "unconscious." In his drip paintings he did this more fully than in any of his earlier work, and what happened when he did so is that he fell back on the methods that he had learned from Benton, which were so familiar, so thoroughly drilled into his mental and emotional fabric, that they had become a kind of reflex. Pollock had only wanted to be an artist before he met Benton. It was Benton who showed him how this will to be an artist could be turned into a process of activity, of action, of gesture, of coordination of forms and rhythmic movements. When Pollock went back to his deepest self as an artist, what he found was that Benton was his foundation.

The other has to do with deeper psychoanalytic issues, with matters of "self" and "identity"—with issues of one's relationship with one's "father," whether one's real father or the one that has been selected as an artistic or personal role model. For a decade Pollock had been moving away from Benton, both through conscious repudiation and through a process of almost accidental drift in the school of hard knocks, as new friends, new rivals and enemies, new experiences, new misfortunes,

pushed him in new directions and toward new feelings and methods of expression. Freud would define this process of rejecting and repudiating one's master as the oedipal complex, in which one seeks to slay one's father, like Oedipus who murdered his father on the road to Colonus; one could also express the matter less drastically as a simple need to separate oneself from one's father in order to forge a personal identity. By this time, Pollock had moved away from Benton to such a degree that he no longer needed to worry about being confused with him. Thus, he could, as it were, shift direction and begin to merge with the father, take on the traits of the father, because he was finally confident enough to take on his own artistic identity.

Fame

Of course, making paintings is just the first step in becoming a famous artist. In the modern world, becoming famous requires a publicity campaign—that is to say, the engagement of critics and the mass media. In Pollock's case, this occurred in two steps. There was an initial blast of publicity by Clement Greenberg, who was essentially his in-house art critic, which in turn attracted the attention of the Luce syndicate, who picked up the story and made Jackson Pollock a name known by every American. There are many parallels to the fashion in which Benton became famous, through the energetic, almost hucksterish boosting of his friend and former roommate Thomas Craven, which then, through a series of happy accidents, caught the attention of Henry Luce.

No question but that it was Clement Greenberg who set the stage for Pollock to become famous, through a series of reviews in which, completely contrary to the views of nearly every other New York art critic, he hailed Pollock as the leading figure of his generation. Greenberg's championing of Pollock is surely the most remarkable and fascinating episode in the history of twentieth-century art criticism. On no other occasion has an American art critic shown such seemingly perverse wrongheadedness in going against the tenor of popular taste, only to be vindicated when popular taste shifted in line with his views. The feat was so extraordinary that for a decade or so Greenberg enjoyed a legendary reputation, and his casual remarks were greeted as profundities.

How did he do it? When people pick a winner or make a million

dollars, we like to think that this reveals special insight on their part— and in a certain way, almost by definition, this is surely correct. Surely they knew something that others did not. What is disconcerting, however, is that often when we investigate what they knew and why they acted as they did, the answer turns out to be extremely strange.

That Clement Greenberg came out in defense of Pollock so early, so long before anyone else, and wrote about his work so forcefully might suggest that he had some deep understanding of what the work was all about. Surely he made a significant connection at some level. But in going over Greenberg's early reviews, what's striking is that they often focus on paintings we now regard as secondary, while skipping over the ones we now consider most important, and that their explanation of what Pollock was doing was quite fragmentary, unclear, and in some instances even contrary to fact. What prompted his enthusiasm seems to have been not full understanding but something stranger and more intuitive—a kind of sixth sense. Indeed, Greenberg himself must have known as much, for he always liked to stress that ultimately art criticism depends not on theory but on some sort of visceral response that lies outside the realm of logic. Writers on Greenberg have always tried to normalize what he was doing. In fact, it was clearly both intuitive and strange.

It's fascinating simply to line up Greenberg's reviews and watch him move from viewing Pollock as someone to watch to hailing him as an American master. The process took five years. Greenberg's first review, of November 1943, mentioned Pollock only in passing and was cautious in its praise, noting merely that Pollock's work offered "surprise and fulfillment." It was not until two and a half years later, in April of 1946, that Greenberg singled out Pollock as perhaps the most exciting American painter of his generation, declaring that "Pollock's superiority to his contemporaries in this country lies in his ability to create a genuinely violent and extravagant art without losing stylistic control."

Early the next year, in February 1947, Greenberg raised the ante one step further, not only praising Pollock over other Americans but arguing that his work ranked above that of Jean Debuffet, the most notable French painter to emerge since World War II. Thus, in a tentative way, he suggested that the Americans might surpass the French.

Then, in October 1947, he compared Pollock with a figure far more

widely admired than Debuffet, Joan Miró, declaring that "Pollock is the most important new painter since Miró." Notably, this was the first instance in which Greenberg's praise of Pollock hit a nerve. His comment was ridiculed by the arch-conservative Alexander Eliot, the grandson of a famous president of Harvard, in the December 1, 1947, issue of *Time*. Rather than retreating, however, Greenberg accelerated. In January 1948 he proposed that Pollock might well be the greatest American painter of the twentieth century.

> It is indeed a mark of Pollock's powerful originality that he should present problems of judgment that must await the digression of each new phase of his development before they can be solved. Since Marin—with whom Pollock will in time be able to compete for recognition as the greatest American painter of the 20th century—no other American artist has presented such a case.

Thus, by 1948 Greenberg's enthusiasm had pushed Pollock to the forefront of discussion about modern art. But Pollock's fame would never have occurred through Greenberg's reviews, which reached too small an audience. What happened is that Greenberg's divergence from other critics became a colorful story in itself, and writing about Pollock became a way to poke fun at egghead New York advocates of modern art.

Shortly after the roundtable discussion, *Life* came up with the notion of doing a feature story on Pollock. The main impetus came from Dan Longwell, chairman of the magazine's board of editors and a good friend of Thomas Hart Benton. Endlessly curious about new things, Longwell had visited Pollock's show in January and had even purchased a painting. It had a fly in it, and that caught his attention as something unusual.

Pollock and Krasner were unsure whether to cooperate. As has been mentioned, Pollock's nemesis at the time, Alexander Eliot, worked for *Time*, which was also owned and managed by Henry Luce. Perhaps fittingly, Eliot was the one who fifteen years before had made Benton nationally famous through his lavishly illustrated article "The American Scene." Eliot took a perverse joy in saying mean things about Pollock's work, though in doing so he generally boosted Pollock's reputation.

While so far *Life* had not been actively unfriendly to Pollock, it had recently panned the work of the French modern master Jean Debuffet, calling his creations "feeble" and "dead end art" and concluding that "there is more dignity in Al Capp's *Dogpatch* than in the whole of Debuffet's gaga cosmos." On the other hand, the day after the article appeared, Pierre Matisse offered to buy back Debuffet's *Smoky Black (Lili)* for twice the amount he sold it for two days before. The lesson was plain: that publicity, whether good or bad, boosted sales. No doubt to remember this lesson, Lee kept a reproduction of the photo from the article tacked to the back of the bathroom door at Springs.

Despite their misgivings, Jackson and Lee decided to play along. In February 1949 Pollock was visited by a photographer from *Life*, Arnold Newman, who took some memorable shots of him scowling in front of his canvases. In July Jackson and Lee went to the Time-Life Building to be interviewed by a young staff writer, Dorothy Seiberling. Pollock was dressed in a tweed coat and loafers, and Seiberling later remembered him as "all kind of knotted up inside." Lee was by far the more talkative of the two and often spoke for Pollock while he sat silent, which may well explain the numerous errors of basic fact that are sprinkled through the final article.*

Pollock's amazing fame would never have occurred without *Life*, a new kind of mass-market magazine, with sales in excess of five million copies a week. In 1935 a technical breakthrough—fast-drying printing ink—made it possible to print on coated paper run through high-speed rotary presses, with the result that photographs of high quality could be reproduced in vast quantities at a fraction of what it had cost to print them before. The publisher Henry Luce immediately recognized that this

* In the story that was published, Jackson claimed to be the first artist in the family and stated that Charles and Sande had followed after him, although of course this was getting things backward. He said that he began studying with Benton in 1929, when the actual date was 1930, and described the experience as "a complete loss," which sounds more like Lee Krasner's commentary than Jackson's. While there is no reason to believe this to be the case, he claimed to have worked extensively with abstract form in both sculpture and painting even before he came to New York. He delicately skipped over the emotional traumas of his years of drunkenness, referring to them as "a kind of seclusion." With regard to the abstract qualities of his paintings he was contradictory. At one point he declared that "I try to stay away from any recognizable image; it it creeps in, I try to do away with it." At another point he stated that "recognizable images are always there in the end."

made possible a new kind of news coverage—more varied, more informative, more immediate, and above all more visual than anything produced before. As Luce explained in a burst of Whitmanesque poetry, his magazine allowed the American people a new kind of news experience:

> To see life; to see the world; to eyewitness great events; to see strange things—machines, armies, multitudes, shadows in the jungle and on the moon, to see man's work—his paintings, towers and discoveries; to see things thousands of miles away, things hidden behind walls and within rooms, things dangerous to come to; the women that men love and many children; to see and to take pleasure in seeing; to see and be amazed; to see and be instructed.

The issue of *Life* in which Pollock was featured nicely fulfilled this program. Readers of the magazine on August 8, 1949, were treated to photo stories covering impressively varied topics: a replica Viking ship landing at Broadstairs, England; a nine-year-old girl who won the "Queen of Freckles" contest sponsored by the Chicago railroad; the mayor of Frankfurt who lost his pants in a swimming race; the last war prisoners returning home to Vienna; women shopping at Macy's for a dress identical to one worn in a Hollywood movie by the busty and glamorous Rita Hayworth; magician and cardsharp John Scarne revealing how crooks cheat at cards; and an unfortunate gentleman named Arthur Smith whose parachute caught in the tail of a plane at an air show in Three Rivers, Michigan, and who died when the plane crashed in front of the crowd.

All these photo stories present interesting, even remarkable things. How can we account for the fact that the story that has become most famous in the issue is something seemingly not particularly unusual or exotic: a photograph of a man in dark blue denim (which in the photograph looks essentially black) standing in front of a paint-splashed canvas, accompanied by the headline "Jackson Pollock: Is he the greatest living painter in the United States?"

In fact, Pollock was not even the only artist in the August 8 issue. Another story, on the wealthy and talented inhabitants of Fairfield, Connecticut, showed the illustrator Stevan Dohanos creating a *Saturday Evening Post* cover of a minister posting his sermon in front of a colonial

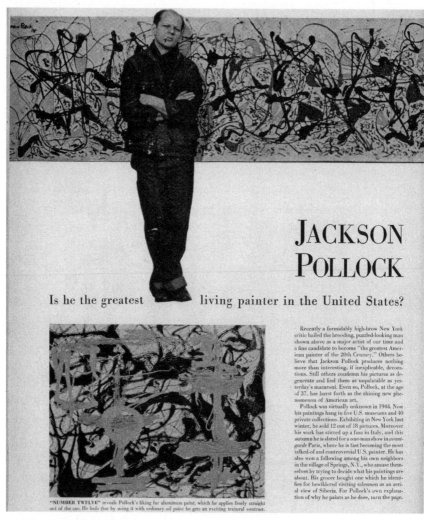

From *Life* Magazine, August 8, 1949. (Photograph of Pollock © Arnold Newman.)

church. But this other story did not leave much lasting impression. The story on Pollock, on the other hand, created a legend.

This was surely in large part due to the story's tone. The final article achieved its impact by being deadpan, notably in its headline: "Is he the greatest living painter in the United States?" Clearly intended to be humorous, in the end the statement proved to be a prophecy. As it happened, the members of the art department, Margit Varga and George Hunt, who had studied with Guy Pène du Bois, were skeptical about the merit

of Pollock's work. It was Longwell's intervention that kept Varga and Hunt's hostility in check and prevented the article from degenerating into a diatribe. He worked closely with them over the early drafts to find the right neutral tone for the story—a tone evident in the first paragraph:

> Recently a formidably high-brow New York critic hailed the brooding, puzzled-looking man shown above as a major artist of our time and a fine candidate to become "the greatest American painter of the 20th century." Others believe that Jackson Pollock produces nothing more than interesting, if inexplicable decoration. Still others condemn his pictures as degenerate and find them as unpalatable as yesterday's macaroni.

Only occasionally did the piece slip into outright humor, as in this comment:

> Critics have wondered why Pollock happened to stop this painting where he did. The answer: his studio is only 22 feet long.

Except for a brief, disparaging mention of Benton there was no discussion of his training. In fact, one of the fascinations of the piece is that it seemed to dispense with all notions of artistic skill and reduce art to a mere matter of feeling or expression. Pollock was a kind of everyman, almost an American antihero. When de Kooning saw the article he commented that Pollock "looks like some guy who works at a service station pumping gas." Pollock's biographers Steven Naifeh and Gregory White Smith have observed that "there was something quintessentially American about this anti-artist, this handsome rough-hewn figure from the American West, living in the country not the big city, working in dungarees instead of a smock, in a barn instead of an atelier, painting with sticks and house paint instead of sable brushes and oil." Benton had figured out that the media needed not just art but a story about art—they were looking for the romance of the rebel, the outcast genius, cast in new contemporary terms. Pollock shifted this story from the idiom of the 1930s into that of the late 1940s and early 1950s.

Probably most readers thought Pollock's work was nonsense, but some were immediately enthusiastic. One Reginald Isaacs sent a telegram

to *Life*: "Jackson Pollock is the greatest painter in the U.S. My enthusiastic opinion is shared by my wife, mother and children." People who hadn't seen Jackson in decades were startled to see that he had become famous. In Springs he became an instant celebrity. When friends brought copies of the article to the house, Jackson was too shy to read it while they were there, but later he arranged to have a hundred copies delivered to him.

America was ready for a great artist. In 1946 Walter Lippmann had predicted the emergence of "the American century," a period in which America would move into a position of world leadership, both as a political power and a cultural force. American wealth and political power made this seem almost inevitable. Europe had been so devastated by the war that its artistic culture had decayed. Indeed, in some strange way, after a century of artistic dominance, the life had largely gone out of modern French painting. Figures like Matisse and Picasso still managed to produce some notable work, but no younger generation of equal stature had emerged to carry artistic innovation forward. By 1948 there was clearly a notable gap to be filled—the New York art market was ready for a star. The number of galleries in the city had quadrupled in a few years, and sales were doubling and tripling year by year.

But who this star would be, and what form his or her work would take, remained a matter in dispute. Clearly Jackson Pollock stood out as one of the most unusual—in fact, as the most unusual artist on the American scene. Of course, the question remained: was his work just some sort of twisted joke, or could it be taken seriously? Somehow, through a remarkable balancing act, *Life* took this element of uncertainty and made it the basis of Pollock's fame and reputation. From this time onward, both those who did and did not like modern art viewed Pollock as an essential reference point.

Notably, Pollock's November 1949 show, held at the Betty Parsons Gallery—Parsons who had arranged to take his work after long and complex negotiations with Peggy Guggenheim—was a public triumph. This time the audience wasn't the usual small coterie of the artist's friends but major artists and collectors, including even Alfred Barr. Pollock stood in the center of the room, apparently sedated, in coat and tie, affably greeting collectors. Lee sat at the receptionist's desk, handing out copies of the *Life* article. Nearly all the reviews were positive. Only Alexander

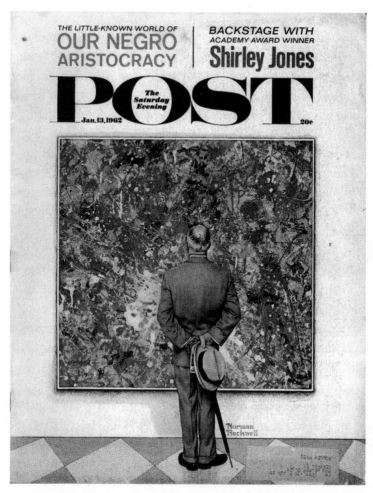

As Norman Rockwell wryly observed, Pollock's explosive paintings burst into popularity in the age of the corporate man, "the man in the gray flannel suit." (Norman Rockwell, *The Connoisseur*, cover for the *Saturday Evening Post*, January 13, 1962, painting © 1962, the Norman Rockwell Family Trust.)

Eliot at *Time* penned a negative response. A number of major collectors acquired works, including Mrs. John D. Rockefeller and the horror film star Vincent Price.

As yet, art historians have not carefully charted the way that Pollock's innovations gained ground in American universities and art schools. But what's amazing is how quickly this occurred, how rapidly modes of art teaching that had been in place for centuries were overthrown, how

thoroughly the new order erased the standards and procedures of the past. One way of measuring this shift is through the exhibition "Contemporary American Painting and Sculpture," a show held annually at the University of Illinois in Urbana-Champaign, which was designed to serve as a sort of broad, unbiased survey, almost a journalistic report, of what was happening all around America in the realm of artistic production. By April 1956, just seven years after the article in *Life* and the triumphant show at the Betty Parsons Gallery, and four months before Pollock's death, the new mode of painting that Pollock had invented, like some invasive species, had virtually annihilated every other artistic approach. As Allen Weller, the dean of the Art School at the University of Illinois, could write:

> It is obvious from the character of the present exhibition that the dominant style which is being produced by student artists in the United States today is what is usually called abstract expressionism—a generally non-objective style, charged with freedom and variety in its material treatment, and rejecting recognizable motifs from the visual world as its primary material.

Not surprisingly, one of Pollock's paintings was a centerpiece of the exhibition. Weller would later confess that one of the greatest mistakes of his career was that he didn't acquire it for the Krannert Art Museum.

Somehow the world had turned upside down. Benton, who had been on the cover of *Time* just a decade earlier and had been the most famous artist in America, was no longer news. Pollock and Abstract Expressionism had triumphed.

Part Ten

The End of the Game

Mere existence is so much better than nothing, that one would rather exist even in pain.

—*Samuel Johnson*

"I Used to Fuck Rita Benton"

The high point of Pollock's career did not last long: only three years, from 1947 to 1950. His creative burst seems to have been possible because for once he stayed away from alcohol, or at least went through fairly long periods when he did not drink. He certainly was not sober all the time; the pattern of his drinking cycles seems to have fluctuated. The first few years were a little rocky: in both 1947 and 1948 he seems to have alternated between sober periods and drunken ones. During this time, however, his productivity escalated—the summer and fall of 1948 were the most productive phases of his life so far—which suggests that he had fairly long periods of sobriety. By the fall of 1948, however, he had returned to heavy drinking, in part because he seems to have been emotionally fluctuating between extreme highs and lows (during the lows he would drink compulsively) and in part because he bought a car and this gave him freedom to go to bars. Around this time there was a series of embarrassing or frightening episodes, including one in the fall of 1948 when he went on a rampage in the apartment of an interior decorator and art dealer, Bertha Schaefer, first insulting her with foul language and then smashing everything in sight including an expensive Chinese screen. She threatened to take legal action but was eventually paid off to stay quiet.

Shortly afterward, during a routine visit to the East Hampton Medical Center, Lee Krasner confided to a young doctor, Edwin Heller, that Jackson was drinking very heavily. Not long after that, Jackson came in

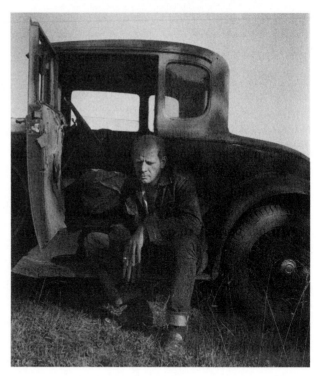

Thomas Hart Benton
(above), as he looked
in the late 1940s, and
Jackson Pollock
(below), as photo-
graphed by Hans
Namuth in 1950. (*Top*:
Benton Research
Collection, Nelson-Atkins
Museum of Art, Kansas
City. *Bottom*: Courtesy
the Center for Creative
Photography, Tucson,
Arizona.)

for medical treatment, after having fallen from his bicycle while return-
ing drunk from the liquor store, with a pack of beer under his arm. Rec-
ognizing that the problem required more than first aid, Heller took it
upon himself to treat Pollock's alcoholism. He arranged for Jackson to
come see him once a week and told him that whenever the urge to drink
became too strong he should pick up the phone and call him. Unlike Pol-
lock's other therapists, Heller seems to have devoted little attention to
the workings of Pollock's unconscious or his deeper emotional prob-
lems. The effectiveness of his therapy was due to the sheer force of his
personality, as well as to the fact that he dealt with the issue of alcohol-
ism head-on, without getting sidetracked by questions of childhood de-
velopment or artistic expression. There are contradictory reports about
whether Heller gave Pollock medication. Steven Naifeh and Gregory
White Smith report that he gave Pollock tranquilizers—apparently phe-
nobarbital and Dilantin. This seems likely, although on various occa-
sions Lee Krasner denied that he did so, perhaps because she feared that
it would give rise to rumors that Pollock was not lucid when he made his
paintings and would cast doubts on the legitimacy of his art.

For a time the treatment seemed to work. Shortly after starting with
Heller, Jackson called his brother Sande in Connecticut and announced
that he had "quit for good," which inspired Sande, who also had an alco-
hol problem, to give up drinking too. At Christmas in 1948 Stella re-
ported in a letter to Charles that "there was no drinking" and that
Jackson "hadn't drank anything for over three weeks at Christmas hope
he will stay with it he says he wants to quit." According to Naifeh and
Smith, Pollock never entirely gave up drinking, but under Heller's guid-
ance there were no public displays of drunkenness. If he drank he would
go up to his bedroom with a bottle of cooking sherry that he had buried
in the backyard. Sadly, in March 1950 Heller was killed in an automobile
accident in East Hampton. Pollock remained sober for another eight
months, but on November 25, 1950, after completing a sequence of
Hans Namuth's movie of him painting, Pollock took up drinking again.

During this period Pollock also received informal therapy from a
personal friend, Roger Wilcox. At one point Wilcox experimented with a
kind of mild hypnosis, based on procedures described in *Dianetics*, by
L. Ron Hubbard, the founder of the religion Scientology; Wilcox had
learned about the book from the back pages of his favorite magazine,

Astounding Science Fiction. For the most part Wilcox simply had long talks with Pollock and went on walks with him that helped to stabilize his moods.

Lee Krasner always gave Heller credit for keeping Jackson sober, and he does seem to have played a very positive role. But the fact that Pollock stayed liquor-free for eight months after Heller's death suggests that other factors were in play. In this regard, it's interesting to look at the pattern of Pollock's artistic productivity. The numbers aren't absolutely reliable, since they are based on known surviving works, and some works are far larger and more significant than others. Nonetheless, a clear pattern is apparent.

> 1947—17 paintings
> 1948—32 paintings
> 1949—40 paintings
> 1950—55 paintings (an average of more than one a week)

What this suggests to me is that Pollock was going through some sort of emotional cycle. If we were to suppose, for example, that Pollock did a painting a week when he was feeling well, this would suggest that he was depressed two-thirds of the time in 1947 but hardly at all in 1950. Of course, I don't pretend that this calculation is precisely accurate: I present it by way of illustration. In actual fact, when he was experiencing a creative burst, Pollock could produce a painting, particularly if it was a small one, in a single day and perhaps even more quickly. At times he must have produced five or six in a single week. Thus, even in 1950 there must have been a good many weeks when he did not paint at all. From the accounts of those who knew him, it appears that even during his "up" periods Pollock was often moody and depressed. During his "down" periods, however, he became so depressed that he was incapacitated—in fact all but immobilized.

At the point when he began drinking, his productivity began to decline, although we can observe two phases of this decline. From 1951 he was reasonably productive, although the numbers are a little misleading since the paintings tend to be considerably smaller and less ambitious than before. Arguably the last of his major paintings was *Blue Poles* of 1952, although Pollock had considerable difficulty bringing it to completion

and worked on it for something like twenty sessions. In addition, we know that nearly everything he created in 1953 was produced in the summer, in the space of a few weeks.

1951—32 paintings
1952—16 paintings
1953—10 paintings

Not only did Pollock's productivity decline, but he also somewhat shifted his artistic direction in 1951. From May through September of that year he produced twenty-eight "black paintings," which have a new look. Like the works of the previous year, these use a dripped or poured technique, but the paint is thinned to a watery consistency, to create drawings with figurative imagery, and there is no buildup of layers of pigment. The most common image is a kind of decapitated head, but one can also discern figures and mutilated limbs. Most writers have felt that these paintings "mark a radical break from the style of his past," and they have been divided about their merits, with most seeing them as a distinct artistic let-down. Such a view, however, is largely based on the assumption that Pollock's earlier paintings such as *Autumn Rhythm* are completely "abstract" and "nonfigurative," which as we have seen is not the case. To a large degree, in fact, Pollock seems to have been disclosing what he was doing in the understructure of his earlier paintings. While no one could argue that they are quite as "major" or "monumental" as the works of the previous few years, they represent a thoroughly intelligent attempt to make a slightly new start, and on the whole they strike me as more emotionally compelling than the works he had made when he first arrived at Springs. In short, in my view at least, Pollock's decline was not so much that his art had hit a dead end as that his increasing depression made it difficult for him to work or paint at all. After the black paintings, his creative bursts grew briefer and briefer.

As his drinking problem grew worse, Pollock began trying new therapists. In March 1951, with Lee's encouragement, Jackson consulted Dr. Ruth Fox, a psychiatrist who had been a friend of Helen Marot. While Fox believed that neurosis played a role in alcoholism, she had learned from experience that analyzing a drunk was generally just a way of indulging the patient's ego and resulted in "a waste of the analyst's time

and the patient's money." The problem at its root was chemical, and the only effective treatment was abstinence. A strong-willed therapist could help bring about abstention, as could group support such as Alcoholics Anonymous. In addition, she sometimes used a new drug, Antabuse, which in combination with alcohol caused nausea and vomiting. In Jackson's case, however, none of these approaches seemed to work. At meetings of Alcoholics Anonymous he became grandiose, boasting, quite inaccurately, that he had more willpower than the other softies in the group. He resisted taking Antabuse. While he twice checked into a private clinic at Regent Hospital in Manhattan for detoxification, he kept a bottle of liquor hidden in the bathroom. In the summer of 1952, at the height of one of his self-destructive binges, Jackson ceased seeing Dr. Fox, in part because she lost Lee Krasner's support by suggesting that Krasner bore some responsibility for Jackson's behavior and was also in need of counseling.

Eager for a healer who would do more to gratify his ego, Jackson moved on to Dr. Grant Mark on Park Avenue, who in fact was not an M.D. Dr. Mark told Jackson that he suffered from "chemical derangement" that could be cured by a diet with no milk products or red meat and lots of eggs, vegetables, and fruit juice. He prescribed daily baths in kosher salt, as well as a mysterious soy-based emulsion, which naturally Dr. Mark sold. Mark also briefly attempted to act as Pollock's art dealer and gain control of his artistic output, although these negotiations ended acrimoniously. During this period Jackson also began visiting a nearby Indian dance instructor, N. Vashti, and his wife, Pravina, with whom he spent much time talking about Hindu religious beliefs, pantheism, and the writings of figures such as Khalil Gibran and Ferdinand Osindowsky.

1954 marked a second turning point, when Pollock's productivity dropped again, this time even more drastically.

1954—1 painting
1955—1 painting
1956—no paintings

The human mind searches for patterns and meanings—for neat little explanations that link "cause" and "effect"—and various reasons have

been put forward for Pollock's catastrophic decline. Some writers have proposed that Pollock was emotionally devastated by the harsh criticism he received during these years, in particular by the fact that his supporter Clement Greenberg turned against him. However, the period of Pollock's artistic and emotional decline was marked by some of the best reviews of his career as well as many other honors. For example, Alfred Barr included his work in the Venice Biennale, and in 1954 he sold a painting to Ben Heller for eight thousand dollars, which was more than the annual income of most Americans and the largest price he received in his lifetime. When we look at the chronology, moreover, it becomes apparent that Greenberg's turn came well after Pollock's downward spiral had started. Even when Pollock began to create semi-figurative paintings, Greenberg wrote glowingly about his work. He did not pull back until 1952, when he organized a retrospective of Pollock's work at Bennington College, and the two got into a fight at the opening. The reason for the split was Pollock's grotesquely drunken misbehavior.

Many writers have proposed that Pollock was the victim of a creative impasse—that he felt unable to move forward. Thus, for example, Deborah Solomon has written:

> By October 1950 Pollock had done everything he could do with his "drip" technique. Although some of his contemporaries would continue to turn out their trademark images for many years— Rothko, for instance, painted floating rectangles for more than two decades, and Motherwell painted his "Spanish Elegies" for more than three decades—Pollock felt compelled after four years to abandon the style that had won him both personal satisfaction and public acclaim. So fierce was his hatred of authority figures that once he became one, once he had mastered his own style, he had no choice but to rebel against his own mastery.

This is not entirely wrong, for by essential temperament Pollock was always in a state of artistic crisis. But much of the criticism of Pollock's very latest work is based on the misunderstanding that the grand drip paintings are fundamentally different from the later paintings, because the drip paintings are "abstract" and the late paintings contain figurative imagery. In fact, the drip paintings contain imagery also, although it is

more heavily "veiled." Indeed, even in his latest paintings, Pollock's essential instincts as a painter strike me as exactly right: he was going back to the fundamental understructure of his drip paintings, going back to the wellsprings of his creativity, trying not to repeat himself but to set a new course.

And, of course, this raises still another possible reason for Pollock's distress: he was certainly aware that the enthusiastic writing of his principal supporter, Clement Greenberg, was based on fundamental misunderstandings. While he made halfhearted efforts to make his work fit Greenberg's theories, Pollock surely knew that the wellsprings of his art came from somewhere very different from Greenberg's humorless pronouncements and mechanistic theories.

But in my view none of these explanations quite gets to the heart of the matter. The real problem was that Pollock was very sick. While medications now exist for bipolar illness, they did not exist in Pollock's lifetime. Surely the real problem that Pollock encountered at this juncture was not that he somehow failed as an artist but that he suffered from a then incurable disease—a depression so crippling that it often made him unable to work at all. What is remarkable is that despite this disease, which incapacitated him most of the time, he nonetheless produced such a memorable body of achievement.

Pollock's last therapist, with whom he consulted until a few days before his death, was Ralph Klein, who came into his life through the influence of Clement Greenberg. Klein seems to have had a captivating manner with desperate people, and both Greenberg and Pollock regarded him as a genius. One friend of this period recalled that Pollock "adored his shrink," although his influence on Pollock's life was probably not beneficial. Pollock first made contact with Klein through Greenberg, who would see him five times a week at Barnes Landing on Long Island and then drop by to see Lee Krasner and Jackson Pollock at Springs, not far away. Lee had been suffering from colitis, so Greenberg suggested that she go see Klein, who passed her on to a colleague, Leonard Segal. Shortly afterward, Pollock went to see Klein, who decided to keep him as a patient. Pollock began working with Klein in 1955. During the winter months, when Klein lived in the city, Pollock would take the train in from Long Island into the city every Tuesday, then board the subway to Klein's

apartment at West Eighty-sixth Street. One consequence of these visits to the city was that it made it easy for Pollock to visit bars. After the sessions he would often unwind at the Cedar Tavern at University Place and Eighth Street, and it was there that he met Ruth Kligman.

Klein was a follower of a kind of renegade version of Freudian psychology, whose leading figures were Harry Stack Sullivan, Jane Pearce, and Pearce's husband, Saul Newton. In 1957 Pearce and Newton founded the Sullivan Institute for Research and Psychoanalysis in Manhattan, and consequently this branch of therapy is generally known as the Sullivanian School, although Greenberg always referred to it as the Newtonian School, and it is also sometimes known as the Barnes Landing Group, for the area in Long Island where many of the group had summer homes. They differed from orthodox Freudian analysts not only in matters of style (Freud had his patients lie down; they had their patients sit upright) but in fundamental matters of viewpoint. Freud had believed that psychic disorder was related to psychosexual developments in early childhood. The Sullivanians traced them instead to imprisoning relationships and saw the nuclear family as a Kafkaseque prison cell whose life-strangling effects could only be countered by drastic measures. To lessen the bad effects of dependency, they encouraged their patients to liberate themselves from bad relationships and spread their dependency feelings around. They were fearful of monogamous relationships, which might provide the occasion for re-creating imprisoning relationships of the past. They often encouraged severing ties with parents, siblings, relatives, and childhood friends. Rather naïvely, they believed that if repression was removed, creativity could flower without restraint: during the 1960s Sullivanian theories were used to rationalize free love, sexual communes, and other unconventional forms of behavior. In Pollock's case, Klein is known to have encouraged his relationship with Ruth Kligman and undoubtedly played a role in breaking up his marriage with Lee Krasner. Like some of Jackson's other therapists, he seems to have paid little attention to his drinking problem, even when the artist showed up for sessions drunk, not even suggesting that he seek help from other sources, such as Alcoholics Anonymous.

In March of 1956, when Pollock met Ruth Kligman at the Cedar Tavern in New York, she was twenty-five, he was forty-four. They began

an off-and-on-again affair, which had intensified by late spring, when she moved to Long Island. By this time Pollock and Lee Krasner had become estranged and were living separate lives, although they both made use of the farmhouse in Springs. One July morning, Lee was on the back porch when Pollock and Ruth Kligman came out of the barn studio, where they had slept together the night before. On July 12 Lee went to Europe, partly to see sights and make contact with European art dealers, but no doubt in large part to escape from the emotional confusions of her relationship with Pollock. At this point Ruth Kligman moved into the farmhouse with Pollock.

On Saturday, August 11, Ruth Kligman and Pollock drove out to the East Hampton train station to pick up her friend Edith Metzger, a twenty-five-year-old beautician from the Bronx. They drove home and changed into bathing suits to go the beach, but Pollock didn't feel like going. He spent the afternoon crying and drinking a bottle of gin, and they paid a brief visit to Montauk, where they visited James Brooks and his wife, who remembered that Jackson looked like a mess. By evening he was feeling better, cooked a steak dinner, and offered to drive Ruth and Edith to a concert in East Hampton. En route, however, he felt ill and pulled over. Two people stopped to ask if he was all right, the first a policeman, the second Pollock's friend Roger Wilcox. In both cases, Jackson told them that he was all right.

After a few minutes he started driving again, but going only about twenty miles an hour. When they reached a little bar, Jackson pulled over and made a phone call. Realizing he was drunk, Edith got out of the car and refused to get back in, but Jackson ordered her back. Once she was inside he turned around and started speeding back toward the farmhouse. Ruth Kligman has noted that she had been with Jackson before when he was speeding, but she had remained silent and after a few moments he slowed down. In this case, Edith began to scream, "Let me out! Let me out!" and as she did so Jackson pushed the accelerator to the floor. As was the case when he attended parties in the 1930s, something about screaming women escalated his behavior—drove him into a frenzy. At a point where the road curved left, the car hit a crown and soared off the road, hit some trees, began to spin, and then flipped end over end, front end over back. Edith clung to the car, and it crushed her when it

Pollock's body at the accident scene, August 11, 1956. (Photograph by Dave Edwardes. Pollock-Krasner Study Center, Jeffrey Potter collection.)

flipped over. Jackson and Ruth were thrown into the air. Miraculously Ruth Kligman survived, although with major injuries. Jackson was killed instantly when his head hit a tree.

The Final Break

Let me conclude with some thoughts about Pollock's emotional anguish and how it was tied to his relationship with Tom and Rita. As I have mentioned, one of the fundamental misconceptions about Pollock's work is that he broke his ties with Thomas Hart Benton. Biographies of Pollock invariably omit references to Benton when they get to Pollock's later career. Yet when I worked on a documentary film on Benton with Ken Burns, what was striking was that everyone we interviewed who knew Benton in the early 1950s spoke of Pollock's continual phone calls to the Bentons, up to the time of his death. Even late in his career, after

he had made many public statements repudiating Benton, Pollock continued to call him on a regular basis; and even though Pollock was often very drunk, Benton never hung up the phone.

Benton himself later noted that something was different about the way he related to Pollock, compared to his other students:

> After leaving my classes, very few of my students kept in contact with me. Quite a number achieved success of one sort or another, but I rarely, or never, heard from them. With Jack Pollock it was different. Even after I had castigated his innovations and he had replied by saying I had been of value to him only as someone to react against, he kept in personal touch with me and with Rita. At frequent intervals, and up to within a few months of his death, he would make long-distance telephone calls and would talk about his early days with us, mostly about those spent at Martha's Vineyard.

Benton and Pollock's personal relationship seems to have remained warm, despite the artistic schism between them. In 1952, for example, Pollock and one of his young admirers, Harry Jackson, went barhopping and then, late at night, at Jackson's insistence, called up the Bentons in Kansas City. Harry had been a cowboy and a marine, and had been wounded in combat in the Pacific, and Pollock was convinced that such a manly man was someone Benton would like to know. Rita answered the phone, and Jackson said to her, "Goddamn, Rita, honey. I got my friend Harry here and he and Tom have got to meet." From the way he slurred his words, Rita immediately sensed that he was drunk and in her vivid Italian brogue responded, "Jack, I'm not gonna disturb Tom at this hour. Call up when you're sober, and you ought to be ashamed of yourself."

In an interview with Ken Burns, Benton's sister Mildred Small noted that Pollock "felt attached to [Benton] always, I don't know that there was any break." "After the drips got very popular," she recalled, "and he sold them as fast as he painted them, he used to call Tom, asking, or really begging, for Tom's approval. Tom never gave it. He said, 'Jack, it's all right, whatever you want to do. It's successful, you're successful. Don't bother yourself about it.'" Then he would hand the phone to Rita and let her cut him off. "In the middle of the night it always was—he

didn't stop to think what time it might be in Kansas City." Pollock "was a terrible drunk," she noted. "He was even at eighteen."

Benton's student Bill McKim never met Pollock face-to-face but talked to him several times on the phone. Pollock "had a longtime attachment to Tom," he remembered:

> After Jack became pretty well known, he'd call Tom quite frequently. I'd be over at Tom's visiting in the evening when he would call. In New York it might be midnight and I'd be there, maybe it would be eleven o'clock, and it would be Jack calling. The Bentons were already ready for bed: they didn't like to stay up too late. They'd say, "Here, Bill," and they'd hand me the phone. I'd never even met Jack Pollock. I never really knew him. So I didn't have any profitable discussions with him on the phone. They were just like listening to any drunk.
>
> They think he was rebelling against Tom's teaching by his drip painting. No, I don't think so. I think the filial devotion of Jack to Tom was manifest in these phone calls, these repeated phone calls . . . I think that when he got to pouring the stuff out, it was just like pouring his frustrations right onto a canvas on the floor. And I can't think of a better way to make an expression. They were honest expressions of a guy that had honest feelings about his art. Tom was very quick to say that Jack Pollock was a great colorist. I think Tom was appropriately proud of Jack's painting.

Similarly, the painter Sidney Larson recalled that "on one occasion while I was living with the Bentons, Pollock called him. It was late at night and Pollock had been drinking and he wanted to talk to his old mentor and adversary . . . When Pollock was depressed or particularly unhappy he liked to talk to old Tom. Certainly you can see the Benton influence in the early work of Jackson Pollock, just as you can see the influence of Greco."

It's not clear to me whether Pollock's New York friends knew of these phone calls, and Lee Krasner never acknowledged or spoke of them. For one thing, Benton was totally out of fashion in the art world of that time, and Pollock's connection with him was a guilty secret. In addition, there is a more disturbing reason for Lee Krasner's silence.

Pollock's tie with Benton went beyond the fact that he viewed Benton as his father. It went deeper and had a second oedipal dimension, which pushed their relationship to the furthest bounds of tragedy. The fact is that the woman Pollock loved most deeply was not Lee Krasner. It was Benton's wife, Rita. Benton was aware of this, although he seems to have shrugged the matter off. Writing of Pollock's phone calls, Benton remembered:

> Often on these occasions he would be pretty well tanked up, but that made him only more affectionate. He would tell Rita that she was his ideal woman and the only one he had ever loved. Maudlin as some of this was, we knew there was truth in it. He did love Rita, and he always remembered how she had taken care of him when his case as a young aspirant of the arts seemed so hopeless.

Benton's statement seems to portray Pollock's love for Rita as that of a son for a mother figure. But Benton was surely aware that it was something more confused and troubling. As he confessed to Polly Burroughs in 1964: "Of course feeling the way [Jack] did about Rita, he came to resent me."

B. H. Friedman remembered Jackson telling him, when they were sitting together at the Cedar Tavern, "'You know, I used to fuck Mrs. Benton.' I was very shocked. He said it just this way: 'I used to fuck her.' Period." Pollock made the same claim to his brothers and to Axel Horn his classmate at the Art Students League. Frank Pollock remembered a conversation he had with Jackson in 1954 at Springs: "He told me right outside the door to his studio that he had an affair with Rita. I was kind of shocked, but then Sande came over and confirmed it. We just gossiped among brothers." Axel Horn heard the same story and seems to have at least half believed it: "I could see her initiating him into sex as a favor, doing it to help him resolve some awkward problems—doing it in a motherly way. Spaghetti and sympathy, you might say."

Personally, I don't lend any credence to Pollock's boast. While Benton was not faithful to Rita, at least in the early years of their marriage, there's no evidence that she ever betrayed him, and Pollock's tendency to make up stories about his sexual prowess is well known. It's hard to believe that if Pollock had been involved with Rita, Benton would have remained quietly on the sidelines and not responded in some fashion.

Significantly, Jackson told Lee Krasner a different story than the one he told to other men: he told her that while he had wanted to make love to Rita, she had turned him down. According to Krasner, he told her that "Rita Benton played with me and titillated me and got me all excited, but when it came to the moment of truth, she wouldn't go through with it." According to Krasner, Pollock proposed marriage to Rita during his drunken last visit with the Bentons in Kansas City.

The most vivid and convincing account of Pollock's infatuation with Rita is that of Ruth Kligman, who was his girlfriend during the last five months of his life, after he had ended his relationship with Lee Krasner. Kligman was twenty years younger than Pollock and nearly thirty-five years younger than Rita. She recalls that shortly before Pollock's death he told her: "I think you're very pretty, but more than that, you are special like no one else I've known except maybe Benton's wife."

"But she's so old," Kligman replied.

"It has nothing to do with age. She had that marvelous quality of being a woman, a real woman and giving. She was so good to me. So understanding. I loved her."

In summing up her relationship with Pollock, Kligman wrote: "I brought him back to his youth, his poetry, his romance . . . I was Benton's wife whom he loved and could not have because she was not available."

Interestingly, while Picasso was chiefly interested in figures such as the Minotaur, which express a troubled masculinity, Pollock was chiefly interested in figures such as the Moon Woman or the She-Wolf, which express a powerful and destructive motherly presence. It seems clear that Pollock's relationship with his own mother was partly responsible for this obsession; but in artistic terms it became Tom and Rita Benton who served as the parental figures against whom Pollock enacted his desire, his rage, and his oedipal conflicts. Benton himself, in an unguarded moment during an interview, remarked: "Jack had problems, lots of them. I don't really know what they were. Of course, feeling the way he did about Rita, and our differing views on art, he came to resent me. "

When Jackson Pollock came to study with Benton in 1930, he was a complete unknown, and Benton was pushing his way to national attention. By the 1950s their position was reversed. Pollock was an international celebrity, and Benton was a has-been, who had broken with his New York art dealer, depended for sales entirely on his wife, and had no

market for his work outside Kansas City. But Benton had seen his father disintegrate when he lost his seat in Congress and seems to have been ready at some level for his fall from fame. Curiously, in fact, during these years when the world had forgotten him, he seems to have come to some sort of inner peace. His daughter, Jessie, has remarked, "I think he paid no attention to all these critics because he would get these things that he had to do.

"I think what hurt my father the most," she adds, "and he used to talk to me about it much later—not when we were kids—was loneliness. He said it was his great motivator. In his youth until he was in his fifties, up until then he was lonely."

While Pollock was in his studio dripping paint, Benton continued to explore America. His pupil Ray Ottinger has listed some places in Kansas City that he advised his students to visit, such as the Blue Room, a bar full of hard-drinking men and women, and the Metropolitan Church of God, which was old-time religion at its finest, with spectacular singing. One of these locales was the Folly Theater Burlesque. As Ottinger recalled of his visit there:

> One dancer with an extremely enthusiastic smile pranced to center stage and, as the momentum from her shimmy worked its way up her torso, her false teeth popped out of her mouth. She caught them on the fly and reinserted them without missing a bump or grind. Benton would have loved her.

But what Benton loved most—as he once told his student Earl Bennett—was to float the rivers of Missouri and lose himself in the experience of nature. As he once wrote:

> The rivers of Missouri are often very beautiful . . . To get in a skiff and row out in the middle of one of these rivers on a summer night when the moon is full is to find all the spirit of Spenser and his "faery lands forlorn" . . . There is over these summer night waters and on the shadowed lands that border them an ineffable peace, an immense quiet, which puts all ambitious effort back in its futile

place and makes of a simple drift of sense and feeling the ultimate and proper end of life.

On one of these river trips, Benton commented to a companion:

If you notice: The careers of abstract artists so often end in a kind of bitter emptiness. It's the emptiness of a person looking into himself all the time. But the objective world is always rich. There is always something round the next bend of the river.

There are some moments of Benton's later life that my mind wants to translate into film. One of them is a scene in which Thomas Hart Benton is working out on his driveway on Martha's Vineyard and two men he has never met walk up the road. One is painter Herman Cherry; the other Willem de Kooning. They had come to the island specifically to tell him that his former student Jackson Pollock had died the night before, when he drove his car into a tree on Long Island, also killing one of the two young women who were with him.

At one level, of course, this is a meeting of two titanic antagonists: Benton, the leader of the Regionalist movement, confronting de Kooning, who with Pollock's death became the leader of the Abstract Expressionists. But to me the poignancy of the moment is that a collision of the two wills never occurred—Benton and de Kooning were both too upset to enact this drama. De Kooning, who was generally quite witty, stuck to the plain facts. Benton, the man who always had something to say, the politician's son who never could keep his mouth shut, for once was almost speechless. They walked back up to the house, and Benton invited the two men inside and offered them chairs, but no one sat down. Benton took the news hard. De Kooning offered to fly him to the funeral, but Benton just shook his head and said that he "couldn't take it." Before the two visitors left, Rita opened a drawer and showed them a collection of newspaper and magazine clippings about Pollock that she had saved over the years.

After a very brief conversation exchange Benton and de Kooning exchanged farewells and turned their backs on each other. They never met again: this was the only time that Benton and de Koonng ever stood face-to-face. Pollock had personally touched them in a way that momentarily

broke down the divisions between them and made a debate about artistic style utterly beside the point.

Of course I do not wish to suggest that Benton's relationship with Pollock was a smooth or easy one, or that Benton was fully able to grasp or appreciate Pollock's work. Pollock's painting clearly went beyond what Benton could comfortably accept. But while he was troubled by Pollock's success, which in many ways went against his own artistic methods and convictions, he could also feel a kind of paternal pride in it and could recognize that this success somehow affirmed his own connections with modern art. He could also recognize that in the seeming formlessness of Pollock's so-called abstractions were imbedded approaches and methods of composition and organization that were ultimately based on his teachings. Indeed, in speaking of his early years as a teacher, Benton once remarked:

> I thought I could give. And some of them got a lot out of it. Now even Jack Pollock. Now I don't say I made him by any means—but if he had had no formal basis for that damn stuff, if he hadn't gone through my class, what the hell would he have done?

In the mid-1960s Earl Bennett tape-recorded a drinking session in which Benton freely engages in denunciations of the latest follies of modern art. At some point in the conversation the name Jackson Pollock comes up, and several times Benton's acolytes set things up so that he can demolish the apostate with a muscular phrase. For some reason, Benton doesn't rise to the bait, and on each missed opportunity one can sense a build-up of tension in the room. Then, on the third or fourth mention of Pollock's name, the tone of Benton's conversation abruptly shifts. After a brief pause he declares: "You know, Jack never made a painting that wasn't beautiful."

Appendix I: Memories of Macdonald-Wright

When I made a museum courier trip to Japan in the mid-1980s, I had a chance meeting with Professor John Rosenfield of Harvard, who reminisced at that time about his friendship with Stanton Macdonald-Wright. While working on this book, I contacted Rosenfield again, and in March 2007 he sent me this informative and vivid statement as an e-mail. Interestingly, his picture of Macdonald-Wright's personality matches nicely with the testimony of Thomas Hart Benton (though, of course, Benton knew Macdonald-Wright years earlier).

To my mind, this little sketch is all the more eloquent because it was written spontaneously, without self-consciousness.

Esteemed Henry:

My eighty-two-year-old brain remembers you vividly, along with Macdonald-Wright, whom I knew well. Not that knowing him was difficult. Germane to your query was the fact that he was extremely personable, approachable, entertaining, and seemed to delight in helping young people. Macdonald-Wright had considerable insight (and sympathy) into Japanese culture. He had some Japanese language skills and was conversant with Chinese Taoism.

When I came to UCLA in 1957 to teach Oriental art, he sent me a note inviting my wife and me to lunch at his modest home in Malibu. He had taught the subject at UCLA in the past, and at lunch he gave me a precious copy of Osvald Sirén's *Chinese on the Art of Painting* with his

copious marginal notes. When we came to Kyoto in 1962, he invited us to lunch at his sumptuous quarters in the ancient Zen temple of Kenninji, and we went there many times. A big treat; he was a zealous gourmet.

He kept up his painting and was beginning to go back to the Synchromism of the sub-Cubist days. I had gotten to know an aspiring American expatriate named Clifton Karhu, who had given up his evangelical mission and was beginning to paint landscapes—muddy and inchoate. I happened to mention this to Macdonald-Wright. He said, "Take me to see this man." Karhu's studio was an abandoned tool shed. Mr. Wright looked at a few paintings, went over to K's paint box, and threw the tubes of black and white out of the window. As he did so, he said, "Young man, you've got to learn about color."

He and Karhu then became close friends. At the time Karhu was learning how to make woodblock prints, and with Macdonald-Wright's guidance in matters of color and composition, Karhu became a very successful, semi-commercial designer of landscape prints that came close to tourist art. Later, however, they fell apart. I don't know why.

Mr. Wright also seems to have been a part-time dealer in Japanese art. I know that he sold some big-ticket items to Avery Brundage. Each morning he would patrol the Kyoto dealer's streets in the morning dressed like a grandee—with cape and cane and a wide-brimmed black hat. I couldn't help seeing the resemblance to Frank Lloyd Wright and the GREAT MAN ways and image of the day. I had not realized the connection with Thomas Hart Benton (who had a GREAT MAN complex and ambitions of his own), but it makes perfect sense in the light of Mr. Wright's character.

As a dealer with an unusual "eye," he had a feeling for artistic quality, but I suspect that he learned much of what he knew from the jolly dealers on Shinmonzen and Nawate streets. His conversation never veered into art history, museums, collectors, or the art world.

My knowledge and memory are vague, but I think he was implicated in a major brouhaha when the Los Angeles County Museum wanted to purchase a large Chinese art collection belonging to General Munther, who had served with the police in Beijing before World War II. Macdonald-Wright vetted the material, as did Berthold Laufer of the Field Museum in Chicago, a skilled German archaeologist—but no connoisseur. The County Museum squirreled up a great deal of money and

bought it, but before it was exhibited Alfred Salmony of New York University (who was no great shakes as a connoisseur, either) came through town and denounced the material. Many of the Buddhist stone sculptures were much later in date than claimed. Most of the paintings were not what they seemed. Other parts—ceramics, lacquers, textiles—were not so bad, but in no way merited the sales price.

There was a great stink. The bad experience caused a chill in the County Museum's enthusiasm toward Chinese art that has lasted to this day. Laufer took his own life (I don't know whether this or something else was the cause) and by my day the collection had been distributed to various area colleges. I never heard that Macdonald-Wright was blamed for the matter, but it may answer your question about his expertise. I think he was more interested in aesthetic theory and philosophy than in careful connoisseurship and art history.

I remember Macdonald-Wright's wife only as a tall, attractive, well-groomed, colorless, rather conventional American lady, cheerful but clearly subordinate to the grand man. I recall that in *her presence* he told me that when he was offered tenure at UCLA, a dean explained that with tenure he could be dismissed only because of incompetence or moral turpitude. The dean said that he had no concerns about the first cause, and about the second he said, "For God's sake, Mr. Wright, take them off campus."

Thinking he would respond to a Parisian, I once took a distinguished French woman art scholar for lunch with the Wrights at Kenninji. She was a scrawny, withered old maid, and to my surprise and chagrin he was perfectly awful to her, rude and dismissive. Lack of pulchritude trumped Francophilia.

This is probably more than you wanted to know, but if I can help you further, please contact me at the home address below.

Hope this helps.

With all good wishes.
John Rosenfield
Professor Emeritus
Harvard University

Appendix II: John Dracopoli, 1890–1975

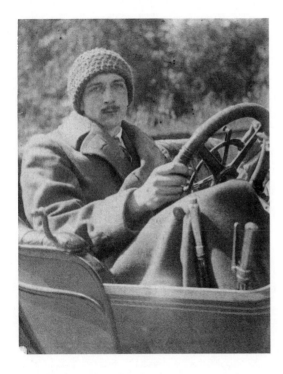

John Dracopoli, 1890–1975.
(Photographer unknown. Courtesy
of Michael Dracopoli, Boxford,
Sudbury, Suffolk, England.)

In an early draft of this book I noted two mysteries associated with the first phase of Synchromism. One was that all the paintings in the first Synchromist exhibition had disappeared. The other was that nothing was known about John Dracopoli, who was the subject of some of these paintings and whom Macdonald-Wright mentioned in his letters, along with Russell, as one of his two closest friends in this period. I conjectured that there might be a link between these two things, and in fact this

proved to be correct. The name Dracopoli is not that common, and through the Internet I was able to locate, in succession, his nephew in France, his great-nephew in Virginia, and his son in England. They provided the outlines of Dracopoli's biography, as well as an account of the fate of the Synchromist paintings he owned.

John Chance Dracopoli was born at Antibes in 1890, one of five children (two sons, three daughters) of an Italian father (Nicholas) and an English mother (Katherine). The family was originally from Genoa, and his father worked as aide-de-camp to the king of Montenegro. John was educated at Malvern, an English public school. Before World War I he accompanied his older brother, Ignazio, on hunting and exploring expeditions in Mexico and East Africa. But he decided not to join the most notable of Ignazio's expeditions, his 1912 venture to discover what happened to the Uaso Nyiro River in Kenya—a journey later written up in the *Journal of the Royal Geographical Society,* as well as in a book, *Through Jubaland to the Lorian Swamp.* The decision not to go seems to have been wise, for Ignazio died a few years later of tropical diseases contracted during this trek.

Instead, in this period John lived the life of an aesthete and dilettante in Paris and Antibes. He probably met Stanton Macdonald-Wright in 1911, when Macdonald-Wright rented a villa in Cassis, not far from Antibes. He is mentioned with some regularity in Macdonald-Wright's letters of this period, as a companion both in Paris and London.

During World War I, Dracopoli served as an ambulance driver on the northwest front and was awarded the Croix de Guerre. After the war he spent some time in Paris studying sculpture, producing work of a decorative sort, which, while not notable in the history of art, is quite attractive and well designed. In the 1920s he married a French Catholic, Suzanne Elizabeth Melera. They settled in Surrey and had one child, Michael. Sadly, Suzanne died in 1936. During World War II, Dracopoli moved to London, where he joined the Air Raid Protection Service as a warden. In 1944 he moved to the rural village of Great Bricett in Suffolk, ten miles from Ipswich, where he lived quietly and simply on a modest private income until his death in 1975. His ashes are in the graveyard there, in the church of St. Mary and St. Lawrence, which has a memorial window dedicated to his memory, commissioned by his son.

For many years, Dracopoli hung a group of Synchromist paintings in

his cottage, but as his book collection expanded he moved them to an attic, and one day, in a fit of housecleaning, he took them down and burned them. Only a few weeks later he discovered an advertisement in the *London Times,* which had been placed there by Macdonald-Wright, asking for information about John Dracopoli. After years of inattention, American collectors were becoming interested in Synchromism, and Macdonald-Wright was trying to locate some early paintings to sell to them. Dracopoli and Macdonald-Wright arranged to meet in France not long afterward. Fortunately, one major painting survived, Morgan Russell's *Synchromy in Orange: To Form,* which was so large that it had been stored under a barn. Since the painting had been badly damaged, it was "restored" by Macdonald-Wright—in its present form it is as much the creation of Macdonald-Wright as of Russell. Shortly afterward, it was sold to Seymour Knox, who donated it to the Albright-Knox Gallery in Buffalo.

Acknowledgments

Like those of most projects, the origins of this book could be traced back to a series of different moments. Shortly after college, my research on John La Farge led me to the owner of a La Farge painting, Slater Brown, who had been a close friend of the poet e. e. cummings and gave me a copy of cummings's favorite book on art, Willard Wright's *Modern Painting*, which I still treasure. At that point I became interested in the art theory that lay behind Synchromism, a mode of painting that I had long admired. The notion that the work of Benton and Pollock had properties in common first fully came home to me when I took my first teaching job at the University of Illinois in Urbana-Champaign. There my colleague was Stephen Polcari, the author of the first article to promote this heretical idea, "Jackson Pollock and Thomas Hart Benton" (*Arts*, March 1979).

In 1989, when I wrote a biography of Thomas Hart Benton, I dealt in passing with his relationship with Jackson Pollock. The specific impetus to tackle this subject more intensely came in January 1998, when I spoke at a colloquium at the Metropolitan Museum of Art devoted to the subject of "Jackson Pollock: The Early Sketchbooks." This coincided with the publication by the museum of *The Jackson Pollock Sketchbooks in the Metropolitan Museum of Art,* with essays by Katherine Baetjer, Lisa Mintz Messenger, and Nan Rosenthal. I am extremely grateful to Nan Rosenthal, who invited me to give the lecture, and to the art historian Richard Schiff and the artist Terry Winters for their encouragement and helpful comments.

With regard to the creation of this book, I owe particular thanks to my agent, Sandy Dijkstra, of the Dijkstra Agency in Del Mar, California, who placed this project, and to Peter Ginna, publisher and editorial director at Bloomsbury Press, who took it on. Throughout the process, Peter has struck a wonderful balance between encouragement and an even greater kindness, brutally frank advice about what should be cut or rewritten. To my delight, Peter's office is now in the Flatiron building, the celebrated New York landmark often photographed by Stieglitz and Steichen.

A host of brilliantly talented people at Bloomsbury, many of whom I've never met face-to-face, and who thus seem rather like those spectral hands in Jean Cocteau's film *Beauty and the Beast*, have coaxed the project into final form. I'm extremely grateful to Greg Villepique, the managing editor who initially handled production, as well as to Mike O'Connor and Nate Knaebel, who later picked up this responsibility. India Cooper, the copy editor, showed quite remarkable skill in catching errors while at the same time retaining those quirks of diction that give writing a personal character. Nancy Gilbert did proofreading and Kathy Barber prepared the index. Natalie Slocum designed the cover; Jiyeon Dew, associate production manager, sensitively designed the interior of the book; Amy C. King played the role of creative director; and Jason Bennett served as the book's publicist.

I owe immeasurable thanks to three close friends who've stood by me and provided encouragement while I was working on this text: the artist Chris Pekoc, the filmmaker Thomas Ball, and the photographer Abe Frajndlich. Other friends who read through the manuscript include Cathie Bleck, Loring Coleman, Nancy Keithley, Indra Lacis, George Mueschler, Robinson Lacy, Katie Steiner, and John Tatlock. Sadly, the library of the Cleveland Museum of Art has become increasingly difficult to use over the last few years. Most of the research for this book was conducted at the Jessica Gund Library at the Cleveland Institute of Art, supervised by Christine Rom, who couldn't have been more wonderful. Arlene Sievers-Hill at Kelvin Smith Library at Case Western Reserve University was also extremely helpful in ordering books for my research. Marianne Berardi read through many drafts and also discovered the letters of Pollock's name in Benton's mural for Peggy Guggenheim, as has been noted in a footnote.

Quite a group of Benton experts or enthusiasts helped in one way or another, including Jessie Benton and Anthony Benton Gude; Michael Owen, Jim Yost, and Andrew Thompson of the Owen Galleries in New York; Burton Dunbar in Kansas City; Vivian Kiechel and Buck Kiechel in Lincoln, Nebraska; Leo G. Mazow; Margaret C. Conrads and Randy Griffey at the Nelson-Atkins Museum of Art; Wesley Nedblake and Bill Sellers in Kansas City; and Art Haseltine in Springfield, Missouri. Two extremely gifted scholars of Pollock's work, my colleague at Case Western Reserve, Ellen Landau, and Sue Taylor, of Portland State University, Portland, Oregon, kindly read through this text, although they are in no way responsible for its content. The immensely gifted San Francisco painter Stephanie Peek provided memories of looking at Pollock's psychoanalytic drawings and also closely read through the rest of the manuscript. John Rosenfield, professor emeritus of Japanese art at Harvard, generously sent me an account of his memories of Stanton Macdonald-Wright and lent me his copy of Osvald Sirén's *The Chinese on the Art of Painting*, with Macdonald-Wright's copious annotations. At the last minute, Helen Harrison, director of the Pollock-Krasner House and Study Center in East Hampton, Long Island, generously read through the manuscript and caught several embarrassing errors.

In the spring of 2008 the students in my seminar at Case Western Reserve read through an early version of this manuscript, about twice the present length, and made many helpful comments. This group included Amanda Bocci, Brian Bauchler, Megan Carpenter, Lauren Hansgen, Christine Herdman, Andrew Keast, Virginia Konchan, Christina Larson, Whitney Lloyd, Alisa McCusker, M. L. Moore, Henry Travers Newton, Hannah Rach, Chris Reed, Margaret Roulett, Ellen Stedtefeld, Amber Stitt, Erin Valentine, and Esther Wysong.

Subsequent to the class, Virginia Konchan helped with editing, provided helpful information on Jung and alcoholism, and even wrote a poem on Pollock that will appear in the literary magazine the *Believer*.

Bibliography

Most readers will probably feel that this book is very large, perhaps even too large, but to me it feels like a haiku, since so many scholarly arguments have had to be compressed to the point where they are not stated but simply evoked. As is surely not uncommon, most of the work of writing this text went not into the book itself but into the numerous alternative ways of telling this story that were discarded along the way. It began with a typescript roughly four times the present length, which was compressed to one merely twice as long, which finally, on the good advice of my editor, Peter Ginna, was struck down to the present size.

While at times this book reads like a novel, nothing has been made up. Every fact rests on a primary source, and none of the dialogue is invented—it is all drawn from magazine and newspaper stories, tape-recorded interviews, or the testimony of witnesses to the event. In some cases, I have found small discrepancies in different accounts—for example, the various accounts of the car crash that killed Pollock differ in minor particulars. In such cases I've tried to sort out which version seems most reliable and to assemble a version that, as much as possible, rests on verifiable evidence.

Like all scholars, I owe a huge debt to my predecessors, particularly those hardy souls who have devoted effort to primary research. Much academic scholarship is simply a reshuffling of existing facts through the lens of some fashionable method or critical theory. Those who take the trouble to dig into primary sources in order to reshape the foundations

of art history are a tiny group, whose dedicated labor is generally little understood and ill rewarded. Seemingly simple facts, like the date of a birth or the date of a painting, are often difficult to pin down, and even rich troves of primary documentation contain frustrating gaps and are often surprisingly difficult to organize or interpret accurately. The fact that I have occasionally disagreed with some of these scholars, or pursued different avenues of interpretation, should not obscure my immense debt to them. This book could never have been written without their hard work.

When I first became interested in the relationship between Benton and Pollock, I had a good grasp of Benton's biography, but there was surprisingly little solid scholarship on Pollock, Russell, or Macdonald-Wright: what had been written about their lives and their art was very incomplete and not always accurate. This situation has changed greatly. To a large degree, in fact, this book is simply an effort to combine three areas of scholarship that have made immense progress over the last twenty years but that have developed largely in isolation from each other.

As noted, most of the material in this book can be grouped under three themes: Synchromism, Thomas Hart Benton, and Jackson Pollock. Let me say a few words about the bibliography on each of these subjects. (I have listed all the sources I consulted in an alphabetical list at the end of this bibliography. Specific citations of quoted material are available at www.TomandJack.com.)

Synchromism
Recently two excellent accounts have appeared on Morgan Russell and Stanton Macdonald-Wright, which fill out their lives and artistic development: Marilyn Kushner, *Morgan Russell* (New York: Hudson Hills Press in association with the Montclair Art Museum, 1990), which is largely based on the collection of Russell's papers and sketches that was deposited at the Montclair Art Museum; and Will South, *Color, Myth, and Music: Stanton Macdonald-Wright and Synchromism* (Raleigh: North Carolina Museum of Art, 2001), which is particularly helpful in its explanations of color theory and of the stylistic development of Macdonald-Wright's work. The weakness of both of these studies is that they take a very partisan approach, celebrating the achievement of their particular subject but devoting little attention to how Russell and

Macdonald-Wright interacted with each other and failing to examine how Synchromism fit within larger cross-currents of artistic friendships, rivalries, and influences. Will South seems to be particularly hostile to Thomas Hart Benton and, ironically, because of that fact fails to fully grasp Macdonald-Wright's larger significance to the development of modern American art. In refreshing contrast to this tone of humorless reverence is John Loughery's carefully researched biography of Willard Wright, *Alias S. S. Van Dine: The Man Who Created Philo Vance* (New York: Charles Scribner's Sons, 1992), which catalogues the misdeeds and escapades of Willard Wright while also doing justice to his authentic accomplishments and moving masterfully from literature to painting, from one cultural realm to another, without ever losing the thread of the story. Because of these important monographs, with their wealth of new information, Synchromism as a movement deserves a new large-scale study. The basic outline of its development, however, has been very well chronicled in Gail Levin's *Synchromism and American Color Abstraction, 1910–1925* (New York: Whitney Museum of American Art, 1978), which was the pioneering study of the subject and still remains the best account of the whole movement. All these books have bibliographies filled with useful references.

For information on Macdonald-Wright I've drawn extensively from the material in Benton's unpublished, never quite finished autobiography, *The Intimate Story*, in the Benton Trust; I found it very helpful to listen to some tape-recorded interviews with Macdonald-Wright provided to me by the late Jan Stussi; and for my account of the Forum Exhibition I've drawn on James Agee's article "Willard Huntington Wright and the Synchromists: Notes on the Forum Exhibition," *Archives of American Art Journal* 24, no. 2 (1984), pp. 10–15. In addition, Professor James Rosenfield lent me his copy (inscribed to him by Macdonald-Wright in 1958) of Sirén's *The Chinese on the Art of Painting* (Peiping: Henri Vetch, 1936, acquired by Macdonald-Wright in 1938), which is filled with Macdonald-Wright's annotations.

Thomas Hart Benton

For the section on Benton, the hardest problem was to cut down what I know to a manageable length. Benton himself wrote most intelligently about his work in two published autobiographies, *An Artist in America*,

(4th rev. ed., Columbia and London: University of Missouri Press, 1983) and *An American in Art* (Lawrence: University Press of Kansas, 1969). He also penned an unfinished, unpublished autobiography, *The Intimate Story*, which exists in manuscript and typescript in the Benton Trust, UMB Bank, Kansas City. Another wonderful source on Benton is the typescript of interviews compiled when I worked with Ken Burns on a documentary film on Benton, including much material that did not make it into the final cut. I've published two books on Benton, *Thomas Hart Benton: An American Original* (New York: Alfred A. Knopf, 1989) and *Thomas Hart Benton: Drawing from Life* (New York: Abbeville Press, 1990). I currently serve on the committee of the Benton catalogue raisonné, sponsored by the Owen Gallery (along with Michael Owen, Jim Yost, Jessie Benton, and Anthony Benton Gude), and this has provided me with a constant influx of new information about Benton. I've also delivered dozens of lectures on his work, many of them still only in typescript; and both my books were based on much longer preliminary typescripts, which I've consulted. Of the articles and catalogues I've published on Benton, the most useful are probably "Thomas Hart Benton as a Teacher," introduction to Marianne Berardi, *Under the Influence: The Students of Thomas Hart Benton* (St. Joseph, Mo.: Albrecht-Kemper Museum of Art, 1994), pp. 1–29; "The Drawings of Thomas Hart Benton," *American Artist: Drawing*, Winter 2005, pp. 40–55; and "The Benton Fake Game," International Foundation for Art Research *IFAR Journal* 9, no. 1 (2006), pp. 16–27. Among the many recent publications by other scholars on Benton, I found three particularly informative and helpful: Marianne Berardi, *The Work of Our Friends: The Collection of Thomas Hart Benton and Rita Piacenza Benton* (Chicago: Aaron Galleries, 1998); Erika Doss, *Benton, Pollock, and the Politics of Modernism* (Chicago: University of Chicago Press, 1991); and Leo G. Mazow, "Regionalist Radio: Thomas Hart Benton on Art for Your Sake," *Art Bulletin*, March 2008, pp. 101–22. I've provided a bibliography of the most important publications on Benton in the *Drawing from Life* book, already cited. Anyone doing truly intensive research on the artist should simply consult the materials on Benton I gathered for the Knopf biography, which are housed in the American Art Department at the Nelson-Atkins Museum in Kansas City. This collection contains virtually every article ever published on Benton, organized chronologically, as well as

files on topics pertinent to his work, such as "The Harmonica" or "Missouri Mules."

Jackson Pollock

While the literature on Jackson Pollock is vast, the number of really substantial publications, as is often the case, is not overwhelmingly large. What follows is a brief listing of the publications I found most useful.

Scholarship on Jackson Pollock owes a huge debt to the business savvy of the art dealer Eugene Thaw, who realized that Pollock's work was both artistically significant and also rare, and consequently that it made good business sense to track down the location of his works. The result of this insight was a monumental achievement, *Jackson Pollock: A Catalogue Raisonné of Paintings, Drawings and Other Works* (New Haven and London: Yale University Press, 1978), which Thaw coauthored with Francis O'Connor, who did much of the work of compiling and organizing the information. The appearance of this book marked the opening of a new era in Pollock scholarship. O'Connor and Thaw's catalogue provided the foundation for Ellen Landau's *Jackson Pollock* (New York: Abrams, 1989), a thoughtful, well-researched, well-illustrated monograph, which in my opinion is still the best general introduction to Pollock's work and does an extremely good job of balancing biography, art history, and cultural analysis.

Landau's book was published in the same year as the other indispensable biography of Pollock, Steven Naifeh and Gregory White Smith's *Jackson Pollock: An American Saga* (New York: Clarkson Potter, 1989). Naifeh and Smith's book is controversial among art historians for its alleged sensationalism and occasional factual errors (art historians seem to be particularly bent out of shape by the insinuation that Pollock might have been homosexual). While these criticisms have a modicum of truth, I side with those who view the book as a monumental achievement, and entirely deserving of the Pulitzer Prize that it received. Based on tens of thousands of pages of interview transcripts and other data, the book introduced a vast wealth of new factual information to scholarship on Pollock. While it is certainly a book to battle with and struggle with, the quality of the writing is often breathtaking, and it is filled with astute and original insights. In writing this study, I generally turned first

to this remarkable volume and then checked its statements against a variety of other sources.

As a kind of counterbalance to Naifeh and Smith I found it helpful to occasionally turn to a less opinionated, more straightforward gathering of data, Jeffrey Potter's *To a Violent Grave: An Oral Biography of Jackson Pollock* (New York: G. P. Putnam's Sons, 1985), which collects fascinating reminiscences from Pollock's family and friends. To avoid becoming lost in endless detail and remain focused on key elements of the story, I found it useful to consult Kirk Varnedoe's catalogue *Jackson Pollock* (New York: Museum of Modern Art, 1999), which sums up Pollock's career and critical reputation in a crisp, easy-to-read narrative, infused with the particular biases that one would expect from a curator assuming the mantle of Alfred Barr. The most substantive contribution to the volume is Pepe Karmel's article on Pollock's working process, which provides an illuminating glimpse into how Pollock made his paintings, step by step. Also well written and useful, if a little dated, is Deborah Solomon's *Jackson Pollock: A Biography* (New York: Cooper Square Press, 1987). Jeremy Lewison has written a helpful account of Pollock's work, devoted largely to an effort to grasp its artistic meaning, *Interpreting Pollock* (London: Tate Gallery Publishing, 1999). This includes useful summaries of recent critical writing. While many writers have scorned the book, I also found extremely illuminating material in Ruth Kligman's *Love Affair: A Memoir of Jackson Pollock* (New York: William Morrow, 1974).

After going to great trouble to locate and photocopy early articles on Pollock, I discovered that most of this material has been skillfully gathered by Pepe Karmel in *Jackson Pollock: Interviews, Articles, and Reviews* (New York: Museum of Modern Art, 1999). Helen Harrison has collected a somewhat more unconventional group of writings about Pollock in *Such Desperate Joy: Imagining Jackson Pollock* (New York: Thunder's Mouth Press, 2000). Clement Greenberg's *Collected Essays and Criticism* have been gathered and edited by John O'Brian in a series of volumes (some still forthcoming) published by the University of Chicago Press, starting in 1986. Among the recent publications on Pollock, some that stand out for their quality are Sue Taylor, "The Artist and the Analyst: Jackson Pollock's 'Stenographic Figure,'" *American Art* 17, no. 3 (Autumn 2003), pp. 53–71; David Anfam, "Pollock's

Drawing: The Mind's Line," in Susan Davidson, organizer, *No Limits, Just Edges: Jackson Pollock, Paintings on Paper* (New York: Guggenheim, 2005); and Ellen Landau, "Action/Re-Action: The Artistic Friendship of Herbert Matter and Jackson Pollock," in Ellen G. Landau and Claude Cernuschi, editors, *Pollock Matters* (Chestnut Hill, Mass.: McMullen Museum of Art, Boston College, distributed by University of Chicago Press, 2007).

Other Topics

For information on Matisse I've consulted Hilary Spurling, *The Unknown Matisse: A Life of Matisse, the Early Years, 1869–1908* (New York: Alfred A. Knopf, 1999); and Dorothy Kosinski et al., *Matisse: Painter as Sculptor* (New Haven: Yale University Press, 2007). Leo Steinberg wrote a provocative article on Picasso's *Three Women*: "Resisting Cézanne: Picasso's 'Three Women,'" *Art in America* 66 (November 1978), pp. 114–33. The figure who largely unscrambled the confusing biography of John Graham is the late Eleanor Green in *John Graham, Artist and Avatar* (Washington, D.C., Phillips Collection, 1988). I've supplemented this with material from Ultra Violet, *Famous for 15 Minutes: My Years with Andy Warhol* (New York: Harcourt Brace Jovanovich, 1988). Graham's most important article for Pollock was "Primitive Art and Picasso," *Magazine of Art*, April 1937, pp. 236–39, 260. He also published an aphoristic book on the nature of art, *System and Dialectics of Art* (New York: Delphic Studios, 1937). For Alfred Barr I've drawn chiefly from Alice Goldfarb Marquis, *Alfred H. Barr, Jr.: Missionary for the Modern* (New York: McGraw-Hill, 1989). For Clement Greenberg I've relied largely on Florence Rubenfeld, *Clement Greenberg: A Life* (New York: Scribner, 1988). The most intelligent, entertaining, and art historically informed book on Peggy Guggenheim is Jacqueline Bograd Weld, *Peggy: The Wayward Guggenheim* (New York: E. P. Dutton, 1986), which was based on a great deal of primary material, drawn from interviews. For a wonderful introduction to Abbott Thayer and camouflage, see Richard Meryman (son of the painter of the same name who worked with Thayer), "A Painter of Angels Became the Father of Camouflage," *Smithsonian*, April 1999, pp. 116–28. For a comprehensive account of Thayer's work, see Gerald H. Thayer, *Concealing-Coloration in the Animal Kingdom; An Exposition of the Laws of Disguise Through*

Color and Pattern: Being a Summary of Abbott H. Thayer's Discoveries,
with an introductory essay by A. H. Thayer, illustrated by Abbott H.
Thayer, Gerald H. Thayer, Richard S. Meryman, and others and with
photographs (New York: Macmillan, 1909).

Bibliography

Abrioux, Yves. *Ian Hamilton Finlay, A Visual Primer.* Cambridge, Mass: MIT
Press, 1992.

Adams, Henry. "Artists Also Rode the Rails: Thomas Hart Benton and the Railroad Song." Unpublished typescript of presentation for the conference *Waiting for a Train: Jimmie Rodgers' America*, held in Cleveland on September 20, 1997, and sponsored by Case Western Reserve University, the Country Music Foundation, and the Rock and Roll Hall of Fame.

———. "Ascesa e caduta di Thomas Hart Benton," "Gli ultimi anni," "Catalogo delle opere," "Notizia biografica," "Exposizioni principali," and "Bibliografia essenziale." In *Thomas Hart Benton*, catalogue of an exhibition at the Museo d'Arte Moderna, Lugano, pp. 26–83, 125–32, 147–72, 173–83, 185–86, 187–88. Milan: Electa, 1992.

———. "The Benton Fake Game." *IFAR Journal*, vol. 9, no. 1 (2006), pp. 16–27.

———. "Benton Paintings Donated to Museum." Calendar of the Nelson-Atkins Museum of Art, Kansas City, October 1987, pp. 2–3.

———. "Benton Sketchbook Donated to Museum." Calendar of the Nelson-Atkins Museum of Art, Kansas City, December 1992, p. 3.

———. "Benton's 'Closest Friend' Enters Collection." Calendar of the Nelson-Atkins Museum of Art, Kansas City, March 1991, p. 3.

———. Biography of Thomas Hart Benton and entry on Thomas Hart Benton's *Persephone*. In *Art and Artists: International Dictionary of Art and Artists.* Ed. James Vinson. Foreword by Cecil Gould. Chicago and London: St. James Press, 1990.

———. *Boardman Robinson: American Muralist and Illustrator, 1876–1952.* Catalogue and checklist accompanying an exhibition at the Colorado Springs Fine Arts Center, September 21, 1996–January 12, 1997. Colorado Springs: Colorado Springs Fine Arts Center, 1996.

———. *Dangerous Drawings: The Radical Line of Boardman Robinson.* Unpublished book-length manuscript.

———. "Did Benton Draw Well?" Brochure to accompany an exhibition of Thomas Hart Benton's drawings, *Thomas Hart Benton: An Intimate View.* Kansas City: Smith-Kramer Fine Arts Services, 1993. Reprinted in part as "Thomas Hart Benton: An Intimate View," *American Art Review*, vol. 5, no. 4 (summer 1993), pp. 114–15.

———. "Director's Letter" on the acquisition of Thomas Hart Benton's *June Morning* (1945). Calendar of the Cummer Museum of Art and Gardens, Jacksonville, Fla., April 1995, unpaginated.

———. "The Drawings of Thomas Hart Benton." *American Artist: Drawing*, winter 2005, pp. 40–55, cover, and 38 illustrations.

———. Entries on a sketchbook and eight drawings by Thomas Hart Benton. In the exhibition catalogue for *American Drawings and Watercolors from the Kansas City Region*, July 19–September 6, 1992, pp. 226–39. Kansas City: Nelson-Atkins Museum of Art, 1992.

———. Entry on Thomas Hart Benton's *Persephone*. In the exhibition catalogue for *A Bountiful Decade: Selected Acquisitions 1977–1987, The Nelson-Atkins Museum of Art*. Ed. Roger Ward and Eliot Rowlands. Kansas City: Nelson-Atkins Museum of Art, 1987.

———. Entry on Thomas Hart Benton's *G.O.P. Convention, Cleveland, 1936*. In *Masterpieces of Watercolor and Drawing*. Cleveland: Cleveland Museum of Art.

———. Entry on Thomas Hart Benton's *Harbor Scene, 1918*. In *Regionalism, Paintings & Drawing*. Lincoln, Neb.: Kiechel Fine Art, 2007.

———. "Henry Clausen." In *A Dictionary of Artist's Models*. Ed. Jill Jiminez. London: Fitzroy Dearborn Publishers, December 2000.

———. *Kansas City Remembers Thomas Hart Benton: 1889–1975*. Brochure for exhibition organized by Smith-Kramer Fine Arts Services at the Federal Reserve Bank, Kansas City, April 6–May 26, 1989.

———. "Karal Ann Marling, *Tom Benton and His Drawings: A Biographical Essay and a Collection of His Sketches, Studies and Mural Cartoons*." Book review in *Winterthur Portfolio* XXII, no. 1 (spring 1988), pp. 102–6.

———. "Our Own Thomas Hart Benton." *WETA Magazine*, November 1989, pp. 12–13.

———. *Thomas Hart Benton*. Exhibition catalogue, with an essay on Benton's *History of New York*. New York: Hammer Galleries, March 2004.

———. "Thomas Hart Benton." In *American National Biography*, Oxford University Press.

———. "Thomas Hart Benton." In *Dictionary of Missouri Biography*, University of Missouri Press.

———. "Thomas Hart Benton." *Southwest Art*, May 1990, pp. 112–18, 220–21.

———. *Thomas Hart Benton: An American Original*. In association with the Nelson-Atkins Museum of Art and the WGBH Educational Foundation, Boston. New York: Alfred Knopf, 1989.

———. *Thomas Hart Benton: An Intimate View*. Catalogue for an exhibition at the Fine Arts Gallery, Federal Reserve Bank, Kansas City, Missouri, October 8, 1985–January 25, 1986.

———. *Thomas Hart Benton: An Intimate View*. Exhibition brochure; not the same text as the catalogue.

———. "*Thomas Hart Benton: Artist, Writer, Intellectual*, edited by R. Douglas Hurt and Mary K. Dains." Book review in *Gateway Heritage*. St. Louis: Missouri Historical Society, 1990.

———. "Thomas Hart Benton: Bad Boy of the Art World." *USA Today Magazine*, November 1989, pp. 32–44.

———. *Thomas Hart Benton: Drawing from Life*. In association with the Henry Art Gallery, University of Washington, Seattle. New York: Abbeville Press, 1990.

————. *Thomas Hart Benton: Drawing from Life.* Gallery guide. Seattle: Henry Art Gallery, 1990.

————. "Thomas Hart Benton and African-American Subjects." Unpublished typescript of a lecture at the J. B. Speed Museum, Louisville, Kentucky, July 28, 1994.

————. "Thomas Hart Benton and Jackson Pollock." Unpublished lecture for the colloquium *Jackson Pollock: The Early Sketchbooks* held at the Metropolitan Museum of Art, New York, on January 17, 1998.

————. "Thomas Hart Benton as a Teacher." Introduction to Marianne Berardi, *Under the Influence: The Students of Thomas Hart Benton.* Exhibition catalogue, pp. 1–29. St. Joseph, Missouri: Albrecht-Kemper Museum of Art, January 1994.

————. "Thomas Hart Benton, *Hoeing Cotton.*" In *Portraits and Other Recent Acquisitions, 2007.* New York: Lawrence Steigrad Fine Arts, 2007.

————. "Thomas Hart Benton, *The City.*" In *American Art*, pp. 94–95. New York: Phillips de Pury and Luxembourg, 2002.

————. "Thomas Hart Benton's 101st Birthday—And a New Benton for the Museum." Calendar of the Nelson-Atkins Museum of Art, April 1990, pp. 1–2.

————. "Thomas Hart Benton's *Boomtown.*" Entry for book on masterworks of the collection. Rochester: Memorial Art Gallery, 2005.

————. "Thomas Hart Benton's Illustrations for *The Grapes of Wrath.*" University of California at San Jose, *San Jose Studies* (winter 1990), pp. 6–18.

————. "Thomas Hart Benton's mural of *The Art of Life in America.*" In *New Britain Museum of American Art: Highlights of the Collection*, pp. 28–33. Munich, London, and New York: Prestel, 1999.

————. "Thomas Hart Benton's Transformation of History Painting." Unpublished typescript of a talk for the session on American history painting at the annual meeting of the College Art Association, New York, February 17, 1990.

————. "Tom Benton's Drawings." Brochure for an exhibition of drawings from the Benton Trust circulated by Smith-Kramer Art Connections, December 1985.

Adams, Henry, and Marilyn Mellowes. "Thomas Hart Benton: An American Original." Corporate grant proposal for a film on Benton, WGBH Educational Foundation, Boston. 500 copies printed.

Agree, William C. "Willard Huntington Wright and the Synchromists: Notes on the Forum Exhibition." *Archives of American Art Journal*, vol. 30, nos. 1–4 (1990): pp. 88–93. Reprint of vol. 24, no. 2 (1984): pp. 10–15.

Allentuck, Marcia Epstein. *John Graham's System & Dialectics of Art.* Annotated from unpublished writings, with a critical introduction. Baltimore and London: Johns Hopkins University Press, 1971.

Anonymous. "One of Benton Harmonica Boys Is Here for Visit." *Edgartown (Mass.) Vineyard Gazette*, August 20, 1937.

Anonymous. "The Elegant Eccentric" (article on John Graham). *Newsweek*, October 24, 1960. p. 123.

Ashbery, John, and Kenworth Moffett. *Fairfield Porter (1907–1975), Realist Painter in an Age of Abstraction.* Boston: Museum of Fine Arts, 1982.

Benton, Thomas Hart. *An Artist in America.* 4th revised ed. Columbia: University of Missouri Press, 1983.

———. "Benton Answers." *Art Digest*, May 15, 1935, pp. 21, 22, 25.

———. *The Intimate Story.* Unpublished typescript. The Benton Trust, UMB Bank, Kansas City.

———. *The Life of Art in Paris.* Unpublished typescript. The Benton Trust, UMB Bank, Kansas City.

———. "Mechanics of Form Organization in Painting." *Arts*, vol. 10, no. 5 (November 1926), pp. 285–89; *Arts*, vol. 10, no. 6 (December 1926), pp. 340–42; *Arts*, vol. 11, no. 1 (January 1927), pp. 43–44; *Arts*, vol. 11, no. 2 (February 1927), pp. 95–96; *Arts*, vol. 11, no. 3 (March 1927), pp. 145–48.

———. "On the American Scene." *Art Front*, vol. 1, no. 4 (1935), pp. 3, 8.

Berardi, Marianne. *American Prints from the Collection of Thomas Hart Benton and Rita Piacenza Benton.* Catalogue 4, Aaron Galleries, Chicago, fall 1998.

———. *Under the Influence: The Students of Thomas Hart Benton.* Exhibition catalog, with an essay by Henry Adams on "Thomas Hart Benton as a Teacher." St. Joseph, Mo.: Albrecht-Kemper Museum of Art, 1993.

Berardi, Marianne, and Tyler Osborn. Unpublished transcript of interview with Ed Voegele and Sam Stephen Lispi at Lispi's home in Kansas City, Mo., May 19, 1992.

Boswell, James. *Life of Samuel Johnson, LL.D.* London: G. Cowle and Co., 1824.

Braught, Ross. *Phaeton.* 100 numbered and autographed copies with original lithographs on zinc, published December 1935, proofs by Emmet Ruddock, type set by hand and printed by the Lowell Press, Kansas City, Mo., binding by H. Engel and Son. Text from the translation of Ovid's *Metamorphosis* by Joseph Addison. The John Dryden translation is used in the verse on Chaos.

Braun, Emily, and Thomas Branchick. *Thomas Hart Benton: The America Today Murals.* New York: The Equitable Life Assurance Society of the United States, 1985.

Burck, Jacob. "Benton Sees Red." With an editorial introduction by Stuart Davis. *Art Front*, vol. I, no. 4 (1935), p. 4.

Burns, Ken. Unpublished transcripts (circa 1987) of interviews with Matthew Baigell, Earl Bennett, Jessie Benton, John Callison, Vincent Campanella, Ann and Lee Constable, Dick Craven, Lyman Field, Ed Fry, Lloyd Goodrich, Pam Hoelzel, Burl Ives, Dan James, Hilton Kramer, Sid Larson, Carol Ann Marling, Bill McKim, Roger Medearis, Dorothy Miller, George O'Malley, Eleanor Piacenza, Santo Piacenza, Raphael Soyer, Henry and Peggy Scott, Mildred Small, and Andrew Warren, as well as a copy of a letter from Pete Seeger about Benton and a transcript of a tape-recorded conversation between Earl Bennett and Thomas Hart Benton, October 16, 1966.

Burroughs, Polly. *Thomas Hart Benton: A Portrait*. Garden City, N.Y.: Doubleday, 1981.

Carlton, Patricia M. "Caroline Pratt: A Biography." Doctoral dissertation, Columbia University Teacher's College, 1986.

Cernuschi, Claude. *Jackson Pollock: "Psychoanalytic" Drawings*. Foreword by Michael P. Mezzatesta. In association with Duke University Museum of Art. Durham, N.C.: Duke University Press, 1992.

Cernuschi, Claude, and Andrzej Herczynski. "The Subversion of Gravity in Jackson Pollock's Abstractions." *Art Bulletin*, December 2008, pp. 616–38.

Clark, Kenneth. *The Other Half: A Self-Portrait*. New York: Harper & Row, 1977.

Cleveland, David. *Ross Braught: A Visual Diary*. Exhibition catalogue. New York: Hirschl & Adler Galleries, 2000.

Cocteau, Jean. *Le Coq et l'Arlequin—Notes Autour de la Musique, Avec un Portrait de l'Auteur et Deux Monogrammes par P. Picasso*. Paris: Editions de la Sirene, 1918.

Cowart, Jack, and Juan Hamilton. Letters selected and annotated by Sarah Greenough. *Georgia O'Keeffe, Art and Letters*. Washington, D.C.: National Gallery of Art; New York: New York Graphic Society; and Boston: Little, Brown and Company, 1988.

Craven, Thomas. *Men of Art*. New York: Simon and Schuster, 1931.

———. *Modern Art: The Men, the Movements, The Meaning*. New York: Simon and Schuster, 1934.

Crichton, Michael. *Jasper Johns*. In association with the Whitney Museum of American Art, New York. New York: Harry N. Abrams, 1994.

Cummings, Paul. "The Art Students League, Part I." *Archives of American Art Journal*, vol. XIII, no. 1 (1973).

———. "An Interview with Stuart Davis." *Archives of American Art Journal*, vol. 31, no. 2 (1991), p. 10.

———. Tape-recorded interview with Thomas Hart Benton at his house in Gay Head, Martha's Vineyard, Mass., July 23, 1973. Unpublished transcript. Archives of American Art.

Davis, Stuart. "Davis Explains His Resignation from Artists Congress," *New York Times*, April 14, 1940, section 9, p. 9.

———. "Davis's Rejoinder to Thomas Benton." *Art Digest*, vol. 9 (April 1, 1935), pp. 12, 13, 26.

Doss, Erika. "The Art of Cultural Politics: From Regionalism to Abstract Expressionism." In *Recasting America: Culture and Politics in the Age of Cold War*, ed. Larry May. Chicago and London: University of Chicago Press, 1989.

———. *Benton, Pollock, and the Politics of Modernism: From Regionalism to Abstract Expressionism*. Chicago and London: University of Chicago Press, 1991.

Fitzgerald, F. Scott. *The Great Gatsby*. New York: Charles Scribner's Sons, 1925, 1953.

Fowles, John. *Wormholes*. London: Vintage, 1999.

Fried, Michael. "Jackson Pollock." *Artforum* 4, no. 1 (September 1965), pp. 14–17.

Gallagher, Robert S. "An Artist in America." *American Heritage*, vol. 24, no. 4 (June 1973).

Gantt, James B. *Notes to our Grandchildren.* Unpublished typescript, 237 pages.

Goldberg, Viki, *Margaret Bourke-White: A Biography.* Reading, Mass.: Addison-Wesley Publishing Company, 1987.

Graham, John. "Autoportrait." *Mulch*, spring 1972, pp. 1–3.

———. "Primitive Art and Picasso." *Arts*, vol. 30 (1937), pp. 236–39, 260.

———. *System and Dialectics of Art.* Annotated from unpublished writings with a critical introduction by Marcia Epstein Allentuck. Baltimore and London: Johns Hopkins University Press, 1971.

Graham, John D. *System and Dialectics of Art.* New York: Delphic Studios, 1937.

Grayman, Walter. "Art and Politics: the Radical Artists' Movement, 1926–1945." Doctoral dissertation, University of Missouri, Columbia, 1973.

Green, Eleanor. *John Graham: Artist and Avatar.* Washington, D.C.: Phillips Collection, 1987.

Greenberg, Clement. *Arrogant Purpose, 1945–1949.* Vol. 2 of *The Collected Essays and Criticism*, ed. John O'Brian. Chicago: University of Chicago Press, 1986.

Greenberg, Clement. *Perceptions and Judgments, 1939–1944.* Vol. 1 of *The Collected Essays and Criticism*, ed. John O'Brian. Chicago: University of Chicago Press, 1986.

Gruber, Richard. "Thomas Hart Benton: Teaching and Art Theory." Doctoral dissertation, University of Kansas, 1987.

Guggenheim, Peggy. *Out of This Century: The Informal Memoirs of Peggy Guggenheim.* New York: Dial Press, 1946.

Harrison, Helen A., ed. *Such Desperate Joy: Imagining Jackson Pollock.* Foreword by Ed Harris. New York: Thunder's Mouth Press/Nation Books, 2000.

Heil, Walter. *Meet the Artist: An Exhibition of Self-Portraits by Living American Artists.* Exhibition catalogue. San Francisco: M. H. de Young Memorial Museum, 1943.

Hemingway, Andrew. "Meyer Shapiro and Marxism in the 1930s." *Oxford Art Journal*, vol. 17, no. 1 (1994), pp. 13–29.

Herrera, Hayden. "Le Feu Ardent: John Graham's Journal." *Archives of American Art Journal*, vol. 14, no. 2 (1974), pp. 6–17.

Hills, Patricia. "Meyer Shapiro, Art Front and the Popular Front." *Oxford Art Journal*, vol. 17, no. 1 (1994), pp. 30–41.

Horn, Axel. "Jackson Pollock: The Hollow and the Bump." *Northfield (Minn.) Carleton Miscellany*, vol. 7, no. 3 (summer 1966), pp. 80–87.

Kantor, Sybil Gordon. *Alfred H. Barr, Jr., and the Intellectual Origins of the Museum of Modern Art.* Cambridge, Mass.: MIT Press, 2002.

Karmel, Pepe. *Jackson Pollock: Interviews, Articles, and Reviews.* New York: The Museum of Modern Art, distributed by Harry N. Abrams, 1999.

Kellner, Bruce. *The Last Dandy: Ralph Barton, American Artist, 1891–1931.* Foreword by John Updike. Columbia: University of Missouri Press, 1991.

Kierkegaard, Søren. *The Soul of Kierkegaard: Selections from His Journals.* Ed. and with an introduction by Alexander Dru. New York: Dover Publications, 2003.

Konchan, Virginia. "American Gothic" (poem). *Believer,* June 2009.

Kligman, Ruth. *Love Affair: A Memoir of Jackson Pollock.* New York: William Morrow & Company, 1974.

Kushner, Marilyn S. *Morgan Russell.* Introduction by William C. Agee. In association with the Montclair Art Museum. New York: Hudson Hills Press, 1990.

Landau, Ellen. *Jackson Pollock.* New York: Harry N. Abrams, 1989.

Landau, Ellen G., with the assistance of Jeffrey D. Grove. *Lee Krasner: A Catalogue Raisonné,* New York: Harry N. Abrams, 1995.

Landau, Ellen G., and Claude Cenuschi. *Pollock Matters.* Boston: McMullen Museum of Art, Boston College; distributed by University of Chicago Press, 2007.

Leja, Michael. *Reframing Abstract Expressionism.* New Haven: Yale University Press, 1993.

Levin, Gail. *Synchromism & American Color Abstraction, 1910–1925.* New York: George Braziller, 1978.

———. "Synchromism: The State of the Scholarship—Past, Present and Future." *Arts,* vol. 53 (September 1978), pp. 131–35.

Lewison, Jeremy. *Interpreting Pollock.* London: Tate Gallery Publishing, 1999.

Loughery, John. *Alias S. S. Van Dine: The Man Who Created Philo Vance.* New York: Charles Scribner's Sons, 1992.

Macdonald-Wright, S. *A treatise on COLOR.* Los Angeles: privately printed by S. Macdonald-Wright, 1924.

Marquis, Alice Goldfarb. *Alfred Barr, Missionary for the Modern.* Chicago and New York: Contemporary Books, 1989.

Marsh, Reginald. "Thomas Benton." *Demcourier,* vol. 13, no. 2 (1943), p. 9.

McBride, Henry. "Whitney Museum Decorations Still a Subject for Debate." *New York Sun,* December 31, 1932, p. 22.

Mellow, James R. *Charmed Circle: Gertrude Stein & Company.* New York: Praeger Publishers, 1974.

Monroe, Gerald M. "The American Artists' Congress and the Invasion of Finland." *Journal of the Archives of American Art,* vol. XV, no. 1, p. 15.

Naifeh, Steven, and Gregory White Smith. *Jackson Pollock, An American Saga.* New York: Clarkson N. Potter, 1989.

Nash, Steven A., et al. *Albright-Knox Art Gallery: Painting and Sculpture from Antiquity to 1942.* Foreword by Robert T. Buck. New York: Rizzoli International Publications, 1979.

Newman, Barnett. *Barnett Newman, Selected Writings and Interviews.* Ed. John P. O'Neill. Text notes and commentary by Mollie McNickle. Introduction by Richard Shiff. New York: Alfred A. Knopf, 1990.

O'Connor, Francis. "The Genesis of Jackson Pollock: 1912–43." *Artforum,* vol. 5, no. 9 (May 1967).

O'Connor, Francis V. "Jackson Pollock's Mural for Peggy Guggenheim: Its Legend, Documentation, and Redefinition of Wall Painting." In Susan Davidson and Philip Rylands, eds., *Peggy Guggenheim & Frederick Kiesler, The Story of Art of This Century*, Peggy Guggenheim Collection, Venice, 2004, pages 151–65.

O'Connor, Francis Valentine, and Eugene Victor Thaw. *Jackson Pollock: A Catalogue Raisonné of Paintings, Drawings and Other Works*. New Haven: Yale University Press, 1978.

Ottinger, Gregg. Letter to Marianne Berardi, January 27, 1992, with a transcript of his father's memories.

Pearson, Ralph M. "Rugs in the Modern Manner: a group of our modern artists give us their conceptions." *Country Life*, February 1929.

Polcari, Stephen. "Jackson Pollock and Thomas Hart Benton." *Arts*, vol. 53, no. 7 (March 1979), pp. 324–29.

Pollock Family. *American Letters, 1927–1958*. Choice of texts by Francesca Pollock. Edited and annotated by Sylvia Winter Pollock. Preface by Michel Crepu. Drawings by Charles Pollock. Paris: Editions Grasset, 2009.

Pollock, Jackson. "My Painting." *Possibilities 1: An Occasional Review*, winter 1947/8, p. 79.

Potter, Jeffrey. *To a Violent Grave: An Oral Biography of Jackson Pollock*. Wainscott, N.Y.: Pushcart Press, 1987; reprint of G. P Putnam's edition, published 1985.

Rand, Harry. *Arshile Gorky, The Implications of Symbols*, Montclair, N.J.: Allenheld, Osmun & Co. and Abner Schram, 1980.

Reed, Alma. *Orozco*. New York: Oxford University Press, 1946.

Ricciotti, Dominic. "The Urban Scene: Images of the City in American Painting, 1890–1930." Doctoral dissertation, Indiana University, 1977.

Roberts, James Gordon, Jr. "Thomas Hart Benton's Mural, The Social History of Missouri," Doctoral dissertation, University of Missouri–Columbia, May 1989.

Roskill, Mark. "Jackson Pollock, Thomas Hart Benton, and Cubism: A Note." *Arts*, vol. 53, no. 7 (March 1979).

Rubenfeld, Florence. *Clement Greenberg: A Life*. New York: Scribner, 1997.

Rubin, William. "Jackson Pollock and the Modern Tradition." *Artforum*, vol. 5, no. 6 (February 1967), pp. 14–22; vol. 5, no. 7 (March 1967), pp. 28–37; vol. 5, no. 8 (April 1967), pp. 18–31; vol. 5, no. 9 (May 1967), pp. 28–33.

Schack, William. *Art and Argyrol: The Life and Career of Dr. Albert C. Barnes*. New York and London: Thomas Yoseloff, 1960.

Schnabel, Julian. *C.V. J, Nicknames of Maître D's & Other Excerpts from Life*. New York: Random House, 1987.

[Seiberling, Dorothy]. "Jackson Pollock: Is he the greatest living painter in the United States?" *Life*, August 8, 1949, pp. 42–45.

Siren, Osvald. *The Chinese on the Art of Paintings, Translations and Comments*. Peiping: Henry Vetch, 1936. Copy with Stanton Macdonald-Wright's annotations lent to me by Professor John Rosenfield, Harvard University.

Solomon, Deborah. *Jackson Pollock: A Biography*. New York: Cooper Square Press, 2001; reprint of first edition, 1987.

South, Will, with contributions by William C. Agee, John W. Coffey, and Marlene Park. *Color, Myth and Music: Stanton Macdonald-Wright and Synchromism*. Raleigh, N.C.: North Carolina Museum of Art, 2001.

Sprigge, Elizabeth. *Gertrude Stein: Her Life and Work*. New York: Harper & Brothers, 1957.

Spurling, Hilary. *The Unknown Matisse: A Life of Henri Matisse: The Early Years, 1869–1908*. New York: Alfred A. Knopf, 1998.

Stein, Gertrude. *The Autobiography of Alice B. Toklas*. New York: Literary Guild, 1933.

——. *Everybody's Autobiography*. Cambridge, Mass.: Exact Change, 1993.

——. *Two: Gertrude Stein and Her Brother, and Other Early Portraits* [*1908–12*]. Foreword by Janet Flanner. New Haven: Yale University Press, 1951.

Steinberg, Leo. "Resisting Cezanne: Picasso's 'Three Women.'" *Art in America*, vol. 66 (November 1978): 114–31.

Stevens, Mark, and Annalyn Swann. *De Kooning: An American Master*. New York: Alfred A. Knopf, 2004.

Taylor, Sue. "The Artist and the Analyst: Jackson Pollock's *Stenographic Figure*." *American Art*, fall 2003, pp. 53–71.

Thayer, Gerald H. *Concealing-Coloration in the Animal Kingdom: An Expositon of the Laws of Disguise Through Color and Pattern: Being a Summary of Abbott H. Thayer's Discoveries*. Introductory essay by A. H. Thayer. Illustrated by Abbott H. Thayer, Gerald H. Thayer, Richard S. Meryman, et al. New York: Macmillan, 1909.

Ultra Violet. *Famous for 15 Minutes: My Years with Andy Warhol*. New York: Avon, 1988.

Valliere, James T. "The El Greco Influence on Jackson Pollock's Early Works." *Art Journal*, vol. 24, no. 1 (autumn 1964), pp. 6–9.

Varnedoe, Kirk, with Pepe Karmel. *Jackson Pollock*. New York: Museum of Modern Art, distributed by Harry N. Abrams, 1999.

Weintraub, Stanley. *Whistler: A Biography*. 1974; New York: Da Capo Press, 2001.

Weld, Jacqueline Bograd. *Peggy: The Wayward Guggenheim*. New York: E. P. Dutton, 1986.

Whiting, Cecile. *Antifascism in American Art*. New Haven: Yale University Press, 1989.

Wilkin, Karen. *Stuart Davis*. New York: Abbeville Press, 1987.

Wright, Willard. *The Creative Will: Studies in the Philosophy and the Syntax of Aesthetics*. New York: John Lane, 1916.

Wright, Willard Huntington. *Modern Painting, Its Tendency and Meaning*. New York: Dodd, Mead and Company, 1930; reprint of John Lane edition, 1915.

Wysuph, C. L. *Jackson Pollock: Psychoanalytic Drawings*. New York: Horizon Press, 1970.

Index

Note: Page numbers in *italic* indicate photographs.

A Note on the Author

Henry Adams has been singled out by *ARTnews* as one of the foremost experts on American painting, and his most recent book, *Eakins Revealed,* has revolutionized studies of Thomas Eakins, another icon of American art. He collaborated with Ken Burns on a documentary on Benton, which was watched by twenty million viewers on PBS. He is a professor of American art at Case Western Reserve University in Cleveland.